Print the Legend

Print the Legend

Photography and the American West

MARTHA A. SANDWEISS

Yale University Press New Haven and London

Designed by Sonia L. Shannon
Set in Monotype Bulmer
Printed in Italy by Eurographica

Library of Congress Cataloging-in-Publication Data
Sandweiss, Martha A.
Print the legend : photography and the
American West / Martha A. Sandweiss.
p. cm. — (Yale Western Americana series)
Includes bibliographical references and index.
ISBN 0-300-09522-8 (hardcover : alk. paper)
1. Photography—West (U.S.)—History. I. Title.
II. Yale Western Americana series (Unnumbered)
TR23.6 .S25 2002 770'.978—dc21 2002007038

A catalogue record for this book is available from the British Library.

For Adam and Sarah

Contents

Acknowledgments

This project began many years ago when I found myself spending inordinate amounts of time thinking about historical photographs no one had ever seen. Museum curators generally devote their time to pictures they can lay their hands on, but I found myself intrigued by pictures that had disappeared. How was it, I wondered, that the Mexican-American War daguerreotypes that arrived on my offiice desk one day in 1981 had sat unexamined and unmissed for many years in a Connecticut barn? How could it be that no one seemed to care when the many dozens, perhaps hundreds, of daguerreotypes that John Wesley Jones made along the overland trail between California and St. Louis in 1851 simply disappeared? Why was it that no one could find most of the daguerreotypes made on the federal exploring expeditions of the 1840s and 50s? If my curiosity was sparked by my interests as a western historian, it was flamed too by the burgeoning photographic collecting market of the 1980s that placed such a high value on early American photography. That growing market interest instructed us to value pictures that had been little valued before, but it also encouraged us to value pictures for reasons entirely unrelated to their original purpose. Photographs made to promote particular economic interests, for example, became valued as art. And photographs once valued only for the visual information they contained became valued anew as material artifacts in and of themselves. As early photographs moved onto museum walls and into collectors' hands, they were often severed from the other literary and pictorial material that had once rooted them in a particular historical period. I puzzled about what that meant about our ability to understand those pictures. It took me a long time to realize that many of the little photographic problems I was thinking about might somehow fit together in a larger whole, and to decide that if I could not, for example, always find missing pictures I might at least try to explain why they were missing.

My interest in western American photographs began in 1979, when I left graduate school to become the Curator of Photographs at the Amon Carter Museum in Fort

Worth, Texas, an institution where I was blessed with wonderful collections, abundant resources, and supportive colleagues. I had been studying colonial American history. The leap of faith required to take that job on my part seemed considerable, but it was probably not nearly so great as the leap of faith that my new employers were required to take of me. I will always be grateful to the late Mitchell A. Wilder, founding director of the Amon Carter, who, although he did not live long enough to see it, somehow knew that I might thrive in the world of photographic history. And so I did. Under the acting directorship of Ron Tyler and then under the guiding hand of Jan Muhlert, I spent ten years at the Amon Carter pursuing many of the historical pictures and problems that I explore in this book. From the first day I stepped into the museum world, Ron—a fellow historian—proved a generous mentor and colleague. He taught me how to be a curator, and over the past twenty years he has continued to teach me much about nineteenth-century images, about how to integrate the worlds of history and art history, about how to balance academic and administrative pursuits. My thanks go, too, to Carol Clark, former Curator of Painting at the Amon Carter and now a colleague at Amherst College, for conversations about western art that have now extended across two decades and half a continent. Among the many other Amon Carter colleagues who deserve my thanks are Ben Huseman, Barbara McCandless, Beth Muskat, Carol Roark, Tom Southall, and Rick Stewart.

My research for this book has taken me to archives and museums stretching from New England to Alaska, and with apologies to the many other curators, archivists, and scholars whose names now escape me, I want to thank for their time and generosity: Georgia Barnhill, Barbara Bennett, John Carter, Cathy Corman, Susan Danly, Lynn Davis, Bruce Dinges, Lawrence Dinnean, Paula Fleming, Patrick Folk, Ralph Franklin, Eleanor Gehres, Mick Gidley, Gene Gressley, David Haines, John Hoover, Alan Jutzi, Martha Kennedy, Gary Kurutz, Britta Mack, David Margolis, David Mattison, Karen Merrill, Delores Morrow, Arthur Olivas, Eric Paddock, Terry Pitts, Willow Powers, Chuck Rankin, Richard Rudisill, Eric Sandweiss, Robert Schlaer, Joan Schwartz, Kay Shelton, Rod Slemmons, Andrew Smith, Duane Sneddeker, Jennifer Watts, Richard White, and Richard Wood. My dissertation adviser, Howard Lamar, has remained unfailingly kind and supportive across the miles and years, as my research interests have strayed, sometimes nearer, sometimes further, from his own. William S. Reese, friend and book dealer extraordinaire, has been particularly generous over the years

with tips on photographs, access to research materials, and hospitality on my many research trips to New Haven. Peter Palmquist and Tom Kailbourn, the two most talented and dogged photographic researchers I have ever encountered, likewise deserve my thanks for their willingness to share their research even as they pursued publication projects of their own.

All scholars are dependent upon the generosity of librarians, but I have been particularly reliant on and grateful for the support offered me by three extraordinary colleagues. Alfred Bush, curator of the Princeton Collections of Western Americana, has been of enormous assistance in my work on photography and Native Americans and long been a generous guide to all matters bibliographic and southwestern. Milan Hughston, formerly Librarian at the Amon Carter Museum and now Librarian at the Museum of Modern Art, will recognize many of the footnotes in this book. He was truly a collaborator on many of the long research detours I took during my days at the Amon Carter, enjoying the thrill of the chase every bit as much as I did. George Miles, Curator of Western Americana at the Beinecke Rare Book and Manuscript Library at Yale University, will likewise find parts of this book familiar. George has given me countless opportunities to pursue my work among his matchless collections and to try out new ideas before public audiences and graduate student forums. Over the past two decades he has assembled a truly important collection of early western photographs that, augmenting Beinecke's already superb holdings, make Yale an essential (if geographically improbable) research institution for anyone working in the field of nineteenth-century western American photography.

At Amherst College, where I have worked since 1989, I owe thanks to my many colleagues at the Mead Art Museum and in the departments of American Studies and History who have made Amherst such a supportive and congenial place to work. If the writing of my book has been a somewhat solitary venture, I am nonetheless grateful for their friendship and intellectual companionship. Particular thanks, again, go to the library staff, especially Will Bridegam, Michael Kasper, Susan Edelberg, Daria D'Arienzo, and John Lancaster for their support of my research needs and queries. Thanks go, too, to Karen Graves for her assistance with managing the myriad details associated with the illustrations for this book, to Josh Garrett-Davis for tracking down last-minute queries, and to Frank Ward for photographic help. All who teach at Amherst College benefit from the institution's generous sabbatic leave policy and sup-

port of scholarship, and I am especially fortunate to have received a faculty research grant and a senior sabbatical fellowship to support my work on this project. My thanks to Ron Rosbottom and Lisa Raskin, the college deans past and present, and to college presidents Peter Pouncey and Tom Gerety.

I am grateful, too, for the research grants from the Beinecke Library at Yale and the Huntington Library in Pasadena, which enabled me to make monthlong research trips to each of these wonderful collections. A National Endowment for the Humanities grant for independent scholars launched me on an earlier version of this project in 1988, and a generous grant from the American Council of Learned Societies supported further research. The actual writing of this book, however, was enabled by the support of the School of American Research in Santa Fe, which awarded me a yearlong Resident Scholar award in 2000–2001, supported by grants from the National Endowment for the Humanities and the Weatherhead Foundation, with additional summer support from the Ethel-Jane Westfeldt Bunting Foundation. I owe particular thanks to Douglas Schwartz, Nancy Owen-Lewis, and Leslie Shipman for facilitating my stay at this idyllic research institution where scholars are, by and large, simply left alone to write their books, sustained by lovely gardens, blue Santa Fe skies, and engaging colleagues. I owe thanks to the School's library staff Lee Goodwin, Ellie Gossen, and Shirley Girard for supporting my work, and want to acknowledge the entire staff of the School for being such gracious hosts. I owe particular thanks to my fellow scholars, especially Rebecca Allahyari, James Brooks, Gary Gossen, Mary Eunice Romero, and Ruth Van Dyke, for their friendship and support and for their good questions and patient answers. It was truly a pleasure to spend the year in their company, and many little parts of this book have been shaped by ideas I've drawn from them and their own research projects. James, especially, was a generous reader of portions of this manuscript and pushed me to think in broader terms about my subject.

It is the generous colleague who is willing to indulge a long discussion about a book manuscript, and the rare one who is willing to actually read it. I am fortunate to have two friends and colleagues who read drafts of each of my chapters. Ann Fabian, a friend now of some twenty-five years and one of the most well-read people I know, worked hard to make me less ignorant about the broader field of American cultural history and provided me with many valuable bibliographical leads and thoughts about how to make my specific arguments speak to broader historical questions. David

Blight, my colleague in the Amherst College history department and erstwhile neighbor in Williston Hall, generously shared his thoughts about history and memory and tried his best to make me a more graceful writer. My warm thanks go to them both, not just for the sins they've prevented me from committing, but for the ways in which they have helped make this a better book.

At Yale University Press, I am grateful to Chuck Grench, who first showed an interest in this project, and to his successor, Lara Heimert, who has guided it toward publication with skill and enthusiasm. My thanks go, too, to Jeffrey Schier, Sonia Shannon, and Paul Royster, each of whom helped transform my manuscript into a book.

Finally, my thanks go to my family, near and far, who have nurtured and indulged my interests in things historic, visual and western. Being from St. Louis, the Gateway to the West, we are a family without any roots in the far West, except for the ones I may have laid down. But to my parents, Joy and Jerry Sandweiss, I give thanks for introducing my siblings and me to the pleasures of travel, of books, and of collecting the artifacts of other peoples' cultures. And to my husband, Bob Horowitz, and our children, Adam and Sarah, I offer thanks for sharing the countless adventures—in Juneau and Laramie, in Tucson and Santa Fe—that went into the production of this book. I dedicate this book to Adam and Sarah, subjects of most of my own western photographs, sources themselves of countless stories, and constant reminders that history is made anew, every day.

Introduction

Picture Stories

Photography and the Nineteenth-Century West

This is a story about photography and the American West, a new medium and a new place that came of age together in the nineteenth century. In 1839, the year that the Frenchman Louis Jacques Mandé Daguerre announced his marvelous new photographic invention to the world, much of the land now called the *American* West lay outside the political boundaries of the United States. In British-claimed Oregon, a handful of American immigrants were at work converting Indians; in the recently created Republic of Texas, diplomats were busy seeking international recognition; in the American-held Indian Territory, thousands of exhausted Cherokee people struggled to recreate a community after their forced relocation from the Southeast; and in Mexican-owned California, a Swiss immigrant named John Sutter bought a piece of land in order to construct a trading post along the Sacramento River. It did not take long for photographers to reach such widespread parts of the continent. News of Daguerre's astonishing invention, by which nature herself, through the action of light, seemed to inscribe her own image on the surface of a small metal plate, quickly captured the American imagination. "Their exquisite perfection almost transcends the bounds of sober belief," crowed one of the first Americans to see the daguerreotype plates in Paris.[1] By late 1839, East Coast men of science were experimenting with the new process and adding innovations of their own. And by the early 1840s, daguerreotypists were at work in the trans-Mississippi West.

Over the coming decades, photographers would take to the field with cameras and tripods, chemicals and plates, making vivid pictures of this place whose natural wonders and astounding resources seemed to beckon Americans westward and to ensure the success of their national enterprise. Photographers followed American troops into the war with Mexico that would result in the United States' annexation of California and the Southwest; they recorded the shifting fortunes of California's gold seekers, and they set out across the overland trails to record what prospective immigrants would see. They pictured the West's native peoples, largely to show that they would soon fade before the superior culture of the expanding United States, and they documented the region's highest peaks and deepest canyons to capture visual evidence of the divine blessings bestowed upon the American nation. In such photographs, Americans found persuasive evidence of what they had, who they were, and what they could become; and in the West, nineteenth-century American photography found its most distinctive subject.

2

The West loomed large in the American imagination, of course, before the invention of photography. Known through paintings and prints, maps and drawings, through the voluminous words penned by travelers and explorers, it was for many nineteenth-century Americans a fabled place of fantastic topography, exotic peoples, the place where the nation's future would unfold. Yet photographs seemed to make this imagined place more real. Through a coincidence of timing and opportunity, photographers preceded American settlers, travelers, and tourists into many parts of the West. Their pictures thus made newly vivid a landscape few Americans had seen for themselves; they became substitutes for firsthand experience. And yet for all the fresh detail, astonishing vivacity, and marvelous realism of these photographic images, photography did not instantly change the ways Americans understood the West. Indeed, Americans' preexisting visions of the West shaped, to some extent, how photographs of the

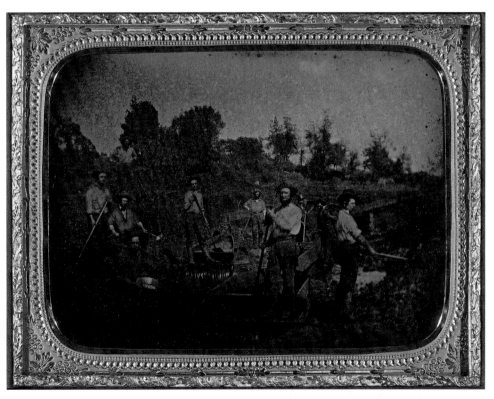

Unidentified photographer, *Gold Mining Scene*. Ambrotype with applied color, half-plate, 1850s.
Amon Carter Museum, Fort Worth, Texas (P1981.88)

place would be made, marketed, and understood. A tension lingered throughout the second half of the nineteenth century between the fabled West of the imagination and the more constricted vision of the place that could be captured on a daguerreotype plate or depicted in the chemical emulsion of a photographic print.

There are any number of stories one might tell about photography and the nineteenth-century American West, about the conjoined tales of a new pictorial medium and the new distinctively American region. This book, however, is neither an illustrated history of American expansionism nor a comprehensive history of photography in the West; indeed, some of the region's most productive, talented, and influential photographers get short shrift here. This is, instead, a kind of social or cultural history of photography in a particular place, that explores how Americans came to understand this new medium and this new region together, how emerging ideas about the West informed an understanding of the potential uses and meanings of photography, and how the evolving pictorial representations of the West in turn shaped popular thinking about the very subjects they portrayed.

This selective survey of western photographs focuses on what I call *public photographs.* If *private photographs,* the vast majority of which were portraits, were made for particular clients and designed to be held and used as private mementoes, public photographs were produced for less personal uses, and intended to be distributed through exhibition, publication, or sale. A history of private photographs in the mid-nineteenth-century West would make for a fascinating, if speculative, study about the history of emotions and the shifting concept of self in the American nation. In the 1840s, as Americans and other peoples from around the world moved into the West, photography provided a way for these immigrants to maintain visual ties to the families and places they had left behind. What did it mean to have this new sort of visual memory of one's own past—in New England or the Middle West, in Europe or in South America? What sort of new dialog could one initiate with the family members left behind by sending along a photograph of oneself in new surroundings? The photographic galleries in Sacramento, an observer noted in 1857, survived through the patronage of "those who have friends in the Eastern States" and sought likenesses to send back home. "It is," he wrote, "quite a novelty in all the Photographic Galleries on the day previous to the departure of a steamer, to witness the strife and anxiety to procure these portraits for transshipment to the East."[2] How long, one wonders, was it before people

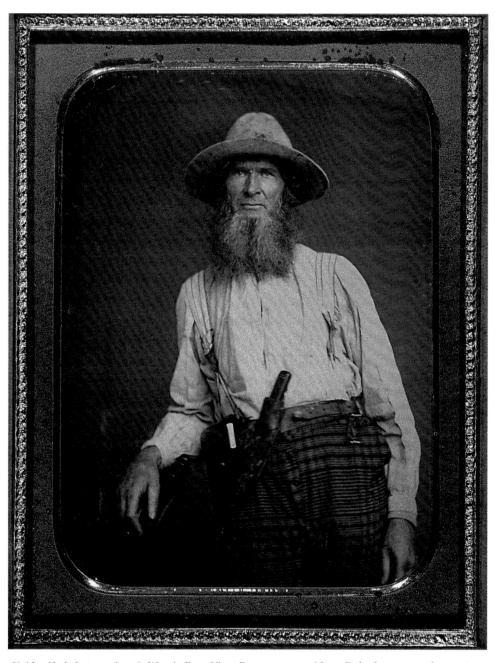

Unidentified photographer, *California Forty-Niner*. Daguerreotype with applied color, quarter-plate, c. 1850.
Amon Carter Museum, Fort Worth, Texas (P1983.20)

discovered that photography could provide images of fictive prosperity or well-being as easily as more true-to-life images of struggle and hardship?

If photographs helped new westerners reconceive their relationships to the people and places from whom they were separated by great distances, surely they also reshaped the way they (like all Americans) reimagined themselves, their family histories, and their relationship to the passing of time. Through photographs, the ordinary American could see what he or she had looked like as a child, gaze at the visage of a deceased relative, or stare into the eyes of a loved one who had set out to seek his or her fortune in the West. In an age of westward expansion, what did it mean to have these visual ties that would bind? From Placerville, California, in November 1864, Frank W. Bye wrote to his mother in Wellsville, Ohio, "I want you to have your and Sue's photograph taken and send me one each will you. I have Anna and Franks and want yours and Sue's to make up the family. . . . I bought a fine album the other day for $25.00 and would like to have all my friends in it."[3] How did the very existence of these visual mementoes alter and shape the ways in which people might form private memories, recollect their own pasts, imagine the ways their personal histories would unfold? And how did these photographs compete with words as a means of communicating sentiment and laying down the memories that would shape how the past would be recalled? Such a speculative study about the psychic or imaginative impact of photography in relation to the movement of peoples into the West would be valuable to students of social and family history.

This book, however, is concerned less with photography's impact on individual Americans' sense of self than with the medium's impact on broader cultural imaginings of the West and with the impact that such imaginings had, in turn, on photography. The public photographs that are the focus of this book were designed for widespread consumption, and intended to pass before the eyes and into the hands of strangers. Most were made with an awareness of the marketplace, with a calculated attention to what would please a patron or appeal to a prospective buyer or reader. This was an ever-shifting calculus; photographs might sometimes inform public opinion, but they could just as easily be informed by it.

The photographic stories recorded in this book unfold in a loosely chronological order. Attitudes toward photography changed during the second half of the nineteenth century, and popular ideas about the West shifted as the place became better known. But chronology also matters here because photography's very capacity to record the

West and to convey stories about it hinged not just on the imagination of its users and viewers, but on the rapidly changing technologies of the picture-taking medium. As the daguerreotype process yielded to the wet-plate negative process, as wet-plates yielded to dry-plates, and as the Kodak camera emerged to make photography simpler than ever, photographers' capacity to make certain sorts of pictures changed. The shifting technologies shaped the form and content of their pictures and dictated the ways in which these photographs might enter into the visual marketplace of nineteenth-century America and come before the public eye. Photography existed within a matrix of other visual and literary ways of narrating stories about the West and its peoples, and as photographic technology changed, the medium's capacity to compete or enter into dialog with these other forms of storytelling changed as well. As photographers struggled to make pictures that could engage the interest of an audience hooked on dramatic narratives of western life, the photographer's craft became a storyteller's craft.

Throughout this book, I focus on how we might understand photographs as primary source documents, as sources of meaning in and of themselves, rather than simply as illustrations that support what has already been established by other means. All too often, historians regard "picture research" as secondary to their real purpose, and visual images as inherently inferior to literary ones. They turn to images when they want to illustrate a point they have already made with other evidence, instead of turning to pictures as potential sources of historical evidence, different in content or quality from what can be obtained elsewhere. The meaning of photographs, or pictures in general, is rarely self-evident, and the cavalier use of historical images as illustrations in historical texts (all too often as publisher-imposed afterthoughts) frequently undercuts the careful logic and attention to rules of evidence with which the literary argument has been built. A lingering bias in historical training teaches would-be historians to value the literary over the visual or material, and teaches them how to query, challenge, and interpret literary documents, while leaving them with few analytical skills for the interpretation of visual records. It is a bias that pervades more general education as well. We are a nation of readers, but our visual literacy lags far behind our capacity to read and understand words. I argue here, however, that photographs can, indeed, be rich primary source documents; they deserve and reward the careful sort of historical attention more often lavished on literary texts.

Photographs, like literary documents, however, are not to be taken at face value. They need to be understood as constructions of the human imagination, as the result

of selective attention to a particular subject. Despite the illusive realism of the image, the role of optics and darkroom chemistry, the photograph is not a self-evident transcription of fact. Like a memoir or a letter, it may describe events, but it inevitably does so through the lens of the recorder's own experience, ambitions, and need to convey a particular point of view. Why, we must always ask, did a photographer make a particular image and who did he hope to influence with it? How did the available technology or his access to materials shape or limit what he could make? What argument or cause did he hope to advance with his picture and how would he bring this cause to public attention? What, in short, was the intended function of the picture? Photographers, like literary authors, are observers, people with particular political, social, and moral perspectives making assessments about what they see. And their work is no more to be embraced uncritically than is the work of letter writers, diarists, or journalists.

The photograph's closest cousin among literary documents is difficult to establish, for photographic evidence, like literary evidence, comes in many different forms. Some photographs do, indeed, seem fragmentary, a piece of some fuller document that is not to be found. Others contain within themselves a more literary sort of narrative, a summing up of a more complex event, a moral judgment about what has transpired. The physical form of the image, as much as its content, can instruct us as readers, conveying information about the creator's intent and tone, the economic circumstances of its production, its likely audience, its intended meaning. Encountered on the worldwide web, all images are constituted in precisely the same physical way, as are all words. But just as personal letters are an intrinsically different sort of literary document than published government documents, so snapshots are different than formal photographs made for distribution in deluxe albums. The physical form of original sources—whether visual or literary—continues to matter. Those who would use historical photographs as evidence must consider pictorial content but must also pay attention to the pictures' physical form and the ways in which they appeared before the public eye. As an engraved reproduction in a newspaper, as a framed print at an exposition, as a stereograph for sale in a railroad office, a photograph could communicate different meanings and convey different sorts of authority. As this book argues, a great many nineteenth-century western photographs were marketed as serial images, taking on added meanings and narrating more complex stories through their relationship with other images. Once paper photographs came to predominate over images on metal, such as daguerreotypes or tintypes, words also came to play an increasingly significant

role in shaping the meaning of images for viewers. Words printed on or with the photographs directed viewers' understanding of the images, imposing meaning where none seemed apparent, privileging one interpretation over others, where many seemed possible. These words inevitably enhanced the narrative potential and function of photographic images, helping to transform static images of fleeting scenes into elegiac stories or predictive pronouncements, records of disappointments or visions of triumph. So fully and persuasively did such words shape the public meanings of the photographs that viewers could remain unaware that the pictures might illuminate the intentions of their creators more fully than they could illuminate the subjects they purported to describe.

Photographs are primary source documents that can be encountered both *in* history and *through* history. To encounter the image *in* history, tangled in the dense time-bound web of economic needs, technological know-how, and cultural ambition that enabled its production, we must inquire about the circumstances of its making, the photographer's intent, the public function of the image, the ways in which it was received and understood by contemporary audiences. Reinserted into the world of its production, the photograph becomes more than a visual record of material fact. It becomes a tool for understanding larger issues about economic ambition and patronage, about the role of photographs as purveyors of information and creators of myth, about the complicated interplay between photographers and their audiences. To consider the image *through* history, however, without the ties that once bound it to a particular historical moment, we must give attention to the shifting fate of the image—the ways in which it might have moved into archives or attics, museums or scrapbooks, and the ways in which it has been reinterpreted over time. But we must also become more aware of how our own knowledge and imagination shapes our reading of the picture as we encounter it in the here and now. Our readings may be informed by our understanding of historical events that transpired after the making of the photographs, by an instinctive empathy or sympathy for the subject, by experiences that have unfolded in our own lives. Such are the elements that also make us good and sympathetic readers of literary documents. The differences between our response to an image and the response of its original audiences matter; the very disjuncture can help us understand an image in new and useful ways. Our needs for an image—whether we approach it as an historian, a filmmaker, a collector, a family member—are always and necessarily diff-

erent from the needs of the picture's creator, its subjects, or its original audiences.

In considering photographs as material artifacts to be read in and through history, the parallels that suggest themselves are not simply to literary documents but to other sorts of two-dimensional pictorial images, such as paintings or sketches, prints or scientific drawings. And indeed, a central concern of this book is the way in which photography competed with these other sorts of pictures in the nineteenth-century marketplace, often struggling to find a way to win the interest and understanding of an American public that preferred more imaginative renderings of the West and its native peoples. Photography entered into American culture at a moment when there were many other pictorial ways of narrating stories and conveying information about the West: lithography was a newly popular form of printmaking; painted panoramas provided information and entertainment; scientific drawing had reached a new standard of descriptive precision. Photography could not perform the narrative and dramatic labor done by these other sorts of images. In part because, unlike other sorts of picture-making, photography required maker and subject to be in close temporal and physical proximity. The resulting photographs may have seemed precise, but they often seemed insufficiently informative, unable to depict what remained known or felt but ultimately unseen. New photographic technologies provided Americans with new ways of making pictures, but they did not instantly create for the new images a secure niche in the visual marketplace.

Despite the seeming specificity of information in a photographic image, historical photographs share with other visual images an illusive timelessness or universality that makes them difficult to grapple with as time-bound bits of historic evidence. They can evoke a sense of familiarity that belies the essential unknowability of the past. It is easy to imagine that we understand the expression on a subject's face, can feel precisely what it is like to gaze at a particular view, can know what emotions we would feel were we actually witnessing a particular event. And yet, of course, we cannot. The instinctive empathy we can feel for photographic subjects can push us to assume more than we can truly know about the actual subject of the image.

Indeed, no photographic image conveys a universal meaning or message. All photographic meaning is contingent on the viewer's understanding, an intellectual or visceral empathy shaped through culture, through experience, through the memory of other images. As we encounter photographs in and through history, as we encounter them in different ever-shifting contexts, what, this book asks, what can we learn about them and

what can we learn from them? The slippery, shifting meaning of photographic images does not lessen their potential value as historical evidence. It instead deepens it, reminding us that as photographs are reinterpreted anew in different times and in different places they provide us with a new way of understanding the values and assumptions, the experiences and expectations of the viewers who would make them speak.

With an attentiveness to this tension between past and present readings of photographs, to the difference between the photographs encountered *in* history and *through* it, this book takes a selective look at photography in the trans-Mississippi West from the mid-1840s, when daguerreotypists set out to make the very first photographs of this place and its peoples, to the early 1890s, when Kodak cameras helped make photography a truly ubiquitous part of American culture. The first three chapters focus on the daguerrean era, looking at the pictures produced by the photographers who followed the United States troops into battle against Mexico in the war of 1846–48, the work of the entrepreneurial daguerreotypists of the early 1850s who sought to create a comprehensive record of the West and its prospects, and the photographs made by the daguerreotypists who accompanied government expeditions into the West during the 1840s and 1850s. In each case, I stress the ways in which these early photographers struggled to understand the conceptual and economic potential of their medium and to create a market for their work in a world filled with other sorts of visual representation. Forced to compete with dramatic lithographs and moving paintings, symbol-laden banners and ethnographic galleries, they generally failed to enlist popular interest in their small photographic images. Indeed, many of their images no longer survive; in some cases, I write about photographs I have never seen. But should these daguerreotypes miraculously reappear now, they would have enormous value as rare artifacts of another place and time, as the first photographic records of places central to the iconography of the American West. In the disjunction between our longings for these pictures and contemporary audiences' utter disinterest in them lies an important lesson about the ways in which the value and utility of photographs mutate over time.

The second part of this book considers what happens when the new wet-plate negative process supplants the older daguerreotype technology, allowing photographers to produce photographic prints on paper that could move in new ways into the marketplace of images and ideas. As chapter four suggests, the possibilities for the process were not immediately apparent to the photographers who struggled with it on

Carleton E. Watkins, *El Capitan.* Albumen silver print, 1866, from J. D. Whitney, *The Yosemite Book* (1868). Yale Collection of Western Americana, Beinecke Rare Book and Manuscript Library

the American and Canadian exploring expeditions of the late 1850s. But in the decade after the Civil War, covered here in chapter five, western American photography reached a kind of golden age. By linking their pictures with printed words that clarified and expanded their intended purpose, the survey photographers who accompanied the private railroad expeditions and federal exploring expeditions into the West found new ways to cast their work before the public eye. Through the combination of text and image, they spun predictive tales of a new western world that was yet to unfold. But it was a West that could *be* only through the disappearance of the West that *was*. Chapter six considers how photographs created and reaffirmed the logic of a "vanishing race," aiding and abetting in the imagined disappearance of the West's native peoples that would enable a new social and political order to take root in the United States' western territories and states. From the 1860s on, photographs became increasingly influential as a way of creating and shaping national visions of the far West. As the discussion of photographically illustrated books in chapter seven suggests, however, Americans never truly gave up their lingering taste for more dramatic narrative renderings of western life. And thus, from the advent of the daguerreotype to the invention of the point-and-shoot camera, Americans remained conflicted over the value of western photographs. If these pictures seemed to enlarge the imagination through their depiction of unfamiliar places and people, they also seemed to contract it through their insistent portrayal of what actually appeared before the camera lens. Photographic images could rarely provide the drama and excitement found in more imaginative paintings or drawings, novels or Wild West shows. They were hard-pressed to support the popular stories steeped in myth.

Still, no part of the American historical imagination is so shaped by visual imagery as its image of the nineteenth-century West. Photography's role here is central, for photographers truly bore witness to the epic story of the American settlement of the western half of the continent. Countless Americans can summon up visual memories of nineteenth-century photographs of Geronimo and Custer, gold miners and homesteaders, the rock peaks of Yosemite and the steep walls of the Grand Canyon. But how, I ask in the epilogue, should we consider such photographs *as* history; in what ways can we use them to construct our own stories of the western past?

This book, then, is an intertwined study of a medium and a place that examines how photographs function in and through history as documents that can help us better

understand the past. I consider it a book of "picture stories." It is a book that tells stories about pictures, as they lived in their own time and in ours. It narrates stories about the creation, consumption, and commodification of nineteenth-century western photographs, and suggests how we might use these pictures today. But it also considers the stories told by the pictures themselves, both those told to their first attentive viewers, and those they still tell to their ever-shifting audiences. "The past is not simply there in memory," writes the literary historian Andreas Huyssen, "it must be articulated to become memory."[4] In photographs of the nineteenth-century West are the visual articulations of a national past, potent bits of pictorial shorthand that summon up from our collective psyche a deep social memory of a particular place and particular moment in American history. For nineteenth-century viewers, the pictures often resonated differently than they do for us. To those actually caught up in the exploration of the West, in the prospective economic development of the region, in the ongoing debates over the fate of the western Indians, these photographs held political, economic, and cultural implications difficult for us to recover. Yet even in the nineteenth century, these photographs plucked the mystic chords of memory and stirred the imagination of Americans curious about the social and geographical landscapes of the nation's new West. Here then are the stories of some of the earliest photographs of the American West and how they eventually found a place—as document and as art, as economic prospect and as political argument—in the cultural imaginings of that place.

1

"The Spirit Is Wanting"

Photography and the Mexican-American War

. . . at any given moment the accepted report of an event is of greater importance than the event, for what we think about and act upon is the symbolic report and not the concrete event itself.

—William M. Ivins, Jr.,
Prints and Visual Communication, 1953

On the night of May 15, 1847, at precisely 7:30 P.M., cannons fired a "national salute" in the streets of New Orleans, and at the mayor's request, the city's patriotic citizens lit tens of thousands of candles that bathed the city in an eerie glow. From the windows of public and private buildings across the city, the candles illuminated large painted "transparencies" on thin sheets of fabric or canvas that hung from the structures' front facades. To the throngs of pedestrians in the streets, the city suddenly seemed a gallery, filled with pictures that celebrated the nation's triumphs in the ongoing war against Mexico. Full-length likenesses of Generals Taylor and Scott hung from the Municipal Hall, flanking lists of American victories from the Revolutionary War and the War of 1812. Flickering above them in the candlelight hovered a painted bust of George Washington, "the greatest of the great." A painting of the Kentucky Regiment on the battlefield of Buena Vista fluttered from a nearby private residence. The newspaper office of the *Delta* glowed with a picture that celebrated the recent conquests of New Mexico and California. An eagle featured on a painting at the office of the rival *Times* held in its beak a painted scroll listing America's recent military triumphs. Hanging from the facade of the city's arsenal was a "well executed transparency representing the American flag with artillery, mortars and all other implements of war appropriately blended." "Nothing could surpass the brilliancy of the scene," reported the *Delta*, "nothing could surpass its picturesque appearance. The sidewalks of the principal streets presented a moving mass of human beings; the pavements were crowded with carriages and equestrians. The whole was a great panorama of life—beauty, patriotism, and animation, such as can only be seen when a great city disgorges its dense population."[1]

Such painted transparencies—invoking an iconography of war that linked current events in Mexico to a long history of American battles in the cause of liberty—were

16

a common sight at public celebrations across America that spring of 1847, from smaller towns like Jonesville, Virginia, "which looked like a little Heaven lighted up by a thousand stars clustered together" to the large cities of the eastern seaboard.[2] For a civic celebration in downtown Philadelphia in mid-April, the local newspaper, the *Ledger,* used 750 candles to illuminate its large transparency of "Scott and Taylor with the fields of Buena Vista and Vera Cruz in the back ground, the whole surmounted by an American Eagle." From the building next door, there hung a 20 × 17 foot painting of an imagined moment at the Battle of Buena Vista, which the Americans had won some two months before.[3] "Thousands were engaged throughout the day in preparing for the scene," reported the *Philadelphia Inquirer.* In the crowded streets "the numerous paintings were criticized in every possible way, and all their beauties and defects commented upon and pointed out. . . . Generals Taylor and Scott were presented to the public eye in a thousand different forms, while the glorious achievements of our gallant little army were sketched by a hundred artists."[4] In New York, the energetic employees of one company managed to light twelve hundred candles in just seven seconds.[5] In the nation's capital "the President's mansion was brilliantly illuminated" in the grand celebration of May 8, but "it was considered best not to illuminate the offices of the public departments," reported a Richmond paper, "because they contain the valuable records of the government, and most of them are not fire-proof."[6]

The United States had declared war on her southern neighbor on May 13, 1846, following a year of increased hostility over the Republic of Mexico's refusal to recognize the United States' annexation of Texas or to acknowledge the Rio Grande as an international boundary. Lingering disputes over reparations to Americans who had lost property in Mexico during various political upheavals dating back to the 1820s lent an air of righteous grievance to American complaints. But under President Polk's leadership, it was less the resolution of old complaints than the desire to acquire northern Mexico that animated the United States' hostility toward her neighbor. When halfhearted diplomatic efforts to resolve the conflict failed, military action was the inevitable result.

If some Americans harbored doubts about the legitimacy of a foreign war whose scarcely veiled aim was the territorial expansion of the American nation, such doubts had no place amid the patriotic and nationalistic fervor of the public illuminations. Frequent visual references to the Revolutionary War enveloped the Mexican-American War within a venerated tradition of democratic struggles, while other symbols evoked the current debates about America's Manifest Destiny: did the nation in fact have a divine imperative to claim and populate the continent all the way to the shores of the Pacific Ocean? Senator Thomas Hart Benton, a leading proponent of Manifest Des-

17

tiny, certainly thought so. He decorated his house for the spring 1847 Washington, D.C., celebration with a painting that celebrated the achievements of the Missouri volunteers from his home state. From his upper windows he proudly flew the "first and only flag that ever waved from the loftiest peak of the Rocky mountains," planted there on August 15, 1842, by his son-in-law, the great "pathfinder" John Charles Frémont, in an extravagantly theatrical gesture that would come to symbolize the nation's westward expansion.[7] At times, the visual iconography of the illuminations became so generalized, so generic, it could become difficult to sort out precisely whose heroism was even being celebrated. A *Baltimore Sun* correspondent, commenting on a painting of an officer on horseback that he had seen while strolling through the streets of Washington, D.C., observed, "Of course it was impossible to tell who it represented; whether Scott or Taylor, or General Washington or Lafayette, or anybody else. I admired *that* ingenuity too, which exhibited political wisdom and diplomatic forecast, as the transparency alluded to may serve in any future contingency—for I defy any jury to prove the identity of the man."[8] In the crudely painted, fire-prone paintings that hung from buildings across the nation, such symbolic meaning had more value than detailed accuracy; such stylized heroism held more attractions than biographical truth-telling. The transparencies may have been useless as visual reportage, but they proved immensely useful as images that rallied public sentiment. And why should they not? They provided the American people with the patriotic iconography of war they most wanted to see.

Some seventeen hundred miles from the nation's capital, also in the spring of 1847, a few enterprising Americans were at work creating a quite different kind of iconography of the military actions in Mexico. They were daguerreotypists, and their pictures were neither large nor theatrical: they included formal portraits of military officers, architectural views of occupied towns, the occasional out-of-door scene of American troops. Struggling to make images with the new technology that had been announced to the world only eight years before, they had to contend with a shortage of materials in a war-torn nation whose ports were periodically blockaded, with harsh brilliant sunlight that could confound even the most careful calculations, with an uncertain market of American troops who rarely stayed long in any one place. Yet a handful succeeded in capturing on the reflective silver-plated surface of a copper daguerreotype plate the world's first photographs of war.

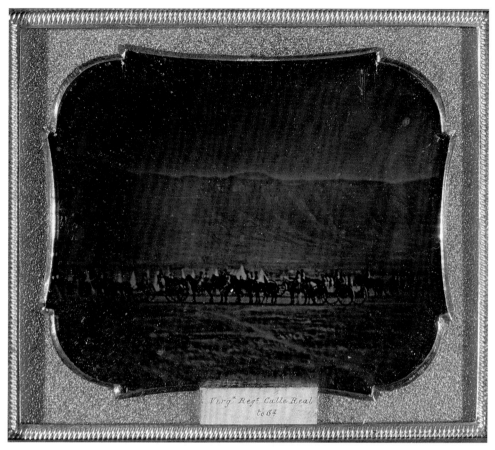

Webster's Battery, Minon's Pass—Mountains Just North of Buena Vista to Eastward. Daguerreotype, sixth-plate, c. 1847. Mislabeled in its case, this daguerreotype depicts Major Lucien Webster's artillery battery near the battlefield of Buena Vista in northern Mexico. Yale Collection of Western Americana, Beinecke Rare Book and Manuscript Library

In retrospect, it seems fitting that this should become the first war to be photographed, for the Mexican-American War was truly the first American conflict of a new technological era. In the dawning age of ocean steam navigation, men and goods could be transported with marvelous speed. Newly strung telegraph wires could transmit news almost instantaneously. Taking advantage of these innovations, the so-called penny press instituted a new kind of press coverage that relied on eyewitness reporters rather than on official government dispatches, and some enterprising papers even sent

to Mexico full-time reporters who became the nation's first professional war correspondents. Newspapers used illustrations sparingly until the development of new mass production techniques in the 1850s, but wartime printmakers employed the relatively new technology of lithography to satiate public desire for news from the front with inexpensive prints, hawked on the streets, that featured quickly consumed visual narratives of battlefield heroics and the likenesses of the war's key players.[9]

Daguerreotypes might have been expected to convey the most accurate news of all to American audiences hungry for the latest dispatches from the front. Indeed, the very word "daguerreotype" had already entered into popular parlance as a way to describe highly detailed and accurate images of any sort. In providing detailed literary coverage of a social event, *The New York Herald Tribune* promised its readers a "daguerreotype sketch" of the scene; and it gathered the daily comings and goings of ships in New York Harbor in a column called "New York Daguerreotyped." A correspondent in Mexico, writing back to a St. Louis newspaper, provided his readers with clues to help them visualize his surroundings so that they would "have an accurate daguerreotype of the writer and his ranch."[10] Yet actual daguerreotypes—the small, exquisitely detailed photographic images on copper plates—utterly failed to capture the public imagination. If Americans professed to value accuracy in literary and visual reportage of the nation's first war to be fought on foreign soil, the daguerreotypes' faithfulness to actual *appearances* somehow seemed at odds with a more widespread fascination with images faithful to *experience,* either imagined or remembered. The daguerreotype—like its fellow marvels of technology, the steamship and the telegraph—might, in the phrase of the day, "annihilate time and space," allowing the distant to be brought near. But in a world crowded with other forms of visual representation, the daguerreotype's astonishing accuracy did not instantly win it acceptance as a new way to document events. If photography was present at this war that signaled the birth of a new American West, it did not create a new way of visualizing or understanding what that West might be about. Indeed, it would take nearly two decades for photography to emerge as a potent force in the shaping of a public image of the American West. During the daguerreian era, technological constraints, limited markets, and a public preference for more narrative sorts of images left the photograph more an historical curiosity than a powerful tool of mass communication.

The Mexican War formally ended with the signing of the Treaty of Guadalupe Hidalgo on February 2, 1848; with that stroke of a pen the United States acquired some

1.2 million square miles of land extending from Texas to the Pacific and north to Oregon, including much of present-day New Mexico, Arizona, Nevada, Utah, and California. Coupled with the recent annexation of Texas and acquisition of Oregon, the treaty helped give final definition to the geography of the American nation, and gave to the United States a new "west," still international in terms of population, but now firmly American in terms of its political structure. Yet if the Treaty increased the size of the United States by some 66 percent, altered the way Americans imagined their nation, and ushered in a new era of unprecedented westward migrations, the most popular visual representations of the Mexican War were those that looked backward to an older, more familiar kind of iconography rooted in the patriotic rhetoric of the American Revolution and the comfortable traditions of history painting. Photographs did not yet seem sufficiently evocative or persuasive to engage the American imagination or to show Americans a vision of war that they *wanted* to see.

Admittedly, the photographic documentation of the war was limited. The two most significant collections of surviving Mexican War daguerreotypes, now in the collections of the Beinecke Rare Book and Manuscript Library at Yale University and at the Amon Carter Museum in Fort Worth, Texas, include only a narrow range of subject matter, a fact that bespeaks the technical limitations of daguerreotype equipment, the limited opportunities available to the photographer or photographers, the photographer's sense of how his pictures might be marketed and sold, and the maker's limited imagination as to how these first photographs of war might ultimately be used. There was no model for how to put such images before the public eye, no established strategy for engaging public interest in the small detailed images. The twelve sixth-plate daguerreotypes neatly labeled and mounted in a handmade walnut case at Yale include ten images made in and around Saltillo, Mexico, most probably in 1847 or early 1848 during the American occupation of the town, and two views of Fort Marion and nearby St. Augustine, Florida, a departure point for troops leaving for Mexico. Most of the thirty-eight outdoor scenes and portraits in the Amon Carter collection likewise depict people and locations in and around Saltillo in 1847–8, suggesting that a single photographer may have made both sets of views. In the most dramatic image, a variant of which is in each of the collections, Brigadier General John E. Wool and his horse-mounted troops pause for the daguerreotypist during a parade down Saltillo's Calle Real, halting in the middle of the road to accommodate the relatively long exposure time required for a daguerrean view. In an age when the actual movement and chaos of battle was all but impossible to capture on a daguerrean plate (and

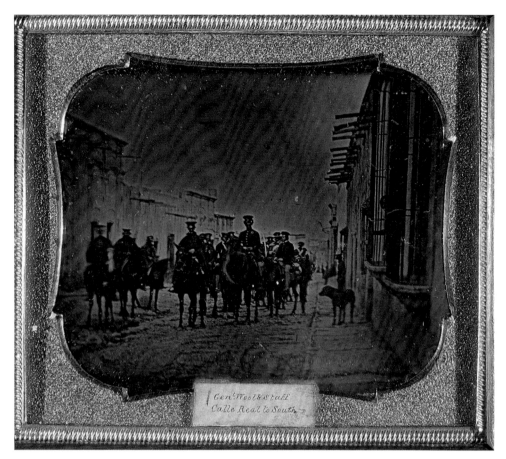

General Wool and Staff, Calle Real to South. Daguerreotype, sixth-plate, c. 1847. Yale Collection of Western Americana, Beinecke Rare Book and Manuscript Library

what photographer would want to expose himself to such personal danger?), this street scene was as close to an action scene as one might capture. And if it failed to convey the causes or consequences of warfare, it nonetheless conveyed something of Wool's anxiety about his own personal safety. Josiah Gregg, a translator with the Arkansas Volunteer Cavalry, noted that although General Taylor rode through the streets of Saltillo with only an aide or two, "Gen. Wool was not only everywhere followed by a portion of his staff, but a guard of some 20 dragoons, with drawn sabres! In this style he not only entered the city, but his guard, with sabres drawn, thus followed him from house to house, and from hospital to hospital, in his visits through the city!"[11]

If the Wool daguerreotype documents the general's well-known penchant for extravagant displays of power, it is harder to second guess the intended documentary import of the other surviving daguerreotypes. There are several rooftop views of American troops in the streets of Saltillo; two views of Major Lucien Webster's artillery battery in the redoubt south of Saltillo, perhaps made to mark the importance of their contribution to the American victory there in the Battle of Buena Vista in February 1847; a series of formal military portraits of officers stationed in and around Saltillo in the spring and summer of 1847; three close-up views of the Parroquia de Santiago, now the Cathedral of Santiago in Saltillo; and several bird's-eye views of the town with the church featured prominently in the background. During the Battle of Buena Vista, a few American troops were posted in the towers of the church, and afterward it was briefly used as a hospital for the wounded. But the church's richly carved and painted interior made it an object of wonder to the occupying American forces, and it is unclear whether the daguerreotypist intended his views as architectural souvenirs or as documents of a military site. Two daguerreotypes of the grave of Lieutenant Henry Clay, Jr., the son of the Kentucky statesman and a casualty of the battle of Buena Vista on February 23, 1847, hint at a more narrative story. But the stark images of a cross-marked open grave and adobe vault can convey little of the dramatic import of the death of the young Kentucky hero, buried here the day after the battle.[12]

In an era when some 95 percent of daguerreotypes were portraits, largely produced on commission for paying clients, such outdoor views of public scenes were rare. In the absence of any firm identification of the views' maker, one can only speculate as to why they were made. Were they self-conscious documents of American activity in a particular theater of war? Were they made as mementoes for a particular client? Were they intended to reach a wider audience through either exhibition or reproduction as engravings or lithographs? Whatever their intended purpose, they met with a fate of utter indifference, exercising absolutely no effect on public perceptions of the war. There is no evidence that more than a few people ever saw them; no evidence they ever entered into the channels of distribution established for other sorts of literary and visual reportage.[13] Photography may have enabled new ways of seeing the world, but virtually no one saw these daguerreotypes. Sketch artists and painters, printmakers and the producers of transparencies remained firmly in control of the public visual imagery of America's first war of the photographic era.

The indifferent technical quality of the surviving outdoor war daguerreotypes testifies to their maker's technical struggles in the field. By the mid-1840s, the daguer-

reotype process was simpler than it had been when Daguerre announced his invention to the world in 1839, but it remained challenging even in a well-equipped studio, and immensely more difficult outside. One would begin with a special precut sheet of silver-plated copper, carefully polishing and buffing its surface to a high gloss. To render it light-sensitive required a two-part "coating" process, in which the plate would be exposed first to vapors of iodine, and then to the vapors of an accelerating agent such as bromine. After a second brief exposure to iodine vapors, the plate could be loaded in a plate holder, and inserted into a camera. Exposure times would vary depending on the lens being used, but once exposed the plate had to be promptly developed in hot mercury vapor, before its latent image began to fade. Once developed, the image would be stable and the plate could be stored to be gilded, finished, and packaged later. Every step of the process became more difficult out-of-doors: buffing tools had to be kept clean and dry, coating boxes had to be heated to a uniform temperature to release the chemical vapors, and clean water had to be obtained for the final finishing steps. Heat and humidity, cold and wind: all were potential hazards for the daguerreotypist working outdoors.[14]

But technical problems were only one of the difficulties faced by the enterprising American daguerreotypists working in war-torn Mexico. They also shared a fundamental inability to establish firm links to the broader marketplace, to find either secure sources of supplies for their craft or established outlets for their finished work. Once they had made their hard-won views, it is not clear they knew what to do with them. If they were uncertain of their audience, their audience was also a bit wary and uncertain of them. Neither picture-makers nor picture-viewers had yet settled on a meaningful or easily communicated photographic iconography of war.

The journal of Richard Carr, a remarkable young man who traveled through Mexico making photographs from late 1845 until late 1847, provides the most detailed account of the physical and technical hardships these daguerreotypists faced. Born in England in 1818, Carr came to America in 1837. On July 28, 1845, he went to New York and paid $40 to the prominent photographer John Plumbe "to learn me to take daguerreotype portraits." By late October, he was in New Orleans, where after just two weeks of operating a daguerrean portrait studio, he wrote his brother, "I have had very bad success at my new undertaking have not cleared half my expenses, as such must try it else w[h]ere." On December 1, he boarded a schooner and sailed for Veracruz, on Mexico's eastern shore.

Carr tried to avoid political turbulence, but he could not elude the economic upheavals and social unrest that surrounded the United States' declaration of war against Mexico in May 1846. From Veracruz, he had ordered $100 worth of supplies from Langenheim and Company, a leading Philadelphia supply house, but it is unclear whether these materials ever arrived. The month that war was declared, Carr left Veracruz for Orizaba, with two donkeys to carry his baggage. In July he moved on to Oaxaca, where he was "several times employed to take the likenesses of females that [the priests] told me was their scister [sic], or niece, but have afterwards been told by others it was their sweethearts or children." By November, he had exhausted his supplies and, unable to "import any on account of the blocade," was compelled to make a two-month journey to Campeche, on the Yucatan peninsula. Finally, in January 1847, he obtained there "a small supply of Daguerreotype articles, such as I stood most in need of, commenced taking portraits, in the mean time sent to the United States for a further supply." When the supplies had not arrived after some three-and-a-half months, during which he had barely been able to make ends meet, Carr sailed for New Orleans to buy supplies himself. From there, he sailed back to Merida to set up yet another studio. When it, too, failed, he set out on a tour of Yucatecan villages, and in November 1847, left Mexico altogether to travel through Central America. In Guayaquil, Equador, he caught early word of the California gold strikes. "I have got to leave here," he wrote in his journal, "and phraps shall do better their than elsewhere though the Americans I detest." He set sail for California and on January 1, 1849, became the first photographer to set foot in San Francisco, a rapidly growing city where on this New Year's Day there was "scarsely a sober man to be found."[15] A man of enterprise and ambition, fearlessness and dogged persistence, Carr had found war-torn Mexico a difficult and even dangerous place to ply his trade.

None of the American photographers operating in Mexico left such a detailed account of their business practices, but the scattered records of their activities suggest they, too, experienced difficulties operating at the periphery of the American markets for daguerreotypes. American A. J. Halsey established himself in Mexico City in September 1845, eight months before the outbreak of war, and had the longest tenure of any of the war-era daguerreotypists. He had opened the first daguerreotype studio in Montreal in September 1840 in partnership with another American, named Saad, and the following month opened another in Quebec. Their clients' gullibility matched their own inexperience, for contemporary accounts suggest their daguerreotypes faded

when exposed to light. Yet by the time he arrived in Mexico, Halsey could boast of his four years of experience and superior new machines, as he offered to instruct others in the art of daguerreotypy.[16] He altered his marketing strategies to suit his shifting audiences, advertising in the local Spanish-language papers in 1846 and early 1847, and switching to the unofficial American army paper, the *Daily American Star,* after General Winfield Scott's troops entered Mexico City in September 1847. A businessman attuned to his local market, he advertised his portrait services to the American officers and offered large views of the city's "churches, castles, public buildings, &c." When the American troops left the city, Halsey reoriented his practice toward his Mexican clientele, maintaining his studio in the capital into the 1860s.[17]

Most of the other American daguerreotypists seeking to capitalize on the war had briefer careers. J. R. Palmer, from New Orleans, opened a daguerreotype portrait studio in Matamoros in June 1846, but by October had abandoned the studio to become a staff writer and later co-editor for the local paper, the *American Flag.*[18] Charles Betts moved in to fill the void Palmer had left in Matamoros by September 1846 but, instead of trying to build up a long-term local business, decided to follow the American army of the southern campaign. By April 1847, Betts was with the American army in Veracruz, where for "two weeks only" he was prepared to take portraits and, on request, would "go to residences to take miniatures of the dead and wounded." In July, he followed General Scott's army from Jalapa to Puebla, and by September was in Mexico City, with Scott and his occupying troops. There he advertised his portrait services to "the citizens of this city, as well as the officers etc. of the U.S. Army," offering to let his clients pose in front of a large painted backdrop of Chapultepec.[19] Betts, too, focused on the audience he had at hand, making portraits or postmortem views only when paid in advance, giving little thought to the more speculative sorts of images he might make to market to more distant buyers. Other itinerant photographers, including L. H. Polock and J. C. Gardiner, likewise geared their short-lived businesses to commissioned portraits.[20] George Noessel, a New Orleans daguerreotypist who set up shop in Veracruz in September 1847, had more ambitious aims for his portrait studio, for a New Orleans paper reported that he was "picking up interesting subjects with whose portraits to enrich his gallery," a description that evokes images of the celebrity galleries with which ambitious American daguerreotypists tried to lure paying customers into their galleries. But by February 1848, Noessel was on his way out of Veracruz and the daguerreotype business, leading a merchants' caravan to Mexico City. He and his daguerrean gallery then drop from view.[21]

Ironically, though the daguerreotypes made in Mexico failed to find a public audience—through either exhibition or reproduction—American newspapers lavished great praise on the work of artists in other media who traveled to Mexico, precisely because their work seemed to offer the authenticity that could be obtained only through eyewitness observation. The New Orleans *Daily Picayune* wished good luck to painter William Garl Brown, Jr., as he set off to Monterrey in the spring of 1847 to capture a likeness of General Taylor, and in frequent dispatches to the paper the *Daily Picayune*'s Mexico correspondent, J. E. Durivage, charted Brown's progress. "Although you cannot get a glimpse of the general *in propria persona* before the end of November," he wrote in early July, "you will soon see his 'picture in little.' A very accurate likeness of him has been taken by Mr. Brown." Reporting later on Brown's painting of Taylor and his staff, Durivage noted, "The figures are all in miniature, and executed with a most life-like faithfulness and exquisite finish." A report that Taylor himself had pronounced Brown's portrait "*the best* likeness that has been taken of him," piqued still further the public interest that attended Brown's exhibition of the paintings back in Richmond in September 1847.[22]

The work of the Philadelphia painter Jesse Atwood generated similar enthusiasm. The army newspaper, the *American Pioneer*, followed his trip to Monterrey in May 1847 and reported that his portraits of General Taylor were "excellent likenesses." Taylor himself thanked the artist for "the undeserved compliment you have paid me in the danger, fatigue, labor and trouble you have undergone and encountered in traveling from the City of Philadelphia to this place for the purpose of painting my portrait." And the *Herald* of New York argued that Atwood's efforts to obtain an eyewitness sketch deserved special attention: "The artist who encountered the toil and dangers of a journey to Monterrey for the purpose of getting a true likeness of the old hero ought to be well repaid for his outlay of money and labor."[23] These artists themselves had become exotic adventurers, media heroes of the foreign war. So great was the interest in their exploits that the New Orleans papers even followed the misadventures of a French sculptor named Garbeille who traveled to Monterrey to do a sculpted *bust* of General Taylor from life. Garbeille lost his tools when his supply wagon was ambushed, and had to fashion new ones from the bones of mules. Undiscouraged, he advertised to studio visitors that he had in stock "the unfinished mouth and nose of Gen. Taylor."[24]

While such paintings and sculptures made from direct observation of Mexican War figures and events garnered public attention for their eyewitness veracity, Ameri-

cans remained most likely to encounter eyewitness images of the war in the form of lithographs.[25] Invented in Munich in 1798, lithography had become commercially viable in the United States in the 1820s, and it had considerable advantages over the older printmaking techniques of engraving and etching. These older printmaking methods generally required the intervention of trained draftsmen with special tools who could translate the drawn lines of an original painting or sketch into a pattern of carved lines on the surface of a metal or wooden printing plate. But the greater ease of the lithographic process meant that artists themselves could draw directly onto the surface of a specially prepared printing stone, exercising greater control over the final image. Such a process would have been welcomed by the war veteran George C. Furber, whose memoir, *The Twelve Months Volunteer; or, Journal of a Private in the Tennessee Regiment of Cavalry, in the Campaign in Mexico, 1846–7,* appeared in 1857 with twenty-three wood engravings made after "drawings by the author." Furber complained that the engraver had made a mess of his originals and altered their meaning. Though he had instructed the engraver to include a single cavalry soldier in the foreground for scale and to put a scouting party in the background, "To the author's surprise . . . he found that the engraver had put in the scouting party, but had set them all to cooking; and the volumes of smoke inserted, would convey the idea that the scouts were more anxious for their dinner than to catch an enemy. . . . This is wrong; and the reader will therefore, in imagination, put out the engraver's fire, and place the party in a position of vigilance."[26] Like all artists who turned their original drawings over to printmakers, Furber was at the mercy of a stranger's imagination.

In addition to giving greater control to the artist and eliminating the need for a middleman, lithography was both faster and cheaper than older printing techniques. Moreover, mistakes were easily corrected, a factor of some importance as printmakers vied to produce the most accurate accounts of current events. Nathaniel Currier, the innovative and enterprising lithographer whose office was just a few blocks from that of the *Herald,* almost single-handedly created a market for inexpensive prints of topical events, even creating a system of pushcart salesmen to hawk his prints in the street. He followed the news closely, and as updated reports flowed in from the war front, he would have his artists redraw their lithographic stones to incorporate the latest news about military tactics or the appearance of a particular military figure.[27]

Currier produced seventy different lithographs depicting Mexican War scenes, each crudely colored by hand both to reinforce its seeming accuracy and to enhance its

visual appeal. Such color played an increasingly important part in American printmaking during the 1840s, creating and feeding a new public taste that the monochromatic daguerreotype was ill-equipped to satisfy. Some of the finest (as well as some of the crudest) lithographic war scenes were printed in black and then hand-colored by artists using a wide range of translucent watercolors to enhance their visual appeal, narrative drama, and seeming accuracy. But the development of a color printing process called chromolithography gave printmakers another way to produce color images for the American market. Using multiple lithographic stones inked with different colors and printed, with careful registration, one on top of the other, printmakers could produce colored images with greater speed and without the intervention of handworkers.

The wartime printmakers who, like Currier, scrambled to meet market demand with lithographic prints hastily produced from available newspaper reports could ill-afford the luxury of gathering or sorting through conflicting reports from the front. But with the close of the war, there remained an interest in visual documentation of the war's key battles and a market for views that functioned less as news dispatches and more as retrospective recreations of decisive moments. The most ambitious and widely praised series of such prints was *The War Between the United States and Mexico Illustrated* (1851), a portfolio-sized edition of twelve hand-colored lithographs of battle scenes produced in Paris by artist Carl Nebel in collaboration with the New Orleans *Daily Picayune*'s war correspondent, George Wilkins Kendall. The German-born Nebel had witnessed none of the battles himself. But he was an accomplished artist with considerable experience in picturing the Mexican countryside. Indeed, his lavishly produced fifty-plate volume *Voyage pittoresque et archéologique dans la partie la plus intéressante du Mexique,* published in Paris in 1836, had supplied choice bits of topographic detail that were copied by other printmakers during the war.[28] In the closing months of the war, Kendall met up with Nebel in Mexico City and proposed to him a new project. Kendall, himself, would draw upon his own work as a correspondent attached to the southern campaign and his brief foray into the North, as well as from the dispatches, maps, and official reports gathered from others, to write the explanatory texts for each of twelve new lithographs to be executed by Nebel. Nebel agreed. He had visited only a few of the battle sites himself—and long after the battles had actually taken place—but working from the literary and visual reports of others, he produced a series of views that quickly garnered praise for their faithfulness to actual places and events. In the summer of 1850, when Kendall returned to America from

Paris with proofs of Nebel's prints, his own paper, the New Orleans *Daily Picayune,* boasted that the pictures "with all their beauty as finished works of consummate art, are exact delineations of the topography and natural scenery . . . and true representations in every point of the military positions and movements." The military officers who had served in Mexico offered assurance that the "accuracy of the representation of these famous spots is like daguerreotyping."[29] The *Knickerbocker* evoked precisely the same metaphor in its review of the finished product, noting that the natural scenery in Nebel's prints was depicted "with the faithfulness of a daguerreotype reflection."[30] But for American audiences of the mid-nineteenth century, the pictures actually had value precisely because they were *better* than photographic images; instead of being true to appearances they were true to memory. Instead of having merit because they were accurate in the most minute details, they had value because they could evoke a spirit of nationalism and a familiar narrative of heroism. Their much-lauded "authenticity" had little to do with their fidelity to actual events. "It is hard to write the history of an exciting event . . . [long] after it has transpired," observed a contributor to the *American Review* in June 1848, in words equally applicable to the challenge of pictorial representation. "While the *statistics* may be correct," he noted, "the *spirit* is wanting," for mere accuracy alone can not convey the "*facts* of history." Certainly, no daguerreotype could convey what this writer identified as the essential feature of any historical account, "the feeling which originated the movement, and the enthusiasm which bore it onward."[31]

Artist James Walker discovered how difficult it could be to capture the spirit of memory or to mediate between competing recollections of an event. An English-born painter who had lived in Mexico before the war, Walker worked as a translator for the American troops. After producing a number of eyewitness battlefield sketches, he set up a studio in American-occupied Mexico City to paint larger versions of the scenes. But while working on his picture of the battle of Chapultepec, he got caught up in a dispute between General Gideon J. Pillow and the followers of General John A. Quitman. At stake was whose forces should be in the foreground of the painting and thus get the most credit for the American victory.[32] Eventually, the enterprising and judicious Walker pleased both generals by painting a different version of the battle for each.

Walker's story suggests the inherent tensions between photographic and drawn or painted versions of an event. A photographer necessarily captures a particular point of view, delimited by his own physical position at a given moment in time, that may or

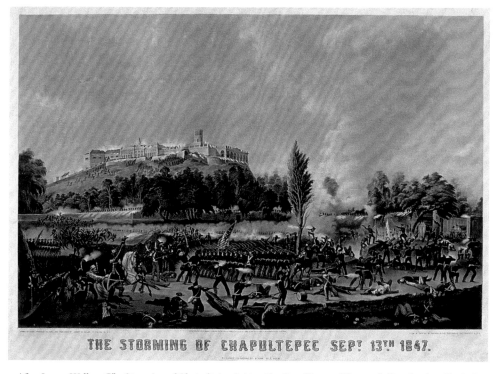

After James Walker, *The Storming of Chapultepec Sept. 13th. 1847.* Chromolithograph (hand-colored), 1848. Amon Carter Museum, Fort Worth, Texas (1974.48)

may not actually depict a signal or decisive moment of a complex event. Conversely, a painter or sketch artist can simultaneously explore an event from different perspectives, combine or adjudicate between conflicting accounts, and look back with the wisdom of hindsight to select an exemplary or decisive slice of action. George Wilkins Kendall knew that this was the challenge he faced in directing Nebel's depiction of the Battle of Buena Vista, a battle neither man had witnessed and on a battlefield neither had seen. Kendall drew his own understanding of the battle from a book by Captain James H. Carleton of the First Dragoons, a participant in the fight, that highlighted the moment when an American soldier "was so gallantly striving to hold the Mexicans in check during their last attack upon the great plateau." Kendall seized upon this as the decisive moment of combat, a moment emblematic of the greater American struggle. "In painting a battle scene some particular feature of the conflict must be taken up as the subject

for the pencil," he wrote, and this seemed "the most important of all the varied struggles which made up the battle of Buena Vista."[33] Good history pictures, he believed, required a measured assessment of what was important and what was not, what spoke to general principles and what recorded mere fact. Even an eyewitness observer might be unable to assess what he saw. "Each witness sees but a part, and often a small part, of the strife around him," wrote Kendall, "while all who participate, being actively engaged and strongly excited, are more or less incapacitated for the cool and steady observation requisite to the acquirement of just impressions of what is passing."[34] No Mexican-American War photographer could ever hope to be more than a witness, recording a selected fragment of a fast and furious action. His pictures could never compete with those made by a painter who, with hindsight on his side, could craft pictures to suit the shifting shapes of public memory and taste.

Photographers operated at a disadvantage not only because they were confined to recording what lay in physical proximity to their camera, but also because they lacked the iconographic repertoire of the sketch artist or painter. Jesse Atwood may have won praise for undertaking the arduous trip to Monterrey to paint General Zachary Taylor from life, but critics noted that it was the more imaginative elements of the composition that enhanced the portrait's symbolic resonance and ultimate value. "The gun by which Captain Bragg's men sent their compliments to the enemy five times per minute during the engagement at Buena Vista, helps as a relief," noted a reviewer in *The New York Herald Tribune,* "as does the smoke enveloped battle scene at the left of the piece."[35] With such additions, the painting could better suggest that its subject would see his "chivalrous acts and unexampled bravery lauded by every lover of free institutions and republican glory."[36] In praising the work of William Brown, who had likewise traveled to Mexico to make field sketches for his war paintings, the Richmond *Enquirer* suggested that the virtue of his paintings of Taylor and the heroes of Buena Vista extended beyond a mere faithfulness to appearances. By "bringing up the noble achievements of the American arms," the pictures evoked a whole host of associations that merited "the cordial attention of the public."[37]

The narrative and symbolic elements incorporated into these pictures, like the patriotic iconography writ large across the painted transparencies of Mexican War scenes featured in the public illuminations held across America in the spring of 1847, simultaneously evoked and confirmed popular sentiment about the war as no daguerreotype image ever could. In terms of sheer imaginative power, no daguerreo-

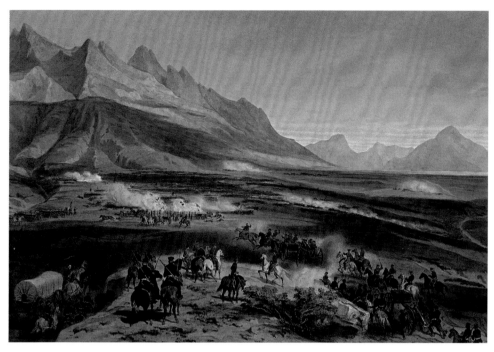

Adolphe-Jean-Baptiste Bayot after Carl Nebel, *Battle of Buena Vista*. Toned lithograph (hand-colored), 1851, from George Wilkins Kendall, *The War Between the United States and Mexico Illustrated* (1851). Amon Carter Museum, Fort Worth, Texas (1982.186.3)

type of troops standing in the streets of Saltillo, some seven miles from the battlefield at Buena Vista, could possibly match the drama of the large painted transparency of the battle that hung from a building in downtown Philadelphia during the illumination of April 1847. "The canvass represented the battle of Buena Vista, the Mexicans in the perspective, while in the foreground is seen Captain Bragg, with his noble band, dealing death and destruction upon them, at the particular point of time when Gen. Taylor, in full uniform, and seated on his faithful white charger, whispered in the ear of the captain the memorable words, 'A little more grape, Capt. Bragg!'"[38] The daguerreotype is small, just a few inches square, and difficult to see, except when held in one's hands at just the right angle to avoid the distraction of reflected light. The painted transparency, on the other hand, was large, easy to see from a distance, and normally viewed in public crowds that allowed one to study and talk with others about the meaning of the picture. If the daguerreotype was intrinsically private, the transparency was inherently

public, a collage of visual symbols around which Americans could begin to forge a collective memory of patriotic nationalism. The daguerreotype may have been a relatively stable physical object, in contrast to the crudely painted transparencies which not infrequently went up in candle-fed flames, but during the nineteenth century no Mexican War daguerreotype was ever seen by as many people as the number who viewed a transparency on a single night at any large urban celebration.

Prints were likewise public objects, intended to be seen by mass audiences, and printmakers knew that to engage the interest of these viewers they, too, would have to resort to symbolic elements that could evoke associations with other events and include narrative details that could confirm, or even deepen, widely held views about the necessity and inherent correctness of the military action in Mexico. Most of the daguerreotypists working in Mexico produced their pictures for clients who paid up front, but printmakers operated in a more speculative market, producing images in advance of having a market for their work. They had to calculate carefully, second-guessing whether their would-be buyers would want pictures that provided new information or reassuring confirmation of existing beliefs. In focusing on battle scenes as a particularly popular subject for their prints, the printmakers capitalized on public interest in the most widely reported incidents of war, but their focus on topical events did not necessarily imply a commitment to reportorial accuracy or social analysis. Indeed, their choice put them squarely in a long tradition of artists and writers who had found in battles a kind of diversion from the deeper meanings of war. In battle scenes, soldiers become little more than men caught up in a drama taking place within a particular geographical space; the moral and political dimensions of war are pressed out of the frame, squeezed out of a visual narrative that focuses on military tactics and personal heroism.

In the American-made prints of the war, formulaic strategies of representation allow the battle scenes to evoke a simple sort of nationalism. Almost invariably, the American forces occupy the foreground and the viewer is thus with them, interpreting the scene from an American point of view that enforces one military and political perspective at the expense of another. Often, one can make out the expressions on the faces of some of the American troops; they have an empathetic humanity that the faceless Mexican enemy lacks, and the viewer's eye is drawn to the small genre scenes depicting action within the American forces. Soldiers lie wounded; the able tend to the disabled; the broken wagon wheels, guns, and drums that litter the ground testify to

what has happened moments before. And inevitably, the American troops fight bravely onward, against their faceless enemy. Such prints were ill-equipped to lay out the historical sources of the conflict or to reveal that there was, in America, considerable discussion about the moral righteousness of the war. But with calculated appeal they could make a case for the correctness of the American cause and invoke a narrative of triumph, both reiterating the patriotic rhetoric of war-time reportage and laying down visual memories of the war that would persist long after a day-by-day fascination with news from the front had faded.

Daguerreotypes could evoke no such narrative. In the spring of 1847, an unidentified American daguerreotypist traveled to the military graveyard at the southern edge of Saltillo to photograph the gravesite of Lieutenant Colonel Henry Clay, Jr., who had been killed at the Battle of Buena Vista on February 23.[39] He made at least two views. In each, low bare-branched trees arch over two gravesites: in the foreground is a deep hole, dug to hold a coffin; behind it lies an adobe vault, built to protect a coffin from predators. Over each stands a simple wooden cross. The daguerrean views are spare and chilling, evoking an image of the finality of death. But their capacity to convey information or meaning is limited. A simple, contemporary handwritten label glued to the back of one of the plates identifies the site, "Burial Site of Son of Henry Clay in Mexico," and thus imposes the barest of narratives upon an image which, in and of itself, conveys little specific information. With the label, a contemporary viewer, immersed in the news reports flowing from Buena Vista and well aware of the outpouring of public sentiment that greeted the news of the young Clay's death, might understand that this was the foreign resting spot of a young American whose very name evoked a long tradition of national service and who had given his life for his country. But nothing in the image, or its spare label, could evoke the more literary narrative of heroism and sacrifice that instantly surrounded the story of Clay's death.

Heroism is an inherently narrative concept involving an action that unfolds over a period of time as a protagonist exhibits great courage or bravery in the face of a particular challenge. And the news of Clay's death instantly evoked the rhetoric of heroism. "And what shall I say of Clay—the young, the brave, the chivalrous—foremost in the fight—the soul of every lofty sentiment?" wrote one of his colleagues in an account published soon after the battle.[40] Clay's father echoed these thoughts, poignantly stretching for a kind of self-reassurance, "I derive some comfort from knowing that he died where he would have chosen, and where, if I must lose him, I should have pre-

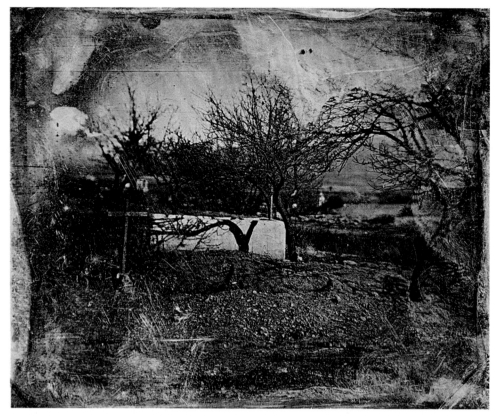

Unknown Photographer, *Burial Place of Son of Henry Clay in Mexico*. Daguerreotype, sixth-plate, 1847. Amon Carter Museum, Fort Worth, Texas (P1981.65.40)

ferred: on the battlefield, in the service of his country."[41] How could such heroism, or the notion of heroic sacrifice, be conveyed in a daguerrean view of Clay, his death, or his gravesite? With the limited spatial vision and compressed time span of a photographic view, how could one possibly depict such abstract notions as bravery or sacrifice? How could one depict the unfolding of events that culminated in the moment of heroic death? The daguerreotype of Clay's gravesite echoes with meaning only to the extent that such meaning is imposed on it from without; by the paper label on the back, by a knowledge of current events, by a familiarity with the Clay family name, by an immersion in the sentimental poetry that appeared in contemporary papers to mark the death of fallen officers.

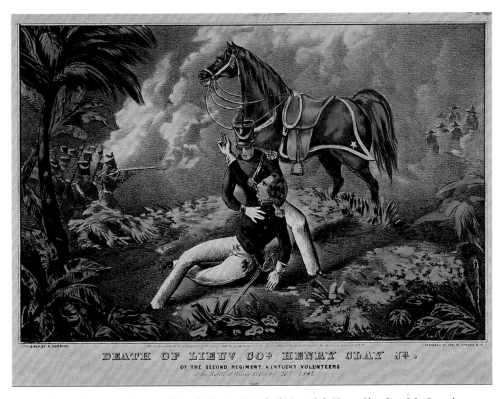

James Cameron, after an unidentified artist, *Death of Lieut. Col. Henry Clay, Jr. of the Second Regiment Kentucky Volunteers at the Battle of Buena Vista Feb. 23rd 1847*. Lithograph (hand-colored), published by Nathaniel Currier, 1847. Amon Carter Museum, Fort Worth, Texas (1971.68)

Printmakers had a vast array of pictorial options that daguerreotypists lacked, and the seven popular prints issued to commemorate Clay's death underscore this enormous gap between the available photographic and lithographic means of narrating stories. No daguerreotypist was present to record Clay's death; indeed, the technology was too cumbersome and slow to operate in the midst of military action. Yet because a battlefield death is what defined and marked the sacrifice and heroism of Clay's service and established him as a martyr to the national cause, Clay's imagined death scene became the moment most favored by popular printmakers who had ample eyewitness accounts to follow. A lieutenant colonel of the Kentucky Second Regiment, Clay had been wounded while fending off an attack from Mexican lancers. His companions

attempted to carry him from the battlefield, but as the enemy closed in across the rugged terrain, Clay ordered the soldiers to leave him behind. He asked that his sword be placed in his hand, and requested that his pistols be sent to his father with the words that he "used these to the last."[42] In Nathaniel Currier's hand-colored lithograph *Death of Lieut. Col. Henry Clay Jr. of the Second Regiment Kentucky Volunteers at the Battle of Buena Vista Feb. 23rd, 1847*, Clay lies wounded in the arms of an attentive comrade. His uniform is immaculate, his sword is at his side; a riderless horse stands alert behind him. With his right arm, Clay gestures firmly toward his comrades, who, at the left of the scene, fire their rifles at the faceless Mexicans, dimly seen through the smoke of battle at the right. Clay's gesture signals the Americans to abandon him on the battlefield and fight on, becoming and epitomizing an iconographic symbol of heroic self-sacrifice. By depicting the ongoing battle as well as the wounded Clay, and inscribing the picture with a title that not only identifies the scene but also announces Clay's imminent death, the printmaker constructs a narrative of events that both encompasses and compresses a past, present, and future. With graphic specificity, the print thus fixes the moment of death as Americans would wish to remember it, and invents a kind of memory that encodes with familiar iconography the faraway and unseen death of a young American. The unfamiliar and strange is reimagined here to be remembered later, with the visual specificity of something comfortingly and tragically familiar.

Ultimately, the photography of the Mexican-American War marked the end of an older tradition of battlefield art—one marked by imaginative drawn and printed reconstructions of self-serving visual narratives—more forcefully than it announced a new age of photojournalism. The technological constraints of the daguerreotype medium, the photographers' inability to put their images before the public eye, the intrinsic incapacity of a daguerrean image to meet the narrative or illustrative demands of an audience schooled in more descriptive and iconographic forms of battlefield art, all these left the Mexican-American War daguerreotypes mere footnotes to history. If their failure to become more public forms of art is set in sharp relief by the popularity of contemporary lithographs and painted transparencies, the daguerreotypes' limitation as a form of graphic narration is likewise put in focus by the widespread popularity of the Civil War photographs that would burn themselves into the collective American imagination less than two decades later. The Civil War photographs, like the Mexican-American War lithographs, would often participate in the formulation and confirmation of partisan narratives. But their seeming realism captured the public interest as the exqui-

site detail of the daguerreotypes never did, and their simultaneous evocation of minute detail and epic drama raised new questions about the capacity of photography to serve as a record of historical events.

By the Civil War, photography had been transformed as a tool of battlefield documentation. Enterprising photographers like Mathew Brady, Alexander Gardner, and George Barnard made use of the new wet-plate photographic technologies that allowed them to produce glass negatives from which they could produce a theoretically limitless number of paper prints. The process remained awkward and cumbersome: because photographers had to coat sheets of glass with light-sensitive chemicals, load their cameras, and expose and then develop their glass negatives, all before the light-sensitive surface dried, there are scarcely any actual scenes of battle. But paper prints had considerable advantages over the older daguerreotype views because they could be printed and marketed in quantity. A long and risky trip to photograph a particular battle site, field camp, or devastated town might pay off as no daguerrean excursion could, because a photographer could reap continued financial rewards from a successful set of negatives. And if photographers still found themselves confined to capturing a single static moment of time, the newfound capacity to inscribe the photographs with descriptive words meant they could impose narrative meanings on their still images, much as printmakers did, and reach out to their public with stories that appealed to and reinforced popular sentiment about the war. Their photographs could be mounted on boards with printed titles or with descriptive captions glued to the back; they could be mounted in albums that revealed sequential stories of war. Because photographic prints on paper are easier to see than daguerreotypes, they could also be redrawn on engraving plates with greater ease. They thus found their way into the marketplace as printed illustrations as well as photographic prints.

With no knowledge of the Mexican War daguerreotypes that had been made less than two decades before, the Civil War photographers invented their own photographic iconography of war.[43] And none of their pictures garnered more public attention than those that showed the carnage of battle. When Mathew Brady exhibited Alexander Gardner and James F. Gibson's photographs of the dead at Antietam in his fashionable New York gallery in the fall of 1862, the *New York Times* noted, "Mr. Brady has done something to bring home to us the terrible reality and earnestness of war. If he has not brought bodies and laid them in our dooryards and along the streets, he has done something very like it." Lured by a "terrible fascination" with the features of the slain soldiers, visitors

thronged to marvel at the "terrible distinctness" of the pictures.[44] "It was so nearly like visiting the battle-field to look over these views," wrote Oliver Wendell Holmes, who had in fact rushed to Antietam to search for his wounded son, "that all the emotions excited by the actual sight of the stained and sordid scene, strewn with rags and wrecks, came back to us, and we buried them in the recesses of our cabinet as we would have buried the mutilated remains of the dead they too vividly represented."[45]

But for all this attention to and fascination with the gritty specificity of these pictures and the horrific specter of death they portrayed, photographers and viewers alike still struggled to create and find in these photographs larger, more metaphorical meanings. Even the unnerving realism of the Antietam photographs seemed somehow incapable of giving full expression to the tragedy of war. The pictures could not depict the "desolate" homes of the families left behind. "All of this desolation imagination must paint," wrote a contemporary observer, "broken hearts cannot be photographed."[46] On the battlefield of Gettysburg in July 1863, Alexander Gardner's crew deliberately moved and arranged the body of a soldier for the picture *The Home of a Rebel Sharpshooter*, a visual parable, its label explains, for the loneliness and unredemptive nature of death for the Confederate cause. And in his monumental album of one hundred photographic views, *Photographic Sketch Book of the War*, an unapologetically pro-Union collection of photographs and descriptive captions, issued just after the war in January 1866, Gardner included a number of staged genre scenes. Such pictures as *The Halt*, a staged image of an officer reclining on a grassy field and enjoying a cigar, did less to show off the fact-recording capacity of photography than to suggest the ways in which photographers had learned to manipulate and arrange their subjects in order to produce images that imitated other forms of decorative art. Formulaically arranged photographs such as *Studying the Art of War* might convey an ideal of military and gentlemanly conduct, but they conveyed nothing about a particular moment in the conduct of the war.[47]

Striving to find a moral or larger lesson even in the horrific photographs of the Antietam battlefield death, a reviewer for the *New York Times* wrote, "There is a poetry in the scene, that no green fields or smiling landscapes can possess. Here lie men who have not hesitated to seal and stamp their convictions with their blood,—men who have flung themselves into the great gulf of the unknown to teach the world that there are truths dearer than life, wrong and shames more to be dreaded than death. . . . Have heart, poor mother; grieve not without hope, mourn not without consolation. This is

Alexander Gardner, *The Home of a Rebel Sharpshooter, Gettysburg*. Albumen silver print, 1863.
Amon Carter Museum, Fort Worth, Texas (P1984.30.41)

not the last of your boy. . . . [there] is reserved for him a crown which only heroes and martyrs are permitted to wear."[48] In imposing such a poetic reading about the heroism of Union sacrifice upon photographs recording the carnage of battle, the critic sought to find and create larger moral meanings for a photograph that, in and of itself, could convey no such broad story. Even as Civil War photographs garnered attention for their "terrible distinctiveness," viewers valued and honored them less as artifacts of war than as images of symbolic and poetic import. Their seeming realism—like that of the Mex-

ican-American War daguerreotypes—seemed unable to shape or support the broader public effort to draw from human conflict a more ennobling moral lesson. But because the photographic images were larger and easier to see than the small daguerrean plates, because they could come before the public eye with evocative titles and detailed captions, they could more easily fulfill and sustain a public longing for grander moral meanings. They could simultaneously invite viewers to reimagine the moral lessons of the past and to look ahead to the future, when the silent landscapes of battle would be sites of historical tourism, places to go to reflect on the larger dimensions and meanings of the nation's Civil War.

The tension between the specific documentary value of the photographs and their capacity to represent broader truths was not easily resolved. Thus it seems fitting that the final image in Gardner's *Photographic Sketch Book* should depict the dedication of the monument on the Bull Run battlefield in June 1865. The *Sketch Book* includes pictures of sites where horrific battles had taken place, powerful and moving images of the dead at Gettysburg, a haunting photograph of a burial party at Cold Harbor, Virginia, collecting the mutilated skeletal remains of fallen soldiers. But the album ends with an image of a monument, presciently suggesting the not too distant day when the war would be remembered through the grand rhetorical stories represented by monuments and reunions and veterans' self-serving tales rather than through horrific photographic documents of death that preserved the endless personal tragedies of the war.[49] At the 1897 dedication of the Robert Gould Shaw Memorial on Boston Common that honored Shaw and the black soldiers of the Fifty-Fourth Massachusetts regiment that he led in defense of the Union cause, William James mused over the place of photographs in the memory of the Civil War. "Only when some yellow-bleached photograph of a soldier of the 'sixties comes into our hands, with the odd and vivid look of individuality due to the moment when it was taken, do we realize the concreteness of that by-gone history, and feel how interminable to the actors in them were those leaden-footed hours and years. The photographs themselves erelong will fade utterly, and books of history and monuments like this alone will tell the tale." James suggested that legendary stories of the war would ultimately prevail over the fragmentary photographic records of horror and the mundane routines of camp life. "The great war for the Union will be like the siege of Troy," he said; "it will have taken its place amongst all other old, unhappy, far-off things and battles long ago."[50] Epic stories would remain, where the fractured stories preserved in photographic records would fade away.

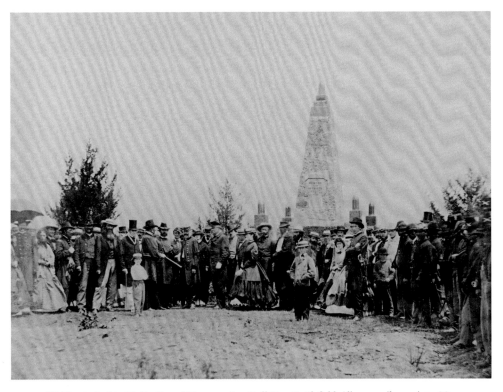

W. Morris Smith, *Dedication of Monument on Bull Run Battlefield*. Albumen silver print, 1865.
Amon Carter Museum, Fort Worth, Texas (P1984.30.100)

The Civil War has, indeed, become an epic and even mythic moment in the American past, an event understood in grand terms of fratricidal violence, of reunion, of the rebirth of the American nation. The Mexican-American War, by contrast, so lacking in the inherent drama of a war fought on American soil that pitted brother against brother, is little remembered, except as an early chapter in United States imperialism and the means by which the United States acquired the present-day Southwest. In both cases, though, political causes, social repercussions, and internal dissent have been pressed to the margins of the stories told in popular memory. Yet as the gritty realism of life in mid-nineteenth-century America drops from the popular retelling of its war stories, the specificity of information recorded in the Mexican-American War and

Unidentified photographer, *American Volunteer Infantry Standing Along a Street in Saltillo.*
Daguerreotype, quarter-plate, c. 1847. Amon Carter Museum, Fort Worth, Texas (P1981.65.25)

Civil War photographs has taken on new value. The mundane realism of the photographs whose fading importance James lamented at the end of the century is now back in fashion precisely for its capacity to convey the details of military dress and arms, battlefield topography, or the aspect of a particular building or ship.[51] The Mexican-American War daguerreotypes likewise have been rediscovered anew and reinvested with meaning not just for their ability to convey detailed information about military dress or the appearance of particular American officers, but for the vivid immediacy of their status as eyewitness views and their almost visceral connection to the events of 1847 that surpasses that of any other historical artifact. The daguerreotypes of General Wool parading with his escort down the streets of Saltillo were actually created *on* those Saltillo streets with Wool. Light bouncing off of Wool's body impressed itself upon the light-sensitive surface of the plates, and like a mirror with a memory the

daguerreotype plates continue to record the physical traces of that long-ago event. To hold the plates in one's hand is to hold actual physical eyewitness evidence that Wool was there, that these events happened, that, an absence of literary documentation notwithstanding, a particular gathering of Mexican onlookers and American soldiers once took place as a dog looked on from the side.

But the quotidian nature of the evidence conveyed by these photographs—the sort that might now be useful to military or social historians, or valuable to collectors of historical photographs—is exactly what made them so useless to contemporary nineteenth-century viewers who sought affirmation, not information. The detailed immediacy of the Mexican-American War daguerreotypes held little emotional weight against other more narrative and iconographic visual renderings, particularly those that could convey more vivid narratives of battlefield dramas and deaths. No daguerrean record of an afternoon's event on a Saltillo street could hold its own against the patriotic stories writ large across the face of popular prints and transparencies, or the self-aggrandizing memories of returning veterans. The daguerreotype lacked symbolic stature, narrative clarity, and the capacity to reaffirm or lay down a kind of invented graphic memory of what had transpired. Its seeming "authenticity"—its capacity to seem trustworthy for its close accordance with fact or actuality—did not translate into explication of a complex event. Photography may have provided an eyewitness glimpse of the events that led to the final geographical definition of the western continental United States, but it did not yet have the power or capacity to serve as an important way of conveying information about that place or to prompt Americans to consider different ways of imagining their own newly expanded world.

2

"Of Instruction for Their Faithfulness"

Panoramas, Indian Galleries, and Western Daguerreotypes

Works of art are received and valued on different planes.
Two polar types stand out: with one, the accent is on the cult value; with the other,
on the exhibition value of the work.

—Walter Benjamin,
"The Work of Art in the Age of Mechanical Reproduction," 1955

In December 1846, as United States troops battled Mexican forces in the war that would redefine the geographical West, John Banvard's enormous moving panorama of the Mississippi River opened at Amory Hall in Boston. "The largest picture ever executed by man," sprawled across a hyperbolic "three miles" of canvas that unscrolled from one upright cylinder to another across a stage, giving viewers the illusion of traveling twelve hundred miles along the Mississippi River and its tributaries, the Missouri and the Ohio.[1] Imaginatively gliding down the mighty "Father of the Waters," viewers would enjoy a topographical tour, while being exposed to the rich variety of national culture: "the dense forest, the castellated cliffs, the well-cultivated fields, the splendid steamboats, the planters' palaces, the squatter's cabin . . . all represented with a truthfulness which delights as well as astonishes the viewer."[2]

Seated in the darkened hall, waiting for the gaslit painting to begin to move, viewers would anticipate Banvard's own appearance as well as his dramatic, colloquial narration. "He is a greater curiosity than his picture," Charles Dickens remarked.[3] And as the anticipation mounted, the crowds would grow restless. The poet John Greenleaf Whittier recalled the "restless cane-tap and impatient foot, / And the shrill call, across the general din, / 'Roll up your curtain! Let the show begin!'"[4]

No laggard when it came to self-promotion, Banvard advertised his painting as an intensely nationalistic work, the result of an idea that had come to him as a "fatherless, moneyless youth" of fifteen when he first floated down the Mississippi and contemplated an article he had read in a "foreign journal" about America's failure to produce a native artist who could picture her magnificent scenery. "The boy resolved within himself that he would take away the reproach from his country,—that *he* would paint the beauties and sublimities of his native land," creating a painting of the Mississippi "as superior to all others, in point of *size,* as that prodigious river is superior to the streamlets of Europe." And for a reported four hundred days, he floated along the river, mak-

48

ing sketches that he could then transfer to canvas for his grand moving painting, which quickly proved the national success for which he had hoped. The Massachusetts State Senate, treated to a special showing of the panorama, formally declared that "as Americans, it is with emotions of pride and pleasure we commend this splendid painting; and its talented artist, who, by its production, has reflected so much honor upon himself, and upon the country of his birth."[5]

During Christmastime 1852, six years after the Boston debut of Banvard's panorama, another grand moving painting took the stage in the city's Amory Hall. John Wesley Jones's *Pantoscope of California, Nebraska, Utah, and the Mormons* opened with a view from a "balloon elevation" that gave onlookers a glimpse of the entire overland trail from the Missouri River to California, then took them down to ground level so that they could struggle westward with the emigrants. Through frightening storms and Indian assaults, by picturesque rock formations and across South Pass, viewers could follow the journey to California, where they would glimpse a new American world. The old California, the poet John Ross Dix explained, was nowhere to be found in this painting.

Where "the wild Indian [roved] o'er the untilled lands: / *Now* the rich miner boasts his fine hotel." The region's Spanish and Mexican pasts were equally remote, as "sounds of trade, in lieu of monkish stories, / Are heard at Santa Clara and Dolores."[6] Playing out against the backdrop of westward expansionism and heated political debates about the extension of slavery into the western territories, such unabashed appeals to a more unified vision of American nationalism won the painting broad praise. "As a picture alone—a work of art—it is admirable," noted a Boston newspaper, "but as developing the vast scenery of our own

John Banvard, *Banvard's Geographical Panorama*. Yale Collection of Western Americana, Beinecke Rare Book and Manuscript Library

country and revealing to us that land so romantically interwoven with our nation's destiny, it is *intensely interesting and instructive.*"[7]

Like Banvard's painting, Jones's pantoscope thrilled audiences with its intimations of vicarious travel, its allure as an instructive geography primer, its unabashed appeal to national pride. However, if it echoed the basic format and central themes of Banvard's work, it nonetheless differed from it in two important ways. In providing an image of overland travel—rather than a leisurely float trip down the Mississippi—it marked just how much the national imagination of the far West had expanded since the mid-1840s when the Mississippi River seemed the boundary between the settled East and an only vaguely understood West, parts of which still remained under Mexican or British control. By the early 1850s, the western half of the continent was firmly American, and California, once dimly imagined as a distant outpost of Spanish America, was tightly bound up in the body politic, a destination for overland emigrants and, since the Compromise of 1850, a central focus of the debates over slavery's future.

But in addition to its subject matter, the pantoscope differed from Banvard's painting in its mode of production. As any viewer reading Jones's promotional material or listening to his narration would have known, the pantoscope was produced not just from eyewitness sketches, but from an extraordinary collection of some fifteen hundred daguerreotypes. To produce the painting, Jones had undertaken the most ambitious photographic expedition of the age, leading a team of daguerreotypists east from California across the snow-capped Sierras, the vast arid stretches of the Great Basin, the challenging slopes of the Central Rockies, capturing along

Jones's Great Pantoscope of California. Broadside, c. 1852. California Historical Society (FN 19207)

the way the first photographs of these quintessentially western sites, the first photographs of many western Indian communities, the first photographs of the still-ubiquitous buffalo. His very ambition suggested just how far enterprising daguerreotypists had come in the few short years since the Mexican War. But the final disposition of the daguerreotypes suggested that photography had not yet found an easy way to compete with the more compelling narrative imagery of other visual media. Like a novelist drawing on newspaper stories for a work of historical fiction, Jones used the daguerreotypes as preparatory sketches for his big painting, as visual ideas that his team of artists could consult as they painted their large, loosely drawn scenes on sheets of canvas. For his viewers, this seemed to confer a special kind of authenticity or authority upon the painting. "In *accuracy* it probably *exceeds* any [of the panoramas exhibited in this city]," wrote Henry Ward Beecher, "as the daguerreotype has been used to give exactness to its delineations."[8] But once the painting was completed, the daguerreotypes were discarded: they had little value as objects in and of themselves. Jones, for all his entrepreneurial savvy, could not imagine any other way to find a market for his daguerreotype views. In a world crowded with other forms of visual representation, his daguerreotypes did not win instant acclaim; they were the means to a more dramatic and enthralling end.

Banvard's hugely successful painting—which earned him a reported $50,000 in six months—would inspire a host of other panoramas devoted to western themes in the late 1840s and 1850s. But for all the fleeting novelty of its subject matter, it fit squarely within a tradition of popular American theatrical art.[9] While the picture was on view in Boston in late 1846 and early 1847, attracting crowds transported on specially chartered trains from across New Eng-

Broadside for Banvard's Panorama. London, 1852. The St. Louis Mercantile Library at the University of Missouri–St. Louis

land, Boston's theatergoers could also be entertained by the more historical "mechanical Diorama of the BATTLE OF BUNKER HILL. . . less than Three Miles Long" (accompanied by dancers, magicians, and Ethiopian minstrels), and by the more topical "GREAT MOVING PANORAMA OF THE MEXICAN CAMPAIGN," which alluded to events that had transpired only two months before.[10] Panoramas of Mexican-American War scenes had been exhibited as early as May 1846, just after the first engagements of the conflict, but most appeared after the war when, with the hindsight and wisdom afforded through retrospection, painters could carefully select those emblematic moments that seemed richest in nationalistic resonance, narrative import, and popular appeal. If the public allure of their topic seemed to wane, especially after America's victory, the painters of these Mexican-American War panoramas and their publicists could resort to other strategies. The New York impresarios staging the panorama *The Bombardment of Vera Cruz* added fireworks to enhance the realism of their production. In St. Louis, the producers of a panorama based on the memoirs of Mexican War veteran Corydon Donnavan added scenes that depicted the "sublime and beautiful scenery of the Garden of Eden," the biblical flood, and pictures of a midnight mass in Rome, all climaxing in yet another bombardment of Vera Cruz.[11] One can only hope the assembled emotion of the scenes outweighed the unfathomable logic of their sequencing.

Part entertainment and part education, part hyperbolic bluff and part high-minded instruction, the panoramas engaged topical events as well as escapist travel fantasies. They functioned as precursors to the public pageants, newsreels, and grade B westerns that would captivate later audiences, enfolding descriptive information about places and events within grander stories of American life. Accompanied by spoken narrations and live music, the long, painted canvases could take up to three hours to view, and the sequential nature of the picture meant that viewers always saw the story unfold in precisely the same way. Or, in an ordered backward fashion. The sheer weight and physical awkwardness of the paintings meant that they were difficult to rewind; an imaginative afternoon trip *down* the Mississippi would be followed by an evening voyage *up* the river. The need for a spoken narration that could unfold equally well in either direction surely limited the speaker's storytelling possibilities.

Like the transparencies that were a staple of the public celebrations surrounding the Mexican-American War, the panoramas were large, crudely painted pictures on fabric that emphasized graphic effect over minute detail. Displayed indoors, rather than outside, they were nonetheless public forms of art created, like the transparencies,

to be viewed in social situations. And they echoed the patriotic emphasis of the war paintings. If some American panoramists wandered as far as the Holy Land in search of subject matter for their pictures, most turned to American themes, implicitly celebrating the same sort of cultural nationalism venerated by the transparencies. After viewing a Mississippi River panorama, the writer Henry David Thoreau remarked, "I saw that this was a Rhine stream of a different kind; that the foundations were yet to be laid, and the famous bridges were yet to be thrown over the river; and I felt that *this was the heroic age itself.*"[12] But while invoking a familiar rhetoric of nationalist pride, the panoramas differed from the transparencies in depending on a rigid narrative structure of presentation and interpretation. The movement of the painting across a stage required that audiences "read" the picture, and the accompanying spoken (and sometimes printed) narration enforced one reading at the expense of others, enhancing the illusion of reality and "truthfulness" that was the hallmark of the panoramic medium.

With words more often applied to the miraculous technology of the steamship, railroad, or telegraph, a reporter for the St. Louis *Weekly Reveille* declared in 1850 that the panorama was a "wonderful invention for annihilating time and space" that gave new meaning to the concept of armchair travel. "The necessity of taking long sea voyages for the recovery of health, or short trips for purposes of pleasure, has been superceded [sic] by the modern introduction of panoramas," he wrote. "The valetudinarian who has been recommended to change of scene, may now, comfortably seated in a pleasant room, and, without being subjected to the annoyance of rail way porters, disagreeable travelling companions, and the perpetual losses of trunks and carpet bags, enjoy all the varieties of scenery, and revel in all the riches and beauties of nature."[13] The makers of panoramas, like documentary video producers of a later era, could thus imagine themselves as public-minded citizens of the highest sort, satisfying a deep public need for educational diversion. "The love of travel is inherent in mankind, but the occupations of life preclude its gratification," wrote the panoramist John Rowson Smith with self-serving pride. "He, therefore, who by means of panoramic exhibitions makes travellers of those who would otherwise tarry at home, is no ordinary benefactor to his fellow creatures."[14] Lest the visual and auditory pleasures of the panorama not be sufficient, painter Leon Pomarede exhibited his Mississippi River panorama with smoke and steam, making even more real the illusion of modern travel.[15]

Like the publishers of Mexican War prints who claimed the "daguerreotype"

accuracy of their eyewitness prints, but actually satisfied their audiences through imagined anecdotal details and extravagantly exaggerated renderings of American heroism, the panorama painters claimed that their paintings were both highly accurate *and* better than the real thing. Arguing for the absolute accuracy of his 1850 overland trail panorama, James F. Wilkins claimed this was "the first time that this great hidden storehouse of nature's beauties, is brought to view, dragged forth I may say from their fastnesses in the mountains and exposed to public gaze." But he simultaneously asserted that his painting was better than the thing itself, because it was less trying and tiresome than an actual overland trek. "It was indispensable," he wrote, "to omit all sameness to leave out a many weary miles of desert, of sagebrush, of tameness in the scenery which would weary you almost as much as the traveler who passes over it. . . ." His selective presentation of the West's attractions was like "a bouquet of flowers chosen with care from the heart of this vast continent and laid at your feet."[16] So accurate did this truncated topography seem, a correspondent to the Peoria, Illinois, *Democratic Press* could assert in 1850 that a viewer would "actually believe that he was on his way to California." But Wilkins, who had made the trip himself, knew his imagined version of travel was considerably more pleasant. "The spectator, with very little assistance from the imagination, may fancy himself in an air balloon, overtaking and passing the Emigrants on the road, witnessing their distress, seeing the country and the nature of the obstacles they have to contend with; and with all the safety and comfort of sitting at your own fireside."[17] The experience of viewing America through the vicarious pleasures of the panorama was infinitely better than experiencing her firsthand. The imagined West was more accessible, more safely attractive, than the real one.

Given this appeal of the more fictive and imaginative aspects of the panoramas, it seems ironic that the moving paintings would become an important model for daguerreotypists interested in photographing the varied landscapes of the western United States. But from the panoramas, enterprising western daguerreans learned much about how to create an audience for their hard-won views. By using their daguerreotype plates in ways that mimicked the expansive topographic scope, narrative structure, and public aspects of the moving paintings, they found new ways to compete in the crowded visual marketplace of nineteenth-century America. By turning to the storytelling strategies of the panorama painters, they found new ways to make their daguerreotypes speak to the central concerns of American life.

It is difficult to imagine two visual media more different than the grandiose panoramas and the small daguerreotype plates, or two sorts of images that demanded such different kinds of viewing encounters. A panorama viewer would purchase a ticket—an act that seemed to confer a certain cultural authority upon what he was about to see—then enter a theater to share with others the experience of seeing and hearing a carefully orchestrated performance. Each portion of the panorama would be accompanied by a spoken narration that honed and clarified the intended meaning of a painted scene, and in the darkened theater (or later as crowds exited the building) there would be ample time to turn to one's neighbor to discuss the enterprise. Against the panoramas' monumental size stood the daguerreotypes' small form. It was inherently difficult to make daguerreotype viewing a shared or public act, or to confer upon daguerreotypes the rigid narrative structure of a panoramic story. For all the rhetoric about the realism of the panoramas, most viewers surely understood the paintings to be constructed works of art; daguerreotypes, however, retained the aura of unmediated, literal accuracy. Finally, while the panoramas were designed to convey a sense of movement across space and time, the specific place and particular moment preserved in the daguerrean image were fixed forever. Yet by mimicking the narrative structure and public quality of the panoramic paintings, enterprising western daguerreotypists reimagined photography as a narrative storytelling medium that could describe events stretching across time and space. Straining against the technical and conceptual limitations of a medium that could capture only a particular moment and place, they exposed the inherent tension between the photograph's technological capacity and the cultural demands placed upon it.

The term "panorama" was coined around 1789 by Robert Barker, an Irish-born artist working in Edinburgh, to describe the sort of large scale painting he had first exhibited in London two years before.[18] Installed in a specially constructed circular rotunda, forty-five feet in diameter and sixteen feet high, Barker's painting surrounded the viewers at eye level, wrapping around them in a 360 degree sweep. The picture itself was static, but by turning and letting their eyes scan the entire expanse of the painting, viewers could experience the illusion of taking in a vast expanse of landscape. "Panorama" is a word "employed of late to denote a painting," noted a contemporary text, "which represents a view of any country, city or other natural objects, as they appear to a person standing in any situation, and turning quite round."[19] The Ameri-

can steamboat inventor, Robert Fulton, and his friend, the American poet and diplomat Joel Barlow, took out a French patent on the panorama in 1799 and that same year opened in Paris a widely acclaimed panorama of the burning of Moscow. Although Fulton was soon forced to sell out, a popular market for the panorama was quickly established in France.[20]

And indeed it is in Paris that one first finds links between these public narrative paintings and the newly emerging art of photography. Louis Jacques Mandé Daguerre, the Frenchman who announced the first practical photographic process to the world in 1839, had previously been best known as the creator of large transparent paintings known as "dioramas," stationary panoramas popular throughout France in the 1820s and 1830s, as well as in England and America. Displayed in specially constructed rotundas, the pictures did not move, but cleverly managed lighting gave the illusion of movement and the passage of time: weather seemed to change, fires seemed to burn, the sun seemed to set.[21] In 1829, with the exhibition in London of the first moving panorama—a painting of the south bank of the Thames—entrepreneurial painters acquired a new way to mimic movement across space and time, and the very word "panorama" took on an added meaning that embraced this idea of physical motion, as a "continuous passing scene; a mental vision in which a series of images passes before the mind's eye."[22] Although the frequent exhibition of these moving panoramas placed physical stress on the paintings as they scrolled back and forth across a stage, the moving pictures did not require a specially constructed theater, and were easily transported from one venue to another. By the 1840s, a host of curiously named static and moving paintings testified to a popular "panoramania" in Europe and the United States, where the picture-going public could see betanioramas, cosmoramas, cycloramas, georamas, kaloramas, physioramas, and the oddly named and unexplained "nausorama," with its intriguing hints of odd olfactory sensations.[23]

Thus just as the Mexican War photographers found themselves in a competitive market in which their small daguerrean plates had to struggle for attention against the more dramatic productions of printmakers, so, too, did landscape daguerreotypists in the mid-nineteenth-century West have to compete with the compelling narratives of the popular panoramas. And it was difficult, indeed, for daguerrean images to vie with the inherent drama, grandeur, and nationalism of the panoramas that focused on the geographic splendor of the American nation. The mere topographical accuracy of the daguerrean view was not enough. For despite the panoramists' almost obsessive con-

cern with accuracy—Banvard had more than one hundred steamboat captains vouch for his painting, and then had the mayor of Louisville vouch for the captains—the appeal of the paintings depended on more than geographic correctness.[24] Banvard's own panorama, for example, entranced viewers with its politics as well as its romantic nationalism. Upon viewing the panorama during the winter of 1846–7, William Lloyd Garrison, the abolitionist editor of the Boston *Liberator*, pronounced it evidence of the horrors of southern slavery. Henry Wadsworth Longfellow cited it as an inspiration for his romantic poem "Evangeline."[25] John Greenleaf Whittier viewed it as a meditation on what might happen should slavery spread across the West, for it evoked two alternative futures for the nation. Banvard's painting depicted the West as "the new Canaan of our Israel," the land of promise to "the swarming North," "to the poor Southron on his worn-out soil," "to Europe's exiles seeking home and rest." But Whittier understood that Banvard's was a predictive picture, and he imagined an alternative West, stained by slavery the "evil Fate," until "From sea to sea the drear eclipse is thrown. / From sea to sea the *Mauvaises Terres* have grown, / A belt of curses on the New World's zone!"[26] More than mere topographical reportage, panoramas had the capacity to help viewers reimagine the future as well as the past and to tap into deeply felt anxieties about the very nature of the American nation. Their widespread popularity during the 1840s and 1850s testifies to their power as mass culture, as widely seen and discussed images that simultaneously stimulated debate and assuaged doubts about the rapidly shifting shape of American life. By the early 1880s, when Mark Twain satirized panoramas in *Life on the Mississippi*, the moving paintings seemed easy targets for their flowery, overblown rhetoric, what Twain deemed "lurid eloquence." But satire implies familiarity; some three decades or more after their peak of popularity, panoramas remained a familiar part of American popular culture.[27]

The three key themes to emerge in American panorama painting during the late 1840s—Mississippi River travel, overland exploration and migration, and the growth of San Francisco—each reflected the national interest in the westward movement of the nation, and posited the West as a place that stood above the sectional strife of North and South. Each subject had its own inherent logic of pictorial organization. The river paintings took viewers on a linear trip along the water; the overland paintings followed a sequential path across the continent; the city views unfolded from real or imagined viewpoints that allowed the viewer to scan the horizon in all directions. And each type of painting inspired private daguerrean ventures, in some cases stimulating the pro-

duction of photographic views that attempted to cover a similar subject, in some cases inspiring ambitious daguerrean projects whose aim was actually the fabrication of a moving painting *based* on daguerreotype views. Significantly, a number of important western photographers also had prior experience as panorama painters, an experience that prepared them to think about how they might present their photographic views as an unfolding visual story and engage a public audience in their work.

Banvard's success inevitably inspired imitators, and by the late 1840s there were at least four rival Mississippi River pictures, all vying over the authenticity of their views, the dramatic quality of their narrations, and, above all, the extravagant length of the canvases. John Rowson Smith, Banvard's first great challenger, dismissed his rival's painting in 1848 with the claim that his own Mississippi River panorama covered "an area of 20,000 square feet, more than half again as large as Banvard's and 700 miles more of [the river's] scenery."[28] Arguing for the picture's instructive value and foreshadowing many of the claims that would be made for photography's historical merit, the promoters of the Smith panorama asserted that the painting would prove a valuable record of a rapidly changing part of America. "How much might be gathered of ancient manners and history, had our ancestors bequeathed to us works of a similar description," they lamented.[29] In short order, in 1848 and 1849, three other major Mississippi River panoramas appeared, by Samuel B. Stockwell, Henry Lewis, and Leon Pomarede, each claiming factual authority based on its artist's sketching voyages down the Mississippi.

Given the widespread popularity of these paintings, it is not surprising that enterprising photographers should seize upon them as a model for their work. In July 1851, *The Daguerrean Journal* reported that two photographers named Lamartine and Sullivan had fitted a boat for daguerreotyping along the Muskingum River in Ohio that "would be convenient for taking panoramas."[30] The Mississippi, however, proved the most popular subject and river route for photographers, just as it had for painters. Daguerreotypist Samuel F. Simpson was operating along the river as early as 1854, and in July 1855 he wrote to a photographic journal to say that he had run two floating galleries down the Mississippi and was now outfitting a third. "This kind of Gallery, I suppose, is rather new to most of your eastern operators," he explained, "however, it is becoming quite popular in the west." Arguing for the practicality of the operation, Simpson explained there was no need to unpack and set up before starting to work in a new town, no reason to linger where business was poor, no need to rely on another for

transportation. But he dropped his businessman's pose and wrote with the eye of an artist when he shared with his readers his sheer delight at the diversity of the people he encountered along the river. "There are merchants, grocers, carpenters, cabinet-makers, blacksmiths, tinners, coopers, painters, shoe-makers, wagon-makers, plough-makers, (and I should have said likeness makers), saddlers, jewellers, potters, glass-blowers, doctors, dentists, showmen, ventriloquists, machinists, jugglers, Barnums, black-legs, gamblers, thieves, humbugs, museums, concerts, circuses, menageries, Tom Thumbs and baby shows, 'till you can't rest."[31] The photographer J. R. Gorgas likewise embraced the romance of river life, recalling the three years he had spent on a floating gallery on the Ohio and Mississippi Rivers as "the happiest years of my life." On his "handsome" and well-appointed boat were a good cook as well as a flute, a violin, and a guitar, all of which afforded him a "jolly time," especially on Sundays, when he took the day off.[32] Fun it might be, but to make a living one truly did need some photographic skill. The gambler George Devol recalled that he had once won a floating daguerrean gallery in a game of cards but sold it two weeks later "as it was outside of my line" and more profitable to stick to his "legitimate business."[33]

Floating photography galleries survived beyond the daguerrean age, enjoying a resurgence during the mid-1870s when New Jersey photographer John P. Doremus set out in a flatboat to float from "the foot of the Falls of St. Anthony to the mouth of the Mississippi," intent on photographing "all the points of object along the Mississippi from Minneapolis to the mouth."[34] In 1878, after four years on the river, he lamented that it would take him another five to do all the cities, towns, and "picturesque landscapes" along his route.[35] "The photographic business on the rivers West and South is not overlooked," reported E. J. Stewart to *Anthony's Photographic Bulletin* in November 1875. From his vantage point in Clarksville, Missouri, he knew of at least seven floating galleries in operation on the Mississippi and its tributaries, with operators making both ferrotypes and photographic prints.[36] Stewart reported that the boats did a brisk portrait business during cotton harvest season in the South. The economics of the business dictated that portraiture was likely the most profitable part of the floating photographic galleries; the lure of a paying customer was hard to resist. Yet the painted panoramas remained compelling models for the photographers. Doremus produced stereographs, "charming pictures of the Father of Water," as part of a project designed to "contribute towards the illustration of picturesque America," carefully ordering and numbering the pictures to mimic a trip down the river.[37] But such sequential stereo-

J. G. Evans, *Muscatine, Iowa*. Albumen silver print, portion of stereographic panorama, c. 1870s.
Yale Collection of Western Americana, Beinecke Rare Book and Manuscript Library

graphs, like the five-part stereographic panorama that J. G. Evans published of the Mississippi River town of Muscatine, Iowa, were ultimately thin imitators of the grand painted panoramas.[38] Viewed one at a time in a stereo viewer, these pictures could convey nothing of the grand sweep or public quality of their painted predecessors. Nor could the small, intimate daguerrean views made by Simpson and his contemporaries. There was simply no way to get around the insistent physical borders of the photograph, no way to make a series of these pictures scan as one continual whole. The fixed edges of the pictures and the fleeting moments of time they fixed forever denied the leisurely pace of travel, the constantly changing scenery, and the visual references to the grander themes of American life that made the painted Mississippi River panoramas such enjoyable and valued forms of entertainment.

The success of the Mississippi River panoramas, coupled with the intense interest in the far West spurred by the discovery of California gold, soon created an audience demand for panoramic depictions of the overland (and overseas) routes to the mines. "Since Banvard's great Mississippi Panorama was first brought before the public, there has been no lack of scenic exhibition on the stupendous scale introduced by him," wrote a columnist for the San Francisco *Alta California* on December 19, 1849. "But now we wonder why some clever artist doesn't undertake a stupendous painting of Cal-

ifornia scenery—her rising cities and mountain mining and trading posts." A well-done picture promised to be a "placer" or gold mine of its own when "opened for exhibition in the States to those who may have never conceived an idea of 'Going to California, its gold mines for to see.'"[39] Unbeknownst to the writer such pictures were already on view in the East. As early as September 1849, a panorama of the route around Cape Horn was being exhibited in New York, and that October a panorama detailing John C. Frémont's overland travels west went on view in Boston. In 1850, New Yorkers could see a panorama of the goldfields of California by Emmert and Penfield, take in *Meyer's Grand Original Panorama of a Voyage to California and the Gold Digging* [sic], and imaginatively venture west again with Beale and Craven's *Voyage to California and Return.*[40] If these East Coast performances stimulated the wanderlust of would-be gold seekers, the panorama exhibitions in California towns served a different function, simultaneously reminding viewers of the heroism of their own westward treks and reassuring them that, present difficulties aside, there remained the possibility of a golden future. Panoramas never detailed the stories of those who turned back eastward, their dreams dashed, their pockets empty. Onto the ever-triumphant paintings, with their pre-Hollywood versions of happy endings, Californians could project their own dreams of success. Theatergoers in San Francisco in 1851 could relive their own heroism in the *Grand Panoramic Views of the Cities and Scenery of California*; San Francisco and Sacramento audiences of 1853 could watch the *Grand Moving Panorama of California*; in 1853–54, small mining town residents could see artist George Weaver's touring *Grand [Moving] Panorama of the Overland Route to California.*[41] The regional popularity of such performances continued throughout the decade, with the panoramas shown again and again until they simply wore out and fell apart.

For their appeal, the panoramas relied on their simultaneous ability to tap into bigger cultural myths and their capacity to convey a certain specificity of information. Hence, the San Francisco *Alta California* reported in November 1850 that William Cogswell had just repainted his panorama of the city to reflect the changes incurred by two recent fires.[42] Daguerreotypists could compete reasonably well with scenic painters with respect to this sort of reportorial accuracy, even though the very concept of a long, horizontal panorama seemed at odds with the rectangular format and fixed borders of a daguerrean image. And so, particularly in San Francisco, photographers turned to urban panoramas as models for their work. The former dentist S. C. McIntyre displayed a daguerrean panorama of the city in January 1851 consisting, as the local

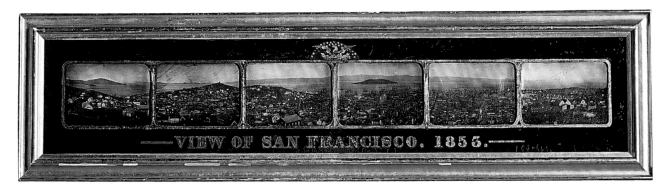

Unknown, *View of San Francisco.* Six whole-plate daguerreotypes in vintage frame, 1853. The Oakland Museum of California, gift of Minna McGauley Stoddard

paper explained, of "a consecutive series of Daguerreian plates, five in number, arranged side by side, so as to give a view of our entire city and harbor." That same year, an unidentified daguerrean produced a rare 360 degree panorama of the city. The following year, William Shew exhibited his own five-plate panorama, and at about the same time an unidentified photographer unveiled a formidable seven-plate panorama of the city nearly seven feet in length. With each single daguerrean plate of the panoramas mounted in its own protective case, framed by a gold-colored edging mat to protect its fragile surface from a sheet of cover glass, it was exceedingly difficult to truly mimic the long continual flow of a panoramic painting. Yet despite the intrinsic irony of the format, at least eight multipart daguerrean panoramas of San Francisco were executed between 1850 and 1853.[43]

Such multipart photographic panoramas remained an established genre well into the era of paper prints. Indeed, by 1877 at least fifty multipart photographic panoramas had been produced in San Francisco alone, where the hilly topography afforded photographers the necessary vantage points from which to make their views.[44] None was more spectacular than Eadweard Muybridge's 360 degree panorama of the city, produced in 1878, that was composed of paper prints produced from thirteen 24×20 inch glass negatives, which, when pieced and mounted together, stretched more than 17 feet in length.[45] Like their painted counterparts, these photographic panoramas demanded a close reading from viewers drawn into the rich detail of the imagery. And like the paintings, they seemed to defy the inherently limited temporal scope of what they pic-

tured. In fire-prone San Francisco, urban daguerreotypes almost instantly became meditations on the past. "It is almost impossible," noted a local paper in 1851, "for a resident to recollect some of the quarters, representations of which have been lately exhibited in the windows of daguerreotypists."[46] But the photographic panoramas—both the daguerrean sort and those made of paper prints—functioned simultaneously as dynamic narratives about the urban future. They depicted a palpable trajectory of change and growth, with new buildings replacing the old, new roads moving out into the urban peripheries, tangible signs of material progress popping up all over the urban landscape. Though the individual photographic images captured fixed moments of time, when assembled into panoramas they served narrative functions that looked to the past as well as to the future. In imitating the painted panoramas of their city, San

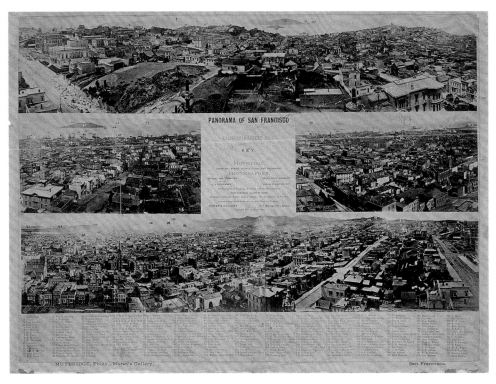

Eadweard Muybridge, *Panorama of San Francisco, from California Street Hill—Key.* Albumen silver print, 1877. Muybridge printed a reduced version of his 1877 eleven-plate picture that included a numbered key to points of interest. Yale Collection of Western Americana, Beinecke Rare Book and Manuscript Library

Francisco's photographers found one way to escape the seeming physical and temporal boundaries of the photographic plate.

If the painted panoramas of the Mississippi River and urban San Francisco inspired a host of photographic imitators, the overland trail panoramas—because of the sheer distance and diversity of the topography—proved more difficult to mimic in the daguerrean medium. James F. Wilkins called the overland panorama he produced from his own eyewitness sketches the *Moving Mirror of the Overland Trail*, evoking not just an aura of accuracy, but the literal specificity of a daguerreotype, colloquially known as a "mirror with a memory." But the story of John Wesley Jones, perhaps the most ambitious of all western daguerreotypists, suggests that the cultural borrowing went both ways. If Wilkins took his cue from the seeming accuracy of the daguerrean image, Jones would demonstrate just what a powerful model moving paintings could be for photographers.

Jones's own version of his life is the scarcely credible tale of a frontiersman and Civil War hero, country lawyer and crusader for women's rights, who became the first white man to see the Yosemite Valley and who counted among his friends both Mark Twain and Abraham Lincoln. His bombast is easy to dismiss, yet there is a kernel of truth, or near-truth, in each of his claims, and ample evidence to support his assertion that in 1851 he led a party of daguerreotypists and sketch-artists across the overland trail from California to St. Louis, making daguerreotypes that would serve as studies for an ambitious painted panorama, the *Pantoscope of California*. If his claim of fifteen hundred daguerreotypes seems scarcely plausible, he nonetheless produced the most comprehensive photographic document of the interior West yet made, capturing the first photographic images of significant topographic features and important sites along the overland trail, the first pictures of western Indian communities, even the first daguerreotype of the then-ubiquitous buffalo. His trip ranks among the most ambitious photographic projects in the history of the medium. But the pantoscope, not the daguerreotypes, was always imagined as the end product of Jones's labors. Like countless other western expeditionary daguerreotypes of the 1850s, also valued mainly as studies for other forms of representation, once the daguerreotypes had served their purpose, they disappeared.

Jones was born in Philadelphia on May 3, 1825, the son of a prosperous builder and Methodist lay preacher, William Patterson Jones, and his wife, Ursula.[47] During a

local economic depression in 1836, the Joneses moved west with their five children to Alton, Illinois, and the following year Wesley, age 11, enrolled in McKendree College, a Methodist school in the nearby town of Lebanon.[48] There, Jones claimed, he befriended Samuel Clemens, who, while not a formal student, "came to McKendree, when a very young boy, every time that he could possibly arrange to do so."[49] After a year or two at McKendree, Jones returned home to the family farm in Highland, Illinois. In the fall of 1843 he began teaching at a local school, and in 1846 became a tutor at the Rock River Seminary in Mt. Morris, Illinois, some eighty miles west of Chicago. In the summer of 1847 he moved to Quincy to study law with Archibald Williams, a longtime legal and political associate of Abraham Lincoln's; it was a tangential relationship that scarcely supports Jones's claim that he "studied law one year with Mr. Lincoln" himself.[50] In any case, Jones enrolled in the Illinois State Bar on January 6, 1849, and by spring was working as an attorney in Oquawka, Illinois.[51]

But like so many young men, Jones soon felt the lure of the far West. In March 1850, he chaired a meeting of Oquawkans determined to head west to seek their fortunes in the California mines.[52] Some

111 men from the small town declared their intentions of setting out to California, some with horses, others with oxen.[53] Jones and his younger brother, Thomas, left with the ox teams in the early spring of 1850. When Thomas fell ill shortly after their departure, Wesley took him back home and then hurried to catch up with his emigrant company.[54] By May 11, when he wrote from the Loupe Fork of the Platte River, Jones had been elected lieutenant of the "Oquawka and Lyons (Iowa) Inde-

Unidentified photographer, *John Wesley Jones.* Albumen silver print, c. 1860s. Collection of the author

pendent Company." By July 1, he was in Salt Lake City, having narrowly missed a fight between Ute and Snake Indians not far east of town. The city seemed "very unique, romantic and picturesque," but Jones hurried on to California, arriving in Sacramento in late August.[55]

It is unlikely he ever worked in a mine. Jones claimed that within hours of his arrival in the mining town of Hangtown, he was recognized as an attorney and pressed into service in a property claims case.[56] Within a month he had signed on as the assistant census agent for Calaveras County.[57] From late September through November 1850 he traveled more than fifteen hundred miles throughout the county enumerating the region's transient and largely foreign-born population, and by February 1851 his statistical reports were complete.[58] In the dispatches he filed with the Sacramento newspaper, Jones conveys the self-mocking humor, the eye for descriptive detail, and the interest in narrative storytelling that would later serve him well as an entrepreneurial panoramist. Already, he was turning his California travels into fame and capital.[59]

His travels through California soundly reconfirmed Jones's belief that money was not to be had from mining. By late December 1850, with most of his census work behind him, he was in partnership with J. S. Chapin in a "trading establishment" in Calaveras County, noting that there were "very dull times everywhere. Hundreds are daily starting home." Those who were "doing a *living* business at home" should remain there, he wrote, and "not set upon a wild goose chase after gold in the mountains of California."[60]

Jones, however, soon had his own scheme for making money devised, said a colleague, "to retrieve an unlucky throw of fortune and make use of circumstances." The idea was to exploit public interest in California and the continuing popularity of the Mississippi panoramas by creating a grand overland painting. Frederick Coolwine (Kuhlwein), the Burlington, Iowa, gardener and farmer who would accompany Jones on his trip back east, reported on April 29, 1851, that Jones and five others had formed a company "with the design of taking panoramic views of the scenery in this country and the route across the plains, having them painted on canvass in the States, to exhibit the whole as a grand panorama. . . ." It would, Coolwine wrote, be "something like the panorama of the Mississippi Valley, with the difference of having by far the most romantic and picturesque scenery and the general public interest in favor of this undertaking."[61] The party consisted of Jones, Joshua Prugh (an Oquawka acquaintance working as a tinsmith in Sacramento), daguerreotypist Seth Louis Shaw, Jacob Arrick (also from Oquawka), N. P. Toplin, and Sheldon Shufelt. Toplin was to be manager of

the project, for which donors had pledged some $30,000, and the entire painting was to be ready for exhibition in New York in 1852.[62]

The crew began working in California, "taking daguerreotype views of San Francisco, San Jose, Stockton, and along the San Joaquin and Sacramento River" before heading east on the overland trail to record, with perfect hindsight (and the reversible logic of all moving panoramas), the sights that westward migrants would face going the other direction.[63] Toplin's involvement in the project proved short-lived.[64] Shaw soon dropped out. But Jones assured investors that the project was indeed solid and progressing smoothly. "They know no such word as fail," he proclaimed.[65] The daguerreotypists worked in California from April into June. In late May, Jones and the daguerreotypist William Shew, who had been engaged to help with the California part of the project, were in Marysville where they made "two excellent views" of a local hotel and the town's newspaper office.[66] Coolwine, who intended to accompany the troupe as a writer and note-taker, reported from Sacramento on June 26 that "Jones and the artist have just come back with their labors, and a most splendid lot of mountain scenery they have brought with them; I must own I have never seen so well executed and happily chosen landscape scenery as they have collected." Coolwine conceded that California "affords any amount of picturesque, romantic and pleasing views, but our artists have chosen the best positions of the most noted places, and spare no pains nor expense in finishing them off, and finished they are as only such artists and such a machine can do it."[67] His very words conveyed the high spirit of romantic adventure that attended Jones's unprecedented enterprise.

Calculating from the very start, Jones always imagined a broad audience for his moving painting, even soliciting daguerreotypes from the readers of an Oregon City newspaper, so that his panorama could include scenes for viewers contemplating a trip to the Northwest. Jones wrote that he sought an artist or daguerreotypist to make some fifty half-plate views of different scenes in Oregon, including the important towns, interesting mountains, and river scenery. He would pay $5 for each view sent to him in St. Louis or "any of the eastern cities" during the coming winter. "The plates may be sent naked in grooved boxes—well soldered; Daguerreotypists understand this," he explained. "There must be notes accompanying each picture—of the color of the prominent buildings—or trees—or rocks, &c. &c. Also of the character of the country it represents, and its whereabouts or geographical position.—This any school boy could soon do. Anything historical or legendary concerning any particular place, we

will be glad to get, and make proper allowance for it fairly gotten up."[68] From this pastiche of ideas, anecdotes, and images, Jones would construct his panorama. His hardearned daguerreotypes would be mere studies for the more grandiose and ambitious painting itself, servants to his grander enterprise.

Still, to the first critics who viewed them, Jones's daguerreotypes seemed nothing short of marvelous. A correspondent for the Sacramento *Placer Times and Transcript* crowed, "we were scarcely prepared for such an Exhibition of Daguerreotypes, of the richest and rarest scenery of our Eden-land." Jones, he wrote, "has gathered a collection of choice views, which give one a perfect view of California, in her every phase, her mountains,—her valleys,—her forests,—ravines,—her towns and cities;—and her aboriginal and adopted inhabitants. To obtain these pictures, he has climbed mountains; swam rivers, and suffered privations and toils, almost incredible."[69] A writer for the rival *Sacramento Daily Union* added, "It is needless to say that they are true to nature; for the Daguerreotype cannot fail to produce things as they really are."[70] But for all their vaunted accuracy, it would still be painted copies of the daguerreotypes— not the daguerreotypes themselves— that Jones would put before the public eye.

Jones and his colleagues began their eastward trek from Sacramento on July 7, 1851, accompanied by William Quesenbury, a writer for the Sacramento *Daily Union,* who intended to keep a sketchbook and file literary dispatches

William Quesenbury, *Last View of Laramie River* and *Continuation of Cañon on North Platte.* Pencil sketch, 1851. Courtesy *Omaha World-Herald* Quesenbury Sketchbook

from along the route.[71] From Hangtown, on July 10, Quesenbury reported, "We have commenced our drawings for the panorama. I yesterday sketched from one of the spurs of the Sierra Nevada, the Valley of the Sacramento."[72] Ten days later, from Mormon Station in Carson Valley, he reported that "the Panorama progresses finely. The noblest field for pictures in North America, lies in the Sierra Nevada. Our pencils and the Daguerreotype have been busy ever since we entered them."[73] Quesenbury sketched the vistas seen from the overland trail, and repeatedly he made multiple drawings from the same spot, scanning the horizon from east to west or north to south, to create sketches that could be combined to imitate a 180 degree panoramic view. On at least one occasion, he paused to do a sketch that showed what lay immediately to the west of a daguerrean view that Jones had already made. The precisely labeled drawing was a frank acknowledgment of the inherent tensions between the carefully framed daguerrean image and the long, continuous topographic drawing that characterized panoramic paintings. Jones could make a single view, then save precious plates and chemical supplies by having Quesenbury sketch in the adjacent topography for transfer to a larger canvas.[74] The daguerreotype and the pencil sketch were merely two forms of preliminary study for something else, of equivalent value and merit to the painters who would translate these field pictures onto canvas.

In mid-August, Jones and his party arrived in Salt Lake City, full of news about an August 9 Snake Indian attack on a company of Galena, Illinois, immigrants near Steeple Rocks, northwest of Salt Lake on the Fort Hall Road.[75] Arriving two days later, Jones and his party helped bury the eight dead.[76] But as in the party game of "telephone," news of Jones's involvement at the scene spread eastward with ever-increasing inaccuracy. Both the St. Louis and Oquawka papers reported that Jones had been "dangerously, if not mortally wounded" while clearing the road of dangerous Indians, before printing retractions just a few days later.[77] Jones later got into the game of misrepresentation, writing a story reprinted in *Harper's Monthly* which described his adventures at Steeple Rocks as a daring charge on his Indian foes with the most improbable of weapons—a daguerreotype camera. With much "coolness and presence of mind," he "turned toward the advancing party his huge camera, and mystically waving over the instrument, with its death-dealing tube, the black cloths in which his pictures were wrapped, held his lighted cigar in frightful proximity to the dreadful engine, whose 'rude throat' threatened to blow any enemy out of existence!"[78] In another retelling of the story, Jones executed the daguerrean charge while "weak and worn out

with the loss of blood" sustained in a Snake and Digger Indian attack.[79] An interest in eyewitness visual reports proved no impediment to his inventive streak or his enduring flair for dramatic self-presentation.

By the end of October, Jones and his party were back in St. Louis, showing their pictures to the editors of the *Missouri Republican,* to stir up public interest in their proposed painting. For the reporter who described them, the pencil sketches and daguerrean views were equivalent and interchangeable as accurate visual representations of overland trail sites. "Their daguerreotype and crayon views embrace every scene of interest along the road," he wrote. "We were shown many of the sketches, and while we acknowledge the skill of the artists who took them, we will say that they evince much greater care than is usually manifested by those who engage in such works." Jones had captured any number of storied overland sites, including "'Chimney Rock,' on the plains; Fort Laramie; Salt Lake City; many landscapes, views of canons, gorges, curious formations of stone, &c., on the Sierra Nevada mountains, and numerous other scenes of interest." The reporter had every expectation that the finished panorama would be "a work of interest for the beauty of its scenes, and of instruction for their faithfulness."[80]

Despite his extended absence of nearly two and a half years, Jones lingered only briefly with his family in Illinois before continuing east to begin work on the panorama.[81] By early 1852, he was settled in Melrose, Massachusetts, just north of Boston, working with a team of artists to transform his small sketches and daguerrean images into large painted scenes. Jones and his crew—including the New York illustrator Alonzo Chappell, Boston drawing instructor William Newton Bartholomew; the Boston painter Thomas Mickell Burnham, and landscape artist W. Pearson—were still at work on the painting in November, when journalist Benson J. Lossing stopped to check on their progress.[82] But around Christmastime, Jones's grand *Pantoscope of California*—now alleged to have been made from fifteen hundred daguerreotypes— opened at Boston's Amory Hall, where Banvard's Mississippi panorama had found such enthusiastic audiences six years before. Jones, the self-proclaimed "Artist, Traveller and Lecturer," narrated performances of the pantoscope seven evenings and two afternoons a week, quickly garnering praise from the local press. "One of the most truthful representations of the Plains, Salt Lake and California ever presented to the public," proclaimed the *Boston Post*. It was instructive as well as entertaining; "as a historical work should be witnessed by old and young." By the second week of January,

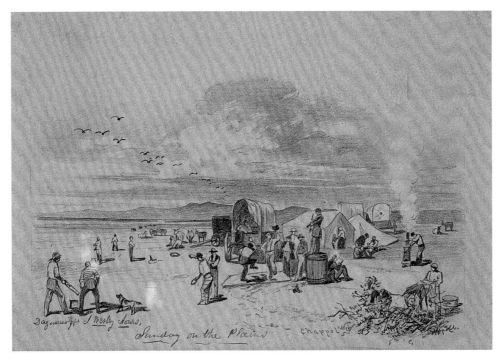

Alonzo Chappel, *Sunday on the Plains.* Pencil sketch after daguerreotype by J. Wesley Jones, c. 1852.
California Historical Society, FN 00892

the panorama was "becoming quite popular," and Jones ensured its continued popularity by organizing charity nights to benefit local organizations such as the "Ladies Charitable Shoe Society."[83] Abandoning his original plans for a series of illustrated magazine articles and travel books, he devoted his energy to the writing of a detailed narrative to accompany the painting, the production of a short-lived journal *The Pantoscope*, and a collaboration with hack-poet and publicist John Ross Dix, who wrote a pamphlet about the panorama.[84]

Jones's painting played in Boston for some six months, moved on to halls in nearby Lowell and New Bedford, and by the fall of 1853 was playing in New York City. In 1854, a Boston paper reported that the pantoscope had been in New York "upwards of eleven months, every where attracting enthusiastic audiences of the elite, and intellectual, and winning the highest encomiums of the press."[85] But behind the scenes, Jones found himself dogged by financial and legal problems. In late 1853, he had

devised a "gift enterprise" in association with his painting, promising one hundred and fifty thousand prizes to be distributed by lottery to purchasers of $1 tickets (each of which would admit four viewers to the pantoscope performance). First prize, valued at $40,000, was the "new and inimitable" pantoscope itself, with other major prizes including a 120-acre farm, and three-story dwellings in New York, Philadelphia, and Boston. Lesser prizes included pianos, watches, and pens.[86] With ever-high hopes, Jones extended the deadline for the lottery from March to July to November 1854. By then, however, his enterprise was being investigated by the district attorney's office, and a committee designated by Jones moved quickly to distribute prizes. Neither the pantoscope nor the real estate found new owners, a fact which provoked even more complaints from consumers.[87] Jones's brother, Joseph, came to New York from Illinois in a last-ditch effort to save the project. But by the spring of 1855, J. Wesley Jones had given up.[88] He returned with his family to Illinois and moved on to a new series of careers: founder (with his brother William) of Northwestern Female College in Evanston, Illinois; Civil War soldier simultaneously honored for heroism and disgraced for financial improprieties; founder of the U.S. Volunteer Life Saving Corps; Customs Service employee; and unsuccessful politician in Brooklyn, New York.[89] He seems never again to have picked up a daguerreotype camera or to have engaged in a project of public entertainment. In the spring of 1863, while Jones was serving in the Union army, his brother Joseph came to Evanston to try to sell the pantoscope. A brief mention of that in his father's diary is the last record of Jones's grand moving painting. It then disappears from the historical record, becoming as elusive as the daguerreotypes which had dropped from view more than a decade earlier.[90]

But Jones's lecture notes survive. Although the scale and color of the painting, the choice of music, and the sound of Jones's voice can only be imagined, the notes document the resounding ethnocentric nationalism of the painting and its attendant story. Across the American landscape Jones led his viewer on a triumphalist march westward; in an era of sectional strife, his West represented a place of common national purpose. Along the Platte River trail to Scottsbluff and Fort Laramie on the windswept Wyoming plains, across the Rockies and through South Pass into Salt Lake City, Jones took his audience toward the golden West. He led them ever onward, across the deserts of the Great Basin, up into the Sierra Nevadas and down into the gold mining community of Hangtown. Safely delivering his audience to California, he abandoned the linear organization of his painting and transformed the panorama into a series of unconnected scenes depicting

Sutter's Fort, Sacramento, and the process of gold mining. He then took his audience on a tour of San Francisco, and concluded with a "Mexican Bullfight," a topic of dubious relevance but one that held considerable possibilities for spirited drama.[91] Like the fireworks launched at the end of the panorama of the Battle at Vera Cruz, it was a gesture that spoke to audiences' clear penchant for rousing entertainment.

Jones's language, coupled with the images in the paintings, conveyed a story that no set of daguerreotypes alone could transmit. No daguerreotype, for example, however "faithful," could do justice to a water scene along the Yuba River whose "deep reflections [have] been pronounced inimitable by many of the first Artists."[92] Nor could any painted or photographic view give full voice to Jones's own social prejudices. Jones might have presented a vision of the United States that transcended the sectional differences between North and South, but he was scarcely willing to embrace the vision of a multiethnic, multiracial America. He pronounced Indians "miserable remnants," "swarthy savages," "loathsome creatures, the worst of slaves."[93] He granted that the Mexicans were good on horseback, but "absolutely good for nothing any where else." "The native Californian and Mexican," wrote Jones, "live in a rude and rustic style, but little removed above the savages from whom he is in part descended."[94] From atop the crumbling ruins of Mission Dolores, metaphorically and literally standing atop the world soon to be vanquished by America's imperial ambitions, Jones turned his gaze to the "magnificent city of San Francisco."[95] The nation's future now seemed assured. "No sooner, however do the stars and stripes wave in triumph over these Hill tops, securing persons and their property from the rapacity of tyranizing & robbing Mexican officials than thousands flocking thither, carrying with them the true genius of American Citizens, and our Glorious institutions Have erected, as it were by majic, an *empire,* which will compare favorably with any state in the world, for its wise, and liberal provisions." In the golden land of California, Jones concluded, was all that was "necessary to make Life, comfortable and home Happy."[96]

Why dwell on Jones's ambitious daguerrean expedition when nothing but words remain to document either the photographs or the painted panorama? His improbable adventure is important for what it reveals about the cultural value of daguerreotypes during the early era of photography in the American West. Jones risked both physical and financial hazard to secure his overland daguerreotypes, to photograph for the very first time the landmarks that would become the iconic emblems of America's westward expansion. Ultimately, however, the daguerreotypes held value not as artifacts, but as

forms of information. The copies, rendered easier to see through the medium of the painted panorama, were worth more than the originals. Jones's public wanted images that could reconfirm what they already believed about the beneficent and necessary American conquest of the West; they wanted pictures that would validate old ideas, not inspire new ones. Daguerreotypes seemed too small to tell the story of westward expansion, insufficiently narrative to relate the drama of American history, too literal to evoke a viewer's passions. To find any sort of audience for his daguerrean views, the entrepreneurial Jones had to transform them into something else.

Although Jones's expedition was the most ambitious of its sort, other daguerreotypists likewise understood that their original photographs were somehow less valuable than the painted panoramas they could be used to produce. A St. Louis business guide of 1858 noted that local photographer John H. Fitzgibbon had once "traversed the Territory of Kansas and with his camera succeeded in obtaining a series of landscapes of that Territory, and a collection of specimens of Kansas life, which were afterwards embodied in a panorama that possesses the merits of accuracy and beauty, and has been pronounced a true representation of the country and its occupants."[97] Fitzgibbon explained that his production, described as a "photographic diorama of Kansas scenery and the events which have occurred there recently," was in fact a painting based on views "first taken on the Daguerreotype plate" and subsequently transferred to canvas by the celebrated St. Louis artist Carl Wimar.[98] In 1846, the young Wimar had worked as an apprentice to the French émigré Leon Pomarede, assisting him in the production of his grand Mississippi River panorama, *Portrait of the Father of the Waters*. Wimar subsequently moved to Germany to continue his formal artistic studies in Dusseldorf and in August 1856, after a stay of nearly four years, returned to St. Louis where he quickly forged an alliance with Fitzgibbon.[99] By the spring of 1857, he and two assistants had transformed the photographer's collection of daguerreotypes into *Fitzgibbon's Panorama of Kansas and the Indian Nations*, covering a reported (and surely exaggerated) twelve thousand feet of canvas "prepared with the view of presenting a truthful picture of the country, without any exaggeration for political effect." But politics were scarcely absent from the painting, which focused on the recent events of "Bleeding Kansas" that pitted pro- and anti-slavery forces against one another over the spread of slavery into the western territories. A surviving broadside for the panorama suggests that Fitzgibbon took an evenhanded approach to the conflict, including "correct likenesses of all the distinguished men, irrespective of party, who have occupied a promi-

nent place in the territory during the recent troubles." With considerable attention to detail, Wimar and his assistants reportedly spent eight weeks painting the *Laying Down of Arms, by 2700 Border Ruffians* ("all the faces . . . painted from Daguerreotypes"). Fitzgibbon's own politics, however, are hard to fathom; although he exhibited his panorama in the abolitionist strongholds of New England, he lived from 1860 to 1863 in the Confederate city of Vicksburg, Mississippi. And it is thus hard to second-guess the narrative role of the western scenes included in the panorama, scenes that ranged as far west and north as the mouth of the Yellowstone River and Fort Union on the Upper Missouri, derived perhaps from the work of other artists rather than from Fitzgibbon's own photographs.[100] The West, usually posited as a site of national reunion, is here paired with a story about sectional factionalism whose own meaning—in the absence of Fitzgibbon's lecture notes—remains unclear. The message of the picture is unknowable. Like Jones's panorama, the Fitzgibbon painting simply disappeared, along with the daguerreotypes upon which it was based. It met a fleeting popular need, then faded away.[101]

In April 1861, "The World's Panorama Company" proposed an even more grandiose photographically based panoramic painting,

Fitzgibbon's Panorama, Broadside, 1857. Courtesy Peter E. Palmquist

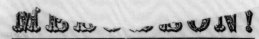

A CORRECT PICTURE
—OF—
LIFE IN KANSAS!

WILL BE EXHIBITED AT THE ABOVE HALL,

On MONDAY EVENING, April 6th, 1857,
And Every Evening During the Week!
AND ON WEDNESDAY AND SATURDAY AFTERNOONS!

FITZGIBBON'S
PANORAMA
—OF—
KANSAS
—AND THE—
INDIAN NATIONS!

This original and great work of art has been gotten up regardless of expense, in the most truthful and artistic manner. The views were first taken on the Daguerreotype plate by J. H. Fitzgibbon, the celebrated Daguerrean and Photographic Artist, of St. Louis, whose connection with the art since the year 1841 has given him a world-wide reputation. These pictures have been illustrated and illuminated on canvas by Charles Weimer, and his assistants, Shell and Beckers. Mr. Weimer is from the Dusseldorf School, where he has been completing his studies for the last five years.

The Painting covers upwards of
12000 Ft. of Canvass,

And has been prepared with the view of presenting a truthful picture of the country, without any exaggeration for political effect. The Free State Settlers, and the Border Ruffians are equally conspicuous, and the actual position of both parties has been truthfully and vividly delineated. The painting embraces correct likenesses of all the distinguished men, irrespective of party, who have occupied a prominent position in the territory during the recent troubles.

An instance of its fidelity to nature may be observed in the great scene of the
Laying Down of Arms, by 2700 Border Ruffians,
To Governor Geary.

All the faces seen in this picture are actual likenesses, painted from Daguerreotypes. This Scene alone occupied the undivided attention of the artist, Mr. Charles Weimer, and his numerous assistants, for eight weeks, and in itself is worth more than double the price of admission. Among the prominent faces may be noticed those of

Gov. Robinson, Gov. Reeder, Col. Titus, Col. Jim Lane, Gov. Geary, Gen. Whitfield, Gen. Reed, &c.

A correct semblance of every
Town, Village and Hamlet in the Territory,
Also some of the
Most Picturesque Views on the Missouri River.

All New England Villages and Border Ruffian Settlements; Scenes on Kansas River; Encampments of U. S. Troops, Free State Prisoners; Border Ruffians; the sacking of Lawrence; Destruction of the Hotel and Press; Burning of Ossowatomie; Battle of Hickory Point; View of Kansas City; Franklin, Lawrence, Topeka, Lecompton, Tecumseh, Fort Leavenworth, Weston, Atchison, St. Joseph, Council Bluffs, Omaha City, Sioux City; Indians receiving their Annuities; Lodges, Encampments; Big Bend, Government Forts, Mystic Valley, Natural Towers, Buffalo Hunt, Indians of many Tribes; the celebrated Mauvais Terre or Bad Lands; Mouth of the Yellow Stone; Sir George Gore's Camp; Fort Union; Western Steamboats; Prairie on Fire, &c.

To all persons who have any idea of visiting Kansas, either temporarily, or for a permanent residence, this painting will afford a vast amount of information, as in the short space of two hours and a half, a correct transcript of the Country is given, thereby enabling them to judge at once to what portion of the territory they will bend their course. The Panorama, while moving, is accurately described, and all the main objects of interest are not only pointed out, but are dwelt upon by the Delineator, affording a great fund of useful information, interspersed with lively anecdote. In short, you are carried thousands of miles and have presented to your vision all the places of note in a large and newly settled Territory, and in much less time than you could even pack your trunk for the real journey.

In consequence of engagements already made in other Cities, its sojourn here must necessarily be brief, therefore improve the present opportunity, which may be the last.

THE PROPRIETOR WILL MAKE VERY
Liberal Arrangements with Schools and Parties.

Tickets of Admission!
ONLY 25 CENTS!

For a Full Description,—See Pamphlet.

J. H. & F. F. Farwell and O. Farrent, Printers, No 3 State Street, Boston.

whose ambitions exceeded even those of Jones or Fitzgibbon. "The purpose for which the said company is formed," explained the company's president, "is to commence, mature, complete, and publicly exhibit, a panorama of the entire route from New York to some point on the Fraser River [site of a gold rush in British Columbia], . . . including the West Indies, Aspinwall, Panama, Acapulco, San Francisco, Straits of San Juan del Fuca, Vancouver Island, Victoria city, Puget Sound, San Juan [Island], Frazer River, British Columbia, &c. &c.; said panorama to connect with a panorama of such portions of the Eastern Hemisphere as may be deemed advisable, especially Palestine and its associations." The photographic views made round the world would be "transferred to canvas by a clever artist" and exhibited in Europe and North America. The sloop *Photograph* was in Victoria, being outfitted for her photographic journey (presumably with wet-plate rather than daguerrean equipment), but by October 1861, before she could embark on her round-the-world mission, the ship was for sale. The American Civil War surely complicated plans for sailing through the coastal waters of the southeastern United States.[102]

Photographers continued to pursue more local panoramic projects, however, suggesting that even in the era of paper photographic prints, the panorama remained an important model for enterprising photographers. In September 1862, the San Francisco photographer Henry Bush was in Victoria, British Columbia, where a local paper noted that he was "engaged in taking photographic views . . . which he will shortly transfer to canvas and exhibit in other parts of the world."[103] The humorist Artemus Ward used his own photographs, as well as some by the Salt Lake City photographer Charles R. Savage, for his parodic 1864 panorama about his life "among the Mormons," which poked fun at the very tradition of panoramas as well as the much ridiculed conventions of polygamy.[104] In the summer of 1868, the deaf-mute artist W. Delavan sketched and photographed along the partially finished Union Pacific Railway for a painted panorama called *Across the Continent*, a variant on the familiar overland panorama route that would soon be echoed in a host of railway albums and sets of individual photographic views.[105]

In addition to these photographers who, like Jones, used photographs as studies for moving paintings, there was likewise a group of artists who pursued the two crafts independently, either producing unrelated panoramas and photographs or working first as panorama painters before taking up a photographic career. The African-American daguerreotypist James P. Ball specialized, like most daguerreotypists, in the pro-

duction of studio portraits. But in the panoramas he displayed in his Cincinnati gallery he explored more ambitious themes: in 1847 he exhibited a six-hundred-yard panorama of *Negro Life in the Ohio, Susquehanna and Mississippi Rivers,* and in 1855 a more ambitious political painting titled *Mammoth Pictorial Tour of the United States Comprising Views of the African Slave Trade,* which followed its subjects from their African villages, across the Atlantic, and into the slave markets and plantations of America.[106] Like Jones and Fitzgibbon, Ball used the panoramic medium to explore more complex narrative stories and make more overt political arguments than he could with the images produced with his daguerreotype camera. His simultaneous use of two distinct media for such two distinct purposes suggests he understood the narrative shortcomings of the daguerrean medium.

If photographs could inform the visual content of painted panoramas, it was likewise true that the structure of the panoramas could inform the content of photographs. The photographers who began their artistic careers as panorama painters carried into their subsequent camera work a keen sense of how to structure sequentially organized narratives. Connecticut artist Alfred A. Hart painted moving panoramas of biblical scenes before going to California and becoming the official photographer of the Central Pacific Railroad in 1864.[107] Andrew J. Russell painted a *Panorama of the War for the Union* based on Mathew Brady's war photographs, less than a year before going off to join the Union army as a photographer himself. Russell personally appreciated the "enterprising and earnest" photographers who captured "truth-telling illustrations" of the war, but he also understood the greater public impact of narrative painting. After the war, he returned to his New York studio and in 1868, with the aid of descriptive materials supplied by travelers, painted two panoramas based on "Dr. Kane's discoveries in the Polar Seas" and "Dr. Livingston's travels in the interior of Africa," subjects that, like Jones's picture, dealt with themes of imperialism, travel, and racial hierarchies. Later that same year, he picked up his camera and headed west to chronicle the construction of the Union Pacific Railroad.[108]

If their previous work as panorama painters gave both Hart and Russell relevant experience in marketing art and working with complicated mechanical equipment, it also provided them with a model for their work as railroad photographers. The linear format of the panorama suggested a sequential organization of scenes that mimicked a traveler's passing views, an arrangement well suited to depicting the overland trails or rail routes, which settlers followed in a set, orderly way from one landmark to the next.

Hart and Russell could organize their railroad photographs just as they had their panoramic scenes, recording one section of track after another, only occasionally turning their cameras to sights out of view from the rails themselves. This linear approach to photographic documentation was adapted not just by their fellow railroad photographers, but also by the photographers who accompanied the great government surveys into the West, recording information along the invisible parallel and meridian lines that crisscrossed the land. The conception and marketing of their views—as sequentially ordered stereograph sets, carefully arranged albums, or individual prints labeled with precise locations along a railroad line—offer evidence of the continuing influence of the painted panoramas and the kind of didactic but entertaining visual diversion they represented. Even after the age of the daguerreotype, western landscape photographers continued to search for ways to construct dramatic linear stories from their carefully sequenced views. The single photographic image remained unable to relate or evoke complex stories of westward expansion, to elicit the approval of entertainment-hungry audiences, or to reaffirm deeply held beliefs about the place of the West in national life.

For American audiences of the 1840s and '50s, traveling "Indian Galleries" provided an alternative to the panoramas, offering yet another way to encounter western images served up with instructive and explanatory narrative accounts. The galleries were made up of painted portraits and genre scenes, gathered in the field, that presented to viewers a thrilling sort of encounter with the exotic cultures of the far West. Like the panoramists, the Indian Gallery operators claimed a special authority for the eyewitness accuracy of the paintings that they exhibited in rented halls. And like the panoramists, they implicitly acknowledged that their pictures might not necessarily speak for themselves. Placing themselves and their knowledge between their viewers and their paintings, the Indian Gallery operators shaped and molded public response to their work. They explained their pictures, suggested meaning and significance where none was apparent, and sought to enfold their paintings into a broader cultural dialog about Manifest Destiny and the future of America's native peoples. If their pictures and words could not do the trick, there were also ethnographic artifacts for visitors to examine and on occasion even actors to enliven the scene.

The most visible of the Indian Gallery entrepreneurs was the artist George Catlin, who began exhibiting the paintings done on his trips among the western Indi-

ans as early as 1833. By the fall of 1837, Catlin's more fully conceived Indian Gallery was on view in New York City where, night after night, Catlin himself explained to curious viewers the rich complexities of Indian cultures. A printed catalog helped place his paintings in context, and "implements of husbandry, and the chase, weapons of war, costumes" provided a fuller introduction to native life. But if the shifting fate of America's native peoples provided one context for Catlin's project, the Depression of 1838 provided another. Catlin moved his Gallery to Washington in the spring of 1838, and tried—unsuccessfully—to sell his paintings to the federal government. It was the beginning of decades of bitter financial disappointment. In November 1839, frustrated by the Gallery's unprofitability despite its evident critical success, he sailed for Europe with eight tons of freight and the hope that foreign audiences might prove more appreciative of his labors. In London and Paris, he augmented his exhibition with living actors—at first, with white men, later with Ojibwa and Iowa Indians he

George Catlin, *Ioway Indians Performing with Catlin's Indian Gallery Exhibition, Egyptian Hall, London.* Engraving, from *Catlin's Notes of Eight Years' Travels and Residence in Europe, with His North American Indian Collection* (1848). Amherst College Library

transported from America—but never found financial success. By 1846 he had given up on his career as a gallery showman, and settled into a long period of bitter exile, not returning to the United States until 1871, when he again found Congress unwilling to purchase his paintings (by then largely in the possession of a creditor) for the national collection.[109]

To an audience schooled in vague images of noble warriors and dangerous savages, Catlin's exhibition was a kind of revelation. His Indians had distinctive and valuable tribal cultures, worth saving from the onslaught of white traders, settlers, and military men. He depicted costumes and customs, architecture and landscape. But nothing so clarified the intended meaning of his paintings as the spirited lectures that carefully shaped his listeners' interpretations of his pictures, or the extravagant theatrical touches that underscored what Catlin saw as the romance of Indian life. In spite of his financial problems, Catlin clearly demonstrated to his colleagues and imitators the possibilities inherent in using western pictures to entertain and educate an audience eager for news of a little understood part of America.

In Catlin's wake, two other ambitious Indian Galleries made claims on the public's attention. In 1845, the painter and daguerreotypist John Mix Stanley opened a rival Indian Gallery of paintings and sketches in partnership with Sumner Dickerman. After a hiatus in which the two traveled to gather additional portraits and scenes, an expanded version of Stanley and Dickerman's North American Indian Portrait Gallery opened in Troy, New York, in September 1850 and slowly worked its way down to New York City for the winter season. Stanley and Dickerman were present at the exhibition to explain their painted scenes and identify their portrait subjects, and when business turned slow they hired the Ojibwa evangelist George Copway to liven things up. For Stanley, as for Catlin, personal experience and struggle formed a critical part of his public narrative, reinforcing the eyewitness authority of the field paintings. What drama the mute paintings could not convey, the narrator would. "If I had known the extent of the task I had assumed," Stanley remarked, "the adversity, the privations and the fatigues to which I was to be exposed, and the frequent despondencies that were to come over me, I would no longer have prosecuted the work upon which I was embarked."[110] By 1852, Stanley, now sole proprietor of the Gallery, was in Washington trying to get Congress to buy *his* collection. But his efforts proved no more successful than those of his bitter rival, Catlin, whom he had futilely tried to upstage. His petitions of 1853, 1857, and 1863 were each turned down. In 1865, virtually his entire collection of

Indian paintings—on temporary loan to the Smithsonian—was destroyed in a devastating fire at the museum.[111]

In the less contentious world of Canadian art politics, artist Paul Kane found more support for the Indian Gallery he first exhibited in 1848, eventually selling the entire collection to a private patron. Like his counterparts in the United States, he viewed his collection as a teaching tool, and noting that his paintings "would necessarily require explanations and notes," he eventually published the journal in which he kept detailed records of his subjects.[112]

This combination of visual artifact and literary narrative was an essential part of each of the Indian Galleries. Though the artists based their claim to public attention on the accuracy of their eyewitness views, they nonetheless assumed the necessity of explaining these views, of essentially reading their pictures to their audience. This public literary performance seemed critical to finding success in the marketplace. Like the painted panoramas, the Indian Galleries required *words* to communicate their larger stories.

For California daguerreotypist Robert Vance, the Indian Galleries and painted panoramas together suggested a way to turn daguerrean views into entertainment and a steady source of capital. Money might be made not from selling individual images, but from charging admission to see them. And public interest might best be engaged by weaving images into a fuller literary narrative of western life. Turning to popular culture, as Jones did, for a model of how to market daguerreotypes, Vance put together *Views of California*, an exhibition of three hundred full-plate daguerrean views of San Francisco and the gold country, second only to Jones's project in the scale of its ambition, expense, and achievement. But while Jones regarded his daguerreotypes as preparatory "sketches" for a public painting, Vance exhibited his daguerrean plates themselves.

Born in northern Maine in 1825, Vance used a family inheritance to establish himself as a daguerreotypist in Boston in 1844–5.[113] He worked there and in New Hampshire for some two years, learning the basics of the trade, and in late 1846 or early 1847 set sail for South America, carrying his daguerrean equipment to a new and relatively untested market. Vance sailed down the Atlantic coast, rounded Cape Horn, and by late February had settled in the Chilean port of Valparaiso where, in March 1847, he first advertised his daguerrean portrait gallery. At twenty-two, the young American had become one of the first ten photographers to operate in Chile, already showing evidence of the entrepreneurial ambition that would characterize his later work in California.

In partnership with a man named Hoytt, Vance worked for a month in Valparaiso, moved to Santiago for ten months, and returned to Valparaiso in December 1847. The partnership dissolved soon thereafter and Vance established his own Valparaiso gallery, one he would maintain continuously for the next two and a half years, until his departure for California. With the urban studio as his base, Vance traveled occasionally into the Chilean countryside, collecting views for his gallery. In August 1848, he traveled by steamer and stagecoach to the silver mining town of Copiapó, witnessing for the first time the kind of frontier mining culture he would later see in California. Though gold was discovered in California in late January 1848, and Valparaiso quickly became a port of call for argonauts headed to the goldfields, it was not until July 1850 that Vance and his new partner, a Mr. Mason, announced their decision to sell their gallery in preparation for a move to California.

Perhaps Vance had some sort of documentary project in mind already, for he made daguerreotypes en route to San Francisco, some involving considerable travel from his ships' ports of call. In Peru, he traveled more than three hundred miles inland to make pictures of the Inca ruins at Cuzco. He photographed the architecture of Panama and continued northward to photograph the port city of Acapulco, Mexico. By late December 1850 he was in San Francisco, and by January 1851 was installed in a gallery, offering to take views "of the city, or any part of it, at the shortest notice."[114] Almost immediately, he went to work photographing

CATALOGUE

OF

DAGUERREOTYPE PANORAMIC

VIEWS IN CALIFORNIA.

By R. H. VANCE.

ON EXHIBITION AT

No. 349 BROADWAY,

(OPPOSITE THE CARLETON HOUSE.)

NEW-YORK:
BAKER, GODWIN & COMPANY, PRINTERS,
TRIBUNE BUILDINGS.
1851.

Catalogue of Daguerreotype Panoramic Views in California by R. H. Vance. Pamphlet (New York: Baker Godwin & Co., 1851). California Historical Society; North Baker Research Library (FN-23397)

the principal cities and goldfields of northern California for his grand daguerrean project.

Despite his long sojourn in South America, Vance likely knew of some of the big western panoramas. He had probably been in Boston when John Banvard's Mississippi panorama opened there in December 1846, and could have seen some of the publicity surrounding Stockton, California, artist W. H. Cressy's work on a painted panorama during the spring of 1851.[115] Around the same time, he may also have learned of Jones's project, first announced in the California press in April of 1851. In any case, while he would borrow the idea of a linear presentation of views from the panoramic paintings, his insistence on showing the original daguerreotypes would make his exhibition more akin to those of the Indian Gallery artists. Unlike Jones, Vance would value his daguerreotypes both as information and as objects intrinsically valuable in and of themselves.

From January through July 1851, Vance photographed in San Francisco and traveled through the California gold regions, making full-plate daguerrean views for a collection that would "afford the information so much sought after and form a popular exhibition in the Atlantic cities."[116] By September he was in New York, installed in exhibition rooms over Jessie Whitehurst's daguerrean gallery at Leonard St. and Broadway, with *Views in California*, a dazzling collection of three hundred daguerreotypes.[117] Vance, himself, presided over the rooms. Like Catlin, he was artist, producer, and impresario—greeting visitors, explaining his pictures, offering advice, distributing copies of his printed guide. "Persons contemplating a trip to the gold regions should avail themselves of Mr. Vance's instructions," a reporter recommended, "as he is intimately acquainted with all the places of note in California, and takes pleasure in imparting any informations desired by his visitors."[118]

Included were several panoramic views of San Francisco and a set of daguerreotypes documenting the city's business districts. After the devastating fire of May 4, 1851, Vance returned to rephotograph some of the same sites, and he added more views to his collection after the fire of June 22. His theme was the city's resiliency. Thus, when he photographed Mission Dolores, he treated it much as Jones did, as a foil for the evident modernity of the American city. One plate depicted the "time-worn and crumbling" mission with the growing skyline of downtown San Francisco in the distance. Another showed a part of the mission transformed into a hotel "with Green and Bowen's omnibuses in front" ready to transport guests along a plank roadway to down-

town.[119] The collection also included "panoramic" views of Stockton, Sonora, Sacramento, Placerville, Coloma, Nevada City, Marysville, and Benecia, along with more specific views of important streets, buildings, Indian communities, and mining operations to be found in and around these sites. Finally, there were the images of Valparaiso, Chile; Cuzco, Peru; Panama City; and Acapulco—cities that Vance (and would-be argonauts) might pass on their sea voyage to California.

Despite the novel form of Vance's daguerrean display, critics evoked comparisons with the more familiar setup of the panoramic painting exhibitions. "This collection comprises a complete panorama of the most interesting scenery in California," wrote a critic in the *Photographic Art-Journal* of October 1851. "There are over three hundred daguerreotypes so arranged that a circuit of several miles of scenery can be seen at a glance." Intended as praise, the comment nonetheless suggests the intrinsic limitations of daguerreotypes, for a display of the small, reflective images was not, in fact, easily taken in at a glance; nor were the discretely framed views easily read as a continuous image. If the daguerreotypes could be valued because they seemed to imitate the admirable qualities of a painted panorama, they could also be faulted because they were not, after all, precisely the same. Another critic, identified only as "one of our best landscape painters," likewise evoked comparisons between Vance's exhibition and a painted panorama. "I have seen nearly all of the painted panoramas that have been before the public for the last six years," he wrote, "and have frequently had occasion to express my delight at the many artistic beauties which they possessed." Monochromatic daguerreotypes were intrinsically hard-pressed to compete with the flamboyantly colored panorama scenes, but Vance seemed to have overcome the drawbacks of his medium. "Form, in color, is perhaps the greatest charm upon which the eye can dwell, therefore a panorama in distemper colors, should be of paramount importance to one produced by the Daguerreotype," the critic continued. "We speak understandingly on this subject, and do not hesitate to say that Mr. Vance's views of California created in us a greater degree of admiration than did Banvard's or Evers' great productions of the Mississippi and noble Hudson."[120] Again, it was praise, but it simultaneously reminded viewers that the daguerreotypes lacked the color that gave such appeal and vivacity to the moving paintings. Vance addressed this distinction head-on in the preface to the catalog he published as a sort of viewer's guide to the pictures. "These Views," he wrote, "are no exaggerated and high-colored sketches, got up to produce effect, but are as every daguerreotype must be, the stereotyped impression of the real

thing itself.[121] Even as he made claims for the superior accuracy of his work, he, too, evoked the imagery of the moving paintings. Not just in his swipe at the "high-colored sketches," but in the very title of his brochure, *Catalogue of Daguerreotype Panoramic Views in California.*

Vance won praise from his fellow daguerreans who recognized full well all he had gone through to obtain his views. "When we consider the disadvantage of operating in a tent or the open air, and in a new country, we are much surprised at such success," wrote a critic in *The Daguerreian Journal,* "as a collection, we have never seen its equal, many of the pictures will compare with any taken with all conveniences at hand."[122] But the public never gave Vance the critical or economic support he needed to recoup his expenses. The gilded rosewood frames, alone, had cost $700 on top of the $3,000 already expended in securing the views. By early 1852, Vance had given up on making his exhibition a money-making venture and was preparing to return to California. "Mr. Vance was disappointed in the realization of his hopes," a reporter noted, "and although they are among the best daguerreotype views ever taken, they failed to attract that attention necessary to the support of an exhibition of any character."[123] Following Vance's departure, New York daguerreotypist Jeremiah Gurney held the California daguerreotypes in his gallery until, in July 1853, they were sold at auction to the St. Louis daguerreotypist (and future panoramist) John H. Fitzgibbon. The pictures were still in Fitzgibbon's studio as late as June 1857, but then disappear from the record.[124] Like Jones's daguerreotypes, they remain one of the great lost collections of early western photography, a holy grail for historians and collectors alike.

These private expeditionary projects were marked by an extravagance of ambition and by an almost equal extravagance of failure. Jones and Vance overcame the most obvious obstacles to success; they raised the money necessary to make their views, overcame the inherent difficulties of outdoor photography, survived trying physical conditions. But despite their best efforts, they could not make their daguerreotypes into objects of intense public interest or curiosity.

In transforming their daguerreotypes into paintings, Jones and Fitzgibbon sought to transcend the physical limitations of the daguerrean view and to expand the narrative possibilities of a group of photographs. Vance likewise arranged his daguerrean plates to create a sequential narrative of California life that could be augmented with his printed catalog and the verbal tour he delivered to gallery viewers. Ultimately, however,

in the popular competition between painted panoramas, Indian Galleries and daguerreotype views of the West, the daguerreotypes lost. The remarkable accuracy of the daguerrean views, the seeming realism that attracted such notice, was, in the end, less appealing than the fictive renderings of more imaginative paintings. Daguerreotypes alone could neither narrate nor explain the allure of America's far West, particularly California, the new "El Dorado," which in the national imagination held such glitter as a land of economic opportunity and a site of national reunion. No mere daguerrean catalog of physical facts could compete with the grander narratives of imagined western life.

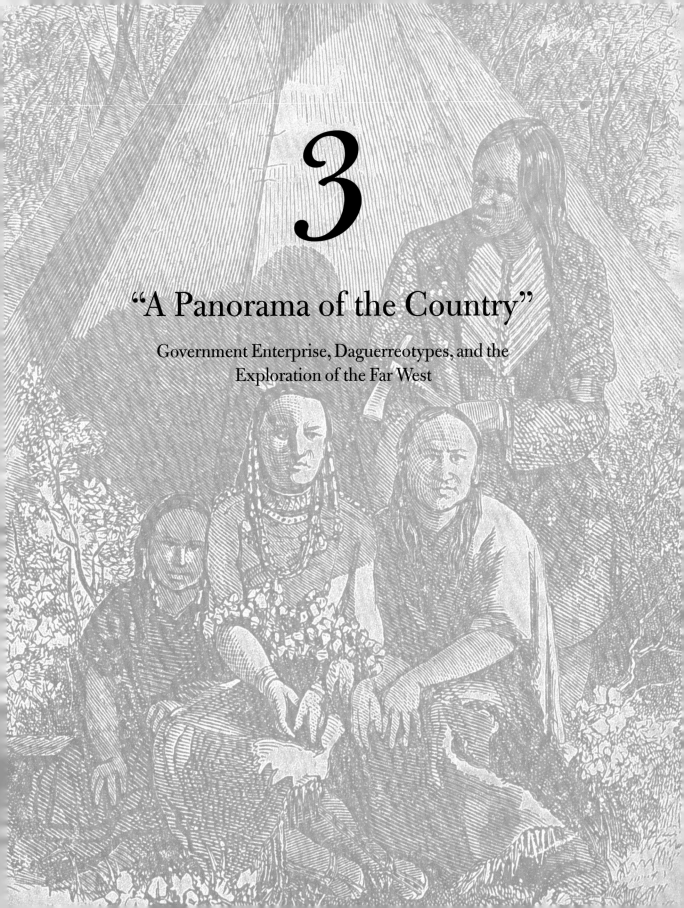

3

"A Panorama of the Country"

Government Enterprise, Daguerreotypes, and the
Exploration of the Far West

[The explorer] was the gatherer of knowledge, "programmed"
consciously or unconsciously by his civilization and his previous experience, who
was then sent out to satisfy a whole range of cultural desires. . . . As such, he was
a unique reflector of the cultures and their aspirations—a trace element,
as it were, in the North American imperial body politic.

—William H. Goetzmann,

Exploration and Empire, 1966

During the winter of 1855–6, as he began work on an illustrated account of his five ambitious and harrowing expeditions across the far West, Colonel John C. Frémont must have felt in a bind.[1] Few American figures were so well known, so revered as a symbol of America's glorious western future. Intelligent, charming, and blessed with a wife whose myth-creating skills were the equal of his own, he had an instinct for the grand gesture. And if he sometimes acted impulsively, he had political protection in high places; his powerful father-in-law, Senator Thomas Hart Benton, viewed him as the perfect front man and spokesperson for his own crusade for western expansion. On his first expedition of 1842, Frémont detoured from mapping an emigrant route through the Wind River Range of the Rocky Mountains, to climb the highest peak he could find in order to plant atop the summit a homemade flag of his own design. The grand theatricality of the gesture captured the American imagination and firmly established Frémont as a romantic hero. Many years later, an Ohio farm boy named Joaquin Miller (later to become one of the West Coast's leading men of letters) recalled that, when his father read to him the story of Frémont mounting that peak with "unknown and unnamed empires at every hand," he himself began to dream of a new life of "action, adventure, glory, and great deeds away out yonder under the path of the setting sun."[2] In the three expedition reports he had already published, Frémont had done little to dissuade such hero worship.[3]

Now Frémont was at work readying the illustrations for a massive two-volume work that would recount all five of his expeditions and engage the ongoing debate about the best route for a transcontinental railroad. He had taken a daguerreotype camera with him on three of his five trips, and though his first two attempts had met with

88

little success, his collaboration with the professional photographer Solomon Carvalho had yielded hundreds of extraordinary daguerreotypes of his fifth expedition of 1853-4, pictures of prairies and mountains that documented the unfamiliar terrain of Kansas, Colorado, and Utah, pictures of the Indian peoples they had encountered en route.[4] But because the objects themselves seemed less valuable than the raw visual information they contained, Frémont never exhibited the daguerreotypes upon his return. Instead, he sent them to the New York studio of photographer Mathew Brady, and went to New York himself to supervise the transformation of his daguerreotypes into something more useful. It was a laborious process of visual translation. Brady's cameramen would rephotograph the daguerreotypes on to glass-plate negatives, which, in turn, could be used to make positive paper prints. These paper images, larger and easier to see than the daguerrean originals, could then be redrawn by craftsmen on engraving plates. These plates would then be used to produce the prints that would illustrate Frémont's books. The challenge was not merely technical. Frémont surely understood that in addition to competing with the extant *literary* versions of his adventurous life, he would also have to compete with the dramatic *visual* representations of his exploits already floating about in the cultural marketplace. How, in particular,

would he compete for broad public attention with the enormous painted panorama of his overland treks that had played to huge audiences in Boston in the fall of 1849, then moved to London where it was seen by an astonishing three hundred and fifty thousand people?[5] How could he present a detailed narrative of his arduous travels and simultaneously represent himself as someone who transcended the travails of everyday life?

Perhaps Frémont thought of his old friend and traveling companion, the

Unidentified artist, *John C. Frémont*. Engraving, from Charles Wentworth Upham, *Life, Explorations, and Public Services of John Charles Frémont* (1856). Amherst College Library

89

mountain man and explorer Kit Carson, who in the autumn of 1849 had rushed to the rescue of the aptly named Mrs. White, the captive of a Jicarilla Apache band, only to arrive just minutes too late to save her life. At the campsite where she had passed her final hours, Carson found a dime novel, "the first of the kind I had ever seen, in which I was represented as a great hero, slaying Indians by the hundred." The discovery gave Carson pause. "I have often thought that Mrs. White must have read it," he recalled many years later, "and knowing that I lived nearby, must have prayed for my appearance in order that she might be saved." Picking up the book, he pondered the unnerving possibility that he had somehow failed to live up to his fictional self.[6] Frémont, who was likewise a larger-than-life creation of the western popular culture industry, must have wondered about his own capacity to live up to the stories and visual images that had already been created for him. About to become the presidential nominee of the newly formed Republican Party, he must have recognized that the romantic version of himself that had circulated in the panorama surely had its merits, even if detailed photographic accuracy wasn't one of them.

During the 1840s and '50s, as American explorers spread out across the West and ever farther around the globe, an increasing number of government expedition leaders, like Frémont himself, began to experiment with daguerreotypy as a tool of visual documentation that could augment, or even replace, conventional field sketching. Across the central and northern plains, into the Rockies, out across the Pacific, through the frigid water of the Arctic seas, daguerreotypists packed their supplies on horses, on mules, or in the holds of sailing ships. In an heroic age of exploration they labored to produce images that could both describe and inspire, documenting the physical appearance of unfamiliar terrain even as they fed the flames of self-confident nationalism that fueled America's expansionist impulse.

These government photographers were the contemporaries of such independent western daguerreotypists as John Wesley Jones or Robert Vance, and they shared with them a deep familiarity with the difficulties of field photography and the conceptual challenges inherent in picturing sites for the very first time. But they faced a different set of economic and commercial challenges in bringing their work before a broader audience. Generally working as paid members of expedition teams, the government daguerreotypists did not, themselves, have to rely upon the subsequent sale or marketing of their work to recoup the costs of travel. But they and their patrons still had to

find a way to position their work within a broader world of visual culture that included the extravagant pictorial narratives of the painted panoramas, cheap book illustrations, and lithographic prints. And they would also have to compete with the topographic drawings, long favored by field artists, that followed well-established conventions of pictorial representation. In competing with these older forms of picture making, the early expeditionary daguerreotypists faced the equally considerable challenge of producing pictures that could satisfy three distinct groups: the explorers, who were intent upon promoting their own exploits; the federal government, which was intent upon spurring western development; and the broader American public, which was accustomed to more dramatic and narrative forms of visual information.

It is unlikely that the expedition leaders of the 1840s and '50s who made use of the new daguerreotype technology imagined that the field daguerreotypes themselves would become marketable commodities. As Frémont understood, the real worth of the daguerreotypes lay in their value as visual information, which was easily separable from the physical images themselves. Only when redrawn for the engraved or lithographic reproductions in the expedition reports could daguerrean images help map emigration routes, secure political reputations, or assist in the never-ending process of securing funding for future exploration. As such, daguerreotypy functioned more as a kind of technology-intensive sketching medium than as the harbinger of a fundamentally new photographic way of recording and conveying information about the western landscape. Like a field sketch, the daguerreotype could reproduce an image of an outdoor scene, but by itself it could not function as a means of mass communication. The visual information contained within its image might circulate in various forms, but the daguerreotype plate remained a unique, singular object. Once it had yielded its information and been transformed into an engraving or lithograph, it had little residual value. Thus, only a handful of daguerreotypes remain from the ambitious exploring expeditions of this era. It is the ones that are lost, abandoned like discarded books and letters along an overland trail, that tell us the most about the cultural response to the new photographic medium as a tool of scientific documentation.

The first documented use of the daguerreotype on an American field expedition occurred in conjunction with the Northeast Boundary Survey of 1840-2.[7] In 1840, President William Henry Harrison appointed architect and engineer James Renwick, a professor at Columbia University, to head a commission that would ascertain the pre-

cise boundary between Maine and Canada. To secure visual evidence that could augment the surveyors' documentation, Renwick hired his former student Edward Anthony to make daguerreotypes of notable land formations in the disputed area. Anthony had studied daguerreotypy with Samuel F. B. Morse, one of the new medium's leading American practitioners, but even Morse could not have fully prepared him for the rigors of field photography. "The country in which the work was done was very wild," Anthony later wrote, "and all the apparatus had to be transported long distances upon boats."[8] Anthony took with him to northern Maine in the spring of 1841 one hundred blank daguerreotype plates. But Renwick's formal report makes scant reference to any photographic activities. Twice, he refers to the use of a camera lucida, a simple optical aid to drawing which allowed an artist to look through a prism at a distant landscape and simultaneously at a piece of paper upon which he could trace the scene's reflected image. And once he refers to a panorama "taken with the camera lucida, along with copies of some daguerreotypes made at the same place," a remark that suggests the interchangeability of the two sorts of visual documentation and the essential redundancy of the daguerrean views.[9] The daguerreotype camera backed up the camera lucida, which in turn facilitated the drawing of a "panorama," a familiar form of topographic sketch. If a sweeping panoramic drawing was the desired result, the daguerreotype could not help but disappoint, for its physical format could record only a truncated version of the scene taken in by a sketch artist's eye. Anthony struggled with the unfamiliar medium, decades later claiming that "the difficulties of making daguerreotypes in such a wilderness can hardly be appreciated at the present day."[10] One imagines he struggled, too, to make sense of what his daguerreotypes should look like, to comprehend what they should do. Were they to replicate the look and feel of topographic drawings or to somehow record visual information in a new and different way? Renwick's unillustrated report conveys no clues, and Anthony's ambitions for his pictures remain as little known as the daguerreotypes, all now sadly lost.[11]

Frémont's first daguerrean experiments followed on the heels of Anthony's. In the spring of 1842, a year after Anthony went to Maine seeking a peaceful resolution to an Anglo-American border dispute at one end of the continent, Frémont prepared to march west on a different sort of expedition that was aimed at paving the way for the American settlement and acquisition of British-held Oregon. Frémont traveled under orders from Colonel John James Abert, chief of the Corps of Topographical Engineers, who had com-

manded Frémont to explore the country between the Missouri River and the Rocky Mountains, leaving unsaid the possible political ramifications of a new emigrant trail that would bring American citizens into British territory.[12] In preparation for his first expedition into the far West, Frémont stopped in New York to purchase a daguerreotype camera, the first ever to be transported into the interior West. He left no account of how he intended to use it, but by taking only twenty-five polished daguerreotype plates, he conveyed his tentativeness about the utility of the new medium.[13] With so few plates, he could never hope to make a comprehensive record of his route. He would have to use his instrument carefully, working only under favorable conditions and recording only those scenes of special visual or topographic significance.

Frémont departed on his expedition from St. Louis, moving westward with his party along the Platte and Sweetwater Rivers, through South Pass and into the Wind River Range of present-day Wyoming, where he planted that homemade flag on a mountain peak in his carefully calculated gesture of patriotic fervor. Rushing his report into press as soon as he returned home, he self-confidently presented himself and his experiences as the stuff of legend. In such a story, failure had no place. Accordingly, the narrative says not a word about his daguerrean experiments. Compelled to conceal the failure of his efforts, Frémont never mentions the bold ambition of his attempts.[14]

But a grumpy traveling companion carefully noted each of Frémont's photographic missteps. Charles Preuss, the German cartographer and sketch artist who accompanied Frémont on three of his five western expeditions, carefully recorded his sour assessments of the explorer in his private diary, undoubtedly confident none of his traveling companions could read his German script. On August 2, 1842, from their camp near Independence Rock, Preuss wrote, "Yesterday afternoon and this morning Frémont set up his daguerreotype to photograph the rocks; he spoiled five plates that way. Not a thing to be seen on them. That's the way it often is with these Americans. They know everything, they can do everything, and when they are put to a test, they fail miserably." Several days later, Preuss added, "Today he said the air up here is too thin; that is the reason his daguerreotype was a failure. Old boy, you don't understand the thing, that is it." But in sight of the scenic Wind River Range, Preuss expressed true regret over Frémont's inability to capture the majesty of the view on the small, polished surface of the daguerreotype plate. "Today Frémont again wanted to take pictures," he noted. "But the same as before, nothing was produced. This time it was really too bad, because the view was magnificent."[15] Even Preuss could understand the

impulse to somehow record such a sight, hoping against hope that the small daguer-rean image could serve as an aide-mémoire, even if it could not replicate the grandeur of the scene.

Frémont submitted the bills for his daguerreotype apparatus and plates to the General Accounting Office, and for his second expedition in 1843–4, an ambitious sur-vey that would take him as far as Oregon and California, he again purchased a daguerreotype camera with government funds.[16] But for this expedition there exist no records of any daguerrean activity. Did Frémont's superior, J. J. Abert, even know of these photographic documentation projects? Surely as commander of the elite Corps of Topographical Engineers he had a stake in their success; he supervised an ambi-tious program of western exploration that depended upon field images as records of fact, as a means of communicating scientific and topographic discoveries to a broader public, and as a tool of propaganda for the securing of additional government funds. Although it seems possible Abert remained unaware of Frémont's failures, more likely he learned from Frémont that the camera was still unproven as a recording device in the field. And thus, whether through ignorance or caution, sketch artists—not daguerreotypists—served as the artists of record for the Topographical Engineers' subsequent surveys during the 1840s, including Frémont's own third expedition to California in 1845–8.[17] Frémont's careful attention to his own reputation assured that his photographic experiments remained unknown until the publication of Preuss's journals more than a century later.

But the visual story of Frémont's exploits did not go untold. The report of his first expedition, *Report on an Exploration of the Country Lying Between the Missouri River and the Rocky Mountains. . . .* (1843), contained small lithographs based on draw-ings by Preuss, as did the combined report of his first two expeditions, *Report of the Exploring Expedition to the Rocky Mountains in the Year 1842, and to Oregon and North Carolina in the Years 1843–44* (1845).[18] This last book, eventually published in twenty-five editions in this country and England, proved to be Frémont's most popular publi-cation, but for sheer visual drama it could scarcely compete with the panoramic version of his exploits, a visual drama of adventure that even the energetic Frémont could nei-ther shape nor control.

The panoramic version of Frémont's expeditions was conceived in 1849, when the entrepreneur John Skirving assembled a team of artists to paint a grand panorama of *Colonel Frémont's Overland Route to Oregon and California Across the Rocky Moun-*

tains. Hoping to secure an aura of authenticity and authority for his project, Skirving applied directly to the federal government for the "use of the original sketches made by the United States' Topographical Engineers sent out for that purpose." And the government was happy to cooperate, making public documents available for Skirving's private, entrepreneurial venture. Robert P. Anderson, Keeper of U.S. Public Documents for the United States Senate, assured Skirving that he was authorized to furnish him "with any of the public sketches, maps, and documents made by Colonel Frémont and Captain Wilkes . . . and they are at your service."[19] To this supply of source material from Frémont's early expeditions and from Charles Wilkes's naval exploration of the Pacific and Northwest Coast in 1838–42, Skirving added sketches by the gold-rush sketch artist William Redmond Ryan, images gathered on William H. Emory's Topo-

graphical Corps surveys of the Southwest, and pictures from the private adventure parties of Scottish nobleman Sir William Drummond Stewart, who had met Frémont at the start of his second expedition.[20] With such sketches in hand, the artists hired by Skirving were well equipped to produce what one of the publicists for the painting described as *"authenticated* scenes of the new 'El Dorado'."[21]

Skirving's visual travelogue and adventure story covered a reported twenty-

Thrilling Sketch of the Life of Col. J. C. Frémont, (United States Army); with an Account of His Expedition to Oregon and California, Across the Rocky Mountains, and Discovery of the Great Gold Mines. London, c. 1850. This English pamphlet combined biographical information about Frémont's life with a description of the moving painting by John Skirving that brought Frémont's exploits to international audiences. Yale Collection of Western Americana, Beinecke Rare Book and Manuscript Library.

five thousand square feet of canvas and, accompanied by a spoken narration and later by a printed guide, took some two hours to view. Its eighty scenes unscrolled in a vaguely geographic order, taking the viewer across the Plains, through the Rockies, into the Oregon country and down into California, with views of distinctive topographic features alternating with dramatic narrative scenes, strategically placed to stir the viewers' interest. "A Wolf Hunt" and "A Deer Hunt" interrupted the "monotony of the prairie," obliquely reaffirming the considerable advantages of vicarious travel.[22] Additional dramatic moments—too fleeting, too dangerous, too remote (and sometimes too improbable) to be captured by any cameraman—punctuated the painting with regularity. Prairie fires threatened emigrants and drove animals from their homes. Indians debated attack, went out on scouting parties, and returned home triumphant after conducting war. Between 1849 and 1851, as the painting continued to tour, its producers exploited its topicality and played to the ever-increasing public interest in California by repeatedly incorporating new information from the goldfields. In successive versions of the painting—as the ending of the panorama shifted from a scene of the Isthmus of Panama, to a picture of "The Best Men for the Mines," to an urban scene of San Francisco, where "enterprise . . . overcame all obstacles"—the painting's function changed from an inspirational how-to guide for prospective emigrants to an affirmation of California's grand economic future. Throughout, Frémont's personal heroism remained front and center, in large measure because his own father-in-law, Senator Benton, had penned the biographical sketch that appeared in the accompanying pamphlet.[23] The Skirving panorama disappears from the record in late 1851, while being readied for a tour of Great Britain after a successful run in London (in the very hall where John Banvard had exhibited his Mississippi River panorama). But a second, and less ambitious, Frémont panorama, *Lectures on Col. Frémont's Travels*, appeared in 1855-6, testifying to the public's continuing interest in one of the great romantic heroes of the West.[24]

The dramatic narrative of Skirving's large-scale panorama, animated by man's battles with the elements and the thrilling if dangerous possibility of Indian warfare, showed up the cramped, limited nature of the illustrations in Frémont's first two illustrated narratives. Frémont must have wondered whether the novel realism of daguerreotypes could help him produce different sorts of pictures for his next project. He must have pondered whether the kind of imagery recorded on a daguerrean plate could ever support a complex narrative about the thrill of westering, the disappearance

of the West's Spanish and Indian past, or the construction of the region's political, economic and decidedly American future. Skirving may have engaged public interest by promoting the "authenticity" of his views, but in an age when the American imagination had been excited by gold fever, what people wanted was, in fact, not an objective rendering of a place or a straightforward topographical report, but a view of a golden West as chimerical and elusive as the gold in California's streambeds.

Such broad cultural expectations, along with the problems inherent in reproducing daguerreotypes, meant that daguerreotypes never achieved widespread recognition as a successful tool of topographic documentation, even during the early 1850s, as photographers became increasingly proficient at overcoming the technical difficulties of the process. In the age of what the historian William H. Goetzmann called the "romantic reconnaissance," exploration imagery was valued for its capacity to fuse romanticism with realism, to meld the grand drama and spectacle of the natural landscape with the detailed topographic information that would allow Americans to plan its future use.[25] And if daguerreotypes continued to fall short as bearers of narrative drama, they also fell short as tools of scientific documentation, largely because the photographic precision of their images inevitably lost something in the necessary translation to engraving plates, lithographic stones, or painted canvases. They were doubly handicapped in the arena of public expectations, both insufficiently narrative and incapable of transmitting useful scientific data.

European and American craftsmen alike had tried to get around this persistent problem of daguerreotypes, searching for ways to reproduce images directly from the daguerrean plate without the intervening hand of the artist. In the early 1840s, the French had developed a way to engrave the surface of a daguerrean plate so that it could be inked and printed on a sheet of paper, but the laborious process was little used. In 1852, American David Dale Owen published five steel engravings of fossilized animal bones "engraved from daguerreotypes of the original specimens" in his *Report of a Geological Survey of Wisconsin, Iowa, and Minnesota*.[26] Following on the heels of Owen's project, the United States Coast Survey Office conducted experiments in the mid-1850s on "actino-engraving," a process designed to facilitate the direct etching of the image on the surface of a daguerrean plate, chiefly for the production of topographic maps.[27] Their efforts produced visible images but did not result in a practical process for mass reproduction. Daguerreotypes, like field sketches, continued to be redrawn for reproduction on the surface of a printing plate.

"The 50s was a transition period of some years before the final adoption of collodion," photographer William Henry Jackson recalled many years later, looking back to the period before collodion, or wet-plate negatives, revolutionized the practice and economics of photography by making possible the production of multiple prints from a single negative. "To explorers," he wrote, "the daguerreotype had some advantages in lighter apparatus, fewer chemicals, and for beginners [amateurs], more facility in operation. On the other hand, the daguerreotype itself, was of little use, serving only as a means for making other kinds [of] pictures."[28] In the early 1850s, the advantage of the nascent negative/positive processes did not outweigh the greater reliability of daguerreotypy. With makeshift equipment and dogged perseverance, expeditionary photographers in growing numbers struggled to make field daguerreotypes. But mastering the process in the field, they found, did not necessarily ensure a market for their work or recognition for their achievements. It was just as well their daguerreotypes were generally work done for hire. They would draw a salary for their labors; it would be up to someone else to find a market for their pictures. Creating an audience for daguerrean images could be as challenging as producing them in the first place.

After Frémont's ill-fated daguerreotype experiments of 1842 and 1843–4, the first documented daguerreotypist to go west with a government expedition was William Mayhew, who in the summer of 1850 accompanied Lieutenant Israel C. Woodruff's survey of the northern boundary of the Creek Nation in present-day Oklahoma, bringing a camera along to document the activities of the surveying crew. His four surviving daguerreotypes include two portraits, a view of Fort Gibson (the starting and ending point for the survey expedition), and a group portrait of seven members of the survey team posing with their gear in a temporary field camp on a hot July afternoon. Mayhew had considerable success producing portraits, even making images to give away to his colleagues, but he experienced much difficulty making landscape views. Nothing suggests he even envisioned using his camera to systematically document the terrain or to create a visual record of the territorial boundary.[29] Such thorough topographic mapping seemed beyond the capacity of his daguerreotype plates.

John C. Frémont, however, did have grand ambitions for the photographic documentation of his fifth expedition to the West in 1853. It was the high-water year for expeditionary daguerreotypy, a year that would see American daguerreotypists in the field in such far-flung places as the Rockies, the northern Plains, Japan, the North

Pacific, and the Arctic. Cameras were easier to operate, exposure times considerably reduced, and supplies more easy to obtain far from the main East Coast manufacturers. But the busy season simultaneously marked the last great burst of expeditionary daguerrean activity. Already, photographers were experimenting with various negative/positive processes, including the collodion or wet-plate negative process that would come to dominate American photography within just a few years.

For Frémont, another daguerrean expedition represented a chance to reverse his photographic ill fortune of a decade before and salvage a flagging career. His third government-sponsored expedition to California had ended in public controversy and disgrace in 1847, when he was court-martialed for his role in the Bear Flag Revolt and for his disobedience to California's new military command. In early 1848, the military court found him guilty on counts of mutiny, disobedience, and conduct prejudicial to military discipline, but President James K. Polk ordered Frémont back to duty. Embittered by his treatment, Frémont instead resigned from the army. It was thus as a civilian that he led his disastrous fourth campaign into the Rockies in 1848–9, hoping to provide geographical information that would buttress Senator Benton's insistence on a central rail route across the Rockies. But deep winter snows stranded Frémont and his men in southern Colorado, and ten men perished from exposure. For the fabled pathfinder, it was a humiliation worse than his court-martial. A fifth expedition offered him the opportunity to redeem himself in the court of public opinion and to reap the financial rewards he would need to salvage his interest in a California gold mine.

Frémont was in Paris in March 1853 when Congress approved the Pacific Railroad Survey bill that called for the secretary of war to oversee a series of topographic surveys and submit reports on all of the practicable railroad routes across the trans-Mississippi West to the Pacific. As Frémont's wife later recalled, when Secretary of War Jefferson Davis failed to name him commander of one of the cross-continental surveys Frémont, "finding himself omitted from this culminating work which was based on his own labors," decided to come home and lead an expedition at his own expense.[30]

Jessie Benton Frémont, always a staunch defender of her husband's reputation, noted more than three decades later that the idea of using photography to document the expedition came to Frémont as he returned to America. While en route from Europe to the United States, she wrote, he found a copy of *Cosmos,* just published by the famed German naturalist and explorer Alexander von Humboldt, and read with interest Humboldt's hope that photography applied in travel could secure "the truth in

Nature."[31] But Humboldt's text, in fact, says nothing about photography. Perhaps Frémont got the idea from the man who had assisted him with the purchase of scientific instruments in Paris, François Arago, an associate of Humboldt's who was secretary of the *Academie des Sciences* and a member of the government committee that had first assessed Daguerre's new invention. More likely, though, the idea was Frémont's own. Though his public did not know it, he had experimented with expeditionary photography in the past. Rather than acknowledging his failures, Jessie likely preferred to credit the idea to one of Europe's great men of science, providing a distinguished lineage for Frémont's own ambitions.[32]

Mindful of his previous failures and desperate to secure success, Frémont this time turned to a professional, the Charleston portrait painter and daguerreotypist Solomon Nunes Carvalho.[33] Carvalho had worked as a portraitist in Philadelphia and Baltimore where, in 1849, he opened a painting and photographic studio with daguerreotypist T. O. Smith. Taking up daguerreotypy himself, Carvalho earned a reputation as an innovator and inventor. After returning to his birthplace of Charleston in 1851, he claimed invention of a transparent enamel that could be painted over the fragile surface of a daguerrean plate, obviating the need for a protective glass covering.[34] The English-language Jewish monthly *The Occident* noted with pride, "It is not often that persons of our persuasion turn their attention to inventions and mechanical contrivances; wherefore, we seize the first leisure we have to record this in our magazine."[35] In August 1853, while in New York to promote his discovery and defend himself against doubting critics, Carvalho met Frémont for the first time. The artist later recalled, "I impulsively, without even a consultation with my family, passed my word to join an exploring party, under command of Col. Frémont, over a hitherto untrodden country, in an elevated region, with the full expectation of being exposed to all the inclemencies of an arctic winter. I know of no other man to whom I would have trusted my life, under similar circumstances."[36] If such a response attested to Carvalho's own spirit of adventure, it likewise testified to Frémont's popular stature as the intrepid "Columbus of our central wilderness," a professional hero in the public realm despite the ups and downs of his military career.[37]

Carvalho spent ten days in New York purchasing "all the necessary materials for making a panorama of the country, by daguerreotype process, over which we had to pass."[38] The word "panorama" implicitly suggested the double burden Carvalho would face. His daguerreotypes would be expected to convey an unbroken view of the

topography, as in the manner of the long detailed sketches prepared by trained draughtsmen, and also convey the kind of sequential scenes that provided the narrative drama and interest of the painted panorama.[39] From the start, it was an almost impossible set of expectations that denied the limited frame of the photographic view, the inability of the daguerrean camera to capture near and distant objects with equal precision, and the difficulty any field photographer would have in depicting scenes of action or inherent drama. As long as a narrative panorama remained Carvalho's conceptual model, his pictures seemed bound to disappoint no matter how heroic his actions in the field.

Frémont himself also alluded to the model of a long, continuous image for Carvalho's work in the reports he sent back home. In a letter to his family in November 1853, he wrote that "after surmounting some difficulties with our *daguerre,* (which it required skill to do) it has been eminently successful, and we are producing a line of pictures of exquisite beauty which will admirably illustrate the country."[40] In a later report, he again alluded to the idea of sequential pictures, noting that the "character" of a particular mountaintop vista was "exhibited by a series of daguerreotype views, comprehending the face of the country almost continuously, or at least sufficiently so as to give a thoroughly correct impression of the whole."[41] Jesse Benton Frémont used similar words to explain that Carvalho's images "so far as is known, give the first connected series of views by daguerre of an unknown country, in pictures as truthful as they are beautiful."[42] The Frémonts' language hints at the more broadly held expectations about what daguerreotypes should look like, what sort of cultural labor they should perform, and how they might be read. Stressing the importance of the daguerreotypes as a "connected series" of views, both Frémonts reiterated the idea that the real importance of the small singular images lay in their collective capacity to narrate a story. As so often happened in the early history of photography, there emerged a gap between what the images could portray and the grander cultural expectations their prospective users held.

Carvalho joined Frémont in St. Louis in September 1853 and traveled west with him to Westport where they joined up with more of the expedition party. Frémont then subjected Carvalho to a test, pitting his mastery of the daguerreotype process against the efforts of a Mr. Bomar, "a photographist" who proposed to use a wax paper negative process to make photographs in the field. Unable to obtain a portable dark-tent, Bomar failed miserably.[43] Carvalho later recalled that Frémont ordered each of the two

men to make a picture as quickly as possible. "In half an hour from the time the word was given, my daguerreotype was made; but the photograph could not be seen until the next day, as it had to remain in water all night, which was absolutely necessary to develop it." Where, Carvalho asked rhetorically, was one supposed to find water on a mountaintop when the temperature was 20 degrees below zero, and how could one expect the entire exploring party to wait for twelve hours every time a photograph was made? Frémont apparently felt the same way. Unable to "see immediate impressions," Carvalho wrote, Frémont "concluded not to incur the trouble and expense of transporting the apparatus, left it at Westport, together with the photographer."[44] Carvalho walked away victorious from the West's first photographic shoot-out. Given the almost impossible cultural expectations the Frémonts held for his daguerrean images, and the sad end his daguerreotypes would meet, it would prove, in retrospect, a Pyrrhic victory.

Carvalho's memoir of the expedition, *Incidents of Travel and Adventure in the Far West. . . .* first appeared in 1856 as a political tract in support of Frémont's unsuccessful presidential campaign, and was reprinted four times before 1860, though never with daguerrean-based illustrations since Frémont alone had the rights to Carvalho's plates. In gripping prose, Carvalho weaves around his fulsome testimonials to Frémont's distinguished character a vivid narrative of his experiences as expeditionary photographer. He recounts with both pleasurable amusement and harrowing detail his adventures from the time he joined the expeditionary party in September 1853 until January 1854, when he cached his daguerrean supplies and equipment in the snow during the expedition's desperate march down the western slope of the Rockies toward the food and shelter of the little Mormon settlement of Parowan, Utah. From the start, the mere mechanics of travel were a challenge for a city boy who confessed, "I had never saddled a horse myself." And the technical problems involved with field daguerreotypy seemed enormously daunting. His "professional friends" told Carvalho they were of the opinion "that the elements would be against my success. Buffing and coating plates, and mercurializing them, on the summit of the Rocky Mountains, standing at times up to one's middle in snow, with no covering above save the arched vault of heaven, seemed to our city friends one of the impossibilities." But drawing on his scientific training and "firm determination to succeed," he persevered. It took between one and two hours to make a single daguerrean view, most of that time spent unpacking his equipment and reloading his pack animals. And more often than not, having paused to make a view, he rode at the rear of the pack, with the stubborn, lazy mules that car-

ried the expedition supplies. Though he often paused to help the muleteers, he faced unending resentment from these packers, who complained incessantly about his 150 pounds of supplies and who sometimes packed his materials carelessly ("done purposely," Carvalho complained) or otherwise sabotaged his material.[45]

And yet, Carvalho found moments of almost transcendental pleasure. From a peak in the San Juans, on the western side of the Continental Divide, he and Frémont "beheld a panorama of unspeakable sublimity spread out before us; continuous chains of mountains reared their snowy peaks far away in the distance, while the Grand River plunging along in awful sublimity through its rocky bed, was seen for the first time." Even in retrospect, Carvalho recalled the intensity of emotion he felt on that peak. "Above us the cerulean heaven, without a single cloud to mar its beauty, was sublime in its calmness. Standing as it were in this vestibule of God's holy Temple, I forgot I was of this mundane sphere; the divine part of man elevated itself, undisturbed by the influences of the world. I looked from nature, up to nature's God, more chastened and purified than I ever felt before." Carvalho felt simultaneously enlarged and diminished; the master of all he surveyed and but a small piece of nature's grandeur. With conflicting emotions swirling about him, he took out the camera laboriously carted to the mountaintop, and plunging "up to my middle in snow . . . made a panorama of the continuous ranges of mountains around us."[46] As Carvalho and Frémont descended the mountain they deflected the feelings they had just experienced by speaking of the more mundane matter of food and the "merits of dried buffalo and deer meat." Surely, no material objects—daguerreotypes included—could ever preserve or recreate the glorious feeling of religious transcendence that they experienced on top of the mountain. But the use of the camera on that mountaintop suggests the grand hopes that both Frémont and Carvalho must have had for their daguerreotypes. And Carvalho's repeated use of the word "panorama" again suggests the sweep of vision and intensity of experience he sought—against all logic—to capture with his daguerreotype camera.

Carvalho photographed topographical formations, distant herds of buffalo (though he was disappointed he couldn't catch them in motion), and some of the Indians he encountered en route. Moving west with Frémont from Kansas into present-day Colorado, he paused to photograph the Cheyenne village at Big Timbers, along the Arkansas River. Here he made the daguerreotype, now in the Mathew Brady Collection at the Library of Congress, that is the only one known to survive from the expedition. The badly abraded half-plate depicts several large tipis, a simple scaffold draped with

Solomon N. Carvalho, *Cheyenne Village at Big Timbers*. Daguerreotype, half-plate, 1853. Prints and Photographs Division, Library of Congress

drying skins or meat, and two partly effaced figures. Carvalho wrote that he made several images at the site. He showed a daguerreotype of a lodge to some of the Cheyennes who gathered around, then made a portrait of an old woman and papoose. "When they saw it," Carvalho recalled, "they thought I was a 'supernatural being;' and, before I left camp, they were satisfied I was more than human." He then took portraits of several

chiefs and "made a beautiful picture" of a princess, the daughter of the Great Chief. Carvalho played to his subjects' fascination with his strange and unfamiliar equipment. With quicksilver he transformed the princess's brass bracelets into silver; with matches and alcohol he made leaping flames. "They wanted me to live with them," he wrote of the Cheyenne, "and I believe if I had remained, they would have worshipped me as possessing most extraordinary powers of necromancy."[47]

But Carvalho was only human. As Frémont and his men struggled through the mountains of southern Wyoming, they grew desperately hungry and cold. "I felt that my last hour had come," Carvalho wrote. He pulled from his pocket a miniature of his wife and children and reminded himself he had something for which to live. Finally Frémont ordered his men to cache everything but the clothes on their back and mount their pack animals in a last-ditch effort to reach the Mormon settlements to the west. Carvalho put his equipment into the large buffalo skin–wrapped package of supplies that the men buried and then covered with brush to conceal from other travelers, but somehow he managed to keep with him the estimated three hundred daguerreotype plates he had made on the trip.[48] He stumbled into the Mormon village of Parowan on February 8, 1854, ill and exhausted. Later, moving on to Salt Lake City, he regained his strength, observed the unfamiliar social practices of Mormonism, and took up work as a portrait artist. Fully recovered he went to Los Angeles in June, and after briefly operating a daguerreotype gallery he returned to his family in Baltimore.[49] There ended the epic drama of his grand daguerrean adventure; Carvalho never again traveled west.

His daguerreotypes were Frémont's to use. Years later, Jessie Benton Frémont claimed that the plates had survived their ordeal in surprisingly good physical condition; "almost all the plates were beautifully clear, and realized the wish of Humboldt for 'truth in nature'. . . . Their long journeying by mule through storms and snows across the Sierras, and then the scorching tropical damp of the sea voyage back across the Isthmus left them unharmed and surprisingly clear."[50] And yet of what value were they? Their main worth lay in the images they portrayed, and such images were easily separated from the physical plates themselves. And so, as Mrs. Frémont explained, her husband spent the winter of 1855–6 working with photographer Mathew Brady, supervising the process of copying the field daguerreotypes with the wet-plate negative process so that positive paper prints could be provided to the artists ensconced in the Frémonts' own house who were at work preparing engraved illustrations for Frémont's account of his five expeditions. Bound up in Frémont's own web of words, book illus-

Cheyenne Family—a Warrior, his Mother, Wife and Child.

After Solomon Carvalho, *Cheyenne Family—a Warrior, His Mother, Wife and Child*. Wood engraving, from Charles Wentworth Upham, *Life, Explorations, and Public Services of John Charles Fremont* (1856). The engravers for Upham's book apparently had access to the daguerreotypes that Carvalho made for Frémont in a Cheyenne village. Amherst College Library

trations could at least lend visual support to the drama of Frémont's narrative, even if they could convey little of that drama themselves.

In a later era, photographers and their patrons would discover the utility of distributing photographic images to members of Congress in an effort to engage their interest in western land issues. But such an idea seems not to have occurred to Frémont. Given his grand agenda of self-promotion, the small, hard-to-read image on the daguerrean plate might, indeed, have seemed disappointing to the viewer who could not simultaneously hear or read about all that the daguerreotype was meant to represent about American expansion and Manifest Destiny. By transforming Carvalho's daguerrean images into the more conventional media of steel and wood-block engravings, Frémont ensured their usefulness as tools of political suasion and personal aggrandizement. Such functional utilitarianism was for him more important than the seeming authenticity of the daguerrean images, or their value as historical artifacts of his perilous trek across the Rockies.

Frémont's unsuccessful presidential bid in 1856 ultimately delayed his work on his illustrated memoirs. Not till three decades later did Jessie push the project through to completion, hoping to create a book, comparable to Ulysses S. Grant's hugely successful memoir, that would redeem the Frémonts from their relative poverty. When the

first volume of Frémont's planned two-volume *Memoirs* appeared in 1887, it covered only his first three expeditions; the planned second volume never appeared. Nonetheless, in volume one are several engraved illustrations derived from the daguerreotypes Carvalho made on Frémont's fifth expedition, with additional daguerrean-based prints in the variant versions of the publisher's prospectus for this work. By the 1880s, such illustrations seemed more like historical oddities than exciting demonstrations of what could be achieved with photographic technology. Daguerreotypes were mere antiquarian curiosities; halftones had begun to replace engravings as tools of photographic reproduction; the Rockies were no longer an unfamiliar outpost of the American West, indeed large photographic prints of remote mountain sites had been in circulation for more than a decade and a half. The daguerreotypes that Frémont and Carvalho had worked so hard to make, to save, to copy for public consumption finally reached an audience with a resounding thud, as prints that never even announced their photographic source.[51]

After Solomon Carvalho, *The Huerfano Butte*. Steel engraving, from John C. Frémont, *Memoirs of My Life* (1887). Amherst College Library

And yet, with the exception of the badly abraded plate of the Cheyenne village at Big Timbers, these engravings are all that remain of Carvalho's extraordinary daguerrean achievement. Having survived the trip from the snowy peaks of the Rockies to California, across the Isthmus of Panama and back to New York, they somehow disappeared in more mundane surroundings. In 1881, fire destroyed the Arizona warehouse where the Frémonts had stored many of their belongings. Mrs. Frémont explained that the steel plates and woodblocks already prepared for the book "had been placed for greater security in the safes below the pavement, where the great fire had passed over them."[52] She mentioned nothing, though, about whether the daguerrean plates were even there. Like Jones's overland trail daguerreotypes, the Carvalho daguerreotypes were consigned to the dustbin of history, no longer useful as artifacts once they had yielded the graphic information contained on their reflective silver-coated surfaces.

Increasingly during the 1850s, expeditionary daguerreotypists found that even if they could master the technical difficulties of the daguerreotype process they continued to face this essential dilemma of what to do with their hard-won plates. Like Frémont, the painter and daguerreotypist John Mix Stanley found that his western daguerreotypes were difficult to translate into useful or intrinsically valuable objects. Indeed, as Carvalho moved west with Frémont's private expedition to chart a rail route across the Rockies, Stanley was at work on the northern plains with Isaac Ingalls Stevens's branch of the official, government-funded transcontinental railroad surveys. Formerly a lieutenant in the Topographical Corps, Stevens was now governor of Washington Territory as well as the territory's superintendent of Indian affairs. He volunteered to lead the Topographical Corp's survey of the northern route, no doubt hoping that a favorable report as to the region's prospects would boost the attractions of Washington Territory for prospective immigrants.

In April 1853, Stevens assembled his survey team, hiring "Stanley the Indian Artist" at a salary of $1,500 per year, more than he offered to any of his other civilian employees.[53] Few American artists had as much experience in the West as Stanley. In the late 1830s he worked as an itinerant painter in the upper Midwest. In 1843 he traveled to Indian Territory (present-day Oklahoma). In 1846 he was in Santa Fe, where as a "draughtsman" he joined Lieutenant William Emory's military reconnaissance to California. He later traveled to Oregon and in 1848 sailed to Hawaii, where he stayed more than a year. All the while, he was collecting images and artifacts to incorporate

into his Indian Gallery, which he exhibited throughout the Midwest and East beginning in 1846. The fading fortunes of his Indian Gallery were intimately tied to his decision to travel west with Stevens. In the spring of 1853, just a few weeks after learning that the federal government was turning down an opportunity to purchase the gallery collection, Stanley accepted the appointment to Stevens's expedition. "With the faculties in my power I will make many captives—on paper and plate," he wrote to his wife.[54] Stanley had used a daguerreotype camera on a private trip to Indian Territory in 1843. Now he intended to use it once more to capture likenesses of his Indian subjects, augmenting the more familiar tools of the sketch artist.[55]

Stanley was a pragmatist with clear ideas on how to use his time in the field to best advantage. "Frogs, toads, and salamanders," he wrote, "ought always to be sketched alive." Birds could be sketched in detail after they had been killed and preserved. And there was no need "to make colored sketches, excepting of such species as are likely to fade after preservation." As for human subjects? "Sketches of Indians should be made and colored from life, with care to fidelity in complexion as well as feature." While quick sketches and notes would suffice for the documentation of some aspects of Indian culture, other parts of native life demanded more meticulous visual records; "It is desirable that drawings of their lodges, with their historical devices, carving, &c., be made with care."[56] By making no mention of what might be accomplished with a daguerreotype camera, Stanley suggested it would not be his primary tool of documentation. And his repeated references to the importance of color further infer that the monochromatic daguerreotype would be inadequate for the thorough visual record of peoples and cultural practices that he hoped to create. Accurate ethnographic documentation and natural history illustration assumed the presence of color.

Stevens's scant references to Stanley's photographic activities confirm that Stanley used the camera mainly as a tool for portraiture, a genre that had been of relatively less importance to Frémont and Carvalho. "Mr. Stanley, the artist, was busily occupied during our stay at Fort Union [near the conjunction of the Yellowstone and Missouri Rivers] with his daguerreotype apparatus," Stevens wrote in his final report, "and the Indians were greatly pleased with their daguerreotypes." Pushing farther west along the Missouri to Fort Benton, Stevens paused for a rest on September 4, 1853, and noted, "Mr. Stanley commenced taking daguerreotypes of the Indians with his apparatus. They were delighted and astonished to see their likenesses produced by direct action of the sun. They worship

the sun, and they consider that Mr. Stanley was inspired by their divinity, and he thus became in their eyes a great medicine man."[57] If later encounters between photographers and Indian peoples were sometimes clouded by the subjects' mistrust of the camera, Stanley—like Carvalho—sensed no wariness on the part of his subjects. The daguerreotype seemed more miraculous than menacing, more astonishing than intrusive, at least so far as the daguerreotypists understood their subjects' response.

Yet despite Stanley's evident technical and political success with the daguerreotype equipment, his plates, too, disappeared, without any evidence that they ever found a public audience. Stanley left Stevens's party in November 1853, arrived home in Washington in January 1854, and went to work preparing his field sketches for publication. Stevens's final report, published in 1859, includes about sixty lithographic illustrations prepared by Stanley, six based on field sketches supplied by other expedition members.[58] The illustrations offer visual support for Stevens's contention that the

After John Mix Stanley, *Lieut Grovers Despatch—Return of Governor Stevens to Fort Benton*. Tinted lithograph, in [Isaac I. Stevens], *Reports of Explorations and Surveys, to Ascertain the Most Practicable and Economic Route for a Railroad from the Mississippi River to the Pacific Ocean* vol. XII (1860). Archives and Special Collections, Amherst College Library

northern route offered a favorable prospect as the site for a transcontinental rail route, but none show any evidence of being prepared from a photographic image. Neither is there any record of daguerreotypes being added to the rich store of materials in Stanley's Indian Gallery, which he continued to exhibit after his failed efforts to sell it to the government. If the daguerreotypes survived the trip back home, they proved useful neither as exhibition material nor as sources for drawn reproductions. One must wonder what had fueled Stanley's daguerrean efforts besides the sheer challenge of mastering the technology and simply seeing for himself what he could capture on the mirror-like surface of the daguerreotype plate.

Certainly, Stanley had an entrepreneurial and inventive bent. While Frémont watched a private entrepreneur develop the panorama that capitalized on his own western experiences, Stanley himself transformed the field materials from his expedition across the northern Plains into a moving painting whose forty-three scenes led viewers along the expedition's route.[59] Fourteen scenes in the panorama corresponded to subjects that would later appear as illustrations in Stevens's report. The additional scenes, however, depicted moments of heightened drama: a buffalo chase, a prairie fire, a war party, a war dance, "wolves at their banquet." Their very drama suggests all that field sketches—and daguerreotype plates—were inadequate to record. The script accompanying the panorama, by the poet and playwright Thomas S. Donoho, mixed the basic facts of Stanley's route with wildly romantic pronouncements about the charm of the western landscape, the fading glory of the Indians, and the cultural superiority and inevitable triumph of the white man's Christian ways. The panorama, argued Donoho, would transmit Stanley's "name to the grateful future, when the 'poor Indian' shall have passed away."[60] Once again, daguerreotype plates proved incapable of laying down such an epic narrative.

Stanley was a market-savvy artist who knew how to bring his work to public attention; he had created an Indian Gallery, overseen the production of graphic reproductions, created a painted panorama. And yet, he never found—perhaps never even imagined—a public outlet or commercial use for his daguerrean plates. Like Frémont and Carvalho, he knew that his daguerreotypes could not compete with other forms of visual information more easily made available and compelling to a broad viewing audience. The daguerreotype as artifact, as eyewitness record, as historical document held little intrinsic worth. Its immediate utilitarian value was all; its potential value to historians of the future was scarcely imagined.

The American daguerreotypists who accompanied the far-flung naval exploring expeditions of the 1850s—to Japan, the North Pacific, and the Arctic—were no more successful than their western counterparts in imagining the potential uses of their pictures or securing broad public interest in their work. Their pictures depicted a different terrain than that documented by the overland travelers, but the essential purpose of the expeditions was the same: to gather scientific evidence about the peoples and natural flora and fauna of distant regions, to help chart the topography of an unfamiliar landscape, and to contribute in a general way toward the creation of new commercial markets. Indeed, the search for a transcontinental railroad route and the exploration of the Pacific were intimately linked in the public imagination. The much-sought-after "Passage to India" and its fabled markets had inspired and impelled western exploration since Thomas Jefferson directed Lewis and Clark to find a route across the continent. Now, with steam-powered locomotives, Americans could imagine crossing the continent in record time; and with steam-powered ships and new Pacific ports, the markets of the Far East seemed within reach.[61]

As John Rodgers, commander of the U.S. Surveying Expedition to the North Pacific Ocean, wrote in 1856, "The Pacific Rail Road, and Steamers to China, will turn the tide of commerce this way."[62] The exploration of the Pacific seemed intimately linked to western exploration; the two were intertwined strands of America's imperial ambitions.

The first of the American daguerreotypists to depart on an organized

After Eliphalet Brown, Jr., *Regent of Lew Chew*. Tinted lithograph after daguerreotype, from Francis L. Hawks, *Narrative of the Expedition of an American Squadron to the China Seas and Japan . . .* (1856). Yale Collection of Western Americana, Beinecke Rare Book and Manuscript Library

overseas expedition was Eliphalet Brown Jr., who set sail with Commodore Matthew C. Perry's naval expedition to Japan on November 24, 1852. Perry sought to establish formal diplomatic and trade relations with Japan using tools of persuasion that included intimations of American military might as well as demonstrations of the western world's technological prowess. After landing in Lew Chew, which is present-day Okinawa, in late May 1853, Perry "resolved to procure a house on shore, and gave notice to Mr. Brown, the artist in charge of the daguerreotype apparatus, that he must prepare his materials, occupy the building, and commence the practice of his art."[63] By June, Brown was "settled on shore in a house outside Tumai" producing daguerreotype portraits that would later be redrawn for lithographic reproductions in Perry's formal report.[64] Perry reported to the secretary of the navy that "exhibitions of the Daguerreotype, the Magnetic Telegraph, the Submarine Armor and other scientific apparatus have been to the utter astonishment of the people."[65] When Perry moved on to Japan, the scientific instruments were again hauled out to impress visitors. Brown's daguerrean camera was a weapon in a war for cultural and political superiority, much as Carvalho's and Stanley's had been among the native peoples of the American West. Its performative or demonstrative value, however, would outweigh its utility as a tool of historical documentation.

It was by now a familiar story. Brown's daguerreotypes impressed his Japanese subjects (as Carvalho's had impressed the Cheyenne), but they never even came to the attention of American viewers. Instead of being put on public display, they went to the studios of the artists and printmakers charged with producing the illustrations for Francis Hawks's formal report of Perry's expedition (1856). The report included among its many illustrations fourteen lithographs and six woodcuts carefully identified as being drawn from Brown's daguerreotype plates. Most are portraits of distinguished notables or unusual character types; a few depict architectural scenes.[66] While Brown's daguerreotypes served as little more than studies for completed illustrations, the sketches made by Perry's sketch artist, William Heine, found a more lucrative public audience in the form of a moving panorama. In New York in February 1856, Heine and a colleague advertised "an excursion to China and Japan. For 25 cents, at Academy Hall." They invited "Passengers" to their evening shows and informed them—in a curious metaphor for trans-Pacific travel—that two afternoon "trains" would depart on Wednesday and Saturday.[67] In Heine's painted panorama—created in part by painter Joseph Kyle, who had also worked on the Skirving panorama of Frémont's expedi-

tion—pictures combined with words to create a coherent narrative of travel.[68] Again, a painted panorama won an audience that eluded the small daguerrean plates.

Perhaps because he knew that his photographs would be valued mainly as sources for graphic illustrations, Brown experimented with a paper negative process known as the talbotype process as well as the daguerreotype.[69] Like Frémont, whose collaboration with Brady suggested his recognition of the utility of the paper image, Brown likely knew that a positive photographic print on paper would be considerably simpler to use than a daguerrean image; its larger size and nonreflective surface made it easier to redraw and copy for printed reproductions. But while Frémont was forced to choose between the two processes when he selected a photographer to accompany him on his 1853 expedition into the Rockies, Brown had the space and wherewithal to travel with two kinds of cameras. His daguerreotype camera, however, proved most reliable. A petition to Congress in 1860 seeking financial compensation for Brown noted that he had used "the apparatus necessary to the daguerreotypist, and took over four hundred pictures, all of which became the property of the government, and many of which were used in illustrating Commodore Perry's work on the expedition."[70] There is no mention of paper prints produced with the talbotype process. And despite the reference to the four hundred daguerreotypes that made their way into the collections of the federal government, none are now known to survive. Like the daguerreotypes of Carvalho and Stanley, they were valued more as aids to the production of conventional printed views than as intrinsically valuable artifacts. Once they had yielded their information, they no longer merited special care.

Working in the Pacific the same time as Brown was Edward Kern, the assistant artist assigned to the United States Surveying Expedition to the North Pacific Ocean, an expedition whose purpose was to add to the scientific knowledge of the Earth's animal and natural resources, and to chart a safe sailing route between California and the potential markets of China and Japan, which even now Admiral Perry was prying open for limited American trade. Kern had worked as sketch artist and topographer on Frémont's third expedition, of 1845–7, to the Southwest and later served under Frémont's command in California during the war with Mexico. Presumably, he knew of Frémont's unsuccessful daguerreotype experiments on the 1842 expedition, and was aware that Frémont had even considered having him use a daguerreotype camera on the southwestern expedition of 1845.[71] Thus in late 1852 when Kern secured an appointment as "assistant artist" with the North Pacific Expedition under the command of Comman-

der Cadwalader Ringgold, he likely understood the potential hazards of expeditionary daguerreotypy. Ringgold, himself, wanted nothing left to chance. Giving Kern responsibility for the expedition's photographic equipment, he ordered him to "immediately apply yourself to practice on the Photographic Apparatus so as to acquire a full knowledge of science, in all its detail."[72] Three times, Kern traveled at navy expense to New York, to buy supplies and learn from the firm of Edward and Henry Anthony.[73] As the first American to use a daguerreotype camera on a government field expedition (the Northeast Boundary Survey of 1840–3), Edward Anthony would have been able to offer some useful tips on daguerreotypy. With Ringgold's encouragement, Kern also attempted to learn about the talbotype process, testing the feasibility of a paper negative system that would allow him to produce multiple paper prints.[74] Ultimately, however, he opted for the daguerreotype process, and he sailed with thirty-six dozen daguerreotype plates, a camera, a large supply of chemicals, and two headrests—an unheard-of luxury for an overland photographer transporting equipment with pack animals—to assist with the taking of portraits.[75]

Kern sailed out of Norfolk on June 21, 1853, with a flotilla of boats heading east across the Atlantic. They sailed to Madeira, around the Cape of Good Hope, and on to Sydney and then Hong Kong, where Lieutenant John Rodgers replaced the ailing Commander Ringgold. From the fall of 1854 to the spring of 1855, the reconstituted expedition forces explored and charted the coasts of the Bonin Islands, Okinawa, the Ryukyu Islands, and eventually Japan. From there they sailed north toward the Bering Strait and the northeast corner of Siberia, where Kern and a small detachment of men stayed behind near Glazenap Harbor to work for a month among the coastal Chukchi tribe, while their shipmates ventured north into the Arctic. In September 1855, the crew headed homeward through the Aleutian Islands (where, if Kern used his daguerreotype camera, he would have made the first photographs ever of Alaska) and landed in San Francisco October 13, 1856, two years and four months after setting sail. After spending part of the winter in California, Kern set out for home by way of Hawaii and Tahiti, eventually reaching the East Coast in July 1857.[76]

Despite some technical problems, Kern apparently succeeded in his photographic mission. Upon his return, he wrote to Rodgers that "the list of daguerreotypes is complete—Many of them imperfect owing to the want of a suitable place for working. Which of course could hardly be expected. Most of them being taken in the broad sunlight and many times the plates prepared in places where the necessary conve-

niences for such could not be had as at Glassnappe [Glazenap]." The daguerreotypes of the "natives of the Sandwich Islands" that he had procured in Hawaii had been shipped home from Honolulu, he said. And the daguerreotypes from the early part of the expedition as well as those made in the Bonin Islands in late 1854 and early 1855 had recently been sent for from Hong Kong, where they had been stored for safekeeping.[77] Perhaps they arrived back safely, perhaps not; like so many expeditionary daguerreotypes of the 1850s they have simply disappeared.[78]

Little remains to hint at the richness of this lost visual record. A. W. Habersham, the navy lieutenant who published an account of his adventures on the North Pacific Expedition, thanked Kern and two others for "the aid of their able pencils in the way of illustrating my very imperfect MSS." Judging from the engravings in his book, it was indeed Kern's sketches—not his daguerreotypes—that provided information and inspiration to the printmakers.[79] A more tantalizing glimpse of what Kern might have

produced with his camera is provided in William Heine's *Die Expedition in die Seen von China, Japan und Ochotsk* . . . (Leipzig, 1858–9), a three volume report—never translated into English—that is the only comprehensive report of the North Pacific Exploring Expedition published in the nineteenth century. The outdoor scenes reproduced in volumes one and three seem derived from drawn or painted sources. In the second volume of the report, however, are several engraved illustrations of group portraits that appear to be made from daguerrean

[After Eliphalet Brown, Jr.], *Kura-Kawa-Kahei, Präfect von Simoda*. Engraving, from William Heine, *Die Expedition in die Seen von China, Japan, und Ochotsk* . . . , vol. 2 (1859). Yale Collection of Western Americana, Beinecke Rare Book and Manuscript Library

originals. Four of the images depict people in Simoda, a Japanese community that Kern visited on his travels. But the uncredited engravings are in fact copied from the lithographs published in the Perry report a few years earlier. And these lithographs were drawn not from Kern's daguerreotypes, but from those made directly for Perry by Eliphalet Brown. In different guises, the images captured on his daguerrean plates served multiple masters.

While Kern was working in the North Pacific, Amos Bonsall was struggling to use a daguerreotype camera under even more trying conditions as a member of Elisha Kent Kane's 1853–5 Arctic expedition in search of the lost British explorer Sir John Franklin. Nearly half a century after the expedition, Bonsall recalled that before their departure Kane directed him "to take lessons in daguerreotyping, in order that I might be put in charge of an outfit of that kind, which it was intended should accompany the expedition, for the purpose of getting plates of the scenes in the Arctic regions."[80] Bonsall seems to have had at least limited success with his photographic apparatus. The expedition surgeon, Dr. Isaac Israel Hayes, reported from Proven, Greenland, on July 20, 1853, that Bonsall had taken "a number of fine pictures" representing the "geological and picturesque character of the country." The photographer, he said, had overcome "the difficulties apprehended in the working of the chymicals" and felt confident he could take pictures "with a great deal of decency" as they sailed farther north.[81] Kane never mentions Bonsall's labors in his two-volume account of the voyage, though he claims with pride that his many engraved illustrations are nearly all "from sketches made on the spot."[82] Perhaps his silence reflected disappointment. On the voyage home, Bonsall wrote, all his hard-won daguerrean images were lost. "The box containing the daguerreotypes was put upon a sledge on the ice, and was carried away, together with the whole collection of Arctic birds, which had been prepared with great care for the Academy of Natural Science. This was an irreparable loss, and one that to this day I have never ceased to regret."[83]

Bonsall's disclaimers aside, however, scattered evidence suggests that daguerreotypes of the Kane expedition did survive to earn public notice. In 1856, a visitor claimed to see an "ambrotype" of the Kane Expedition at Mathew Brady's gallery in New York, a picture more likely to be a group portrait made in New York after the expedition's return.[84] But in 1876, ten daguerreotypes ostensibly from the Kane expedition were on view at the centennial exposition in Philadelphia, alongside twelve oil paintings and forty-eight watercolors from the voyage.[85] And in 1884, a critic commented on

the experience of seeing the images. "I wonder what man ever stood beside Dr. Kane's collection of Daguerreotypes," remarked W. E. Partridge, "and did not feel a respect for the man who, with the thermometer 60 [degrees] below zero and with the old Daguerreotype process, could bring back from those frigid regions beautiful, artistic work."[86] These accounts are hard to reconcile with Bonsall's claim that the daguerreotypes sank in the cold Arctic sea. But they begin to suggest something of the vagaries of the daguerrean marketplace and the ways in which daguerreotypes came to be revalued once the technology that produced them became obsolete. As alternatives to field sketches, daguerreotypes might have seemed inadequate. But as historical artifacts they could be valued, long after the fact, for their seeming authenticity and their worth as historical mementoes. For the daguerreotypes produced on the ambitious expeditions of the mid-1850s, however, such veneration came too late. The daguerreotypes had already been lost—not only through natural disasters, but through disinterest, as well.

The sad fate of these daguerreotypes offers an instructive lesson in how the value of images can change over time. Imagine these images and consider what has changed about them since they were made in the 1840s and 1850s. Not the artist's intent, nor the patron's purpose, nor with any luck, the physical appearance of the daguerreotype plate. What has changed is the audience's needs for these pictures. For American audiences of the 1840s and 1850s, the visual information conveyed by painted panoramas or carefully captioned prints was preferable to and more accessible than the more detailed but difficult-to-view imagery of the daguerreotype, even when that daguerreotype was made as part of an exploring expedition whose very mission involved the gathering of accurate, descriptive information. The daguerreotype was valuable as visual verification, as an aide-mémoire, as a kind of image that could be translated into something more valuable. But it had relatively little value as an historical artifact or unique form of imagery in and of itself. The single daguerrean plate remained hard to view, difficult to experience in a shared or collective fashion, insufficiently narrative to feed a popular interest in the West, or fuel the flames of nationalist sentiment.

Eventually, photography itself would become a medium of mass reproduction. With the advent of new wet-plate negative processes in the 1850s, a medium that generated unique objects, such as daguerreotypes, would become one which could generate a theoretically unlimited number of positive paper prints from a single negative. Then, as the literary critic Walter Benjamin argued in his influential essay, "The Work of Art in the Age of Mechanical Reproduction" (1936), photography would be used to repro-

duce unique objects, like buildings or paintings, transforming them from singular items with a particular history, historical authority, and physical presence into copies that would come into the hands of viewers in new ways and with different meanings. The "technical reproduction can put the copy of the original into situations which would be out of reach for the original itself," he wrote, enabling "the original to meet the beholder halfway." By means of photography, for example, the "cathedral leaves its locale to be received in the studio of a lover of art." But, Benjamin concluded, "that which withers in the age of mechanical reproduction is the aura of the work of art." What is lost is the original's "presence in time and space, its unique existence at the place where it happens to be," all sense of the history that has accrued to the object itself.[87] Such was the fate of the expeditionary daguerreotypes of the 1850s, unique "originals" now known almost solely through the printed "copies" that circulated to viewers who never saw the daguerreotypes themselves.

In the 1840s and '50s, as daguerreotypists first strapped their cameras onto horses or mules and set out to photograph the vast vistas of the western American landscape, photography was not a medium of mass reproduction. Quite the opposite; the singular daguerreotype was itself the object of various reproduction technologies, the original that would be copied to "meet the beholder halfway." The daguerreotypes produced by entrepreneurial photographers like John Wesley Jones and Robert Vance, or salaried expeditionary photographers like Solomon Carvalho or John Mix Stanley, ultimately had value only as replicable scraps of information that could serve the widely varied interests of explorers and politicians, showmen and publishers. As the critic John Berger wrote, "It is a question of reproduction making it possible, even inevitable, that an image will be used for many different purposes and that the reproduced image, unlike an original work, can lend itself to them all."[88] As the visual imagery once contained only upon the daguerreotypes' silver-plated surfaces circulated in painted, engraved, or lithographed form, the original daguerreotypes themselves lost all special value. They became the discarded mementoes of romantic quests, small pieces of metal without historical, or even sentimental, value.

In translation to book illustrations and moving panoramas, in their reduction to pure visual information, the daguerrean originals inevitably lost some of their "aura," their allure as singular physical objects that had actually been on a snow-covered mountain peak, or in a Cheyenne village, that retained on their sensitized surfaces a lasting impression of the wind-blasted rocks or curious people that once stood before

them. If audiences of the mid-nineteenth century valued the daguerreotypes for their informational capacity at the expense of their value as physical artifacts, the tables have now turned. The daguerreotype Solomon Carvalho made from a Rocky Mountain peak would likely tell us little today about a particular stretch of topography that we would not already know from detailed topographic drawings, geological maps, or satellite pictures. But as an historical artifact—as the actual physical object produced by Carvalho as the great explorer John C. Frémont waited anxiously by his side, as the small piece of metal carried through the snow after the expedition cached all but its most essential supplies in their desperate march out of the mountains—what enormous value it now would have. In our own age of mechanical reproduction, as we are bombarded daily by uncountable numbers of still and moving photographic images, we have come to revalue the seeming authenticity, eyewitness authority, and uniqueness of the daguerreotype. But as the disappearance of so many early western daguerreotypes attests, our own response to these pictures has little to do with the response of our nineteenth-century predecessors who found, in the flickering images on daguerrean plates, only a pale and ghostly kind of information, better and more effectively conveyed through other media.

4

"The Attempt Has Not Met with Distinguished Success"

Early Wet-Plate Photography and Western Exploration

Far from holding up the mirror to nature, which is an assertion usually as triumphant as it is erroneous, it holds up that which, however beautiful, ingenious, and valuable in powers of reflection, is yet subject to certain distortions and deficiencies for which there is no remedy. The science therefore which has developed the resources of photography, has but more glaringly betrayed its defects.

—Lady Elizabeth Eastlake,

"Photography," *London Quarterly Review*, 1857

In late 1857, Lieutenant Joseph C. Ives, the leader of the Army Corps of Topographical Engineers expedition to the "Colorado River of the West," traveled into the desert Southwest with a wet-plate camera, eager to test the relatively new technology that had already replaced daguerreotypy in most of America's photographic portrait studios. Like previous topographic explorers, Ives still counted on trained draftsmen to keep a visual record of his travel. The artists Balduin Möllhausen and Baron F. W. von Egloffstein would carefully delineate the scenery along the route with sketches and watercolors that could later be adapted as engravings and lithographs for the final expedition report. And Ives himself, trained at Yale and West Point, would keep a visual record of the topography in his own sketchbook.[1] The camera was not then a tool of necessity, but Ives was sufficiently curious about what it could do to carry into the field all the necessary supplies—the camera, glass plates, chemicals, and the material for a dark-tent in which to prepare his negatives. If the experiment worked, he could produce negatives from which he could make paper prints that he could sell, provide to illustrators, or mass-produce to stir public interest in his expedition. Even if he could not overcome the inherent lack of narrative drama that seemed to limit the photograph's appeal, he might overcome the problem of reproducibility that had always plagued the daguerrean medium.

Sometime around November 30, 1857, Ives made a successful photograph of Robinson's Landing, near the mouth of the Colorado River, the only photograph known to survive the expedition.[2] He tried again a short time later in early December, noting in his journal that he had "taken advantage of the mild and quiet interval to experiment, and having constructed out of an india-rubber tarpaulin a tent that entirely excluded the light, have made repeated efforts to obtain a view of camp and the river." But he had trouble with his photographic chemistry and the intense winter sun. "The

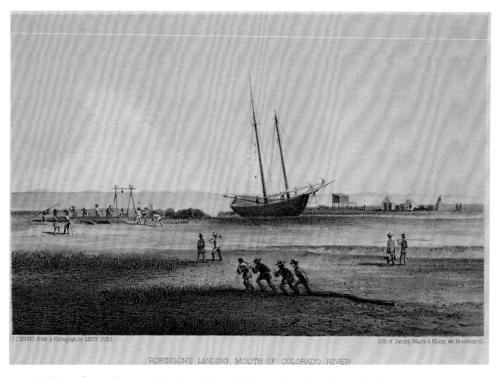

ROBINSON'S LANDING, MOUTH OF COLORADO RIVER

J. J. Young from a photograph by Joseph Ives, *Robinson's Landing, Mouth of Colorado River*. Tinted lithograph, in *Report Upon the Colorado River of the West* (1861). Yale Collection of Western Americana, Beinecke Rare Book and Manuscript Library

attempt has not met with distinguished success," he wrote with wry understatement. "The chemicals seem to have deteriorated, and apart from this the light is so glaring, and the agitation of the atmosphere near the surface of the ground so great, that it is doubtful whether, under any circumstances, a clear and perfect picture could be secured." It thus seemed no great loss when, during the third week of December, a strong gust of wind blew away the makeshift darkroom. "The photographic tent made a clean thing of it, apparatus and all," Ives wrote, "but that was comparatively of little importance."[3] It was an inauspicious debut for a technology that would soon transform the visual documentation of the West and, within two decades, make photographs of the West's dramatic landscapes, native peoples, and growing urban centers a ubiquitous part of American life.

During the late 1850s, as immigrants continued to pour into California and the government became increasingly concerned about potential conflicts between Indians

and settlers on the northern frontiers, government exploration of the West came to focus on the construction of wagon roads that would facilitate the movement of immigrants as well as the transportation of military supplies. Such was the context of Ives's mission; he had been sent west to explore the feasibility of using the Colorado River as a supply artery for military forts in the Great Basin. With the ambitious Pacific Railroad surveys of the mid-'50s concluded, and no consensus in sight for a rail route that could win support from both North and South, federal attention had turned to more local public works projects that might spur western development without directly engaging the increasingly bitter fights about the expansion of slavery into the far West. Visual documentation remained as important for these more regional projects as it had been for the transcontinental expeditions; with images the expedition leaders could record and communicate their findings, documenting the lay of unfamiliar terrain, surveying its prospects, and suggesting how peoples and goods could flow westward across the sparsely settled region. Daguerreotypy had never proven extremely useful for such a project. But with daguerreotypy now an antiquated process, the wet-plate photographers of the late 1850s had a chance to test the utility of a new technology of field documentation. If they could master the difficulties of the medium they would be able to use their hard-won negatives to make paper prints that could convey visual information in new and more commercially viable ways.[4]

Yet as the wet-plate process supplanted daguerreotypy during the late 1850s, expeditionary photographers and their patrons proved slow to realize all of the possibilities of the medium. At first, as Ives's story illustrates, there were technical problems. For amateurs or poorly trained operators, wet-plate field photography remained a difficult and uncertain process, nowhere near as reliable as field sketching, or even daguerreotypy. Even for those adept at handling the photographic chemistry or the mechanics of a camera, there remained considerable obstacles. Wind, rain, snow, muddy water, and hard-to-traverse terrain could frustrate the most competent of technicians. But the disappointments voiced by these early cameramen and the explorers with whom they traveled go beyond dissatisfaction with the mechanics of the process to convey a deeper uncertainty about the very function of field photographs. Were they to expand knowledge, provide visual confirmation of written reports, or function as more decorative forms of art or visual entertainment? To what extent could they fulfill any of these roles in a manner that surpassed the established utility of more conventional sorts of field sketches? And how should they come before the public eye? Before

wet-plate photography could win wide acceptance it would have to establish its usefulness. And its utility would be determined less by something intrinsic to the process, than by the human imagination of those who used it.

The wet-plate, or collodion, process, first described in 1851 by the English sculptor and photographer Frederick Scott Archer, involved the creation of a thin, light-sensitive film on a sheet of glass that could be exposed in a camera to produce a negative photographic image. Archer added a soluble iodide to collodion, a thick, viscous (and explosive) mixture of gun cotton dissolved in alcohol and ether. This mixture could be poured carefully onto a glass plate and manipulated to produce an even coating. Once the ether-alcohol evaporated, the plate would be covered with a thin, transparent film that could be made light-sensitive by being bathed in silver nitrate. The resulting light-sensitive silver iodides would adhere tightly to the collodion film which, in turn, would adhere firmly to the glass support. The plate remained light-sensitive only while it was still damp (hence the process's name).[5] Photographers thus had to prepare their negatives immediately before using them, exposing them in their cameras within an hour or so of having sensitized the plates. A process that was arduous inside the confines of a studio was infinitely more difficult, as Ives discovered, in a rough camp set up along a riverbank.

Yet wet-plate technology had the potential to transform the practice of expeditionary photography from a risky economic venture into a profitable business undertaking. A daguerreotype could be sold by a photographer only once, but the multiple paper prints produced from a glass-plate negative could be sold in different venues and used and distributed in any number of ways. The new markets created for these prints increased the odds of financial success for a field expedition and thus encouraged photographers and patrons alike to take more chances in the gathering of images. A single hard-won negative might be printed again and again, and sold to clients long after the expedition had ended. At the dawn of this new era of photographic technology, it seemed possible that a photograph might become more than simply a vehicle for recording information best communicated in another medium; it might possibly become a collectible object in and of itself, valuable as an artifact as well as an image.

The changes wrought by the new technology forced photographers to rethink the very way that their images could communicate information or narrate stories. As earlier expeditionary photographers had discovered, daguerreotype plates conveyed no easily understood message. Despite their exquisite detail, they lacked dramatic flair, narrative

power, or the directed meanings shaped by spoken or written texts, often proving most useful as studies for other forms of visual documentation. But the paper prints produced from collodion negatives could be married with words—words printed on a mount, scrawled on the back of a photograph, inscribed on an album page—that almost instantly gave photographers a way to enhance the narrative capacity of their images. With words, photographers could direct viewers' understanding of their pictures, just as panorama painters or lithographers had long been able to do, finally enabling photography to narrate more complex stories about American life and to compete in the visual marketplace in entirely new ways.

Daguerreotypes were, in a physical sense, inherently resistant to descriptive words. A few daguerreotypists used fine point styluses to inscribe titles or legends across the fragile surface of their plates.[6] But such inscriptions were necessarily brief and difficult to read and, other than attaching a short paper label to the back of the plate or the inside of a daguerreotype case, there was no other easy way to link daguerreotypes with printed words. One could not, for example, easily glue a daguerreotype plate (and its customary protective glass covering and case) to a sheet of paper printed with text, or cart about an "album" of sequentially arranged daguerrean views. The physical form of the metal daguerreotype plate made this impractical. Paper, however, was easy to manipulate, and paper photographs were quickly integrated into more familiar forms of literary and artistic production. Paper photographs could be mounted on boards inscribed with the sorts of narrative legends made familiar through popular lithographs or engravings that would clarify and develop the intended meaning of the image. Likewise, they could be tipped in the pages of printed books or assembled into albums that, like books, presented a coherent linear narrative from start to finish. Early wet-plate photographers were slow to realize it—the technological innovations alone did not make apparent the medium's cultural applications—but eventually this new union of pictures and words would transform completely the ways in which western photographs could inform and shape public understanding of the region and its prospects. Photographs of western landscapes and the native peoples of the West would move into American parlors and schools, workplaces and exhibition halls; and the words affixed to them would help ensure their importance as popular forms of art that would simultaneously reaffirm and create broadly held ideas about the place of the West in national life.

A wet-plate photographer of the late 1850s traveled with a cumbersome and daunting load of supplies that tested the will of all but the most committed adventurers. For "a few days' trip of landscape Photography," a mere jaunt compared with more ambitious expeditionary travel, a contemporary British manual advised photographers to carry into the field:

Camera, slide, and focussing screen, with extra greyed glass for ditto in case of fracture. Large focussing cloth with strings in front, view meter, and focussing glass. Tripod stand with screw bolt. Lens in case. Nitrate bath filled with solution. Half-pint solution extra in glass bottle. Square dipper for Bath, with piece of marine glue for cementing, if required. Carbonate of Soda, one drachm. Glass plate in box with any number extra. Linen cloth and leather for polishing. Broad camel's-hair brush. Pneumatic plate-holder. . . . Photographic tent, with table, poles, covering, and cords for fastening to the ground. Gutta-percha tray, 12 × 10. Water bottle. Scales and weights. Minim measure. Gutta-percha funnel for filtering the Bath. A yard of yellow tammy or calico. Ditto of black calico. A ball of string. Paper of pins.[7]

Necessary, too, were some seventeen acids or other chemical solutions, as well as extra bottles, sponges, and blotting papers. And the number of items on the list conveys only a fraction of what could make practicing wet-plate photography in the field so very difficult. A typical portable dark-tent could weigh some thirteen pounds, a camera and good supply of glass plates could weigh much more, and fresh water had to be carried if a site had no reliable supply of its own. As much as one hundred and twenty pounds might be the typical load for a wet-plate landscape photographer of the period, and transporting this load was only a part of the photographer's task. The historian Richard Huyda estimates that the production of a single landscape negative might require three and a half hours from the time the equipment was unpacked until it was repacked. Five or six hours might be required for better or more confident results.[8] The camera and dark-tent had to be unpacked and set up. Then a sheet of glass had to be cleaned, coated with an emulsion of photographic collodion, and sensitized in a nitrate bath. The sensitized negative then had to be placed in a plate holder, carried to

the camera (which might be some distance from the dark-tent) and exposed—before its tacky surface could dry—while the photographer removed and replaced the cap covering the camera lens. The plate then had to be returned to the dark-tent, developed, washed, and dried. Finally, if the photographer had time, he might varnish the plate to improve its durability. Paper prints from the negative could be produced either in the field or sometime later, back in the more commodious confines of the photographer's studio.

The earliest field photographers to struggle with this process might, perhaps, be forgiven for neither achieving technical excellence nor realizing the full potential of their photographs as tools of visual communication. Even as they struggled with the technical challenges of the medium, they also had to figure out just how their pictures might possibly be used.

In 1859, two years after Lieutenant Ives's unsuccessful experiments with the wet-plate process, Captain J. H. Simpson, also of the Army Corps of Topographical Engineers, took a camera and "a couple of gentlemen . . . as photographers" with him across the Great Basin of Utah on an expedition aimed at opening up new routes of supply to Fort Floyd in Utah Territory and exploring alternative immigration routes to California.[9] The unnamed gentlemen "took a large number of views," Simpson wrote to Colonel John J. Abert, the chief of the Corps. But in general, their "project proved a failure. Indeed, I am informed that in several of the Government expeditions a photographic apparatus has been an accompaniment and that in every instance, and even with operators of undoubted skill, the enterprise has been attended with failure."[10]

But how was such failure measured? Simpson's expectations for the photographic views were likely shaped, in part, by his training at West Point, the institution that had turned out sixty-four of the seventy-two officers (including Ives) who served with the elite Corps of Topographical Engineers during the group's twenty-eight-year existence, from 1835 to 1863. The Corps, writes historian William H. Goetzmann, was "an instrument of self-conscious nationalism," furthering the agenda of "Manifest Destiny" by mapping America's western waterways and uncharted western landscapes. And the group's officers, trained in the sciences as well as the arts, were broad-reaching Romantics who embraced the West in all its grandeur as a site of mystery, wonder, and abundance.[11] The Corps' mapping work required precise visual information, and the curriculum at West Point was designed to provide the young engineers with the techni-

cal skills they would need to record it. But the military academy placed an equal value on the fine arts, encouraging its students to imagine that pictures could be at once instructive and aesthetically pleasing. Students could study drawing and topographic sketching with Robert Walter Weir, a friend of such noted American artists as Horatio Greenough, Washington Allston, and Rembrandt Peale. In the library, they could peruse Ruskin's books on aesthetics and study current photographic journals. In their classrooms, they could look at pictorial documents from the Mexican War, including Carl Nebel's *The War Between the United States and Mexico Illustrated* (1851).[12]

Simpson expected a high degree of descriptive accuracy from photographs, but ultimately he measured their success not in photographic terms, but in relation to the more familiar conventions established by topographic drawings. Such drawings might not always represent a landscape precisely as the eye observed it, but Simpson and his military peers had learned to accept and interpret their particular forms of delineation and optic distortion. As a contemporary textbook on topographic drawing noted, "Every topographic drawing addresses itself to the eye as if the spectator were situated above [the scene depicted], and looking down equally upon every part of it."[13] Such a bird's-eye view made sense for the purposes of the Corps of Topographical Engineers; to plot a road, for example, one needed a broad and highly detailed topographic sketch to illustrate how a route might be constructed across a particular swath of terrain. But given the lenses available for early wet-plate equipment, it was virtually impossible to capture such a view with a camera; a photographer could neither capture a broad panoramic field of vision, nor render near and distant sites with equal precision.

Using the word "daguerreotype" as a synonym for the act of making a photograph view, Simpson concluded that the problem is "chiefly in the fact that the camera is not adapted to distant scenery. For objects very close at hand . . . and for single portraits of persons and small groups, it does very well; but as, on exploring expeditions, the chief desideratum is to daguerreotype extensive mountain-chains and other notable objects having considerable extent, the camera has to be correspondingly distant to take in the whole field, and the consequence is a want of sharpness of outline. . . a blurred effect, as well as a distortion of parts." Simpson's concluding comments were unequivocal. "In my judgement, the camera is not adapted to explorations in the field, and a good artist, who can sketch readily and accurately, is much to be preferred."[14] Looking back at the Ives and Simpson expeditions in 1935 from the perspective of his seventy-year photographic career, William Henry Jackson defended his photographic

predecessors: "The trouble comes from the expectation that far distant, hazy ranges should show up as plainly as near by objects. The photographer knew the limitations of his process but the commanders gave it no consideration."[15] There remained the longstanding gap between the technological capacity of the photographic medium and the cultural demands placed upon it; wet-plate photographs still fell short as tools of scientific documentation and instruments of narrative drama.

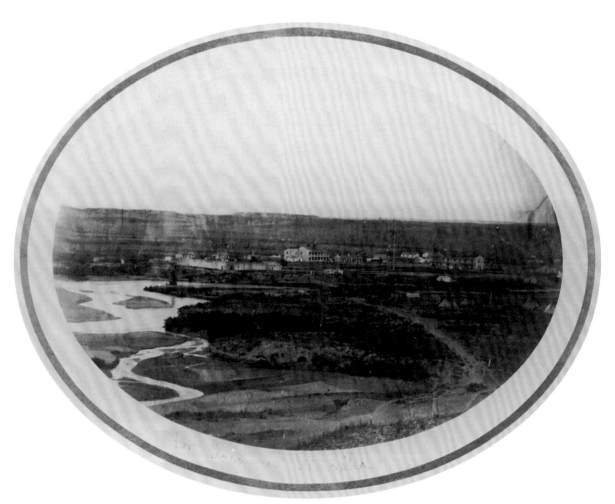

C. C. Mills, *Fort Laramie, Nebraska*. Salt print, 1858 or 1859. William Lee papers, Lee-Palfrey Collection, Manuscript Division, Library of Congress (LC-USZ62–100354)

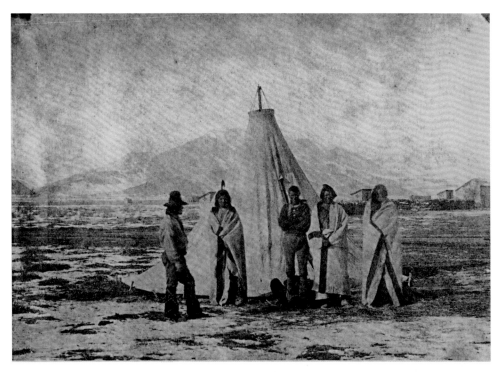

C. C. Mills, *Ute Indians*. Salt print, 1859. Still Photographs Division, National Archives (77-F-149-9-11)

In the letter of transmittal to Abert that accompanied his formal report, Simpson alluded to illustrations in his "journals" that had been derived from photographs. But the report did not appear as he had hoped. The Civil War diverted federal attention and funds away from the publication of the documents detailing the antebellum exploration of the West. An interim report on the Simpson expedition appeared after the war, in 1869, with a long lament about Congress's failure to fund the printing of the complete expedition findings that included "a complete map, meteorological profiles, and numerous sketches."[16] The more complete report did not appear until 1876. By then, photographs and photographically based illustrations were an expected component of all western survey reports, but Simpson's report contained no topographic prints made after photographic views; the only illustrations were lithographs of scientific specimens, prepared in laboratories after the conclusion of the expedition.[17] In the 1869 interim report, Simpson had named his photographer as C. C. Mills with assis-

tance from Edward Jagiello and William Lee. In the final report, however, he never mentioned their names.[18] Such, perhaps, was the measure of his frustration and disappointment with their views.

When Robert Taft first wrote about the photographs of the Simpson expedition in *Photography and the American Scene* in 1938, he could locate none of the pictures and speculated that Simpson's problems were due to improperly trained cameramen and dense mountain haze.[19] But the more recent discovery of Simpson expedition photographs among the papers of William Lee, a young civilian assistant on the survey, reveals that the photographers were not, in fact, incompetent.[20] There are credible photographs of Fort Leavenworth, Fort Laramie, Fort Bridger, and Salt Lake City, a field photograph of Ute Indians, and pictures of the Overland Trail landmarks of Courthouse Rock and Devil's Gate. All now claim a pride of place as the earliest surviving photographic views of important sites in western history, offering visual documentation of particular architectural and geographic forms. But they do not duplicate in either scale or form the detailed architectural or topographic drawings that Simpson, an experienced topographical engineer, had been previously trained to value. The camera seemed a poor substitute for the trained eye and hand of a topographic artist who could selectively emphasize points of particular importance, highlighting with special care the sorts of information he knew his audience would want and expect.

Like Simpson, Captain William F. Raynolds of the Army Corps of Topographical Engineers went to the trouble to transport photographic equipment to the West but found the resulting pictures disappointing and of little use. For his 1859–60 exploring expedition to the Yellowstone and Upper Missouri Rivers, Raynolds hired James D. Hutton as a "topographer" at a salary of $120 a month.[21] By the time the expedition departed in the spring of 1859, Hutton had also taken on the responsibilities of "assistant artist," working with Antoine Schoenborn, the accomplished watercolorist and sketch artist who was to serve as official artist and meteorologist. As the expedition moved west, Hutton not only made pen and pencil sketches of topographic sites but assumed responsibility for the "large photographic apparatus" that Raynolds had purchased for his expedition.[22]

Hutton had considerable difficulty with the wet-plate process; the streaks and stains on his surviving photographs betray the problems he had in coating glass negatives in the field.[23] He experienced difficulty with his commander, too. Raynolds was a devout, almost priggish man, upset by his men's "dissipation" and baffled by their dis-

J. D. Hutton, *Laramie Hills*. Salt print, 1859. Yale Collection of Western Americana, Beinecke Rare Book and Manuscript Library

interest in his Sunday morning sermons. But he reserved a special wrath for his photographer, a man of "inordinate vanity," a hot temper, and "no moral sense of responsibility." Raynolds considered Hutton "little if any better than a confirmed infidel. He is the most quarrelsome, troublesome man to get along with I ever saw. . . . He has fine natural abilities but a perfectly undisciplined mind. A smattering of knowledge on almost all subjects but is master of none." Raynolds even prayed that his influence over the photographer would be "for good and not for evil."[24] But his assessment of Hutton and his work grew worse with time. In his field journals, Raynolds had noted Hutton's "quite successful" efforts to photograph the great falls of the Missouri; in his final published report he called it simply an "indifferent" accomplishment.[25]

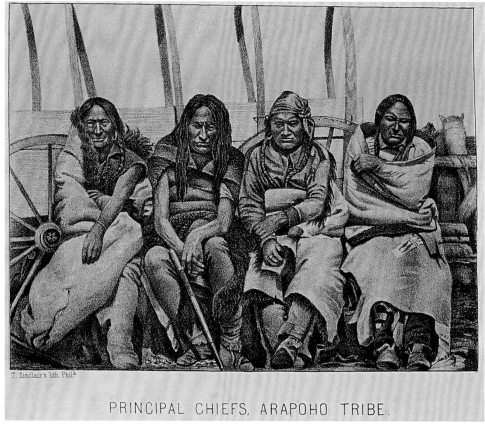

PRINCIPAL CHIEFS, ARAPOHO TRIBE.

After J. D. Hutton, *Principal Chiefs, Arapoho Tribe*. Lithograph, in F. V. Hayden, "Contributions to the Ethnography and Philology of the Indian Tribes of North America," *Transactions of the American Philosophical Society*, vol. 12 (1863). Amherst College Library

The pencil grid carefully marked across a surviving photographic print of the Laramie Hills suggests that Hutton's pictures were to be redrawn on printing plates and used as illustrations in Raynolds's published report.[26] But like Simpson, Raynolds saw the publication of his report delayed until after the Civil War. When the report finally appeared in 1868, it noted the difficulty of constructing road systems along the Yellowstone and its tributaries and the improbability of developing an agricultural economy in such an arid region; it contained a useful map but no illustrations. The war disrupted not only western exploration, but also the process by which early western photographs

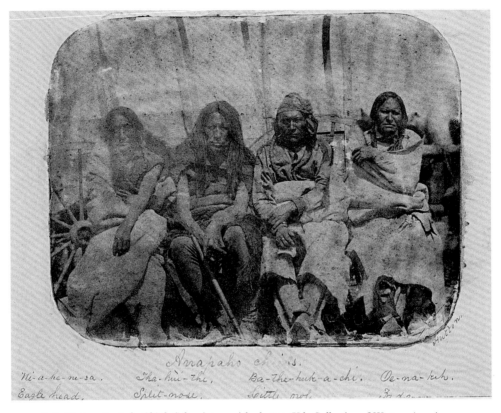

J. D. Hutton, *Arapaho Chiefs.* Salt print, varnished, 1859. Yale Collection of Western Americana, Beinecke Rare Book and Manuscript Library

might have come to public attention; in addition it further slowed the sorts of experimentation by both photographers and publishers that would lead to a more widespread acceptance of photography as a medium of description and cultural explication.

Seven of Hutton's Indian portraits, however, appeared as lithographic reproductions in Ferdinand Vandiveer Hayden's report "Contributions to the Ethnography and Philology of the Indian Tribes of the Missouri Valley," published in the *Transactions of the American Philosophical Society* in 1863. A geologist who accompanied Hutton and Raynolds on their trip in 1859–60, Hayden added illustrations to his ethnological report as an afterthought "at the suggestion of an eminent ethnologist" in order to depict the Indians who had served as linguistic informers for the Americans. Although

it was too late to incorporate mention of the pictures into his text, Hayden appended a note on the plates that identified the subjects of the portraits, attested to their good character, and clarified their importance to the American explorers and, by extension, to his readers.[27] The illustrations represent the first publication of a group of field photographs of western Indians and foreshadow the grand photographic documentation projects Hayden would oversee in the 1870s as commander of the ambitious United States Geological Survey of the Territories and as the figure behind the government's *Descriptive Catalogue of Photographs of North American Indians.* Published under Hayden's watch in 1877, this annotated listing of more than one thousand photographic portraits functioned as an apologia for federal Indian policy, as it argued for the inevitability of the disappearance of native cultures.[28]

That Hutton's photographic portraits were transformed into lithographs while his landscapes were not is attributable to more than the vagaries of government funding for illustrated expedition reports. Hutton's landscape photographs were poor imitations, indeed, of the topographic drawings made on Raynolds' expedition, but his photographic portraits could compete reasonably well with the similarly composed portrait paintings that had long been used to narrate stories of North American Indian life. The lavish three-volume set of hand-colored lithographic Indian portraits assembled by Thomas McKenney and James Hall, *History of the Indian Tribes of North America* (1836–41), had paired portraits and biographical sketches to build a bigger argument about the history and the future of the nation's Indian peoples. The grand Indian Gallery projects of the 1830s and '40s, such as those assembled by painters George Catlin and John Mix Stanley, had likewise used portraits to help narrate an ambitious literary chronicle of Indian history. Hayden's publication of Hutton's portraits thus represented a photographic variation of a time-worn theme. Hutton's portraits closely echoed in form and content (and later, in use) a kind of formal Indian portraiture that had already found a niche in mid-nineteenth-century publications and exhibitions. Unlike the landscape photographs, which seemed to defy the conventions of panoramic scope and scientific clarity that marked contemporary topographic drawings, the portraits—especially when redrawn as lithographs—corresponded to a form of representation with which Americans were already familiar.

The early western photographs of Albert Bierstadt, who traveled into the Rockies with the Lander expedition in 1859, likewise found a place in the cultural marketplace because they echoed an already accepted form of visual picture-making. Bierstadt was

an independent artist, not a government employee. And by producing stereographs, he signaled his intention to compete not with conventional topographic drawings, but with a new and popular form of photographic art. Stereographs consisted of two photographs mounted side by side on a single mount that, when viewed through a specially constructed handheld or tabletop viewing device, seemed to merge into a single three-dimensional image. The photographs were produced by means of a double-lens camera whose lenses were placed roughly the same distance apart as a person's eyes. The resulting pictures were, accordingly, not quite identical, and when examined through a stereoscopic viewer seemed to mimic the three-dimensionality of human vision itself. By 1859, when Bierstadt ventured west, stereographs were in middle-class parlors across America. "The stereoscope, and the pictures it gives are . . . common enough to be in the hands of many of our readers," Oliver Wendell Holmes wrote in the *Atlantic Monthly* in June 1859, "and . . . many of those who are not acquainted with it must before long become as familiar with it as they are now with friction matches." Although portraits continued to be made by the older daguerreotype process, he said, paper photographs were now the preferred medium for "landscape, still life, architecture and genre painting," and they appeared most often in stereographic form.[29] If government photographers and their patrons had been slow to find a niche in the marketplace for their prints of the western landscape, private entrepreneurs had quickly found a way to put their own photographic views in countless American homes.

Frederick West Lander, the civilian engineer who led the 1859 government expedition to survey a wagon route west from South Pass to California, had become familiar with the relative merits of drawing and photography when he traveled with artist and daguerreotypist John Mix Stanley as a fellow member of Isaac I. Steven's 1853 survey for a northern railroad route.[30] Although his own expedition included no allocation for an official artist, Lander wrote in his report, "A. Bierstadt, esq. a distinguished artist of New York, and S. F. Frost of Boston accompanied the expedition with a full corps of artists, bearing their own expenses."[31] It is unclear how the painters Albert Bierstadt and Francis S. Frost connected with Lander's party, but it was an arrangement that seemed to work wholly to the advantage of the artists.[32] Lander provided an escort but exercised no formal command over the men and had no proprietary claim to their work. "They have taken sketches of the most remarkable views along the route," he wrote, "and a set of stereoscopic views of emigrant trains, Indians, camp scenes, etc., which are highly valuable and would be interesting to the country." He must have

regretted his parsimonious budget, for he complained that he had "no authority by which they can be purchased or made a portion of this report."[33] Indeed, Lander's final report appeared without illustrations, and it was through the ingenuity of the artists themselves that the pictures found an audience.

The artists joined Lander's party in Missouri in April 1859 and moved west with them across Kansas, along the Platte River in Nebraska, and on to Fort Laramie and the Wind River Mountains of Wyoming. A route that had still seemed strange and unnerving to Frémont when he traversed it in the early 1840s was now a well-worn path of western migration. Freed from the burden of producing something for an employer, mapping unfamiliar territory, or even keeping an eye out for his own safety, Bierstadt could put aside all wariness and embrace the sites with romantic exuberance. "The color of the mountains and of the plains, and, indeed, that of the entire country, reminds one of the color of Italy," Bierstadt wrote in July 1859 in a dispatch from the "Rocky Mountains" to the journal *The Crayon*. "In fact, we have here the Italy of America in a primitive condition." Searching for other familiar metaphors to convey the sublime splendor of the Rockies to his eastern readers, Bierstadt compared the peaks to the Swiss Alps, the valley areas to New Hampshire and the Catskills. The Indians, clothed in "picturesque dress," provided "important adjuncts to the scenery."[34] For the Dusseldorf-trained Bierstadt, the trip was an awakening to the possibilities of an American subject for his work, and marked the beginning of his career as a painter of distinctively western scenes.

In addition to his sketchbook, Bierstadt carried a stereoscopic camera and the supplies necessary to prepare wet-plate negatives. "We have taken many ideal views," he reported, "but not so many of mountain scenery as I could wish, owing to various obstacles attached to the process." Portraiture posed a simpler technical problem, even if his desired Indian subjects sometimes seemed reluctant to pose. "We have a great many Indian subjects," Bierstadt explained to his eastern readers. "We were quite fortunate in getting them, the natives not being very willing to have the brass tube of the camera pointed at them. Of course they were astonished when we showed them pictures they did not sit for; and the best we have taken have been obtained without the knowledge of the parties, which is, in fact, the best way to take any portrait."[35]

After returning home to New Bedford, Massachusetts, in September 1859 "to avoid the fall deluge on the plains, which renders the roads almost impassable," Bierstadt turned his stereographic negatives over to his brothers Edward and Charles, who

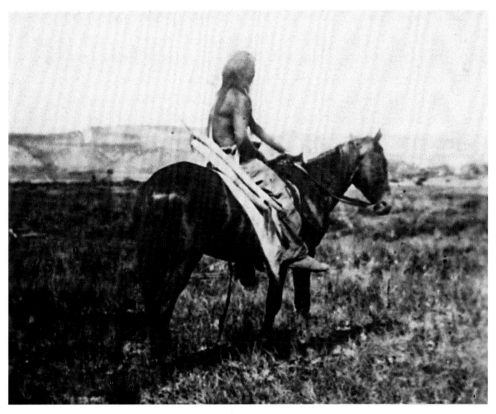

Albert Bierstadt, *Shoshone Warrior, Nebraska*. Albumen silver print, stereograph half, 1859. Kansas State Historical Society

shortly thereafter issued a sales catalogue advertising the western views.[36] It marked the start of Edward's and Charles's long involvement with photography and represented the first time that a collection of paper photographs of the interior West had been offered for sale to the general public. The Bierstadt Brothers' *Catalogue of Photographs* (1860) offered fifty-two stereoscopic "Views in the 'Far West,'" including scenes of emigrant groups, pictures of Lander's party, landscapes made around Fort Laramie and farther east in Nebraska and Kansas, and at least sixteen pictures of Shoshone, Sioux, and Cheyenne subjects. Listed in sequential numeric order, the stereos present no coherent narrative of a trip across the Plains. But with their focus on landmarks along the overland trail, familiar genre scenes, the process of migration, and

the seemingly safe, if exotic, aspects of Indian life, they convey an implicit story about the possibility and promise of westward migration. "These Views were procured at great expense," the Bierstadts wrote, "and as far as we know are the only views in the market giving a *true* representation of Western Life and Western Scenery." Available on either paper or glass, the stereoscopic views could be purchased for $4 per dozen; it was a cautious start for the mass marketing of western views.[37]

If Bierstadt succeeded in finding an audience for his western photographs where his predecessors and contemporaries had failed, it was in part because he successfully mastered some of the technical difficulties of wet-plate field photography. But his success is due also to his entrepreneurial vision, his ability to market photographs of unfamiliar sites in more familiar ways. Positioned in a sales catalogue between reproductions of Raphael's religious paintings and views of New Hampshire's "wild and beautiful scenery," the western stereos were not simply illustrations for an expedition narrative, they were collectible artifacts of an alluring place, bits of parlor entertainment that could stand independent of a long descriptive report.

Oliver Wendell Holmes's three-part essay on stereographs in the *Atlantic Monthly*, beginning in 1859, helped to popularize and promote the medium to the very same middle-class audience toward which the Bierstadts' catalogue was aimed.[38] The three-dimensional images conveyed a thrilling and heightened sense of verisimilitude that allowed viewers to enjoy distant places from the comfortable surroundings of their Victorian parlors, and afforded a kind of vicarious travel experience akin to the experience of watching a moving panorama.[39] If the stereos could not quite provide viewers with the sort of collective social experience that visitors to a moving panorama might enjoy, they could nonetheless provide a broadly accessible kind of entertainment, the sort to be enjoyed in one's own parlor after dinner. Circulating in multiple copies and exchanged among friends, the stereos could provide a common topic of conversation even among people who had not studied them together. Granted, one might look at them in a haphazard sequence, a quite different sort of experience than viewing the carefully constructed linear narratives of the panoramas, but the titles and captions affixed to the stereographs, like the words in the sales catalogues that sometimes accompanied them, identified what one was looking at and sometimes helped to clarify its would-be value or significance. If panoramas conveyed a sense of realism through motion and dramatic lighting effects, the stereos acquired their illusion of realism from their seeming three-dimensionality, an "appearance of reality," Holmes wrote, "which cheats the sense with its seeming truth."[40]

Although the earliest wet-plate landscape photographs made on antebellum exploring expeditions failed to measure up to the needs and expectations of expeditionary leaders schooled on the relative merits and conventions of topographic drawing, the comparative success of Hutton's photographic portraits and Bierstadt's stereos suggested that paper photographs of the far West could find a place in the marketplace of visual ideas. Especially when they could echo—in content, form, or use—other, already proven, forms of illustration.

The challenges of the wet-plate medium were, for its earliest practitioners, thus as much conceptual as technical. And so it seems both surprising and predictable that the most successful North American photographic expeditions of the late 1850s were actually in Canada, a nation that did not even commission its first western exploring expedition until 1858. The United States had an established tradition of western expeditionary art and photography stretching back to the work done by sketch artists Samuel Seymour and Titian Ramsey Peale on Major Stephen H. Long's expedition of 1819–21 and to Frémont's daguerrean experiments of the early 1840s. Yet the western photographers of the 1850s found little there upon which to base their art, no useful models that would aid them in finding a market or outlet for their work. Indeed, the pictorial illustrations produced by these earlier expeditions were in some ways a deterrence to the development of photography as a tool of topographic documentation, creating standards of scientific detail and dramatic invention that photography could not match. Working wholly outside of any previous tradition of Canadian expeditionary art, the photographers attached to the Canadian Assiniboine and Saskatchewan Exploring Expedition of 1858 and the British Royal Engineers' 1858–62 Northwest Boundary survey succumbed to fewer technical problems than their American counterparts, showed greater ambition and imagination for the use of their pictures, and eventually saw their images embraced for both commercial and political ends in a way that prefigures the use of photographs made on the great federal surveys of the American West during the post–Civil War era. Their success, measured by the sheer number of field photographs that entered the public realm, stemmed from their superior technical training and mastery of the wet-plate process, the absence of alternative pictorial models, and their more ambitious entrepreneurial imagination. In Canada—for the first time in North America—photography became a truly integrated part of expeditionary work, essential to field documentation and to the later dissemination of the field research.

The first exploring expedition commissioned by the Canadian government, the

Assiniboine and Saskatchewan Exploring Expedition was a civilian venture charged with surveying the country between Lake Superior and the Red River to determine "the best route for opening a facile communication through British Territory, from that lake to the Red River Settlements, and ultimately to the great tracts of cultivable land beyond them."[41] Canada was in the midst of negotiating a new, more autonomous relationship to the British government, and with the Hudson's Bay Company's monopoly on some of the western lands soon to expire, the Canadian government was eager to assert control over the territory and to survey its potential for viable agricultural settlements. The United States's northern neighbor had virtually no tradition of government-sponsored photography and no legacy of the sort of grand daguerrean documentation projects undertaken by American photographers such as Robert Vance or J. Wesley Jones.[42] But Professor Henry Youle Hind, geologist and naturalist at Trinity College, Toronto, and leader of the party charged with recording the geology and natural history of the region, had ambitious aims for the photographs to be produced under his watch.

Hind was the first North American expedition leader to grasp the full possibilities of the wet-plate process. After purchasing a camera, he secured the services of twenty-four-year-old Toronto photographer Humphrey Lloyd Hime. Hind wrote to the provincial secretary on April 10, 1858, that Hime would "furnish a series of Collodion Negatives for the full illustration of all objects of interest susceptible of photographic delineation, from which any number of copies can be taken to illustrate a narrative of the Expedition and a report on its results."[43] Two weeks later, he requested permission to approach the editor in chief of the *Illustrated London News* to publish a series of views "either drawn by hand or taken by photograph" during the expedition, to which he would append his own descriptions.[44] In understanding that field negatives would permit him to obtain multiple copies of paper prints that could be used to illustrate his report or distributed to muster support for his work, Hind showed greater understanding of the medium and more imagination than any of his counterparts south of the forty-ninth parallel. He seemed to sense that paper photographs could be used as tools of political suasion in a way that daguerreotypes could not.

Hind's generous feelings toward photography did not extend to his photographer. Most of the surveyors who accompanied him were "conscientious, talented and trustworthy." But Hime, the photographer, fell into a different category entirely. Few, Hind wrote, "can conceive the pain and anxiety which the absence or temporary sup-

pression of these qualities in a companion [Hime], is capable of inflicting, when circumstances will not permit avoidance or separation."[45] Hind's frustration began with a dispute over Hime's seeming lack of productiveness, grew when the photographer left behind in the field some negatives that were subsequently lost, and peaked in a dispute over rights to the negatives and the costs of making prints for distribution.[46]

Hime was remarkably successful, however, particularly in contrast to his contem-

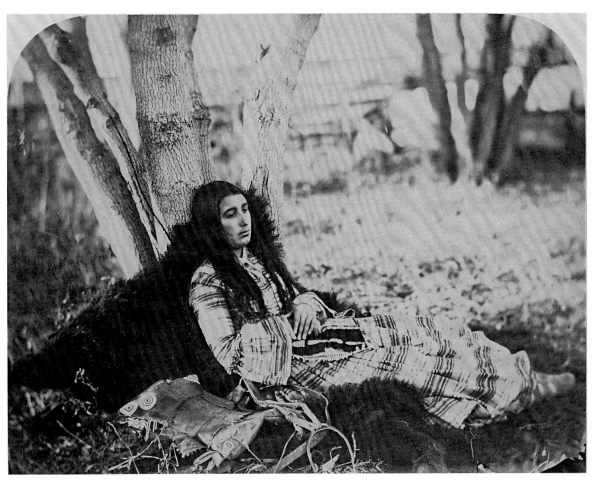

Humphrey Lloyd Hime, *Letitia: A Plain-Cree Half-Breed*. Albumen silver print, 1858. Yale Collection of Western Americana, Beinecke Rare Book and Manuscript Library

Printed by Spottiswoode and Co.] [New-street Square, London.

THE PRAIRIE LOOKING WEST

After Humphrey Lloyd Hime, *The Prairie Looking West*. Chromoxylograph, in Henry Youle Hind,
*Narrative of the Canadian Red River Exploring Expedition of 1857 and of the Assiniboine and Saskatchewan
Exploring Expedition of 1858*, vol. 1 (London, 1860). Yale Collection of Western Americana,
Beinecke Rare Book and Manuscript Library

poraries working in similarly remote areas farther south in the western United States.
He provided Hind with forty-five photographic prints to submit with his official expe-
dition report; fourteen became sources for the "chromoxylographs" and engravings in
Hind's two-volume printed narrative of the expedition, printed in London in 1860.
Two prints were engraved for the *London Daily News* in October 1858. A group of the
photographs went on view in the Fine Arts Section of the Provincial Exhibition in
Kingston, Ontario, in September 1859, and the English publisher J. Hogarth (presum-
ably working with the cooperation of the Canadian government) produced a portfolio
of thirty mounted expedition prints for public sale in 1860.[47] On the remote prairies of
western Canada, in Ontario and London, technical proficiency, creative imagination,
and marketing acumen finally came together to produce a widely seen photographic
record of the western North American continent.

Hime's surviving photographs, all made between May and November 1858, reveal

his struggles with the collodion negative process. Only eight images survive from the summer field expedition west from the Red River settlements to the Qu'Appelle River Valley; thunderstorms, grasshopper plagues, and swift rivers made the work onerous. But back at the Red River settlements in September and October, Hime worked with greater ease and proficiency, documenting the general character of the country, the local architecture, and some of the native and mixed-race inhabitants of the region. The thirty prints later marketed in the English portfolio—the earliest collection of photographic views of the North American prairie—anticipate in form and content the many albums and portfolios of western pictures that would be marketed in the United States in succeeding decades. The pictures are grouped under seven headings—"The Red River of the North," "Churches of Selkirk Settlement," "Houses and Stores of the Settlers," "Indian Tents and Graves," "The Prairie," "Forts and Stores of the Honourable Bay Company," "Native Races"—and, sequentially organized with descriptive captions, they form a literary and visual narrative of a nation's expansionist aims. They present "the general character of the river, and the level country through which it

Humphrey Lloyd Hime, *The Prairie Looking West.* Albumen silver print, 1858. Yale Collection of Western Americana, Beinecke Rare Book and Manuscript Library

flows," document the physical evidence of Canada's spiritual and commercial presence in the remote Red River settlements, and resolutely look to the region's future. If the first half of the portfolio suggests what the region will become, the second half looks back to its past, with photographs of the soon-to-be supplanted Hudson's Bay Company forts, Indian graves, and the "half-breed" settlers whose very being testified to the fading of older native cultures. Placed last in the sequence, a photograph of a Blackfoot warrior's robe marked with drawings depicting tribal history provides the visual affirmation of a native past.[48] The photographs in the portfolio thus justify the need for an exploring expedition to the Canadian West, even as they document that expedition and implicitly predict its outcome. None of the photographs produced by the exploring expeditions in the United States had been so effectively marshaled as evidence for a political cause. Not until after the Civil War would photographs of the western United States so effectively serve the cause of conquest and expansion.

Despite their relative success, Hime's photographs still bumped up against the

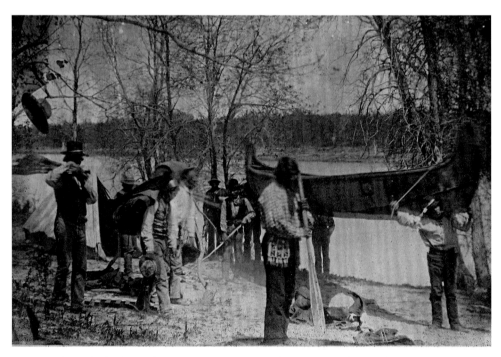

Humphrey Lloyd Hime, *Making a Portage. Voyageurs and Canoemen of the Expedition, June 2, 1858.* Albumen silver print, 1858. National Archives of Canada (C4574)

powerful barrier of viewers' expectations. Lieutenant Simpson had found photography too imprecise to be an effective tool of communication, but the fate of Hime's pictures suggests that the opposite could be true, as well. Consider *The Prairie Looking West*, Hime's most remarkable photograph and the bleakest image ever made on the American or Canadian prairies. A flat, grassless prairie, decimated by a recent grasshopper infestation, stretches across the print beneath a razor-sharp horizon. Under a pale, featureless sky lies a bleached white bone—perhaps a human femur, perhaps an animal bone—and the unmistakable form of a human skull. Writers in the United States, harkening back to explorer Major Stephen H. Long in 1821, had often referred to the arid plains as "the Great American Desert."[49] But no one had ever provided such a vivid and horrific visual image of the terrifying emptiness that stretched across the North American prairies.

Hime's harsh vision found no audience. In its transformation into a "chromoxy-

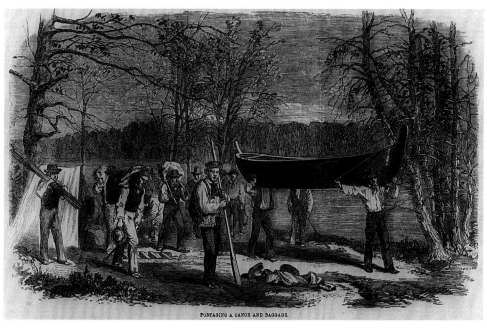

PORTAGING A CANOE AND BAGGAGE.

After Humphrey Lloyd Hime, *Portaging a Canoe and Baggage*. Engraving, from *The Illustrated London News*, 16 October 1858. National Library of Canada (C61755)

lograph" reproduction in Hind's final expedition report, his photograph was altered and sanitized. The sky was tinted blue, the decimated prairies made to bloom with green, and a flock of white geese added to the sky to bring life to this stark image of death.[50] It is not clear who initiated this transformation. It might have been Hime, Hind, or a government functionary intent upon conveying a more positive image of the prairie. Likewise, it might have been a printmaker or publisher who wanted to impose his own marks on Hime's picture. Similarly, it is uncertain who decided to exclude the picture from the portfolio of expedition photographs, which instead uses a comparable view, looking to the south across the prairie along the bank of the Red River. The scene is similarly stark, but includes no bones. In both cases, however, the choices remind us that exploration narratives are not neutral acts of documentation. As literary and scientific expressions of specific economic and political agendas they are carefully crafted arguments built of selective bits of evidence. Visual evidence that seemed too specific could be as useless as visual evidence that seemed too vague, equally unsettling to audiences' preconceived notions about what they should see. When an engraver for the *Illustrated London News* redrew for reproduction Hime's photograph of expedition members portaging a canoe, he transformed the hired Iroquois boatmen into Europeans, thus reaffirming through visual language the broadly perceived connections between the heroism of the exploration and the racial identity of the explorers.[51] Through such acts of creative printmaking, engravers could mediate between photographers and audiences, interjecting their own inflections, helping to create the fictive pictures that would help lay down a social memory of nationalist triumph.

During the summer of 1858, while Hime struggled across the prairies of western Canada with his wet-plate equipment, another expeditionary photographer was at work in that nation's far West. The Oregon Treaty of 1846 had set the international boundary between the United States and Canada at the forty-ninth parallel, and for a decade, the boundary line went unmarked. But the discovery of gold along the Fraser and Thomson Rivers in British Columbia in 1857 gave new urgency to the effort to mark and survey the line in order to avoid legal and jurisdictional disputes. Accordingly, the United States and Great Britain established a joint North American Boundary Survey in 1857 to mark the border. Archibald Campbell, commander of the American team, purchased a photographic outfit for his crew, naively hoping that someone could master the apparatus with the help of an instruction manual. His experiment was a failure and the camera was quickly dismissed "as an impracticable burden to carry

around."[52] The British team, however, produced more than one hundred photographs taken around Victoria and Esquimalt on Vancouver Island in 1858–60 and farther east during the field surveys of 1860 and 1861.[53] Like the pictures from the Hind expedition, these photographs quickly entered into popular currency, both as adjuncts to the reports filed with the British secretary of state for the provinces and as sources for the illustrations in several books published in the 1860s.[54] The expedition photographers, moreover, showed special ingenuity in marketing individual images to their British and American colleagues. Headquartered at Colville, Washington Territory, during the winters of 1860 and 1861, they became the first western expeditionary photographers to make and sell prints in the field, producing copies of field maps for use by the surveyors and selling portraits and scenic views for one shilling each to crew members eager for souvenirs to send home.[55]

Responsibility for the land portion of the British survey fell to the Royal Engineers, who, like their American counterparts, the Corps of Topographical Engineers, regularly assisted with survey projects. Photographic training for the Royal Engineers had begun in the early 1850s, and in 1856 a photographic studio was set up at their training school in Chatham. Trained engineers, posted around the world, were to "send home periodical Photographs of all works in progress, and to photograph . . . all objects, either valuable in a professional point of view, or interesting as illustrative of History, Ethnology, Natural History, Antiquities, &c."[56] In a single year, from February 1857 to February 1858, eighty-five Royal Engineers received photographic instruction.[57] Not surprisingly, then, the Royal Engineers surveying party that arrived in Victoria in July 1858 included a civil engineer or "Sapper" (whose name derived from "sap," an eighteenth-century term for a military entrenchment), with formal photographic training and equipment worth £100.[58] After making only a few surviving views around the British boundary commission's base camp at Esquimalt, the photographer, most likely a little-documented figure known only as J. Johnson, deserted in the spring of 1859, before the season's fieldwork could begin.[59]

With the photographer's desertion, the first season's fieldwork from the coast eastward into the Cascade Range went undocumented. But two additional sappers trained in photography arrived in October 1859 with a team headed by Lieutenant Samuel Anderson, and spent the winter working around Victoria, preparing for the vicissitudes of fieldwork the following season.[60] Their relative anonymity in the historical record speaks to the workaday and unessential nature of their work. "The photog-

rapher has turned out to be rather an invalid and the doctor says he ought never to have been sent out," Anderson confided to his brother. "He gave me a great deal of trouble on the passage out, as he was often very drunk, but was otherwise useful. He has not been drunk since he has been here, so I think he intends to turn over a new leaf."[61] The identities of Anderson's troublesome photographer and his fellow camera operator remain uncertain despite any number of possible candidates. At one point, Anderson suggested that the photographer had previously been his servant.[62] But Arthur Vipond, who received a "certificate of competency in photography" from the Royal Engineers' training program in 1858, was making photographs in Victoria in the winter of 1858–9 and, though not a Royal Engineer, could have been a civilian member of the British survey team.[63] Lieutenant Richard Roche, a member of the British team surveying the water portions of the disputed boundary, also had a camera with him.[64] Indeed, while only two men might have had formal responsibilities as photographer, a number of the British engineers might have had some elementary training in photography and therefore could have occasionally used their cameras. The expedition secretary, Charles William Wilson, for example, remarked casually in his journal entry for October 28–31, 1859, "Tolerably fine weather, during which I have been taking a few photographs."[65] It is the very uncertainty of the official photographers' names that suggests their social and scientific status on the expedition. Despite their special training, they were essentially mechanical operators performing a necessary labor, much like the men who operated surveying devices. They were engineers, not artists. No tradition specified that the creator of a photographic image deserved any more authorial credit than the creator of an astronomical table.

In the spring of 1860 the British team went by sea to the American base at Fort Vancouver (present-day Portland), then traveled up the Columbia River to the old Hudson's Bay Company fort at Colville, in northeast Washington Territory. There they established their headquarters for the next two field seasons and completed their survey of the international boundary east to the crest of the Continental Divide along the border between Montana and Alberta. The surviving expedition photographs document the British camp on Vancouver Island and the trip up the Columbia to Fort Colville, and include numerous multipart panoramas, testament to the continuing allure of the long linear format for expeditionary survey work.[66] With paper photographs, the conceit worked considerably better than it did with daguerreotypes, for the pictures of adjacent views could be trimmed and mounted together on a single sup-

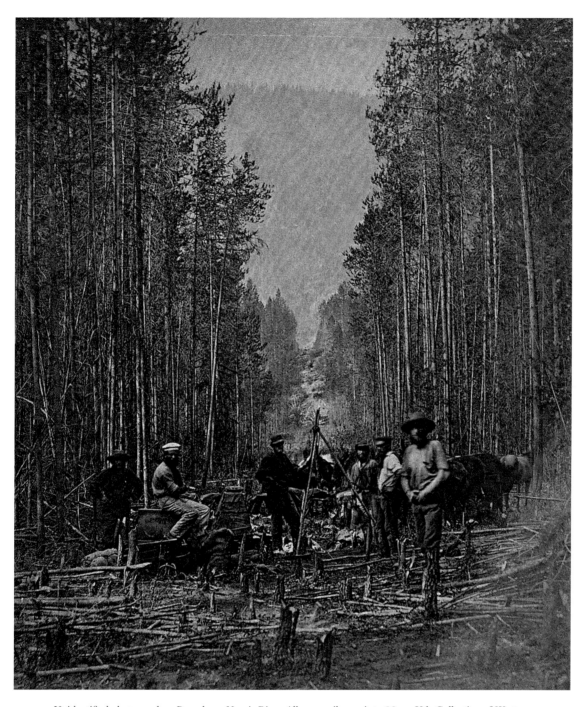

Unidentified photographer, *Boundary, Mooyie River*. Albumen silver print, 1860–1. Yale Collection of Western Americana, Beinecke Rare Book and Manuscript Library

port. The expedition photographs also document the labor of the survey team itself. In the pictures, surveyors site astronomical markers, loggers create clear-cut sight lines through the dense forests, teams of workers build stone monuments to mark the international boundary. During the winters, the photographers had time to make portraits of people in camp. Ridiculing the clothing taste of his commanding officer, Lieutenant-Colonel John Summerfield Hawkins, Anderson wrote his sister in late October 1860, "I believe he is going to have his portrait taken in that costume to send to his wife, telling her that *that* is the dress of the country."[67] The weak winter light made photographing difficult, however. "I would be very glad to send you [my picture]," Anderson wrote his brother from Colville in February 1861, "but there is not sufficient light to take good pictures at this time of the year, so you will have to wait another 6 weeks."[68]

As the light improved, the photographers also made portraits of some of the Indians who visited the British camp during the winter of 1860–1. These formal portraits are the earliest surviving photographs of Northwest Coast Indians; but as is so often the case with photographic "firsts," such pictures do not document first encounters. They in fact provide ample evidence of the long and complicated history of interactions between Europeans, Euro Americans, and Indian peoples that preceded the introduction of photography, a point made clear by the photograph of three Spokane men that appeared as an engraved reproduction in the memoirs of John Keast Lord, published in London in 1866. Lord, a naturalist assigned to the British boundary commission, noted that the man on the left holds a stone celt that he had since obtained for the British Museum. The man in the middle has a rifle, borrowed from the chief trader solely for the purpose of this portrait. On the right, a man holds a bow and arrow, purchased from the trader.[69] Given the subjects' apparent interest in constructing particular public presentations of themselves as men of means and power, one wonders if they, too, purchased prints from the photographer. Clearly, these Indian subjects understood the power of the photographic image to communicate authority.

With the conclusion of the British survey team's work in 1862, sets of photographs went to the British authorities as well as to the American commission and individual members of the survey teams.[70] Although a few photographs were reproduced in personal expedition memoirs published during the 1860s, the joint commission never issued an illustrated report of its work. In 1867, photographs made by the British team, and copied for evidentiary purposes under the supervision of American photographer Alexander Gardner, were introduced as evidence in a hearing held by the British and American joint commission to resolve property claims filed by the Hud-

son's Bay and Puget's Sound Agricultural Companies.[71] The United States filed in support of its claim eleven photographs: five photographic copies of Northwest Boundary Commission photographs and six photographic copies of lithographs done on earlier surveying expeditions.[72] While the variety of sources undoubtedly reflects the limited availability of visual evidence, it also suggests the essential interchangeability of the kinds of pictures provided by field artists, lithographers, and photographers; the drawings, prints, and photographs had equivalent authority as factual documents. Lieutenant-Colonel John Hawkins, who led the Royal Engineers' survey of the land boundary, acknowledged as much when he transmitted a set of eighty-one official photographs to the British secretary of state for foreign affairs in 1863. "The apparatus sup-

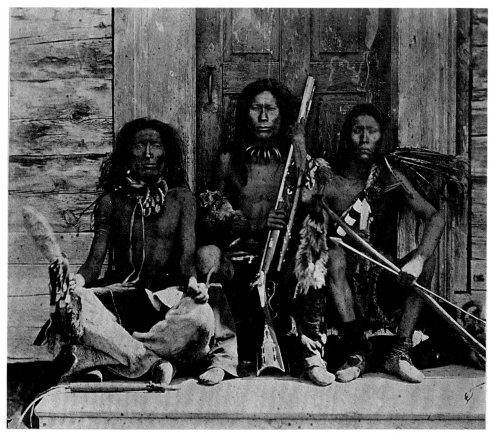

Unidentified photographer, *Three Spokane Men*. Albumen silver print, 1860–1. Yale Collection of Western Americana, Beinecke Rare Book and Manuscript Library

plied was very cumbersome and it proved inconveniently so in view of the demand upon our means of transport for keeping up supplies in the field . . . on the whole . . . I am inclined to think that a competent artist attached to such an expedition . . . would command greater facilities for the production of numerous and interesting sketches."[73] It was a sobering assessment. In terms of the sheer number of field photographs produced for distribution and their ultimate uses as commercial objects, sources for engravings, and technical evidence, this had been the most successful photographic expedition ever in western North America. Its commander, however, still harbored grave doubts about the utility of the medium or its superiority to more conventional forms of topographical drawing.

Within just a few years, however, the United States would turn with renewed interest to the far West, a region whose exploration and development was sharply curtailed during the nation's long and bloody Civil War. As government teams again fanned out across the West to map its resources, assess its economic potential, and plot its future settlement and integration into the American nation, wet-plate photographers would be an essential part of the survey crews. This time there would be nothing tentative or disappointing about their photographs. The pictures made by photographers Carleton Watkins, William Henry Jackson, Timothy O'Sullivan, John K. Hillers, and William Bell would find their way into every corner of American culture, from the halls of Congress and the recesses of the Smithsonian Institution to the nation's centennial exhibition and the living rooms of California's new grandees. In their work, American photography would realize its most compelling and distinctive subject, and through photography the West would at last become a familiar place to millions of Americans.

5

"Westward the Course of Empire"

Photography and the Invention of an American Future

America is the country of the Future. From Washington, . . . through all its cities, states, and territories, it is a country of beginnings, of projects, of vast designs, and expectations. It has no past; all has an onward and prospective look.

—Ralph Waldo Emerson, 1844

In 1726, the Anglo-Irish philosopher and bishop George Berkeley sat down to reflect with bittersweet melancholy upon England's cultural decline. "The Muse, disgusted at an age and clime / Barren of every glorious theme" had already fled; England was in decay. But culture's muse seemed poised to rule again in the North American colonies, "the seat of innocence, / Where nature guides and virtue rules, / Where men shall not impose for truth and sense / The pedantry of courts and school." And so, as he predicted the "rise of empire and of arts" in America and the concomitant decline of Britannia's rule, Berkeley cast out a final pronouncement, "Westward the course of empire takes its way."[1]

Berkeley might have intended his sonorous phrase as a sad commentary on the diminution of British power. But well over a century later, it would become the loud anthem of American nationalism and the rallying cry for westward expansionism, imbuing a social and political movement with a poetic resonance, a dynamic rhythm, and a necessity born of patriotic imperative. In 1862, on the walls of the U.S. Capitol, the painter Emanuel Leutze created a 20 × 30 foot mural with its own distinctively nineteenth-century spin on Berkeley's theme. As North and South stood locked in armed conflict that threatened the very fabric of the American nation, Leutze imagined the West as the site of national healing and reunion. Borrowing Berkeley's phrase, he called his picture *Westward the Course of Empire Takes Its Way*, and he visualized his narrative tale by depicting a group of weary pioneers—young and old, men and women, immigrant and freedman alike—struggling to a mountaintop. A Christian burial scene, dimly visible in the shadows, testifies to the hardships these common folk have endured. But now, all is promise, and with their travails behind them, the stouthearted pioneers look off into the golden land of California. A Daniel Boone–like figure embraces a woman holding an infant—the Madonna and child of this New World—and with a gesture that signals both entitlement and triumph, points to the featureless West that will be given new definition and meaning by such American families. Beside them

a youth stands alone, looking off with calm self-possession into the world that will be his. And in the middle distance, silhouetted against the sky, a figure distinctly reminiscent of John C. Frémont waves in joyful triumph from the highest peak. In the midst of war, the painting suggested another model of conquest; eschewing combat, the common man here prevails through sheer perseverance and hard work. To the writer Nathaniel Hawthorne the painting "looked full of energy, hope, progress, irrepressible movement onward, all represented in a momentary pause of triumph."[2] While the nation struggled to survive civil war and resolve the painful dilemma of its slaveholding history, Leutze's picture scarcely alluded to any past except for the recent march westward that had brought the emigrants to their mountaintop lookout. His picture—as so many western photographs of the 1860s and '70s would likewise be—was resolutely about the future; his America moved inexorably forward toward her western destiny.

That western destiny acquired new definition in the popular print published by

Westward the Course of Empire Takes Its Way [Westward Ho!], study for a mural in the United States Capitol. Oil on canvas, 1861. Smithsonian American Art Museum, bequest of Sara Carr Upton

Currier & Ives in 1868, a hand-colored lithograph based on a drawing by the English artist Frances Palmer, who had never seen the West herself. Leutze claimed that he had sought to generalize in his epic painting, "without a wish to date or localize, or to represent a particular event."[3] But Palmer was explicit about the process of western expansionism, and even as she (or more accurately, perhaps, her publishers) hearkened back to the same literary source that Leutze had used, she imbued her picture of *Across the Continent: "Westward the Course of Empire Takes Its Way"* with countless small details that left the print an anecdotally rich if emotionally diminished version of Leutze's grand narrative epic. A steam locomotive pulls a train diagonally across the picture frame, neatly dividing the world that was from the world that will be. On the right, buffalo graze on a distant prairie, a canoe glides across a sylvan lake, and two horse-mounted Indians watch, with astonishment and resignation, as the steam from the rushing train obliterates their once pristine world. In marked contrast to this passivity, the left side of the picture is all action. The train hurdles across its tracks toward a distant wagon train, soon to pass and render obsolete this old fashioned form of transport. In the foreground a newly created town testifies to the future of America's West. Telegraph poles fringe the settlement, children play outside a school, properly dressed women mark the town's domestication, and men clear the trees to make yet more room for the continued expansion of this American town.

Palmer's print paid oblique homage to the transcontinental railroad, finally completed on May 10, 1869, when a golden spike ceremoniously pounded into a laurel rail at Promontory Point, Utah, joined the tracks of the Union Pacific to those of the Central Pacific, fulfilling the dream of a route across the continent that had animated western exploration for much of the nineteenth century. Word of the triumphant event traveled instantly over telegraph wires; news of the technology that had conquered distance, transmitted by the medium that had annihilated time. And three photographers—Charles Savage, Alfred A. Hart, and Andrew J. Russell—were there to record the event, using their wet-plate cameras to produce views that would be widely exhibited, marketed, and reproduced in the national press, invoking technology in yet another way to bring the distant near, by making visible to countless Americans a momentous event few could witness for themselves. Russell was the official photographer for the Union Pacific, Hart worked for the Central Pacific, and Savage was a commercial photographer in nearby Salt Lake City who recognized the remuneratory possibilities inherent in documenting an extraordinary event right in his own backyard.

Frances Palmer, *Across the Continent: "Westward the Course of Empire Takes Its Way"*. Lithograph, hand-colored, 1868. Amon Carter Museum, Fort Worth, Texas (1970.187)

Placing their tripods just a few feet from one another, Savage and Russell set up their wet-plate view cameras and captured what would become the iconic images of the joining of the rails. Two trains from opposite sides of the continent meet head-to-head on the track; in front of them, chief engineers Grenville Dodge of the Union Pacific and Samuel Montague of the Central Pacific shake hands before the assembled gathering of workmen and dignitaries. In Russell's view, two men mounted on the fronts of the locomotives strain toward each other above the crowd, bottles of champagne in their outstretched arms. The Russell picture appeared in reproduction in *Frank Leslie's Illustrated Weekly,* Savage's variant version was in *Harper's Weekly,* and both were widely embraced as eyewitness bulletins from the front, truth-telling versions of a signal moment in American history.[4] In fact, while both fairly depicted the assembled crowds huddled close to the ceremonial rail, each presented an equally misleading impression of who was actually present that day. Pressed to the edges of the crowd, so far off to the

margins they do not appear in the photographs, were the Chinese laborers of the Central Pacific, composing some 90 percent of the company's construction force, who had blasted and tunneled their way through the granite peaks of the Sierra Nevada. Indeed, in a competition whose only true victor was the company itself, they had beat the largely Irish crews of the Union Pacific by laying a record-breaking ten miles and fifty-six feet of track in a single twelve-hour day. But as the captains of industry came together to celebrate this extraordinary engineering feat, the Chinese were banished from the official visual records of the scene, replaced by the wives and children of dignitaries who had come for the day. The pictures thus stand as potent reminders of the limitations of photographs as self-evident and comprehensive bits of historical evidence. Photographs can describe, but they rarely explain. In this case, they fairly record

A. J. Russell, *East Meets West at the Laying of the Last Rail*. Albumen silver print, 1869. Yale Collection of Western Americana, Beinecke Rare Book and Manuscript Library

who stood before the camera, but nothing more.[5] In serving as celebratory and self-congratulatory images for the railroad owners, the pictures fail to document or explain in any comprehensive way the labor that allowed them this moment of triumph.

If the Russell and Savage photographs of the golden spike ceremony could not quite evoke all of the narrative drama of Fanny Palmer's print depicting the process of western settlement itself, they could nonetheless convey the sense of excitement and epic accomplishment that marked the joining of the rails and suggest, to an American public steeped in the visual and literary rhetoric of westering, a sense of the possibilities engendered by this newly wrought connection between East and West. Even in their other railroad photographs of less inherently dramatic events, Russell, Savage, Hart, and Alexander Gardner (who chronicled the construction of the Kansas Pacific Railroad line across the thirty-fifth parallel) showed that photography could now evoke the metaphorical and narrative stories about western settlement that circulated in popular culture. Their individual photographs, by their very nature, depicted events that had already transpired, scenes that had already been witnessed, people who had long since moved on to other ventures. But collectively, the pictures spoke not to the past, but to a future yet to unfold; and they narrated a single, powerful story about the inevitable and triumphant growth of the American nation. In this post–Civil War era—as narrative captions became an integral part of western photographs, as photographic prints began to circulate through multiple channels, as photographers strained to capture some of the metaphorical elements historically popular in painting—photography could finally compete with the storytelling images that had long circulated in other media. Its protracted apprenticeship as a medium of western storytelling was over.

Gardner illustrated how easy it could be to use words to impute meaning to a picture by titling one of his most popular images *'Westward the Course of Empire Takes Its Way.' Laying Track, 300 Miles West of Kansas City*. Made on October 19, 1867, as the rail line inched westward across the prairie, the picture appeared as view #39 in a series of 127 6 × 8 inch pictures Gardner issued on mounts printed with the title *Across the Continent with the Kansas Pacific Railroad*.[6] Gardner used the title again for a variant view included in his stereograph series, made at the same spot with his smaller stereo camera.[7] As a resident of Washington, D.C., during the 1860s, Gardner was familiar with Leutze's Capitol mural—indeed he had once photographed it—and by appropriating its poetic title he surely meant to evoke a similar narrative of westward movement, even though he did not have the same symbolic figures at his disposal.[8] Gardner's pic-

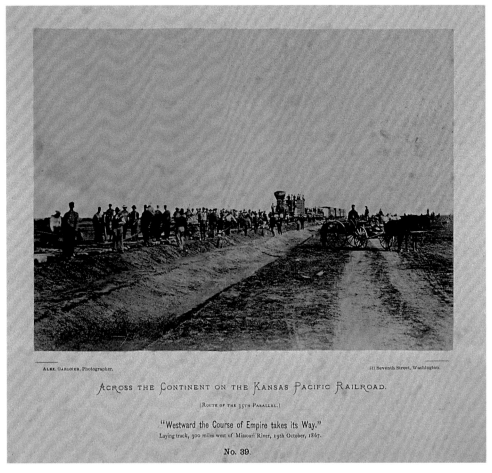

ALEX. GARDNER, Photographer. 511 Seventh Street, Washington.

ACROSS THE CONTINENT ON THE KANSAS PACIFIC RAILROAD.

(ROUTE OF THE 35TH PARALLEL.)

"Westward the Course of Empire takes its Way."
Laying track, 300 miles west of Missouri River, 19th October, 1867.

No. 39.

Alexander Gardner, *"Westward the Course of Empire Takes Its Way." Laying Track 300 Miles West of the Missouri River, 19th Oct. 1867*. Albumen silver print, 1867. John D. Perry Collection, Missouri Historical Society

tures had to convey their message without resort to modern-day Madonnas or the improbable coincidence of people and events that made up the painting. Gardner certainly understood the language of visual symbolism; in his celebrated Civil War photograph, *The Home of a Rebel Sharpshooter*, he had made good use of a corpse carefully moved and arranged for maximum narrative effect. But for his *Westward the Course of Empire* pictures, made near Hays City, Kansas, he had to make do with less dramatic props, constructing meaning from the conjunction of more obtuse visual symbols and

ALEX. GARDNER, Photographer, 311 Seventh Street, Washington.

ACROSS THE CONTINENT ON THE KANSAS PACIFIC RAILROAD.

(ROUTE OF THE 35TH PARALLEL.)

"Seal Rocks," in Pacific Ocean, near San Francisco,
1955 MILES WEST OF MISSOURI RIVER.

"Last scene of all in this strange, eventful history."

No. 127.

Alexander Gardner, *Seal Rocks, in Pacific Ocean near San Francisco. "Last Scene of All in the Strange Eventful History"*. Albumen silver print, 1868. John D. Perry Collection, Missouri Historical Society

the poetry of his title. Workmen laying rails pause to pose beside the supply train halted at the westernmost end of the newly laid tracks; this is the ostensible subject of the picture. But the title also gives symbolic resonance to the more incidental features of the photograph, helping the viewer to understand the contrast between the train and a nearby horse-drawn wagon as a metaphor for the links between technological progress and the advance of civilization, and to see the flat, featureless horizon as evidence of the comfort and beneficence of this particular route. In both the published set

of 6×8 inch views and the more extensive set of stereos, the image appears midway through the sequential series of pictures that lead the viewer west from eastern Kansas to the Seal Rocks, just off the coast of San Francisco, the "last scene of all in this strange, eventful history."[9] The captioned image helps create a narrative trajectory for both series of photographs. Westward with the railroad—implicit, if never quite stated, in these photographs of scenery, railroad construction, and sites along the route—flows the course of American empire.

Gardner's *Westward the Course of Empire* images came before the public in four distinctively different formats, each geared to a different audience. In addition to the luxurious and expensive 6×8 inch album format produced for his patrons, and the less expensive stereograph aimed at a broader mass market, there were two bound book versions of the image. A reduced photographic reproduction of the mounted 6×8 inch view—with its poetic title just barely legible—appeared in an official report issued by William J. Palmer, who in 1867–8 led the survey of possible southwestern routes for the Union Pacific, Eastern Division (later renamed the Kansas Pacific), across the thirty-fifth and thirty-second parallels. One of twenty autotype plates printed directly onto sheets and then bound into the text, the image lent support to Palmer's argument for federal subsidies of the route by visualizing the relative ease of constructing a rail line across the prairie. Obliquely acknowledging the long-standing sectional rivalries that had shaped the search for a transcontinental rail route during the 1850s, Palmer argued that if the southern route had once been held up as a way to expand slavery into the far south, in a reunified nation it could offer new opportunities to all (non–Native) Americans in the sparsely populated southwest. With a southwestern rail line, enterprising Americans could "re-open the mines that were closed by the Pueblo slaves when they rose and drove out the Spaniards; re-populate the valleys and plains, now strewn with Aztec pottery, and open up innumerable avenues of wealth," particularly "in the creation of local trade."[10] For Palmer, western settlement was a dynamic, progressive process, and he invoked words to echo and reinforce the forward motion conveyed by the poetic title of Gardner's more static photographic print.

Gardner's photograph likewise appeared as a woodcut on the title page of *New Tracks in North America* (1869), a book by William A. Bell, the English medical doctor turned photographer who photographed the thirty-second parallel sections of the survey, while Gardner worked farther north along the thirty-fifth parallel.[11] The illustration's spare title, *Laying the Track*, denies it the metaphoric resonance that Gardner's

poetic phrase conferred upon the other versions of the image. Yet the picture's status as the signature image for Bell's photographic adventure tale asserts its symbolic importance. The railway workers pausing here in their labors were not only laying the literal tracks for the locomotive paused just behind them; they were constructing the path by which American civilization itself might penetrate a region alternately desolate and frightening, exotic and intriguing.

In simultaneously functioning as an expensive album print and a low-cost stereograph, a bound-in photographic illustration in a limited edition report, and a woodcut frontispiece in a popular adventure book, Gardner's *Westward the Course of Empire Takes Its Way* pictures showed just how far photography had come as a medium capable of offering Americans a visual explication of the western landscape. If western

Laying the Track.

After Alexander Gardner, *Laying the Track*. Engraving, 1869, from William A. Bell, *New Tracks in North America* (London, 1869). Yale Collection of Western Americana, Beinecke Rare Book and Manuscript Library

expeditionary photographs made before the Civil War generally failed to find a broad viewing audience, Gardner's pictures reached the American public in a wide variety of ways. Part of this was due to Gardner's talent as a field photographer; schooled on the battlefields of the Civil War, he was an adept technician who had kept up with changing photographic technologies and knew how to cope with trying field conditions. But the popularity and symbolic appeal of the picture was due largely to its physical format; no daguerrean view of the same scene could have reached or engaged such a broad audience. Using two cameras—one for his 6×8 inch views, the other for his stereographs— Gardner produced glass plate negatives that allowed him to print images in two sizes and in theoretically unlimited quantities. These paper prints could easily be adapted as book illustrations, either bound directly into books or redrawn as woodcuts or lithographs. Moreover, because they were on paper, the photographs could be mounted on stiff card stock to which descriptive titles and captions could be affixed. Such printed words gave Gardner and his peers new ways to shape public perceptions of their images and to link individual images into a more seamless narrative story. The story of western settlement—whether narrated through overland trail migration stories, images of railroad construction, or didactic tales about the successive stages of cultural evolution on the frontier—was often ordered in a linear and sequential way. Gardner followed this tradition, organizing and marketing his railroad views and stereographs in precise linear fashion (much like a moving panorama), following the extant and prospective rail routes west, labeling his pictures with the literary equivalents of highway mileage markers so that viewers could locate themselves in space. With printed legends and careful sequencing, Gardner suggested how photographs might finally be able to narrate the same sorts of tales that had long drawn Americans to dramatic lithographic prints or moving panoramas. Utilizing photographs, he evoked the familiar rhetoric of Manifest Destiny, presenting westward expansion as a necessary, inevitable, and benign sort of national enterprise.

Gardner's fellow railroad photographers likewise relied on both words and narrative sequencing to assign fixed meanings to their photographs, defining and limiting the ways viewers might read the pictures. Alfred Hart, for example, who became the official photographer of the Central Pacific Railroad in 1866, documented the construction of the railroad tracks from Sacramento east across the Sierras to Utah in a series of 364 published and numbered stereographic views.[12] As a former painter of moving panoramas, Hart understood how to organize sequential linear narratives, apt

Alfred A. Hart, *Indian Viewing RR from Top of Palisades*. Albumen silver print, stereograph, 1869.
Collection of Neil Goldblatt

training for the documentation of a railroad route. In a straightforward manner, the vast majority of his stereographs document the cuts and embankments, the trestles and tracks of the Central Pacific, with short descriptive captions that simply name the subject and sometimes note its distance from Sacramento. But occasionally Hart would resort to visual metaphor or evocative language to hammer home his intended purpose. Some 435 miles east of Sacramento, from the edge of a cliff overlooking the Humboldt River in Nevada, Hart twice photographed a carefully posed but unnamed Indian subject, staring off in quiet contemplation at the newly constructed railroad tracks paralleling the river below. He gave his stereograph a spare caption, "Indian Viewing R.R. from top of Palisades." Nineteenth-century viewers, however, could be expected to read this 1869 image as a photographic counterpart to Fanny Palmer's popular print of the same year, as a visual parable for the way in which one civilization was destined to be superceded by another, the Indian's blanket and all it symbolized to be replaced by the steam locomotive and its attendant trappings of modernity. Hart was more direct in the titles he assigned to two sequentially numbered stereos made farther to the west in the Humboldt Desert: *Advance of Civilization. End of Track, near Iron Point* and *Advance of Civilization. On Humboldt Desert.* The first image shows

Alfred A. Hart, *Advance of Civilization, on Humboldt Desert*. Albumen silver print, stereograph, 1869.
Collection of Neil Goldblatt

tracks stretching out across a decidedly inhospitable landscape; the second, shot from the roof of a train in a similarly foreboding spot, includes workers and the telegraph poles already strung along the tracks. The arid, barren landscape scarcely seems to bode well for prospective settlers, but the words promise that the railroad will be the harbinger of great things; in this desert, civilization will bloom. Hart likewise used language to shape viewers' perception of his most unabashedly metaphoric stereo, made at the north end of the Great Salt Lake, just twenty-one miles from where the rails would be joined at Promontory Point. The picture captures a covered wagon train and a locomotive, heading west in tandem, invoking that association between different forms of technology and different stages of cultural evolution that Fanny Palmer had used as central tropes in her popular print. Ensuring that all of his viewers understood his visual metaphor, Hart labeled the scene *Poetry and Prose*. And so it seemed to contemporary viewers. On April 8, 1869, the Salt Lake City photographer Charles Savage noted in his journal, "The last through mail by coach arrived here today. This is the wind up of the coach travel across the plains henceforth the mail follow [sic] the R. R. Line."[13] A few weeks later, Savage set out to photograph the events at Promontory, and

Alfred A. Hart, *Poetry and Prose, Scene at Monument Point, North End of Salt Lake*. Albumen silver print, stereograph, 1869. Carleton Watkins acquired A. A. Hart's negatives of the construction of the Central Pacific Railroad line and published them as his own. Collection of Neil Goldblatt

wagon trains were quickly relegated to the West's poetic past. So fast was the West's very identity changing that the symbolic representations of the region were hard-pressed to keep up.

None of the railroad photographers of the 1860s took better advantage of the new narrative possibilities afforded by the marriage of words and paper photographs than the Union Pacific's official photographer, A. J. Russell. Schooled in the possibilities of pictorial storytelling through his experience as a panorama painter in the early 1860s, inured to the difficulties of field photography and the special challenge of document-ing construction projects through his work as a photographer for the Bureau of the U.S. Military Railroads during the Civil War, Russell eventually issued his railroad photographs in many forms, including a luxurious photographic album, *The Great West Illustrated* (1869).[14] This leather-bound album of fifty albumen prints, up to 13 × 16 inches in size, included an elaborately printed multicolored title page, a lengthy "preface," and an "annotated table of contents," some five pages long, that employed descriptive captions to direct the reader's understanding of the mounted photographs that followed, detailing the route between Laramie, Wyoming, and Salt Lake City, Utah.

Russell had gone west under the auspices of the Union Pacific in early 1868, trading his work as a photographer and landscape painter in New York City for the more physically strenuous job as a field photographer, which, as he later reported to a photographic gathering in New York, "might well be called photographing under difficulties." The alkalinity of the water he encountered compelled him to carry his own for distances of up to seventy miles. To obtain some of his views he had to walk as much as fifty miles on foot, absent himself from the work parties for four or five weeks at a time, and subsist on wild game.[15] But the *Great West Illustrated* was less about the difficulties of western travel than about the inherent promise of the western landscape. With the "History, Geography, and Geology" of the region "almost unknown," the preface

A. J. Russell, *Dale Creek Bridge from Above*. Albumen silver print, from *The Great West Illustrated* (1869).
Yale Collection of Western Americana, Beinecke Rare Book and Manuscript Library

notes that "the information contained in this volume . . . is calculated to interest all classes of people, and to excite the admiration of all reflecting minds as the colossal grandeur of the Agricultural, Mineral, Commercial resources of the West are brought to view."[16] In the face of such natural splendor and such limitless possibilities, Russell's own struggles seemed unimportant. Even the epic narrative of the railroad workers paled before the vision of the West that was yet to be. The photographs may have documented a recent past, but they narrated a story about the future.

Dramatic as some of Russell's photographs might have been, and useful as they might have been in visualizing remote regions of the West for a distant audience, they could not convey their forward-looking message about the region's promise without the assistance of words. As such, the album simultaneously reinforced the power of photography to convey information and revealed its limitations as a nonverbal form of communication. Repeatedly, the photographic captions call the reader's attention to what is impossible to see in the photographs themselves. The Dale Creek Bridge, for example, might be an engineering marvel but it is of interest because it spans a stream "filled with the finest of trout, which are easily caught at all seasons of the year." A nearby gate in the Dale Creek Canon opens onto an unseen valley "rich in a luxurious growth of grass, wild rye, barley, and other cereals of spontaneous growth." "All kinds of game" and herds of antelope who "fear not the sight of man" lurk out of sight in two photographs made near the Laramie River. Similarly unseen in other images are gold mines and a vein of oily shale that could burn with a "brilliant flame" capable of "illuminating the progressing work at night." The huge windmill in the town of Laramie might present a striking visual form, but Russell uses it to explain that it pumped ample amounts of water, "having never failed to supply the demands of the Railroad."[17] The pictures might depict a landscape that, to eastern eyes, seemed barren and empty, but these captions reimagine it as a landscape of promise. Could there be any doubt that this land was truly a Garden of Eden, with abundant food for the taking and rich mineral resources just waiting to be mined?

Reduced photographic reproductions of thirty of Russell's railroad pictures appeared in explorer Ferdinand V. Hayden's geological travelogue, *Sun Pictures of Rocky Mountain Scenery* (1870), and here, too, their conjunction with words served to shape and define readers' interpretations of the images.[18] Hayden explained that he used photographic illustrations "as the nearest approach to a truthful delineation of

A. J. Russell, *The Wind Mill at Laramie*. Albumen silver print, from *The Great West Illustrated* (1869).
Yale Collection of Western Americana, Beinecke Rare Book and Manuscript Library

nature," and chose carefully to "illustrate some peculiar feature in the geology or geography of that interesting country." The albumen photographic prints, glued down to boards and bound together at the end of the book where they would not interfere with the binding of the printed signature sheets, appeared in loosely geographical order, leading a viewer from Laramie to Salt Lake City, and concluding with two views of California. Hayden explained that this arrangement allowed the book to be used as a "guide by those who will avail themselves of the grand opportunities for geological study, which a trip across the continent affords to every intelligent mind."[19] The physical separation of the prints from related passages of text meant that their intended meanings were not as quickly ascertained as those of the pictures in the *Great West Illustrated*, where caption numbers were easily paired with numbered prints. But for

the attentive reader, the pictures did more than merely document "peculiar" geological features. They supported Hayden's arguments about the picturesque beauty of the rock formations, the abundance of game, the potential of the region's gold, oil, and coal deposits, the wealth of her timber resources. They underscored his argument that even in the arid West the desert could be "made to 'bud and blossom as a rose.'" The Mormons' theocratic state might pose certain political problems for the American people, but no one could argue with their success at creating self-sustaining agricultural communities in an arid land. "It is not the purpose of this work to present a history of the Mormon settlements or of their religion," Hayden wrote, defending his use of photographs of Salt Lake City. "Neither is it the object to criticize or find fault with any person or class of person. We can only say that we regard with great respect the Mormon

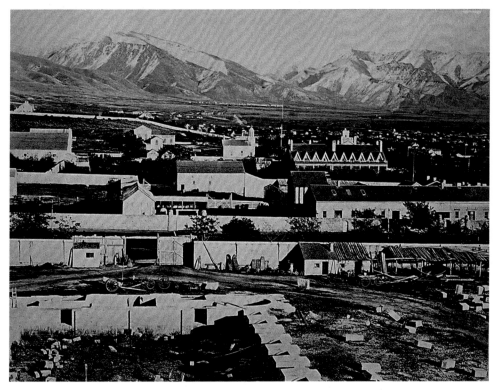

A. J. Russell, *Salt Lake City*. Albumen silver print, from F. V. Hayden, *Sun Pictures of Rocky Mountain Scenery* (1879). Yale Collection of Western Americana, Beinecke Rare Book and Manuscript Library

people for the sacrifices they have made and the industry they have exhibited in changing this desert into a beautiful garden."[20] His concern lay less with the Mormons' peculiar and, for many Americans, off-putting customs, than with their status as skillful cultivators of the soil. The strangeness of their religious beliefs paled beside their symbolic value as exemplars of frontier success.

During the 1870s, Russell's railroad photographs also reached the public as glass lantern slides, presented by the indefatigable Stephen J. Sedgwick in a series of illuminated lectures called "Across the Continent."[21] A former teacher turned academic showman, Sedgwick issued a catalogue in 1873 describing more than a thousand stereographic views, offered for sale either as mounted paper prints suitable for viewing in a handheld stereoscope or as glass lantern slides made for projection. Here, as elsewhere, he represented himself as a member of the "photographic corps of the U.P.R.R." But although he had traveled west in the spring of 1869 and again in the spring of 1870, he was never on the Union Pacific payroll; more likely, he had been a photographic assistant to Russell, or to two other photographers named O. C. Smith and J. P. Silva, who were likewise U.P.R.R. employees. In any case, his collection of photographs came from a wide variety of sources, including Russell and Hart.[22] Later, as he expanded his lecture repertoire to include scenes in Yosemite, San Francisco's Chinatown, and Yellowstone, and a fuller look at the terrain through which the railroad passed, he solicited pictures from photographers in Omaha, San Francisco, and Ogden, Utah.[23] By 1875, he had some two thousand different slides in hand with which to fashion his seven lectures that took audiences west from Omaha to California and on a tour through Yosemite, before giving them a quick glimpse of China (the world made newly accessible by the completion of the transcontinental railroad and steamship travel) and a final tourist's spin through Yellowstone, which had become a national park in 1872. Each lecture was "complete in itself," Sedgwick noted, but "the whole" was notable for the ways in which it showed "the Scenery, Indians, Animals, Vegetation, Geological Formations, Mormons, Mines and Amazing Structure of the Continental Railroad in a manner hitherto unattempted."[24] In exchange for his $100 fee ("no deviation"), Sedgwick would keep his audience "on 'double quick'" with a presentation lasting an hour and a half to two hours, "just as they like."[25]

Sedgwick was an educator, an entertainer, and a shameless promoter in the manner of some of his predecessors who had reached out to the public through moving panoramas. Indeed, his performances evoked the older entertainment medium, not just

in their combination of image and spoken word and in their theatrical venues, but in the very scale of the images themselves. The size of the projected images was "limited only by that of the room in which they are shown," Sedgwick crowed in a New York broadside.[26] And critics describing the illuminated lectures spoke of them in much the same way an earlier generation had described the moving paintings, as an experience preferable to that of overland travel itself. "Far more can be learned of the country from these lectures than by taking the ordinary trip over the road," proclaimed one reviewer. Sedgwick himself seemed cognizant of the panoramic model, noting that his manner of presentation allowed hundreds of people to see the images at once and to be led "from scene to scene, in their natural order, across the wonderful country termed our 'Great West.'" A leading travel guide, *Crofutt's Western World* (with which Sedgwick was briefly connected), evoked an even more direct comparison. The scenes in Sedgwick's lectures, it proclaimed, "are brought

280 Nights! Prof. S. J. Sedgwick's Illuminated Lectures Across the Continent. Broadside, c. 1873. Yale Collection of Western Americana, Beinecke Rare Book and Manuscript Library

home to the people as an ever-varying, gorgeous and life-like panorama."[27] Like the moving paintings, Sedgwick's presentation was part education and part entertainment, a beguiling mix of instruction and novelty.

Russell's railroad photographs thus reached audiences in a variety of new and familiar ways: as stereographs, as album plates and book illustrations, and as glass lantern slides incorporated into public entertainments that echoed the linear, narrative presentations of the popular painted panoramas. In each of these public formats, the relationship between image and text remained as interdependent as it had in the moving paintings. Even as photographs vivified and gave confirmation to the written and spoken word, they were simultaneously dependent on these words, incapable, alone, of ever being self-explanatory or of fully communicating complex narrative tales. In *The Great West Illustrated,* Russell had used words to assure his viewers that the Dale Creek Bridge was not only an engineering marvel, but spanned a creek filled with trout. Sedgwick took his cues from the photographer. When he converted Russell's photograph into a woodcut illustration for his catalogue of railroad views, he had his draftsman add both a hunter and a fisherman to the scene.[28] When wet-plate photography replaced daguerreotypy as the chief way of photographing the West, photographers, publishers, and writers alike gained new ways to put photographic images before the pubic eye; paper photographs were vastly easier to produce in quantity, to bind into books or albums, to publish with explanatory captions. But these paper photographs retained one of the features of their daguerrean predecessors: unless they had been altered in the darkroom, they could depict only what lay before the camera. As such they had limited flexibility as storytelling devices and sometimes failed to meet the needs of those who would use them. Hence the draftsman had to draw that fisherman, to help the viewer better imagine those marvelous trout.

In looking to the future, in suggesting through word and image that the railroad would bring settlers, wealth, and the material trappings of civilization to the nation's far West, the photographs of the transcontinental rail routes also conveyed a particular view of the past. Not, to be sure, a very specific one. For if the glorious future envisioned by these images was dependent on the technological conquest of distance and aridity, and the imagined capacity to mine the region's natural resources, it was also dependent upon a curiously blank notion of the region's human history. The great challenge of the far West, these pictures suggested, lay in the challenge that the physi-

cal environment presented to would-be settlers. Man would battle the elements. But there is scarcely any hint that he might also have to displace or battle or conquer other peoples. The notion of history conveyed in these photographs is thus oddly asocial, lacking in almost any sort of imagined or documented human dynamics. With such a blank slate to draw upon, it is no wonder that the American future could look so bright.

In *The Great West Illustrated,* for example, Russell showed how American engineering prowess could unlock the magnificent natural treasures of the West and make the nation's considerable mineral and animal resources available to all. Cuts could be made through solid granite mountains, new roads would stretch to the coalfields, bridges would cross those trout-filled streams. The land would yield to such technological wizardry. Nothing would be lost; everything would be gained. But what of the people who already used and inhabited the land across which the railroads would stretch? Russell did, on occasion, photograph Indian people he encountered in the field; indeed, he titled one of his views *Shoshone Indians on the Warpath*.[29] But Indians do not appear in *The Great West Illustrated,* and in Russell's more expansive stereo set they are consigned to series #15, "Groups and Indian Series," which lumps together an omnium-gatherum of western souls including Indians, tourists, railroad engineers, and Mormon bishops.[30] Aside from the pictures of railroad construction and the physical evidence of the Mormons' prosperity, the only allusion to the recent human history of the region in *The Great West Illustrated* is a passing explanation of how a scenic bluff called Death's Rock came by its picturesque name. As the album's annotated table of contents explains, a Mormon combatant in the Mormon War of 1857–8 had dared "one of his confederates" to take a shot at him. He did so, with fatal results. Thus, a tense standoff between federal troops and Mormon soldiers over the future of Utah's theocratic government was converted into a breezy anecdote, devoid of any hint of political or social conflict. Such deeply selective and anecdotal history marked the album's approach to the past; the West seemed a veritable tabula rasa of previous human interactions. It was the future that truly mattered.

In using Russell's photographs as illustrations in *Sun Pictures of Rocky Mountain Scenery,* geologist Hayden took the long view of history, emphasizing the value of the pictures as documents of geological change while professing indifference to the more recent past. For Hayden, the geologic features of the West were like an open book, affording the educated reader an opportunity to understand millions of years of geo-

logic history. But human history was of less concern. In writing about the towns that had sprung up along the railroad tracks, he noted that "it is not the purpose of this volume to chronicle the scenes of murder and pillage, which form a part of the early history of all these railroad towns." Promontory Point, just recently the scene of one of the great moments in the history of the nineteenth-century West, was "of interest to geologists, and to none others." Hence Hayden determined to move his travelogue along to Uintah or Ogden, where he might find more engaging stories. Indeed, he took such a long view of historic (and prehistoric time), he even speculated about a day in which the "geologist of the future" would "study and moralize over" the relics of nineteenth-century civilization, finding in the ruins of old city sites and the sediment deposited around river mouths "relics that will illustrate and explain the mingled comedy and tragedy of human life."[31] Hayden's elision of the recent past may have stemmed more from a true interest in geology than from a desire to please the railroad bosses, but the effect was the same. When the West could be won without displacing or oppressing other peoples, there was no reason for Americans to doubt that their Manifest Destiny led them westward.

Alexander Gardner engaged the past more directly, but he, too, glossed over the more complicated contests of nineteenth-century western history. In his 1867–8 series of views documenting the prospective route of the Kansas Pacific, he included photographs of Inscription Rock in western New Mexico and the nearby Zuni Pueblo; each glued to a mount imprinted with the words of a sixteenth-century Spanish explorer.[32] Although both pictures thus alluded to events in the distant past, neither acknowledged the complicated string of events by which political control over this region had passed from Native American to Spanish to Mexican to American hands, and they thus abetted the creation of a kind of selective memory. So, too, did Gardner's pictures of Indian subjects. In his pictures of the Pottawattamie Indian School at St. Mary's Mission in Kansas, and in his four images of Mojave Indians living in and around Fort Mojave, Arizona Territory, Gardner glossed over a history of contested cultural relations to imagine a future of cultural assimilation. The very title of his picture, *The Two Races, at Fort Mojave, Arizona*, seemed to hint at essential cultural differences, but the image of a young Mohave girl, standing somewhat awkwardly off to the side behind an American military officer, his well-dressed wife and their two fair-skinned children, instead spoke to the civilizing and domesticizing possibilities of American culture. The child's western dress and her inclusion in the group portrait testified to her special sta-

tus as a member of the military household and to the possibility that her adult world would be different from that represented by the bare-breasted women in the other Mojave photographs.[33] On the mount of the final picture in his series—a photograph of the Seal Rocks off the coast of San Francisco—Gardner appended a Shakespearian quote, "Last scene of all in this strange eventful history." But precisely what was strange or eventful about it, he never revealed. Like Russell, he had constructed with his railroad photographs a visual narrative about a new western world that *would* be: how

Alexander Gardner, *The Two Races, at Fort Mojave, Arizona*. Albumen silver print, 1867–8. John D. Perry Collection, Missouri Historical Society, St. Louis

Americans would get there (in anything beyond the most literal sense of hopping a railroad car), like the cost of getting there, remained unexplored.

"The past has but little hold" on all the new communities springing up in the West, the journalist E. L. Godkin had written in 1864. "The West . . . has inherited nothing, and so far from regretting this, it glories in it. One of the most marked results of that great sense of power by which it is pervaded, is its strong tendency to live in the future, to neglect the past. It proposes to make history, instead of reading it."[34] In like fashion, despite its seeming utility as a tool of documentation, photography became, in the hands of the railroad photographers, a predictive medium, a way of visualizing events that had not yet unfolded. In telling their visual stories about a western future, the photographers not only satisfied the economic agendas of their corporate patrons, they catered to the popular taste for an imagined West, just as the panorama painters had done a decade before. In a recently reunited nation weary of history, they pictured a West without history, invented a place that would be the site of national healing. In taking only a glancing look at the human history of the region, in imagining it as something akin to a social tabula rasa where man was pitted against the environment rather than against his fellow man, these photographers fell squarely within the predominant strain of American popular thought.

As the rail lines slowly snaked their way across the continent in the years following the Civil War, the federal government revived its own practice of western exploration, resuming the process of exploring and mapping the West that had been in place since the early nineteenth century. The earlier federal expeditions had generally concentrated on simply finding a way across the continent; by contrast, these more comprehensive postwar surveys built upon existing geographical knowledge to focus on cataloguing the region's resources. Their purpose was not merely to chart routes of travel (of less importance now that some survey teams could even travel much of the way to their destination by rail), but to show Americans how they might inhabit and *use* the western landscape.[35] Highly trained civilian scientists largely replaced the gentlemen-soldiers of the earlier expeditions, detailed and illustrated scientific treatises supplanted the simpler travel narratives of the earlier era, and photographers became as essential for the production of useful knowledge as topographers, geologists, or naturalists. Testifying before a congressional committee on public lands in the spring of 1874, Ferdinand Hayden, the leader of an ambitious government survey of the Rocky

Mountain west, explained that photographs had proved crucial to his project, simultaneously providing scientific documentation and a means of communicating his work to a broader audience. "We have found them most essential in the preparation of our geological reports and maps, and we have also found them to be very attractive to the public," he said. "These photographic views are used in schoolbooks, journals, &c., and the demand for them for the purpose of engraving is very great. We all know that it is through the eye that we acquire most of our knowledge, and these pictures help the eye very much, giving, as they do, clearer conceptions of mountain forms than pages of description could do."[36] What the photographs would lay out before American eyes, however, was not just the West's topography but a visual story that affirmed and expanded the central fictions of nineteenth-century western history.

Two decades earlier, John C. Frémont could only have dreamed of having such broad avenues of distribution for the daguerreotypes made by Solomon Carvalho on his own exploring trip through the Rockies. Now, technological innovations in picture making and new conventions of photographic publishing made possible what no amount of personal ambition could have done before. Paper photographs could enter into public circulation in ways that daguerreotypes simply could not; multiple copies could be produced for sale, for exhibition, for distribution to illustrators and printmakers. They could more readily circulate as physical objects, seeming "originals" that afforded viewers a more immediate encounter with a distant landscape than any sort of redrawn lithograph could provide. As Hayden wrote in 1877, "Twenty years ago, hardly more than caricatures existed, as a general rule, of the leading features of overland exploration. . . . The truthful representations of photography render such careless work so apparent that it would not be tolerated at the present day."[37] The relative ease with which photographs could be reproduced, distributed, and physically linked with descriptive (and sometimes partisan) words gave Hayden and his contemporaries a broad array of options for pressing their cause.

The four ambitious multiyear survey projects that operated in the far West between 1867 and 1879, when the government consolidated the often competing projects under the aegis of the newly created United States Geological Survey, proved generous institutional patrons for the production of landscape photographs. Under the operational umbrella of the War Department, the civilian scientist Clarence King led the United States Geological Exploration of the Fortieth Parallel, and army Lieutenant George Montague Wheeler commanded the United States Geographic Surveys West

of the One Hundredth Meridian. Working through the Department of the Interior, Hayden led the United States Geological and Geographical Survey of the Territories, and the one-armed Civil War veteran John Wesley Powell directed the United States Geographical and Geological Survey of the Rocky Mountain Region. As the similar titles for the surveys suggest, and the multiple commands and institutional organizations all but assured, the survey teams not only competed for federal funds, they also competed in the field. Wheeler and Powell both explored the Grand Canyon region; King's broad swath across the fortieth parallel bisected territory surveyed by Hayden and Wheeler. With each survey contingent upon annual congressional appropriations for the continuation of its work, it is no wonder that the survey leaders sometimes eyed one another warily. "Cannot hear a word of Wheeler's movements," photographer William Henry Jackson reported from Washington to his boss, F. V. Hayden, in September 1876, "and of Powell only that he is here a portion of the time at work on his Indian books."[38]

Photographers were key figures on each of the survey crews. Timothy O'Sullivan and, briefly, Carleton Watkins worked for King. Wheeler subsequently employed O'Sullivan for three seasons, and William Bell for one. William Henry Jackson spent nine years working for the Hayden survey, picturing Yellowstone and the dramatic topography of the Colorado Rockies. Powell employed a succession of photographers for his surveys of the Colorado plateau region, beginning with E. O. Beaman and ending with John K. Hillers, a boatman who learned photography in the field and eventually rose to become the chief photographer of the United States Geological Survey.[39] Though each photographer's pictures served as documentation of and propaganda for a particular survey's scientific and political agenda, as both separate and collective bodies of work, the photographs express a relatively coherent point of view. If the published railroad photographs of the late 1860s were simultaneously about the physical process of railroad building and the imagined future of the American nation, the landscapes made by the survey photographers likewise looked to the future even as they documented the very process of exploration. Like the railroad photographs, they pictured the western landscape as simultaneously awe-inspiring in its grandeur and immensity, and as malleable, ready to bend to the iron will and technological prowess of the American people. And like the railroad pictures, they presented a version of American history that was curiously blind to the struggles between and among peoples in the American West of the nineteenth century. If the survey photographers paid

somewhat more attention to Indian life than the railroad photographers had, it in part reflected their status as government photographers, employees of the very agencies charged with executing federal Indian policy.

Although the postwar surveys built upon the foundation of geographical knowledge developed by an earlier generation of topographers and explorers, the photographers remained essentially unaware of the visual record created by their predecessors of the 1840s and '50s.[40] It was hardly surprising; these early western photographs had never found a public audience, even among the Washington government and military officials most concerned with the expeditions' findings. But thanks in part to a receptive climate of interest, and in part to the new technologies and conventions of photographic picture making, the western survey photographs of the 1860s and '70s found an instant market. Distributed in stereograph sets and deluxe albums, redrawn for illustrations in the popular press and in official government reports, hung in public places, and distributed as propaganda to members of Congress, these pictures brought dramatic scenes of the remote West into parlors across the nation and introduced audiences around the world to the distinctive features of America's wonderland. These were no imagined scenes, no fanciful renderings from an artist's pen. Here were photographs of Colorado's snowy peaks and the dizzying depths of the Grand Canyon, Yellowstone's geysers, and the limitless expanses of the arid Southwest. Such pictures, Hayden argued, were "a real contribution to science as well as to landscape photography"; they represented the very best of America's natural wealth.[41] In an era consumed with the bitter factionalism of Reconstruction, these pictures of the West represented an alternative vision of America, not one fettered by the legacy of conflict, but one of boundless resources, unending wonders, and limitless possibilities for the remaking of the American nation. Through these pictures, countless Americans truly visualized the West for themselves for the very first time. And in these pictures, American photography itself seemed to discover its most distinctively national subject.

In the 1930s, as historians first began to write a coherent linear story of the development of photography in the United States, the survey pictures garnered praise for two distinctive reasons: their value as an accurate historical record of the "frontier scene," and their contribution to what photohistorian Beaumont Newhall and photographer Ansel Adams argued was a uniquely American esthetic, emphasizing clear, straightforward description of the physical world.[42] When he included Jackson, O'Sullivan, and Watkins in the show he organized for the Golden Gate Exposition in

San Francisco in 1940, Adams explained that "the work of these hardy and direct [western] photographers indicated the beauty and effectiveness of the straight photographic approach. No time or energy was available for inessentials in visualization or completions of their pictures." Their work, Adams wrote, "has become one of the great traditions of photography."[43] Over the past thirty years, survey photographs have been valorized by a burgeoning photographic art market and museum exhibition industry, and lauded as signal achievements of a "golden age of landscape photography."[44] Under increasing pressure from the marketplace, albums have been broken up; photographs once meant to be encountered in series or with interpretive texts have been matted, framed, and asked to bear the weight of new stylistic and cultural arguments.

Survey photographs, however, were never meant to stand as independent works of art. The vast majority were issued with printed texts and marketed in series that enabled them to narrate stories about the western landscape and America's western future. In the engineering section of the 1876 Centennial Exhibition in Philadelphia, for example, fourteen photographic "landscape views" from the Wheeler survey hung as works of art, mounted in frames and displayed on the walls beside some related watercolor drawings. On view with them, however, were two bound photographic albums from the survey, the first with fifty photographic views covering the years 1871–3, and the second with twenty-five pictures from 1871–4. In this latter volume appeared nearly all of the framed photographic images, paired with lengthy printed legends that explicated their importance to the Survey's mission. Adapted versions of these captions appeared in a subsequent exhibition catalogue (and perhaps on the walls themselves), guiding the viewer's interpretation of the pictures, making the case for the essential beneficence of the western landscape, clarifying that it had been newly cleared of Indian threats, and arguing for the potential attractions of the West as a site for both settlement and tourism. The two sets of carefully sequenced and captioned stereographs on display narrated a similar story about the region's potential as both a source of natural wealth and a market for American manufactures, a place where the nation's political destiny would unfold.[45]

Certainly, the collected survey pictures are not resistant to stylistic analysis. A discerning viewer can pick out stylistic markers that distinguish the photographs of Carleton Watkins from those of William Henry Jackson or find in any number of landscape photographs evidence of the formal concerns with light or form or composition that marked contemporary painting of the period. But to begin to understand how these photographs

functioned in their own time, how they reiterated and conveyed ideas about the West to a broad audience, how they helped secure for photography a firmer status as a medium of visual communication, it is important to look at how they came to public attention in the 1860s and '70s. Contemporary viewers would have been most likely to encounter them in series, in albums, or in books, bound up with and mediated by words penned by the survey leaders or their employees. The vagaries of time and collecting practices have broken up many of these serial sets and albums of survey photographs, separating images from the words that once described and clarified their intended meanings. But enough survive to make it possible to reconstruct some of the narratives of western history these pictures once told, and to glimpse how they once functioned as potent tools of politics and culture in late-nineteenth-century American life.

Meaning in nineteenth-century western landscape photographs is a slippery concept. At what point is it created? Is it when the photographer frames the scene and removes the cap from his camera lens; or later, either in the field or back in an eastern studio, when he prints his negative and produces a photograph? Given that the picture has no capacity to communicate ideas until it is seen by other people, one could argue that meaning does not really adhere to the image in a more concrete way until the photograph is published, affixed to a printed mount, labeled, captioned, and cast forth into the marketplace. Making meaning contingent upon artistic intent is particularly problematic with western survey photographs for several reasons. First, in the absence of literary evidence it is hazardous to impute intention based upon our own twenty-first century reading of nineteenth-century pictures. Second, there are numerous problems of attribution with the photographs, stemming from the practice of swapping negatives in the field, or combining the work of several uncredited photographers into a single series of work.[46] And third, by the time these photographs found a public audience they were no longer simply the production of the original photographer. They were corporate productions whose appearance might betray the involvement of a number of hands. In 1872, for example, John Wesley Powell contracted with Hayden survey photographer William Henry Jackson to make some 4,288 stereographic prints from negatives made by the Powell survey photographer, E. O. Beaman. Powell subsequently contracted with at least two different companies—J. F. Jarvis in Washington, D.C., and William B. Holmes in New York City—to publish his survey views.[47] Who actually wrote the descriptive captions affixed to the stereo mounts is unclear, but as much as anything, these captions carried the weight of descriptive labor, naming the scene,

sometimes describing its location, sometimes playfully labeling a genre scene so as to shape a viewer's interpretation of the Indians or survey members shown in the picture. Lieutenant Wheeler's survey pictures were likewise joint productions. In the spring of 1874, Timothy O'Sullivan set to work printing stereos and larger views from his own Wheeler survey negatives. The New York lithographic firm of Julius Bien & Company produced the mounts for the large prints; Collins, Son & Company printed the stereograph mounts; and the Government Printing Office printed the captions for the mounted pictures.[48] Within this collaborative project it is again hard to identify precisely who actually wrote the descriptive captions appended to the backs of the stereos, or the lengthy legends included in some of the deluxe albums of Wheeler survey photographs. Given the expense and public visibility of the work, however, one might assume that Wheeler approved and endorsed the captions, even if he did not directly pen them himself. And such words were critical; they shaped and gave very specific meanings to landscape pictures that might otherwise support any number of speculative interpretations.

Consider, for example, the six different kinds of photographic albums issued by the Wheeler survey, only three of which were printed in editions of any size.[49] The two different albums documenting the seasons of 1871–3, one with twenty-five prints, the other with fifty, contain no descriptive text. But the text in the volume of twenty-five prints chronicling the 1871–4 seasons provides the key to understanding the logic of all the albums and gives us a clue as to how Wheeler understood the photographs produced under his watch.[50] The pictures in the album—taken by O'Sullivan during the 1871, 1873, and 1874 seasons, and by William Bell in 1872—are affixed to survey mounts, imprinted with the Army Corps of Engineers' logo, the name of the expedition, the identity of the photographer, a title, and a number giving its order within the album sequence. Printed "descriptive legends" are bound into the album between prints; the reader encounters a description of a view before turning the page to see it. And so, before looking at the first photograph, a view that looks out across one mountain slope to two other snow-covered slopes in the distance, one is instructed as to how to understand it. As with the railroad pictures, what is most important here remains hidden from view: the caption explains that deep in a canyon where the camera cannot peer there lies a silver mine. This caption accompanying the picture of the Bull Run Mountains in Nevada thus hints at the West's potential, even as it underscores that the region remains at a somewhat incomplete stage of development. The survey crew members

had reached the point at which the picture was made with "great difficulty and danger in the deep fields of snow." Within the snowy fastness of the mountains, "the inefficient means of transportation" also hampered the work of the miners who simply had to hunker down and wait for better weather before they could transport their ore.

The opening caption of the album thus introduces some of the central themes of Wheeler's work. As an army man, Wheeler was a bitter rival of the three civilian scientists—King, Hayden, and Powell—who were leading the other western surveys. Wheeler insisted that his survey would be more practical. While the scientists' maps were "controlled by the theoretical considerations of the geologists," his army maps would stress "astronomical, geodetic, and topographic observations."[51] His reports would steer away from abstract science to focus on useful information for the establishment of still more roads and rail routes and examine in detail the exploitable economic resources of the country "to meet the wants of those who at some future period may occupy or traverse this portion of our territory." Accordingly, he would also need to give some attention to the habits and customs of the Indians he encountered on his travels, assessing the extent to which they might prove an impediment to settlement.[52] It was less a keen ethnographic interest on his part than a practical move aimed at reassuring prospective immigrants.

In pressing the case for the utility and merit of his survey, Wheeler also stressed the heroism of his men, a message that could sometimes seem at odds with the visual content of the images that he used to convey his argument. The second and third photographs in the album are O'Sullivan views of Black Canyon, a site that Wheeler and his 1871 crew traversed during a harrowing two hundred mile trip *up* the Colorado River, rowing, pulling, and sailing their modest boats against a swift current. Like a number of the other views that O'Sullivan made at the site, both pictures include a member of the survey team seated in thought; in one view the figure looks out at the water, in another he hunches over his notes in a boat that sits tied to the shore. The pictures convey a deceptive air of calm, for the relatively slow exposure times of a wet-plate camera represent the rushing water as a sheet of pacific stillness. The pictures (like all photographs, of course) represent an abstraction of experience; no sound here, no motion, no smell, feel, or color vision. In the Black Canyon pictures, one modern-day art historian argues, "man is presented as cerebral and reflective in the face of nature, an unobtrusive presence rather than a vehicle for dramatizing a confrontation with the sublime."[53] But such a subjective reading reveals nothing about O'Sullivan's

intent (undocumented), Wheeler's ambitions (revealed in the album), or contemporary audiences' reading of the pictures; it instead illustrates the ways in which nineteenth-century photographs, unmoored from their original dockings, can become free-floating and ahistorical images, made to mirror the interests of latter-day critics. In Wheeler's album, the Black Canyon photographs serve to establish the physical challenges of survey work. The cliffs are "too steep to be scaled," the canyon is bathed in "sombre shadows which are perpetual in its depths," and it is hard to find a beach "commodious

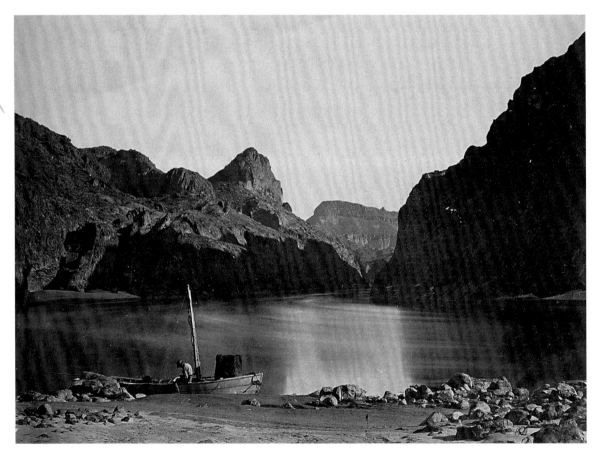

Timothy O'Sullivan, *Black Canon, Colorado River, From Camp 8, Looking Above*. Albumen silver print, 1871, from George M. Wheeler, *Photographs . . . Obtained in Connection with Geographical and Geological Explorations and Surveys West of the 100th Meridian* (1874). Yale Collection of Western Americana, Beinecke Rare Book and Manuscript Library

enough for the explorer's camp." Wheeler uses O'Sullivan's pictures to visualize "the impossibility of easy navigation on this river," the "perils and fatigues encountered on this journey," the "arduous and hazardous" labor of his trip. The words limit the viewer's imagination in one regard, cautioning him against reading the picture as a picturesque idyll amidst a calm and scenic landscape; but they expand it in another, encouraging him to imagine the physical travails of the photographer and his fellow explorers. They are key to the creation of a public meaning for these pictures, making the pictures part of an epic adventure narrative in which heroes struggle against tremendous obstacles to lay the path that American civilization will follow.

The words in the album likewise do the labor of making the strange and unfamiliar landscape of the desert southwest a place more familiar, if not quite hospitable, to eastern Americans. Hence a saguaro cactus, the *cereus gigantus*, is introduced as a plant whose fruit supplies an important food source to both Indians and birds. A picture of scenic Apache Lake in the White Mountains of Arizona is offered as proof that "Arizona, in its entirety, is not the worthless desert that by many it has been supposed to be." Canyon de Chelly is described as a place whose canyon soil supports the raising of corn, melons, peaches, and vegetables. In thus presenting the southwest as a place of rich resources and unlimited opportunity for the prospective settler, Wheeler must also establish that the region's long-standing residents pose no threat to American expansionism. And so he uses an image of *Cooley's Park, Sierra Blanca Range, Arizona*, a picture of a tree-framed clearing with several small-scale ranch structures, to the left, to explain the subjugation of the Apache peoples, an improbable historical argument to be made with a landscape photograph. "It is only within the last few years that the whites, except in large bodies, have been able to enter the Sierra Blanca region, on account of the hostile Apaches who were at home there," the descriptive legend explains. But since their subjugation by General Crook in 1873 (the very year the picture was made), they have been confined to reservations like the one pictured in the photograph and "instructed in the various arts of peaceful self-support." In a similar fashion, Wheeler uses a landscape photograph of the Conejos River Valley in southern Colorado to explicate recent historical developments. "Hitherto the settler has been deterred from entering this promising district by fear of the Ute Indians, from whose power it is now reclaimed," the caption explains, "and when visited, in 1874, it did not possess any permanent inhabitants, and used only by the Mexicans of the Rio Grande, who were in the custom of driving their herds hither for the summer season." Imagina-

tively confining the Indians to reservations and dismissing the region's longtime Hispanic settlers whose seasonal patterns of land use seemed so at odds with those of Anglo-Americans, Wheeler thus depicted a world safe for American immigration and full of promise. In words and pictures he was laying down a selective memory of the western past. If he had to concern himself with the *has been,* it was only to better establish the *will be.* The human history of the region mattered only to the extent that it had been effectively erased.

The meanings that Wheeler created for the photographs in his album were situationally dependent; that is, they depended on the conjunction of text and image and did not necessarily adhere to the images when they reappeared in other contexts.

Timothy O'Sullivan, *Apache Lake, Sierra Blanca Range, Arizona.* Albumen silver print, 1873, from George M. Wheeler, *Photographs . . . Obtained in Connection with Geographical and Geological Explorations and Surveys West of the 100th Meridian* (1874). Yale Collection of Western Americana, Beinecke Rare Book and Manuscript Library

Timothy O'Sullivan, *Cooley's Park, Sierra Blanca Range, Arizona*. Albumen silver print, from George M. Wheeler, *Photographs . . . Obtained in Connection with Geographical and Geological Explorations and Surveys West of the 100th Meridian* (1874). Yale Collection of Western Americana, Beinecke Rare Book and Manuscript Library

Thus, in his album Wheeler uses an 1873 O'Sullivan photograph of four Navajo Indians gathered around an outdoor loom to argue for the Navajos' docility. These are "an intelligent and fierce people by nature," he explains, who have made "good progress towards civilization" since their defeat by U.S. troops in 1859–69. Now they are talented weavers and shepherds, "raising enough of grain and vegetables to satisfy their own needs." Linked to these words, the picture affirms the self-sufficiency of the Navajo people and offers proof that prospective settlers would find them independent and industrious neighbors, which is precisely what Wheeler, himself a proponent of American expansionism, wanted to demonstrate. When Wheeler's photographic album appeared in 1876, as the American military continued to battle Indian tribes on the northern Plains and to skirmish with the Apaches in the far Southwest, prospective

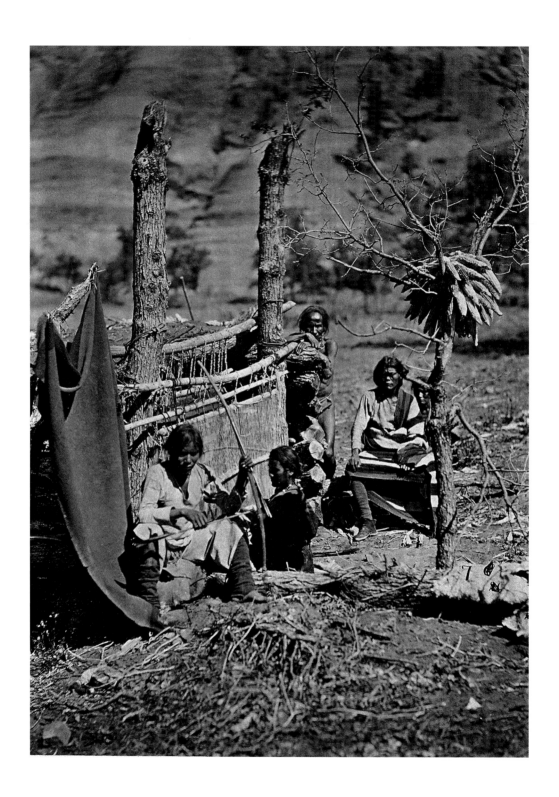

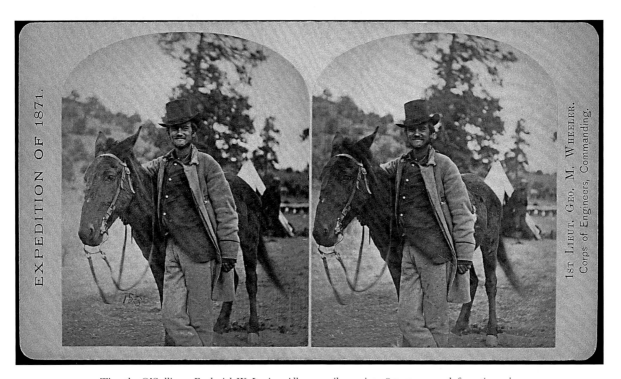

Timothy O'Sullivan, *Frederick W. Loring*. Albumen silver print, 1871, stereograph from the series *Geographical and Geological Explorations and Surveys West of the 100th Meridian.* Yale Collection of Western Americana, Beinecke Rare Book and Manuscript Library

settlers did, indeed, need to be reassured about their safety. But by 1889, when Wheeler included a lithographic variant of the Navajo picture in his published report, the political and military climate had changed, and Wheeler wove a different web of words for the image. Now the Navajos were merely quaint figures, dependent on government rations, whose glorious past had long since disappeared. And words that had once depicted them as industrious farmers now portrayed them as exotic anachronisms.

Timothy O'Sullivan, *Aboriginal Life Among the Navajoe Indians*. Albumen silver print, 1873, from George M. Wheeler, *Photographs . . . Obtained in Connection with Geographical and Geological Explorations and Surveys West of the 100th Meridian* (1874). Yale Collection of Western Americana, Beinecke Rare Book and Manuscript Library

"The head and lord of the family looks on with phlegmatic equanimity at the patient industry of the squaw and indulges in day dreams, undoubtedly of war or excitement of the chase, performed by him or his ancestors."[54] As Wheeler's needs for the picture changed, his descriptive interpretations changed, and in the absence of other evidence one can only surmise that public understanding of the images shifted accordingly.

Words functioned somewhat differently to retrospectively reconstruct the meaning of O'Sullivan's stereographic portrait of Frederick Loring, a young man O'Sullivan had photographed in early November 1871, shortly before starting east for Washington with the negatives from the Wheeler survey's first season of work. Loring was the son of a prominent Boston family, ostensibly traveling with the survey as a kind of general assistant but really there to act as a publicist. About the same time O'Sullivan started east, Loring boarded a stage near Fort Mojave, heading west toward San Bernardino. On November 5, some forty hours after he had posed for his picture, he died, the victim of an Indian attack. A portrait made at a moment of high hopes, as Loring set off to publish articles about his adventures with the survey, became almost instantly a picture that narrated the continuing travails of southwestern life and argued for continued military intervention in the region. Printed words appended to the back of the stereo explained that Loring, who "gave promise of becoming one of the most facile of American literary writers," had been "brutally murdered by Apache Mohaves."[55] His place in history was thus fixed not by the enthusiasm evident in his photograph, but by the elegiac words appended to its back.

Because words had the capacity to freight pictures with meanings, to shape and control the sorts of literary and historical narratives that images could tell, it was often not the subject of the image that conveyed a message, so much as the words that directed viewers how to read it. And these words could send conflicting messages. Consider, for example, the photographs that Timothy O'Sullivan made of Shoshone Falls in Idaho; in 1868, while employed by Clarence King, and again in 1874, while working for the Wheeler survey. O'Sullivan made a total of twenty full-plate and more than thirty stereoscopic views of Shoshone Falls, more pictures than he made of any other western site. On both trips, he circled the falls and photographed them from different angles, moving in close and pulling his camera back to show the Snake River Canyon. The views of 1874 proved to be the last western pictures he would ever make.

In an article published in 1869, O'Sullivan noted that "below the falls, one may obtain a bird's-eye view of one of the most sublime of Rocky Mountain scenes." And

from an island above the falls, he assured his readers, "you will certainly feel sensible of the fact that you are in the presence of one of Nature's greatest spectacles as you listen to the roar of the falling water and gaze down the stream over the fall at the wild scene beyond."[56] Instead of the glorious scene that O'Sullivan described in what is essentially the only surviving literary record of his response to the western landscape, Clarence King saw the falls as a repellent, churning inferno. King was a believer in the scientific theory of "catastrophism," which held that sudden catastrophic changes in the natural environment—rather than the slow, gradual processes of evolution—were responsible for the Earth's changing life forms. In the black gorge, steep canyon walls,

Timothy O'Sullivan, *Snake River Cañon. Idaho. View From Above Shoshone Falls*. Albumen silver print, 1874, from George M. Wheeler, *Photographs . . . Obtained in Connection with Geographical and Geological Explorations and Surveys West of the 100th Meridian* (1874). Yale Collection of Western Americana, Beinecke Rare Book and Manuscript Library

and pounding waters of Shoshone Falls he saw unsettling reminders of God's terrible wrath. "After sleeping on the nightmarish brink of the falls," King wrote in a popular book about his western adventures, "it was no small satisfaction to climb out of this Dantean gulf and find myself once more upon a pleasantly prosaic foreground of sage."[57] King was a gifted writer and the most literary of the survey leaders, but he never wrote direct captions for O'Sullivan's photographs. With his pen, he responded to the sites the pictures depicted, but not to the pictures themselves.[58]

O'Sullivan's Shoshone Falls photographs of 1874 visually echo the views he made for King in 1868, with the picture made above the falls taken from a nearly identical vantage point just a few steps closer to the water. But in Wheeler's annotated 1876 album, the Shoshone Falls photographs appear with descriptive captions that co-opt them for a quite different visual narrative. To Wheeler, the site compared favorably to Niagara Falls, the most popular American symbol of nature's grandeur. While King could not wait to escape the mad inferno of the falls, Wheeler thought "without doubt it is destined to become, in time, a favorite place of summer resort for the tourist and artist," and he offered travelers directions from the nearest railroad line. Indeed, he concluded his album with four O'Sullivan photographs of the site and used the final image, *Snake River Cañon, Idaho. View from Above Shoshone Falls,* to create a climactic ending for his forward-looking tale of western exploration and settlement. The river flows through an area, he tells us, that "has been freed from the terror of hostile Indians" and can now be used for hunting and grazing. Using words to make visible the unseen, he underscores the beneficence of this site by describing the gold diggings miraculously renewed "by the agency of the river" and a magnificent eagle's nest perched high on a boulder just above the falls. If his words vivify the photograph, they simultaneously underscore its inability to carry the weight of Wheeler's argument without the directive clarity of the accompanying language. The photograph alone might spark any number of ideas in a viewer's mind; in conjunction with words, however, it seemed to do Wheeler's bidding.

This sense that survey pictures could be retrospectively reimagined as a part of a cohesive argument is nowhere better illustrated than in the series of catalogues of Hayden survey photographs published by the team's photographer, William Henry Jackson.[59] Jackson published his first catalogue of views in 1871, following his first season of work for the Hayden survey in 1870. The expanded 1873 edition included some thirteen hundred landscape views, the 1875 version more than two thousand. "The increasing interest in and demand for the more striking views," Jackson wrote in the

1875 edition, "calls for a complete description of the collection," supplied here with excerpts compiled from Hayden's annual reports. The greater part of the subjects, Jackson argued, "had never been taken, and probably will not be for many years to come, or until the country has advanced into civilization. By no other means could the characteristics and wonderful peculiarities of the hitherto almost unknown western half of our continent be brought so vividly to the attention of the world." That the pictures were much appreciated, he said, was evident from "the demand for them, from all quarters of the globe."

Though Jackson's 1875 catalogue is titled *Descriptive Catalogue of the Photographs of the United States Geological Survey of the Territories, for the Years 1869 to 1875, Inclusive,* it opens with a listing of pictures Jackson made in 1869 before he even joined the Hayden survey. That summer Jackson, then the proprietor of a photographic business in Omaha, traveled west to photograph along the recently completed Union Pacific Railroad. He intended to bring some of the negatives back to Omaha to print and sell. But because he also hoped to make money in the field, he took pictures of railroad crews that he could print up and sell on the spot, produced photographs of hotels and other commercial establishments that he could peddle to local businessmen, and even made twenty prints of the women at Madame Cleveland's Cheyenne brothel to sell to the women themselves.[60] The frankly commercial pictures acquire a somewhat different significance, however, in the catalogue of survey views (which did not include Madame Cleveland's employees), where they lay out a way the West could be accessed and experienced by casual travelers. Hewing close to the sites already photographed by A. J. Russell (a logical consequence of traveling west on the same rail line), Jackson argues similarly for the potential utility of the landscape and the civic possibilities represented by the Mormons' achievements in Salt Lake City. Indeed, some of the language in his captions is pulled directly from the words Hayden had written to explicate Russell's photographs in *Sun Pictures of Rocky Mountain Scenery* some five years earlier. Russell's and Jackson's photographs—each made for the photographers' own entrepreneurial purposes—thus end up caught in the same web of words, transformed into illustrations that support Hayden's own ends. As the photographer's own voice is silenced, the captions make the pictures interchangeable representations of the same idea.

The survey pictures themselves, representing five years of fieldwork with Hayden, are organized by year and further subdivided by format. Each image thus finds its

own place within the larger project of the survey, and anyone ordering a print from the catalogue could see how that individual picture fit into the bigger story. Jackson is coy here on the issue of authorship. He acknowledges that some of the Yellowstone photographs are by Bozeman photographer J. Crissman, but fails to note that some other pictures in the catalogue were acquired from Salt Lake City photographer Charles Savage.[61] It was less an incipient sort of plagiarism on Jackson's part, a way of hoping that readers would assume unidentified pictures were his, than a reflection of the ways in which the overall content of the project was more important than issues of artistic identity or authorial intent. Indeed, the confederacy of western landscape photographers was a close and congenial one (despite the rivalry of the expedition leaders), and the swapping of negatives was not uncommon. He and O'Sullivan "traded many a negative" during their days with the Hayden and Wheeler surveys, Jackson told photocurator and historian Beaumont Newhall more than sixty years later.[62] Why climb a mountain to take a view if someone had already done it for you? In like fashion, Savage had been happy to accept from A. J. Russell some negatives of railroad-related sites he had been unable to photograph for himself.[63] The assembled body of visual knowledge mattered more than the authorship of any one view.

In his presentation of the Yellowstone views from the 1871 and 1872 survey seasons, Jackson describes the region much as Hayden, the survey's leader, does—as a wonderland of fantastic geysers and waterfalls, spectacular canyons and dramatic vistas, made comprehensible to readers through analogies to "castles," "temples," and other man-made forms. The pictures lead the reader from sight to sight, laying out Yellowstone as a series of consumable vistas, an approach still echoed in the park's carefully plotted roads, vehicle turnouts, and photographic viewing points. In Jackson's captions, Yellowstone's past is measured in geological time, an emphasis that reflects Hayden's scientific training and approach to survey work. But there is more at play here than an interest in geologic phenomena. If Wheeler had to dispatch with Indians in order to argue for the benignity and safety of the southwestern landscape, Jackson and Hayden had to ignore them in order to construct Yellowstone as a pristine wilderness, a wonderland that had never felt the shaping hand of man.

Hayden and his men were, in fact, not the only people wandering about the Yellowstone region in the early 1870s. Small bands of Shoshone people moved seasonally throughout the region, gathering food and important medicinal plants. The Mountain Crow wintered just north and east of the park boundaries, and viewed the parkland as

William Henry Jackson, *Great Falls of the Yellowstone*. Albumen silver print, c.1871–3, from *Photographs of the Yellowstone National Park and Views in Montana and Wyoming* (1873). Yale Collection of Western Americana, Beinecke Rare Book and Manuscript Library

an important piece of their homeland, critical for hunting game.[64] In the early writing about the region, and in the material presented to Congress in early 1872 in support of the legislation making Yellowstone America's first national park, long-standing Indian claims to the region and any reference to various tribes' continuing use of the region's resources were ignored. Indeed, in popular writing about the region, Indians were widely represented as fearing the region with its bubbling pools of scalding mud and fearsome geysers spewing water and steam.[65] But such claims can only seem a willful misreading of the past. The so-called Washburn expedition party of 1870 actually used Indian trails to traverse Yellowstone, found evidence of recent habitations and game runs, and posted a nighttime watch to guard against Indian attack, before one of its members wrote a story for *Scribner's Monthly* that popularized the myth of the Indian absence from the region.[66] In 1871 and 1872, Jackson himself photographed nomadic Indian groups not far from the boundaries established for the park.[67] In the American future visualized by Jackson's photographs, however, there was no room for an American past. In service to larger political and social ends, his photographs erased an Indian presence from the Yellowstone.

As the first widely distributed photographs of Yellowstone, Jackson's pictures quickly gained a kind of authority as documents of the region's fantastic topography and unique geothermal features. If they were not, as has often been written, *the* decisive factor in the congressional decision to set Yellowstone aside as a national park in March 1872, they were nonetheless embraced by congressmen as part of a package of literary and physical evidence testifying to the region's wonders.[68] In short order, they circulated in a variety of ways: as original photographic prints sold through the survey itself, with a logic and order dictated by the various iterations of Jackson's published catalogues; as deluxe photographic albums (some with original prints, others with elaborate Albertype reproductions) issued with descriptive captions; and as images redrawn for engraved illustrations in such popular publications as *Scribner's Monthly* and the *Illustrated Christian Weekly.*[69] Jackson's photographic series "well illustrates the advantage of photography over any hand-drawings in bringing out details of structures," the Yale geologist James Dwight Dana argued in 1873. Indeed, he said, the pictures of geothermal formations "may be studied with much of the satisfaction to be had from actual examination."[70] While Dana read the pictures as scientific documents, viewers of Jackson's elaborate thirty-seven-print album, *Photographs of the Yellowstone National Park and Views in Montana and Wyoming Territories* (Washington: Govern-

ment Printing Office, 1873), were directed to read them somewhat differently—that is, less as technical documents of geological forms than as stirring pictures of America's scenic wonderland. The printed legends drew the viewer's attention to the "marvels of beauty," to scenes "without a parallel in the known world," to a water fall of which it could be said "there is . . . not a more beautiful sight in existence."[71] In either case, the photographs acquired authority as the *first* photographs of a place theretofore known only through printed reproductions of crude drawings. And they thus seemed to underscore the idea that Jackson was somehow present at the moment of discovery; that the Yellowstone was a virgin territory, scarcely seen by man until the moment Jackson set up his wet-plate view camera to record the sights spread out before him. They convey the impression that Jackson and Hayden were witness to the beginning of a story; that from here history will unfold. But Jackson, like every other photographer of the nineteenth-century West, actually pictured a place that already had a long history of human use. In glossing over that past, in participating in the construction of a literary and visual story that depicted the West as a virgin land, Jackson and his colleagues helped pave the path for continued American expansion into the West. If places like Yellowstone had no complicated history of human use or interaction, they were easily appropriated for other ends; for settlement, for resource exploitation, for tourism. Without a past, such places could easily have whatever future their chroniclers could imagine.

Indians were not entirely ignored by Hayden and his crew, however. During his first four seasons of work with the Hayden survey, from 1870 to 1873, Jackson took some two hundred negatives of Indian subjects, "chiefly," he said, "scenes and studies among their habitations in the wilds of the far west." In 1874, as he assembled an annotated listing of pictures made on the Hayden survey, he not only added the pictures he had made on his own along the Union Pacific Railroad line in 1869, he pulled together nearly eight hundred other negatives of Indian subjects, donated by the English amateur ethnologist William Blackmore, "for the advancement of ethnological studies." Some four hundred of these pictures, Jackson explained, had been originally gathered from a variety of sources by the Washington, D.C., photographer A. Zeno Shindler and extended back to the daguerrean era. Three hundred came from Alexander Gardner's collection of portraits of Indian delegates, made during their visits to the nation's capital. Another forty-five pictures taken in the Southwest during 1871 had been made to order for Blackmore. On his own, Jackson had also acquired additional studio portraits

of visiting Indian dignitaries, made by a variety of Washington, D.C., photographers. Rather than interspersing the field pictures with the landscapes made in the surrounding areas, instead of locating the studio portraits in close conjunction to pictures made near the subjects' western homes, Jackson segregated the Indian images in a separate section at the back of the 1874 edition of his catalogue, grouped by tribe and listed by name. "A fully descriptive catalogue," he said, would eventually be prepared.[72] In the 1875 edition of his catalogue, to which he added landscape images from the 1874 and 1875 survey seasons, he eliminated the listing of Indian pictures altogether, as he laid the groundwork for an independent catalogue of these photographs. Gathering the needed information proved time-consuming. "I have been & am still at work on Indian Catalogue," Jackson wrote to Hayden in September 1876. "Have done all I can do at

William Henry Jackson, *Ruins in the Cañon of the Mancos*. Albumen silver print, 1874–5. Yale Collection of Western Americana, Beinecke Rare Book and Manuscript Library

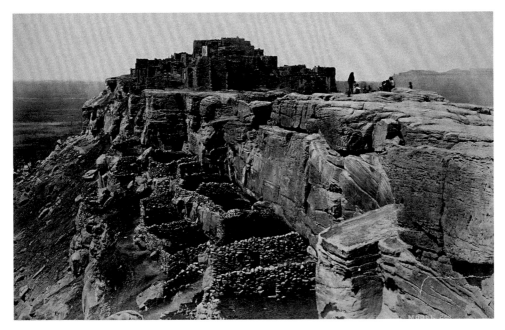

William Henry Jackson, *Moqui*. Albumen silver print, 1875. Yale Collection of Western Americana, Beinecke Rare Book and Manuscript Collection

present, except writing evenings, until I hear from enquiries I have sent out to various agents & others."[73] Not until 1877 would Jackson's *Descriptive Catalogue of Photographs of North American Indians* finally appear.[74] Native Americans remained a vital presence in the 1875 edition of the landscape catalogue only through the inclusion of a handful of 1875 negatives of Hopi views, included chiefly for the architectural interest of the mesa-top dwellings. Otherwise, they were present only in an attenuated manner, in Jackson's 1874 and 1875 negatives of prehistoric dwelling sites in the Mesa Verde region of the Four Corners area. In the absence of more pictures of contemporary Indian life, such pictures of abandoned sites only underscored the disappearance of the region's native peoples.

Given the growing size of the photographic collections, there were practical reasons for separating the landscape pictures from the Indian portraits. But the publication of two catalogues also served a deeper ideological purpose. Making liberal use of Hayden's own words, Jackson's landscape catalogue depicted a world of untold won-

ders, a pristine Rocky Mountain landscape just awaiting the miners, the settlers, the tourists that would help its future unfold. Like the story related by Wheeler's photographic albums of the Southwest, or by A. J. Russell's annotated album of railroad photographs, it told a tale about the West that *would be*. The Indian catalogue, by contrast, memorialized a fast-disappearing world, and the Indian pictures were offered less as an enticement or inducement for western travel than as a kind of archive of pictorial relics. The Indians "are fast passing away or conforming to the habits of civilization," Jackson wrote, "and there will be no more faithful record of the past than these photographs. To their future historian they will prove invaluable."[75] The two stories, one a trajectory of progress, the other a trajectory of decline, were fatefully intertwined; each animated and gave a sense of urgent meaning to the other. As expansionist sentiment put new pressure on the West's beleaguered Native American communities, the real or imagined decline of these communities spurred westward expansion. "The red man will pass into oblivion before many years have flown," read the introduction to a book of inexpensive reproductions of Jackson photographs that appeared in 1894, "but the glory of the scenes they dwelt in will never be eclipsed."[76] Dramatic photographic vistas helped persuade countless Americans that the essence of the West was not its social communities, not the interactions between its diverse peoples, but the physical landscape itself.

The pictures, with their associated words, suggested the kind of geographical determinism, long latent in nineteenth-century thinking about the West, that would find its most explicit statement in the historian Frederick Jackson Turner's celebrated 1893 pronouncement about the significance of the frontier in American life. "The existence of an area of free land," Turner wrote, "its continuous recession, and the advance of American settlement westward, explain American development." Discounting the importance of inherited European traditions, he argued that America's distinctive social and political culture resulted from a long history of facing the challenges "involved in crossing a continent [and] in winning a wilderness." On the frontier—a place evoked more through poetic metaphor than geographical precision—settlers shed their old habits, returned to the "simplicity of primitive society," and coped with the challenges of the physical landscape by developing a new and distinctively American character: "that coarseness and strength combined with acuteness and acquisiveness, that practical, inventive turn of mind, quick to find expedients, that masterful

grasp of material things, lacking in the artistic but powerful to effect great ends, that restless, nervous energy, that dominant individualism, working for good and for evil, and withal that buoyancy and exuberance which comes with freedom."[77] As Henry Nash Smith argues so persuasively in *Virgin Land* (1950), Turner recapitulated a long tradition of American thought, quickly acquiring "the authority of one who speaks from the distilled experience of his people."[78] His frontier thesis echoed with the old myth of the West as a garden, with the Jeffersonian faith in a democracy of yeoman farmers, with the rhetoric of Thomas Hart Benton, William Gilpin, and other mid-century expansionists who had linked the western lands to the future of American democracy. Within each of these strains of thought, nature presented a formidable challenge, but it was simultaneously a source of spiritual renewal and regeneration, a place and a force somehow capable of drawing out the very best of the American character.

In his focus on man's struggle to "transform the wilderness," Turner paid scant attention to the land's current or previous inhabitants; his very use of the phrase "free land" and his invocation of a sharp dividing line between "savagery and civilization" suggests his essential disinterest in the ways in which native peoples had long occupied and used the western landscape. Like the western landscape photographers of the 1860s and '70s, his interest lay in what would transpire when Euro-Americans moved into a wilderness, and by virtue of hard work and technological know-how transformed the virgin land into a new, distinctively American kind of space. Turner wrote out of a kind of melancholy—his essay had been triggered by the findings of the 1890 Census, which proclaimed that the United States no longer had a continuous frontier of sparse population. Ultimately, he had to acknowledge that the process of westering that had regenerated and sustained American culture for several hundred years was now at an end. He thus supplies an elegiac coda to the forward-looking optimism of the western photographers of the 1860s and '70s who found in the physical landscape of the American West a place where Americans could yet find and realize their best and finest selves.

The capacity of photographs to convey abstract ideas about the potential of the western landscape was a reflection of technological innovations and shifting modes of photographic distribution. Most of the photographs made of the pre–Civil War explorations of the West had been ineffective as a means of communicating complex ideas about the region, hard-pressed to compete with the symbol-laden paintings and prints that visualized more literary arguments about the West's resources and the process of

westward emigration. Daguerreotypes were difficult to see and hard to reproduce; they were unique objects that resisted mass distribution. The photographers who produced paper prints with the nascent wet-plate process struggled with technical problems, and a general uncertainty as to how their pictures might compete with older, more established media of representation. But the professional photographers in the employ of the railroad companies and federal surveys who went west in the decade following the Civil War operated in a different climate, made possible by the perfection of wet-plate negative technologies in the late 1850s and early 1860s. They and their patrons were quick to realize the potential of the new medium that enabled them to produce multiple paper prints from a single hard-earned negative. Their photographs were published in expansive series, promoted in printed catalogues, distributed in annotated albums, widely reproduced as woodcuts or engravings in official reports and popular journals, all in ways that gave visual amplification to concrete social and political ideas. And the key to their effectiveness as a new form of communication was language. Until photographers could link words to their pictures, photography remained ill-equipped to become a tool of mass communication. But married with words—mounted on printed boards, bound into albums, explicated by captions in catalogues or glued on labels landscape pictures could narrate stories. Words could animate the visible or describe the unseen; they could explain the typical or clarify the unusual. They could rein in the viewer's imagination or direct it to strange new places. Paradoxically, they could transform visual records of the past into pictures that seemed to predict, even illustrate, events that were yet to transpire.

As the western landscape became a compelling subject for photographers in the 1860s and '70s, it was quickly promoted as part of, and embraced within, broader currents of American popular thought. Shaped and bounded by printed words, western landscape photographs became a potent part of prevailing myths about the West as a blank slate upon which Americans could inscribe their own future. In focusing on the most dramatic features of the western landscape, in minimizing the presence of people with earlier claims to the land, in illustrating what Americans could accomplish through focused use of the West's resources, the photographers and their patrons turned their backs to the history of human conflict in the West and set their eyes squarely on the region's future. The West's past would be largely narrated through the story of the inevitable and natural decline of its native peoples. For the rest of America, what mattered most was what was yet to come.

6

"Momentoes of the Race"

Photography and the American Indian

Just at this time when the Pacific Railway has threaded through the heart of our great Western wilds, and a stream of immigration is following the star of empire on its western way . . . any truthful record of the aboriginal race becomes valuable not only to satisfy present inquiry, but also as a contribution to that history which will soon be all that is preserved of our native races.

—*Appleton's Journal*, Aug. 13, 1870

On the afternoon of May 30, 1843, the young Hawaiian chief Timoteo Ha'alilio took time out from his diplomatic rounds in Paris to pose for a local daguerreotypist. A private secretary to the King and a member of the Kingdom's House of Nobles, Ha'alilio was on a political mission that had already taken him to the United States and Britain in search of international support for Hawaiian independence. His traveling companion, the envoy William Richards, noted in his journal that they sought to commemorate the trip with a formal portrait, but having searched for "a good portrait painter for Ha'alilio found none at leisure, had daguerotipe [sic] likeness taken." Ha'alilio himself died in 1844, en route home to Hawaii. But his daguerreotype portrait survives, and it claims our attention not only as the earliest photograph of a native Hawaiian, but as the first documented photograph of any native person in what would become the United States. In the sixth-plate portrait, a pensive gentleman in a dark tailored suit sits beside a small table, his hand resting on a book meant to signal his learning and intellect. Only the handwritten label now attached to the inside of the case indicates the subject's identity or ethnicity; if the photographer perceived anything exotic or unusual about this sitter, nothing in the portrait betrays any marks of cultural difference. And nothing about the picture suggests it was to be used for anything but the subject's own private purposes.[1]

In early June 1843, less than two weeks after Ha'alilio sat for his portrait in Paris, an unknown number of Indian people posed for their photographic portraits some forty-seven hundred miles away in Tahlequah, the center of the Cherokee Nation, in present-day Oklahoma. They were delegates to the large conference convened by the Cherokee leader John Ross to forge new alliances between some of the southwestern tribes recently displaced to Indian Territory by the federal government's policy of

208

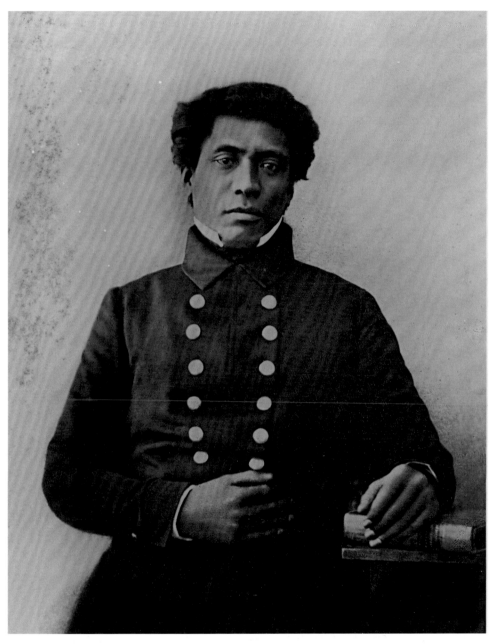

Unknown Photographer, *Timoteo Ha'alilio*. Daguerreotype, sixth-plate, 1843. Hawaiian Mission Children's Society Library, Mission Houses Museum

Indian Removal. A reporter noted that the portrait painter John Mix Stanley and his associate, Caleb Sumner Dickerman, were there gathering portraits for their traveling Indian Gallery of paintings and artifacts "both with the pencil and the Daguerotype [sic] apparatus," one of the first daguerreotype cameras to appear on the southern Plains. Intrigued by the device, Lewis Ross, the brother of the Cherokee leader, invited Dickerman and Stanley to his home at the conclusion of the council meeting to make photographs of his family. Over a period of four days, the artists made some ten daguerreotype portraits. The present whereabouts of the pictures are unknown (as are those of the portraits Stanley made at the council meeting), but the very fact of their making speaks to the rapidity with which photography spread around the globe—from Paris to Indian Territory—and reiterates the lesson of the Ha'alilio portrait: native subjects were fully capable of understanding the photographic process, in participating as full partners in the collaborative process of making a picture, and in understanding how photographic portraits could serve personal needs.[2]

Some two years later, on August 4, 1845, Kahkewaquonaby, known also as Sacred Feathers or the Reverend Peter Jones, took time out from his lecture tour of Great Britain to pose for the celebrated Scottish photographers David Octavius Hill and Robert Adamson. The son of a Welsh surveyor and an Ojibway Indian woman, Jones had been raised with his mother's tribe until his father removed him at the age of fourteen. Now a bilingual Methodist missionary among the Ojibway, Chippewa, and Iroquois, he was a skillful speaker and an adept cultural broker, moving fluidly between the Indian communities along the northern shores of Lake Ontario and the halls of power in London. By 1843, he had made several extended trips to Great Britain: in 1831, he met his London-bred English wife, and in 1838 he met Queen Victoria herself. Now on a lecture tour to benefit the "Indian Manual Labor Schools," with "Heathen Gods and Indian Curiosities" to pique his listeners' interest, it was not surprising that he would accept Hill and Adamson's invitation to pose. Nor would it seem unusual that Hill and Adamson, who had photographed many of the nation's leading clerics, should want a likeness of the famous Native American missionary. Using the calotype, or paper negative process, for which they were well known, Hill and Adamson made at least eight portraits of Jones; five depicted him in European dress, with an Indian sash about his waist, and three showed him in a deerskin coat with leggings and a feathered headdress. The pictures were staged. The pipe Jones holds in the "Indian" pictures was not a family piece, but a gift given him several years earlier by Sir Augustus d'Este,

David Octavius Hill and Robert Adamson, *The Reverend Peter Jones*. Calotype, 1845. Yale Collection of Western Americana, Beinecke Rare Book and Manuscript Library

an Englishman active in the Aborigines Protection Society. Often acknowledged as the earliest surviving photographs of a native North American, the portraits of Jones (like that of Ha'alilio with which they compete for such a title) confound prevailing notions about the photography of Native Americans as an inherently inequitable encounter, designed to fix their subjects in a world of unassailable "otherness" unsullied by contact with Euro-American civilization.[3] The subject we encounter here clearly understands the process of picture making; he deliberately poses in different modes of dress in order to obtain pictures that could illustrate and serve his various roles as missionary, fundraiser, and inspirational speaker.

In March 1847, the Sauk and Fox chief Keokuk and his associates traveled from their new reservation in present-day Kansas to St. Louis, via Missouri River steamboat, most likely to conduct official tribal business with the resident Indian agent. While there, the local paper reported, the chief and "ten of his warriors" also performed a "war dance" with the Grand Olympia Circus "superbly decorated in genuine Indian style." And somehow, they also found time to stop in at the studio of daguerreotypist Thomas Easterly and pose for their portraits. They thus became perhaps the first Native Americans to have their pictures made inside an American portrait studio. Keokuk prepared for his portrait with care, posing with a silver-tipped cane, bear-claw necklace, and silver peace medal. Despite all its descriptive specificity, though, the picture remains mute as to Keokuk's own ambitions for the portrait. Was he seeking to impress his diplomatic counterparts from the federal government, second-guessing what might appeal to prospective visitors to his "war dance," or simply searching for a private memento?[4] Keokuk had posed for portrait painters in the past. Did he thus understand that in this situation it was also unlikely he could control the uses to which his portrait would be put once it left his hands? He may or may not have understood the commercial marketplace, but the studied formality of his pose suggests he did understand the potential power of a two-dimensional image.

Easterly, Stanley and Dickerman, Hill and Adamson, and the anonymous French daguerreotypist each had commercial reasons for making their portraits of native subjects. Easterly exhibited Indian portraits in his St. Louis gallery; Stanley and Dickerman sought material for their touring show; Hill and Adamson made multiple copies from their paper negatives to sell; and the unnamed Frenchman would have welcomed a well-dressed foreign client with cash. But the subjects likewise had uses for these pictures. Ha'alilio and Jones could use their portraits to advance their political or religious

Thomas M. Easterly, *Keokuk or the Watchful Fox.* Daguerreotype, quarter-plate, hand colored, 1847.
Missouri Historical Society, St. Louis

Thomas M. Easterly, *Keokuk's Wife (Nah-wee-re-coo) and Grandson*. Daguerreotype, quarter-plate, 1847.
Missouri Historical Society, St. Louis

missions. Lewis Ross sought more personal keepsakes; after all, he *invited* daguerreo-typists to his home. Perhaps Keokuk, too, wanted personal mementoes. Additional Easterly portraits of Keokuk's wife, son, and grandson suggest the possibility that the chief might have posed in exchange for family pictures he could keep.[5] Such an imag-ined exchange seems prosaic. But it reminds us that native sitters—like any other pho-tographic subjects—could have personal ambitions for their portraits. Countless later nineteenth-century photographs of Native Americans would, indeed, be used to endorse a political agenda that involved a systematic attack on native cultures. But nothing embedded in the very concept of photography itself dictated such a use of the pictures. Indeed, to imagine that every photograph of an indigenous person represents an act of cultural imperialism is to deny the ambitions of the sitter, the capacity of that sitter to understand the collaborative process of portrait making, and the cultural mal-leability and contingency of any photographic image. Countless turn-of-the-century photographs, such as those by Edward S. Curtis and his contemporaries, would pre-sent Indian culture as timeless, unchangeable, and therefore doomed, but these early daguerreotypes record a more complicated cultural present, and assert that native sub-jects could be active collaborators in the process of picture making.

At the outset, every photographic portrait represents a particular time-bound moment and a specific set of historical contingencies. As long as it remains in the phys-ical possession of its subject or that person's family, and retains a concrete identifica-tion, a portrait can commemorate a specific person, evoke a set of memories or family stories, serve as an historical memento of a particular human life. But when it ceases to be a private picture and becomes a public one, when it passes into the hands of others or loses its identification as the likeness of a particular person, a photographic portrait can be used to tell or illustrate any number of stories. "Brother Jack" might become an archetypal forty-niner; a favorite uncle might be transformed into an unnamed member of a vanishing race. For all the specificity of the visual information contained within a photographic portrait, such pictures always have the latent power to slip the bonds of biographical explicitness and to assume more metaphorical meanings in the eyes of a beholder. The portrait that once memorialized a personal, private moment is easily reimagined as a public commodity, the record of a specific historical event reembraced as an ahistorical visual metaphor.

The overwhelming majority of nineteenth-century American photographs were portraits, the vast majority made for the sitters themselves. At first, such portraits were

private documents, owned, controlled, and interpreted by the people who had paid to have them made. But with the exception of carefully identified celebrity portraits or the pictures labeled by forward-looking family members, these pictures quickly lost their capacity to narrate specific stories. As unidentified portraits in an attic trunk or unlabeled pictures in a flea market stall, they are now simply portraits of strangers, pictures that can evoke much, but tell little. They may document the material culture of a particular era, the prevailing styles of dress or architecture, but they are incapable of describing in any comprehensive way virtually anything about the circumstances of their production, the ambitions of the sitters, the uses to which they once were put. They are the frayed fragments of a story, stray anecdotes or footloose characters in search of a plot that would give them purpose and meaning. Without the personal link they once had to their subjects, such portraits remain astonishingly specific and agonizingly vague, full of information and time-bound stories beyond all recovering. They speak to an absence as much as a presence.

Nineteenth-century photographs of Indians, however, fall into a different pattern. As the stories of Ha'alilio, the Ross family, Peter Jones, and Keokuk suggest, there was a moment in the 1840s when portraits of native peoples were—like most other American portraits—made for the sitters' own purposes (and often at the sitters' own behest). It is a moment that correlates with a particular period in the history of photographic technology. Jones's portraits were made with the calotype process, an early paper negative process never much practiced in the United States. But the other portraits were daguerreotypes, inherently private sorts of images, not easily reproduced or displayed, that lent themselves to private ownership and private use. As illustrated by all the ill-fated efforts of landscape daguerreotypists to find markets for their work, these images could not easily find an audience; they remained difficult to view and hard to link with the sorts of explicatory texts that would give them greater symbolic or narrative resonance. Easterly did display daguerreotypes of Indian subjects in his St. Louis gallery, but by and large even enterprising daguerreotypists had relatively little to gain from making portraits of Indian subjects because the unique pictures could be sold but once. However, just as a change in photographic technologies triggered a transformation in the ways in which landscape views could be used to narrate complex tales about the future of the American West, the development of glass-plate negative processes in the late 1850s heralded a change in the business of photographing Indians. The new technology infused the encounter between photographer and subject with greater

commercial possibilities. Instead of a single and singular daguerrean portrait, photographers could produce multiple copies of paper prints and reach out to a market that extended well beyond that of the sitter and his immediate family. As photographers began to imagine the commercial utility and marketability of their prints, as they began to second-guess the tastes and needs of their prospective audiences, the personal desires of their subjects became increasingly less important. The emergence of this expanded market for photographic views of Indian life made it far less likely that a photograph of a native American person would be made for the subject him- or herself, and correspondingly more probable that the picture would be made as an object of commerce, intended not as a private remembrance, but as a piece of a public story.

As the native subjects of these portraits lost control over the physical objects themselves, they also lost control over the stories that the pictures would be used to tell. Keokuk, for example, might once have had something to say about how his daguerreotype portrait was used. But he certainly had no control over the subsequent use of a copy negative made from the portrait that was used to produce the paper prints marketed and described in a government catalogue published in 1877 (indeed, by then he was dead). The brief catalogue entry for Keokuk's portrait described him as a "magnificent savage." Although "bold, enterprising and impulsive," he was also "politic" and shrewd, qualities that helped him become a successful leader of his people. The brief biography noted that there were scant historical records with which to trace Keokuk's ascent to power, but scarcely noted its own ahistoricity. The words in the 1877 catalogue, describing a daguerrean portrait of 1845, came directly from Thomas McKenney and James Hall's *History of the Indian Tribes of North America,* published in 1842, and there they described a portrait of Keokuk painted some years earlier.[6] As paper photographs came to prevail over daguerreotypes, and other singular sorts of images such as tintypes or ambrotypes, the vast majority of photographs of Indian subjects came to serve the needs of their non-Indian makers and publishers. And most quickly found their place within a single overarching narrative story—the inevitable decline of the nation's native cultures, the determinist tale of a "vanishing race."

A central premise of the vanishing race ideology was that traditional Indian cultures and peoples would inevitably disappear because they were incapable of adapting to changing political and material circumstances. "How shall it be with us when they are gone, / When they are but a mem'ry and a name?" asked Ella Higginson in "The Vanishing Race" (1911), a poem inspired by Edward Curtis's celebrated 1904 photo-

Edward S. Curtis, *The Vanishing Race—Navajo*. Photogravure (1907) from *The North American Indian*, vol. I. Yale Collection of Western Americana, Beinecke Rare Book and Manuscript Library

graph of the same title.[7] Where men, women, and children would fade away, images would remain. Concerned lest the "corporeal traits" of the Indians be forgotten, the American Antiquarian Society, for example, gratefully accepted a collection of photographs from one of its members in 1876 because they would "prolong a conception of the personal attributes of an expiring race, such as the real aspect of the living face and figure alone can give."[8] This faith in the power of the image to serve as a simulacrum or historical record of a people fated to extinction can be traced back to the 1820s, before photography, when the federal government's commissioner of Indian affairs, Thomas McKenney, began collecting painted portraits of Indian leaders for an educational "Indian Gallery" that would offer a lasting visual record of the peoples he believed were doomed to disappear. The painter George Catlin likewise explained that the

visual records he had created on his ambitious, almost frenetic, western painting expeditions of the 1830s were intended to snatch "from a hasty oblivion what could be saved for the benefit of posterity."[9]

By the 1850s, photographers were invoking language similar to that of their artistic predecessors. The Washington, D.C., studio photographer James E. McClees predicted in 1858 that his collection of Indian delegation photographs would have lasting importance "as momentoes of the race of red men, now rapidly fading away.[10] The value of the government's collection of Indian pictures, argued geologist and expedition leader Ferdinand Vandiveer Hayden in 1877, "increases year by year; and there will be no more trustworthy evidence of what the Indian have been than that afforded by these faithful sun-pictures."[11] Such sentiment reached its extravagant peak in Edward S. Curtis's mammoth twenty-volume project, *The North American Indian* (1907–30). Titling his signature image *The Vanishing Race*, Curtis simultaneously proclaimed the fate of the American Indian and asserted the heroism of his own photographic salvage project.

The romantic primitivism and imagined antimodernism embedded in the vanishing race ideology is largely responsible for the widespread cultural assumptions about Indian fears of photographic technologies. "The American Indian is extremely superstitious," Hayden wrote in 1877, "and every attempt to take his picture is rendered difficult if not entirely frustrated by his deeply rooted belief that the process places some sort of himself in the power of the white man, and his suspicion that such control may be used to his injury."[12] But the widely expressed belief that Indian peoples feared that photography would steal their souls is, like so many other myths about Native American life, a gross overgeneralization and cultural stereotype created with little regard for the widely varied beliefs and experiences of different peoples. Many native peoples were intrigued by the new medium. In the mid-1840s, the Ojibway author George Copway, known also as Kahgegagahhowh, traveled some one hundred miles from his father's village to Toronto for the purpose, he said, "of witnessing the operation of taking Daguerreotypes. Having sat for mine, I viewed it with much curiosity." Returning to his village with a daguerreotype to show his friends, he found them incapable of comprehending how such a thing could be produced by "the rays of the sun." "They soon pronounced it 'a spirit,'" commented Copway, but he was persuaded it was a "beautiful art."[13] T. Elwell, a photographer operating in St. Anthony, Minnesota Territory, in 1854, found it worthwhile to advertise to his Indian neighbors, proclaiming his studio open to everyone, "even the SONS OF THE FOREST" who would be "received with

that consideration due to their rank as NATIVE AMERICANS."[14] In Washington, D.C., the secretary of the Smithsonian Institution, Joseph Henry, observed in 1859 that visiting Indian delegates seemed interested in posing for their portraits. "Nothing would be more agreeable to the Indians themselves who might be furnished with a copy" of their pictures, he wrote.[15] And far off in Wyoming Territory, during the summer of 1866 the Philadelphia Quaker photographer Ridgway Glover found that some of the Sioux "think photography is 'pazuta zupa' ('bad medicine')." But when he passed neatly framed tintype portraits out to his sitters he discovered that "they think they are *wash-ta-le-poka*. (Their superlative for good.)." Such feelings of appreciation were not, however, uniformly extended to Mr. Glover, who was killed by a group of Sioux near Fort Kearney, in Montana Territory, just a few months later.[16]

Not surprisingly, the response to photographic technology on the part of individual people and particular communities depended, in part, on their previous experience with Euro-Americans, their exposure to the tools of American technology, and the particular context in which they encountered cameras. When John Mix Stanley, the artist attached to Isaac Stevens's survey of a potential transcontinental railroad route, photographed the Blackfeet at Fort Benton on the upper Missouri River in 1853, he was warmly received by his sitters. Stevens reported that "they were delighted and astonished to see their likenesses produced by the direct action of the sun. They worship the sun, and they considered that Mr. Stanley was inspired by their divinity, and he thus became in their eyes a great medicine man."[17] Similarly, Solomon Carvalho found that the Cheyennes he encountered on his trip across Kansas with John C. Frémont in 1853 "worshipped me as possessing extraordinary powers of necromancy," especially after he demonstrated the use of his matches and his alcohol burner.[18] But the painter and photographer Carl Wimar, who tried to photograph the Mandan in 1858, was rebuffed by people who recalled the smallpox epidemic introduced by previous white visitors and feared that the photographer and his camera would reintroduce the disease.[19] Photographer E. O. Beaman encountered both hostility and curiosity among the Hopi in 1872, with one group fearing the camera as an instrument of death and another embracing him as a "great medicine-man."[20] But in no uncertain terms, the Utes he tried to photograph the previous year warned that if either they or their ponies should become ill after having their photographs made, his "stay in the country would be short."[21] A year later, the Canadian photographer Charles Horetzky met with a comparable situation in northern British Columbia. A few months earlier, a missionary had brought to

the region "a small magic lantern and slides" with which to entertain the local residents. Shortly after his departure, an outbreak of cholera spread through the region, "the origin of which," Horetzky wrote, "they most illogically attributed to the 'one-eyed devil' in the lantern and its exhibitor." Horetzky's own camera bearer and cook fled "in mortal terror" of his camera box.[22]

Such associations between photography and illness survive well beyond the first encounters between particular groups and the technology of the camera. Southwestern photographer Charles Lummis later explained that when he began photographing Pueblo Indians in the late 1880s he had to "break" his subjects into photography. Notwithstanding the fact that photographers had been visiting the Rio Grande pueblos for a decade or so, Lummis reported, "They believed that the photograph was taken not only of them, but *from* them; and that, with enough prints, they would waste away to nothingness."[23] It was thus not so much the *process* of making photographs as the *subject* of those photographs that produced concern. And not surprisingly, portraiture seemed the most problematic subject of all. When E. O. Beaman took his wet-plate photographic outfit to the Hopi villages in the fall of 1872, he noted that the Hopis "looked upon pictures that I made of their houses with wonder and amazement." But, he added, "when I presented them with some of my best efforts in the way of photographs of themselves, so soon as my back was turned they were immediately destroyed or thrown away."[24]

The words that emerge in different native languages to describe photographs and photographic technologies likewise testify to the culture and group-specific nature of early responses to the medium. The Navajos near Kanab, Utah, in early 1872 referred to photographs as "paper faces."[25] Similarly, on the Northwest Coast the word for photograph in the Chinook jargon, used as a simplified lingua franca among tribes along the lower Columbia River, meant "face picture."[26] Farther to the north, the Haida people named the camera "k'laaga nijangwe," or "copying people," and equated the camera with a mask, which they also called "nijangu," or "copying."[27] Such phrases underscore the prevailing use of the camera as a tool of portraiture, and in the case of the Haida hint at an understanding of the photograph as a commodity, which, like a mask, could be wrenched from the culture in which it had been produced. The Makah, on the Olympic Peninsula, likewise used language that equated a photograph to a public sort of commodity, describing it as a "finished design," the same phrase used for a drawing enclosed in a frame.[28]

For other tribes, photography was associated less with the creative arts than with a more passive sort of recording process. In 1872, a group of Paiutes in southern Utah gave to the photographer John K. Hillers the name "Myself in the Water," a reference to the seeming analogy between seeing themselves reflected in still water and seeing their likeness preserved in the photographer's images.[29] The Lakota dubbed the late-nineteenth-century photographer D. F. Barry "Icastinyanka Cikala Hanzi," or the "little shadow catcher," a variant of a name also given to the photographer Edward Curtis.[30] Such language obliquely acknowledged the photographer's role in capturing the image so easily shed by the subject. But the Hopi words implied a more autographic sort of process, with the word "naavena" meaning both to have one's photograph taken and to sign one's own name.[31] In Lushootseed, the language of the Puget Sound Salish, the word for photograph likewise relates to writing, suggesting an image one makes of oneself.[32]

In English, the metaphorical language used to understand photography likewise veered between language that evoked an image of self-inscription and words that suggested a more aggressive process, even linking the camera to a firearm. In his influential 1859 essay "The Stereoscope and the Stereograph," writer Oliver Wendell Holmes had imagined that photography gave its user the power to preserve "form" without "matter." "Every conceivable object of Nature and Art will soon scale off its surface for us," he wrote. "Men will hunt all curious, beautiful, grand objects, as they hunt the cattle in South America for their *skins,* and leave the carcasses as of little worth."[33] Later he wrote of "flaying our friends and submitting to be flayed ourselves . . . by the aid of the trenchant sunbeam."[34] The noted German photographic chemist Hermann W. Vogel toyed with similar metaphors, commenting in 1867 that "landscape photography and hunting resemble each other . . . we have mainly holiday hunters among landscape photographers who waste their ammunition on every sparrow, but never succeed in killing nobler game."[35] The term "snapshot," already in vogue by 1860 as a term to refer to a quickly made photograph, evolved from the word's traditional meaning of a hurried shot, taken without deliberate aim at a moving animal. "Stalking" likewise acquired a new meaning in the nineteenth century as a word to describe the photographer's pursuit of his prey, foreshadowing the modern "photo-safari."[36] Photography did seem a bit like taxidermy. By being "shot" with a camera, one might live forever on a living room wall—not stuffed, but fixed forever in the chemical emulsion of a photograph. "How these shadows last, and how their originals fade away," Holmes marveled.[37] He was contemplating human mortality in the broadest sense, but his words aptly charac-

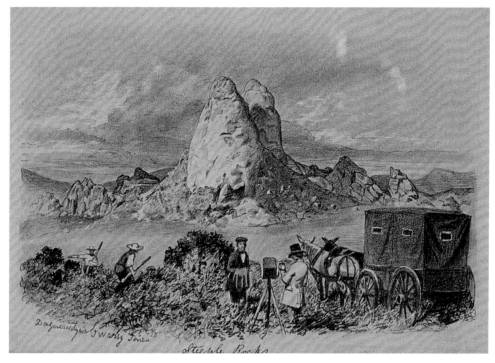

Unidentified artist after a daguerreotype by J. Wesley Jones, *Steeple Rocks*. Pencil on paper, c. 1852.
California Historical Society (FN-19215)

terize the logic behind the impulse to photograph the vanishing race; the photographic image would preserve what time and fate could not.

For some nineteenth-century photographers and their Indian subjects, the links between cameras and weapons became more than mere metaphorical wordplay. In 1851 (or so he claimed), the intrepid overland daguerreotypist John Wesley Jones pretended his tripod-mounted camera was a lethal cannon in order to scare away a group of Snake Indians who had surprised him on a trail near Salt Lake City. "The strange mortar followed them all," Jones explained, "its dangerous muzzle ever keeping them in a straight line. Pop! pop! pop! went the revolvers from beneath the instrument. This was but the prelude of the death-waging storm that was about to burst upon them. They could no longer stand the shock, but with a simultaneous yell broke away toward the rocks."[38] Fifteen years later, in 1866, the ill-fated Ridgway Glover was traveling near

Fort Kearney with a military detachment that suddenly found itself surrounded by a group of Sioux. Glover set up his camera, for the Indians "looked very wild and savage-like while galloping around us; and I desired to make some instantaneous views." Had he been successful, Glover would have captured the only views of actual combat between federal troops and Plains Indians. But the commanding officer ordered him to shoot with his rifle rather than his camera, and the civilian Glover obeyed.[39] In midsummer 1871, the photographer E. O. Beaman found that his Uintah Ute subjects—people who had never even seen a camera before—quickly associated the photographic tool with more familiar weapons. Beaman, who was attached to John Wesley Powell's federal survey of the Colorado River plateau, had stopped at a federal Indian agency near the headwaters of the DuShine and Uintah Rivers, some two hundred miles southeast of Salt Lake City, to photograph the local Indians. "Photography is a new science among the Utes," he wrote, and the very smell of his chemicals had quickly persuaded his would-be subjects that he was a "'koch weno' (no good) Medicine man." But after the local trader intervened and guaranteed the safety of the process, Beaman found that "we had an opportunity of shooting our gun, as they called it, at a group of these noble sons of the forest."[40]

Such stories suggest a source for the vehemence with which photographic supplies might be attacked. During the summer of 1864, for example, the photographers Sarah and William Larimer were en route to Idaho Territory with a group of other emigrants when they were attacked by a group of Oglala Sioux some eighty miles west of Fort Laramie. Mr. Larimer was wounded and escaped; Mrs. Larimer and their son were taken hostage, escaping less than two days later. Their fellow hostage, Fanny Kelly (with whom the Larimers would later fight over rights to the written version of their captivity narrative), claimed that their attackers fell with particular vengeance upon the Larimers' photographic supplies. She explained that Mrs. Larimer's grief "seemed to have reached its climax when she saw the Indians destroying her property, which consisted of such articles as belong to the Daguerrean art. . . . As she saw her chemicals, picture cases, and other property pertaining to her calling, being destroyed, she uttered such a wild despairing cry as brought the chief of the band to us, who, with gleaming knife, threatened to end all her further troubles in the world."[41] Mrs. Larimer survived, but her photographic equipment did not.

Given the slow exposure times and tripods required for both the daguerreotype and wet-plate cameras, the cannon was a more apt metaphor for the photographic

devices than either a pistol or quick action rifle. It was difficult for a subject to be caught off-guard by a process that required a sitter to hold still for up to several seconds. And thus the vast majority of nineteenth-century photographic portraits of Indian subjects involved a collaboration between a willing (or at least aware) sitter and photographer, a kind of suspended moment that belies the normal interaction between hunted and hunter. But the gun and hunting metaphors associated with photography (by photographers and subjects alike), persist throughout the nineteenth century and into the twentieth. When he photographed the Kwakiutl village erected at the Chicago Exposition of 1893, John Grabill found his well-traveled subjects "afraid of the camera, thinking it was a gun."[42] By then, in fact, various technological developments actually made such connections between cameras and weapons more apt than ever. The wet-plate process had long since been supplanted by the dry-plate technology that had become popular during the early 1880s. This new technology enabled photographers to use factory-prepared negatives, sparing them the arduous task of sensitizing their negatives immediately before making their exposures. The dry-plate process had in turn been supplanted (or augmented) after 1888 by the Kodak camera, a small camera preloaded with a roll of flexible film that not only had a faster exposure time but eliminated the need to reload negatives between shots.[43] With a Kodak, photographers could finally make large numbers of exposures without a subject's knowledge. For the Norwegian-born photographer and essayist Frederick Monsen, the little camera was thus of great assistance in documenting southwestern Indians during the first decade of the twentieth century. Previously, with his 8×10 camera, tripod, and glass plate negatives, he had obtained good pictures only with the "greatest difficulty." Monsen recalled placing his large camera in front of his Indian subjects and pointing "the lens straight at his heart with my hand on the focusing-screw in an attitude suggesting a cannon about to be discharged. That was always a signal for poor Lo to move, and he generally did so with alacrity." But with the new "cartridge films and the rapid action of the hand-camera," he could "snapshot any number of Indian subjects who are entirely unconscious that they are being photographed." Long experience at focusing, he wrote, enabled him to "do it almost by instinct, as a rifleman will hit the target when firing from the hip . . . and my subjects seldom know that they are being photographed."[44] It was an odd way to record a culture; instead of speaking to his subjects, he would simply shoot them.

This image of the camera as an instrument of death received its fullest explication at the hands of novelist Owen Wister, a Harvard-educated easterner who liked to imag-

ine that he knew a thing or two about western gunplay. In his best-selling novel *The Virginian* (1902), Wister helped establish the characters and situations that would become the stock-in-trade of the western novel and film: the laconic hero, the black-garbed villain, the eastern schoolmarm, the shootout on Main Street. Native Americans were notably absent, as they would prove to be in countless cowboy westerns. But more than a quarter century later, Wister published "Bad Medicine"(1928), a short story that placed Indians front and center, in a tale about the impact of the camera on native life. The plot revolves around Sun Road, the grandson of the celebrated Shoshone chief Washakie, who firmly resists all entreaties to pose for the tourists' Kodak snapshots, associating the "bad medicine" of photography with the "bad medicine" of Yellowstone's geysers and the human remains he encounters in a water-filled crater. But while leading the narrator and his companions on a trip through Yellowstone National Park, Sun Road succumbs to the wishes of two women who spy him in a tourist hotel. Carefully protecting his son from their camera's gaze, he poses for a snapshot. To Wister's

Frederick Monsen, *Mojave Indian Children on the Rio Colorado, Arizona.* Toned gelatin silver print, c. 1897–1910. Amon Carter Museum, Fort Worth, Texas (P1980.50.1)

narrator, the moment seems electrifying; "At the click of the machine I saw his taut muscles respond as if a galvanic current had struck them." From that day on, the lenses of the tourist cameras turn upon Sun Road "like the evil eye of civilization, piercing to his weak spot." And the cameras become tools of some terrible force. The Kodaks, writes Wister's narrator, "were an influence more malevolent than any cave with a white jawbone. In truth, they had drained out of him a portion of himself, something that he had been was gone, as if he had lost his spiritual virginity." At the conclusion of the story, Sun Road agrees to pose for a larger, more formal portrait to be made by Yellowstone's official photographer in front of Old Faithful, the park's most recognizable feature. As the photographer rushes to get his camera ready to capture the geyser's imminent eruption, Sun Road stands "tall and motionless." Then the geyser shoots up, the camera flash goes off, and Sun Road is struck with terror by "this portent, for which he has been so utterly unprepared, and whose arrival from the depths below had apparently been attended by lightening from above." Stepping backward, he falls through the fragile crust that surrounds the geyser, and sinks to his death in a cavern of scalding water and steam.[45]

Wister's story summons up a host of older ideas: the presumed pan-Indian superstition about photography, the notion that Indians would vanish because they could not adapt to cultural or material change, the belief that photographs would survive though Indian peoples would not. But if such ideas drew from long-standing and widespread cultural beliefs about Native American life, no one had so forcefully evoked the camera as an instrument that not only recorded the past but actually hastened its demise. In Wister's story, the camera is truly an agent of change. And so, in actuality, it could be. In 1902, photographer George Wharton James noted that the presence of a "line of cameras" at the Hopi Snake Dance at Oraibi had frightened away the snake priests. Instead of kneeling on the edge of the wall just below the kiva to vomit after drinking a ceremonial emetic, they huddled around the bowls containing the mixture "and then each priest got as far away from the camera as he could." It would not be long, James predicted, before one could "write a learned and accurate paper from the standpoint of scientific ethnology on 'the change in religious ceremonies owing to the camera.'"[46]

Some Indian communities fought back against the perceived intrusiveness of the camera. Several Rio Grande pueblos, including San Felipe and Santa Ana, seem to have banned the photography of ceremonial events from the start. Others banned the practice beginning in the 1920s. In 1928, two busloads of tourists at Santo Domingo Pueblo

who disobeyed requests not to take pictures of a Happiness Dance were quickly set upon by angry pueblo residents with clubs who knocked their cameras to the ground and then jumped on the equipment.[47] Farther west, at Hopi, the ban on photography of the hugely popular Snake Dance in 1913 came not from the Hopis themselves but from the federal government's commissioner of Indian affairs, in response to the chaos caused by the large number of still and motion picture photographers disrupting the event. Previously, the Hopis had accepted the onslaught, even negotiating with their resident Indian agent to collect one dollar for each camera permit he issued.[48]

Certainly, even within a small community there could be widely divergent responses to the medium. When John Hillers arrived at Zuni Pueblo in 1879, as a part of the federal Bureau of Ethnology's first expedition, the governor and other pueblo leaders seemed open to photography, viewing it as a concession that would accrue some future benefit for their community. The tribal religious leaders, however, thought such a concession unacceptable, and they protested any efforts to photograph their ceremonials.[49] In the summer of 1874, William Henry Jackson was refused permission to take pictures by a group of Uncompahgre Utes. The medicine men had pronounced the process "no bueno," and some of the chiefs reinforced this opposition on the basis of the technology's capacity to cause illness. When Jackson insisted on persevering anyway, setting up his camera to take a distant view of the village, he found that "three or four Indians were detailed to get in my way. As I attempted to focus, one of them would snatch the cloth from my head; or toss a blanket over the camera; or kick one of the supporting legs."[50] Yet Jackson recalled that Ouray, a head man of the group, was more welcoming of the technology, explaining that "any person's right not to be photographed was his own, and that while he would readily sit for us himself, he would not issue any orders." "Chief Ouray himself," Jackson later wrote, "was very interested in photographs, and could hardly understand why anyone would not like having his picture made. He was always ready to pose, therefore he was probably the most photographed man in the Rocky Mountains. He continually asked me questions about photography."[51]

Unidentified photographer, *Ouray*. Albumen silver print, n.d. In his catalogue of the government's collection of Indian portraits, William Henry Jackson notes that Ouray "is a steadfast friend of whites" who "lives at the Government agency in a comfortable house, in a somewhat civilized style, and has a carriage with driver while his people live altogether in tents." Yale Collection of Western Americana, Beinecke Rare Book and Manuscript Library

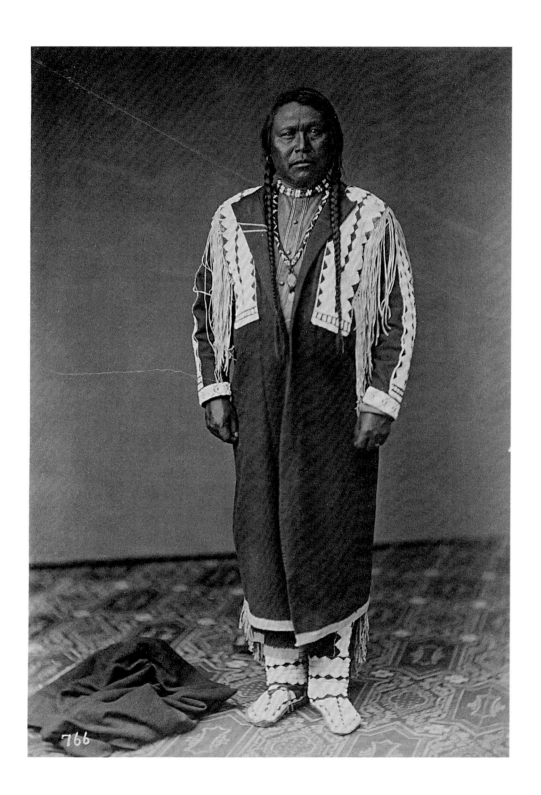

The story of Ouray suggests the ways in which individual Indian subjects might learn and prosper from their repeated contacts with Euro-American photographers, and again cautions us against assuming a victimization model for all Indian photographic subjects. When the Hunkpapa Sioux medicine man and war chief Sitting Bull signed a contract with Buffalo Bill's Wild West show in 1885, he demanded the exclusive right to sell souvenir pictures of himself and to charge a fee to patrons who wanted to pose with him for a tintype.[52] He was like an "early Warhol" selling his autograph for pocket change, says Comanche writer Paul Chaat Smith. "Afraid of cameras? *Talk to my agent first* is more like it."[53] When the Apache leader Geronimo posed for Edward Curtis in 1905, he dressed the part of the "historical old Apache" Curtis needed for the first volume (1907) of his work, *The North American Indian*. But like Sitting Bull, Geronimo actually knew how to manipulate the picture-taking process. The year before posing for Curtis, he had traveled to the St. Louis World's Fair where, he tells us, "I sold my photographs for twenty-five cents, and was allowed to keep ten cents of this for myself. I also wrote my name for ten, fifteen, or twenty-five cents, as the case might be, and kept all of that money." He sometimes made as much as $2 a day, he said, and left the fair with more money than he had ever before had in his life.[54] The year after Curtis made his retrospective portrait, Geronimo—still in military custody—published his own "as-told-to" autobiography, blasting the military establishment that had imprisoned him and including several photographs that seemed to illustrate the trajectory of his life. These photographic illustrations depicting Geronimo "dressed as in days of old," and garbed as if "ready for church," together contradict Curtis's image of him as a figure unable to adapt to changing times. Geronimo knew how to play to his audience, through pictures as well as words.[55] "On his own," writes the Cherokee poet and artist Jimmie Durham, "he reinvented the concept of photographs of American Indians. At least he did so as far as he could, concerning pictures of himself, which are so ubiquitous that he must have sought 'photo opportunities' as eagerly as the photographers."[56] In their relationship to photography, Indians are often portrayed as "victims, dupes, losers, and dummies," writes Paul Chaat Smith. "Lo, those pathetic Indian extras in a thousand bad westerns. Don't they have any pride? I don't know, maybe they dug it."[57] Certainly, Geronimo seems to have had fun, accommodating photographers even as he asserted his own control over the images they captured with their cameras.

Countless less well-known subjects likewise found something to value in the portraits of themselves or their families. "Photographs have always had special

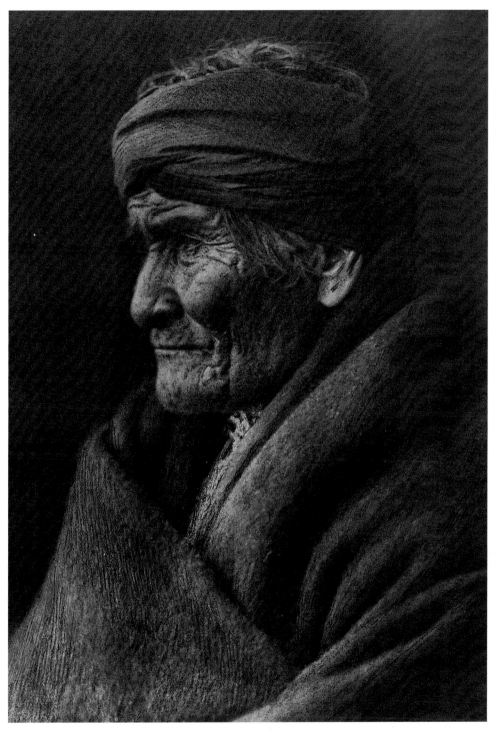

Edward S. Curtis, *Geronimo—Apache*. Photogravure, from *The North American Indian*, vol. I (1907).
Yale Collection of Western Americana, Beinecke Rare Book and Manuscript Library

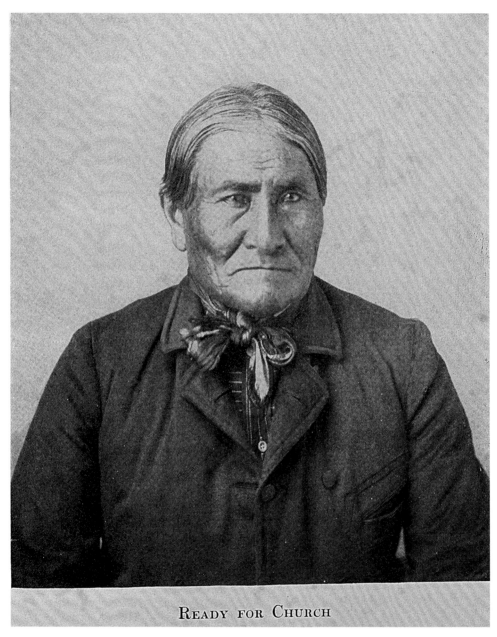

READY FOR CHURCH

S. N. Barrett, *Geronimo, Ready for Church*. Halftone reproduction, from *Geronimo's Story of His Own Life* (1906). Amherst College Library

significance / with the people of my family and the people at Laguna," writes the Laguna novelist Leslie Marmon Silko, explaining that she includes family snapshots in her book *Storyteller* "because they are part of the stories / and because many of the stories can be traced in the photographs."[58] As for any other family, photographs could record the visage of a beloved ancestor, reveal what one's parents had looked like as children, preserve a social memory of a particular house, garment, or artifact lost or altered by time. In the early 1880s, the Zuni leader Lai-iu-ah-tsai-ah (known also as Pedro Pino) saw the family photographs owned by the soldiers at Fort Wingate and marveled that "the faces of [the soldiers'] fathers, who have long since passed from earth . . . still were looking down upon their children from the wall." He subsequently tried to assure a Zuni colleague that sitting for a portrait would be alright. "Though your body perish," he said, "nevertheless you shall continue to live upon the earth. Your face will not be forgotten now; though your hair will turn gray, it will never turn gray here."[59]

Photographs might likewise preserve the appearance of a ceremonial event, and the Gros Ventre scholar George P. Horse Capture speculates that his ancestors collaborated with photographer Sumner Matteson in the documentation of a 1904 Sun Dance because they themselves wanted a record of the activities.[60] In some Northwest Coast Indian communities, photographs were actually incorporated *into* ceremonial practices. In 1913, the anthropologist Homer G. Barnett observed a commemorative potlatch among the Cowichan of Vancouver Island, and noted that the cloth figure representing the deceased had been replaced by a photograph. At another Cowichan potlatch held on the occasion of a naming ceremony, he observed a framed photograph being used, presumably of the individual who owned the name being bestowed upon the young girl being honored.[61]

But such stories of resistance, entrepreneurship, or incorporation of photographs into daily practices notwithstanding, the overwhelming majority of nineteenth-century photographs of Indian peoples neither served the needs of the sitters, nor remained in their private control. They became, instead, caught up in larger cultural narratives about race, Manifest Destiny, and the impending disappearance of native peoples, an event that to many nineteenth-century Euro-Americans seemed as necessary as it was inevitable. Cut loose from the physical ties that might have bound them to their subjects, these pictures were bound up in elaborate visual and literary narratives and cast out into the marketplace. The sorts of photographs that for other Americans might always have remained private images became, in the case of Native Americans, pieces of

intensely public stories; stories invented and narrated by private entrepreneurs, by anthropologists, and by the federal government itself.

As was the case with landscape photography, the emergence of new photographic technologies helped reshape the social and commercial uses to which these photographs of Indians could be put. The capacity to make and market photographic views on paper infused every encounter between photographer and subject with new commercial possibilities; and as photographers contemplated how they might market a view they inevitably considered just what their prospective audiences might wish to see and purchase. The first photographer to market a set of paper images of the interior West—a set that included a number of images of Plains tribes—was the well-known painter Albert Bierstadt. In 1860, Bierstadt offered for sale fifty-two stereoscopic "Views in the Far West," made in 1859 when he accompanied Frederick West Lander's surveying expedition west into the Rockies.[62] The pictures, advertised in a photographic catalogue published by his brothers Charles and Edward, included eighteen views of Plains Indian peoples and their villages.[63] Although the pictures are sequentially numbered and supplied with brief titles, the listing neither traces the westward progress of the expedition, nor groups views of like subjects. Such narrative strategies would become more common as photographers gained experience marketing photographic views. Nonetheless, the Indian images acquire a particular meaning within the logic of the Bierstadts' list. While some photographs document the process of westward migration, show the ease with which rivers can be crossed, or picture landmarks along the way, others depict the Indians as nonthreatening, if exotic, peoples who would present little impediment to the westward flow of American people, merchandise, and political government. These first Plains Indian portraits to be widely marketed thus proved predictive of how countless others would be published and sold during the nineteenth century. From the start they were marketed as part of a broader cultural and political story about westward migration. The pictures had value less as documents of native life than as narrative elements in a story about the expansion of the American nation.

The earliest published reproductions of a series of Plains Indian photographs tell a similar tale. When Ferdinand Hayden illustrated his 1863 essay "Contributions to the Ethnography and Philology of the Indian Tribes of the Missouri Valley" with lithographic portraits based on the photographs James Hutton had made on the upper Missouri in 1859, he used literary captions to enlist his Crow and Arapahoe subjects as unwitting characters in a tale about assimilation and cultural accommodation. He

implicitly argued that the most valuable Indians were those who cooperated with whites and exhibited seemingly non-Indian behaviors. A "Shyenne brave" who provided linguistic assistance possessed "fine natural powers, quick perceptions and intelligence, increased by long association with the white." The Dakota medicine man "Iron Horn" was "a warm friend of the whites and has done much to harmonize difficulties among his people." The Yankton chief "Smutty Bear" managed "the affairs of his people with ability and prudence."[64] Such characterizations, of course, met the needs of the publisher and the imagined needs of the consumer, rather than the needs of the sitters themselves. And they simultaneously reconfirm the value and accuracy of the linguistic information provided by these men, while neutralizing any potential threats they might pose. Hayden's words are critical to the formulation of these public meanings for the pictures. If the portraits alone might seem to suggest any number of possible readings, the words restrict and clarify the ways in which Hayden wanted them to be understood. The intentions, needs, and ambitions of the sitters are nowhere to be found. In the public marketplace of viewers, Hayden's needs win out. And his memory of a complex cultural encounter becomes the dominant one, erasing whatever countervailing perceptions the other participants—including the subjects of these portraits—might have held.

Over the coming decades, the message put forth by photographers of Indians would be refined, but change little in its general message. The Indians existed as a foil and backdrop for the inevitable Americanization of the West. Though a single photograph, alone, might not be able to convey this message, photographs juxtaposed in pairs, arranged in series, or explicated with words could convey to the buying public the evolving story of the vanishing race. The story was not a static one. As the Indians ceased to be a military threat by the end of the nineteenth century, the pictorial and emotional quality of the story began to change. A loss that had once seemed necessary to enable American expansionism came to be viewed through the haze of romantic sentimentalism. It was a classic case of what the anthropologist Renato Rosaldo calls "imperialist nostalgia," a people mourning the passing of a world they themselves have transformed.[65] And indeed, in late-nineteenth-century America, Indian culture came to be valued most at precisely the same moment it seemed most likely to disappear—in no small measure as a result of federal political and military policies.

Commerce helped drive and shape the creation of the pictorial story of the vanishing race. The Omaha photographers Mitchell and McGowan, active in the mid-

Mitchell and Magowan, *Military Posts and Indian Views*. Cabinet card (verso). Nebraska State Historical Society

1870s, marketed their stereoscopic views of Sioux, Arapahoe, and Cheyenne subjects in several series, with the back of each image bearing the titles of all the pictures in the related group. This common practice not only saved the photographer money (by providing him with a printed mount he could use for a great many images) but gave the buyer a sense of how any one image fit into an organized sequence of views. The "Indian Chiefs Portrait Series" presented a group of tribal leaders in collectible form, and in its emphasis on military leaders—rather than women, children, or domestic genre scenes—subtly conveyed the idea of Indians as threatening military foes. But the companion series "Military Posts and Indian Views" conveyed the bigger story. The Plains Indians existed within the political and military context framed by American forts, outclassed by the superior technology and political power the military outposts represented. The chiefs featured in the other series of views were implicitly contained, rendered powerless by the framework in which they lived.[66]

The Yankton, Dakota Territory, photographer Stanley J. Morrow likewise tipped his hand in the mere organization of his stereoscopic views of northern Plains life. While sets of views of *Custer's Battlefield* and *Crook's Expedition Against Sitting Bull 1876* related the story of the military conquest of the Plains, and a set of views identified as *Local Series, Yankton* carefully documented the growing commercial prosperity of Yankton's downtown commercial district, his *Indian Series* was set apart. The eighty-three stereos, mainly of Sioux, Cheyenne, Bannock, and Crow subjects, existed as a

kind of separate story. It was as if Indians existed outside of history, outside the story of military actions or urban growth. The trajectory of change for white settlers might lead ineluctably upward. But for Indians, change could move only in the opposite direction. They did not act upon history; history acted upon them.[67]

Stereographs such as these generally had brief descriptive titles affixed to the front of their mounts, and often had on their backs the printed list of titles in a particular series of views. The somewhat larger images published in the cabinet or boudoir card format might have lengthier narratives or biographical accounts appended to the back of the photographic mounts that created more elaborate public meanings for the images. In 1882, for example, the Fort Randall, Dakota Territory, photographers Bailey, Dix, and Mead published a series of twenty-four photographs relating to Sitting Bull and his band of Hunkpapa Sioux, then confined to a military camp. There is no record of what the photographs might have conveyed to the subjects themselves. Without consulting the captions, Euro-American viewers might glean from the photographs evidence about tipi construction, information about the material culture of Lakota life, a sense of what a particular group of Lakota men and women actually looked like. And any frisson of fear they experienced would have been mitigated by the sight of the military men and their families, who were visible in many of the camp scenes, always standing or mounted on horseback, beside the seated and obeisant Indians. Consumers who paused to read the captions, however, would acquire even more information, less about the Lakota subjects, perhaps, than about how the entrepreneurial photographers thought they might best be described for the marketplace. In this case, the words inscribe Sitting Bull and his band with a kind of exotic strangeness and cunning, informing viewers that Sitting Bull lives with two of his nine wives and had fathered children by six of them. And they note that though he boasts of his battles with his Crow enemies, he is "too shrewd to acknowledge to having killed any whites." The words describing the division of labor within the community likewise convey an image of uncivilized strangeness and upturned conventions to a Victorian American audience. The photograph jokingly called *Woman's Rights* depicts "two squaws sitting beside their Teepe [sic], resting after carrying the wood seen beside them on their backs . . . for half a mile, while their leige lords and masters, (the noble red men,) are smoking." Again and again, words direct a reader's understanding of the pictures. Without words, how would one know enough to be intrigued by the picture of Eat Dog, who would steal dogs, "give all his food to the dog until he gets fat," then kill the animal to eat? Without words, how would one know that a particular seated man was in fact "a full

Bailey, Dix, and Mead, *Woman's Rights*. Albumen silver print, stereograph, 1882. Haynes Foundation Collection, Montana Historical Society

brother of the noted Indian, Brave Bear, (under sentence of death for murder)"?[68] The words spoke more loudly than the photographs, creating instructive tales where none were visible.

In a similar fashion, Zalmon Gilbert, a photographer active in Mandan, Dakota Territory, in the 1880s and '90s, used the printed biographies on his cabinet cards to create an abridged history of upper Missouri Indian life that focused on the Indians' cooperation with whites. Running Antelope, for example, "has always been a friendly Indian. . . . On several occasions he has been instrumental in saving the lives of white men, and was very much liked by the old settlers." Gray Bear "was a scout in General Terry's command. He was always considered a good scout and friend of the whites." Big John, "a famous man among the Rees and Upper Missouri Indians . . . has been a scout in the employ of the government for twenty years, and holds twenty 'good' government discharges."[69] While Bailey, Dix, and Mead stressed the strangeness of their

Indian subjects, Gilbert focused on the essential goodness of his. But despite their different narrative strategies, their basic argument was the same. The simultaneous existence of "good" and "bad" Indians (more or less equivalent to progressive and traditional ones) hinted at the possibilities for cultural transformation and thus reiterated the bigger story of which most nineteenth-century Indian portraits were a part: traditional Indian ways of life would fade before the superior values and mores of Euro-American culture.

Only in the Southwest, where the Pueblo Indians lived in long-settled communities that posed no threat to the growing American population of the territories, did photographers seem to imagine an enduring value for the quaint and decidedly non-threatening strangeness of native cultures. In the early 1880s, the Santa Fe photographers Bennet and Brown attached a lengthy caption to the backs of their mounted pictures of the nearby San Juan Pueblo: "The peculiar hopping-dancing to the dismal music of the Indian drums, and more dismal Indian chant; the strangeness and grotesque holiday costumes of the people, all are enough to excite the interest and curiosity of the most world-worn traveler."[70] Even here, however, Indian culture was not valued on its own terms so much as for its capacity to entertain world-weary tourists.

The celebrated before and after photographs made by J. N. Choate, official photographer for the Carlisle School in Pennsylvania, conveyed the widely told story of cultural transformation with scarcely any resort to printed words, relying on viewers themselves to imagine

Bailey, Dix, and Mead, *Woman's Rights*. Albumen silver print, stereograph (verso), 1882. Haynes Foundation Collection, Montana Historical Society

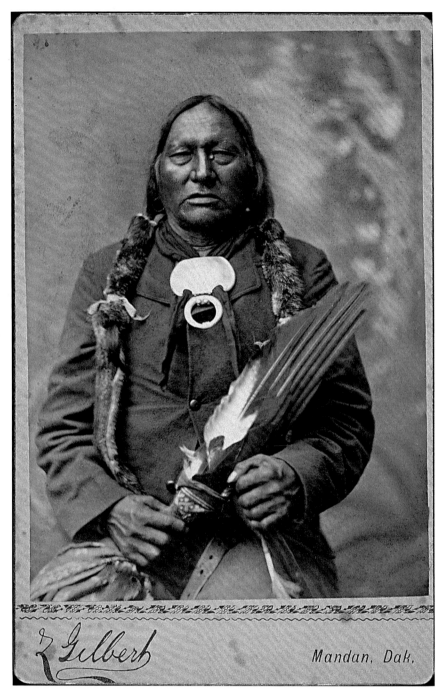

Zalmon Gilbert, *Running Antelope*. Albumen silver print, c. 1890. Yale Collection of
Western Americana, Beinecke Rare Book and Manuscript Library

the narrative links between the paired photographs of children made upon their arrival at the school with those made some weeks or months later. Invariably, the dishevelled Indian children with long hair and native dress in one picture would become neat, alert, and "properly" dressed young people in the second; their Indian names would be replaced by English ones, their dark skin lightened by darkroom magic. The school had been founded in 1879 by the reform-minded military officer Richard Henry Pratt, who firmly believed that "the Indian must die as an Indian and live as a man." To lead the Indian from barbarism to civilization, it was necessary to isolate him from his tribal community and customs. In training schools such as Carlisle, located at some remove from its students' reservation communities, young Indians would shed the cultural and physical trappings of their tribal cultures and acquire the language skills and technical training that would equip them to live as fully assimilated citizens of the United States. For Pratt, Choate's carefully orchestrated photographs provided the visual aids he needed to prove the efficacy of his argument; in the transformed appearance of the sitters was evidence of deep cultural and spiritual change, a progressive trajectory from barbarism to civilization.[71]

Such an emphasis on "good" Indians in part represents technical imperatives. Though a St. Louis newspaperman might note with forced jocularity in 1878 that a series of Indian views made by the Sioux City, Iowa, photographer J. H. Hamilton "are quite refreshing from this standpoint, when we know there is no danger of losing our scalp," few photographers ever put themselves in true danger to make their

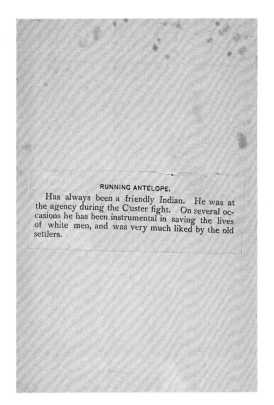

RUNNING ANTELOPE.

Has always been a friendly Indian. He was at the agency during the Custer fight. On several occasions he has been instrumental in saving the lives of white men, and was very much liked by the old settlers.

Zalmon Gilbert, *Running Antelope*. Albumen silver print (verso), c. 1890. Yale Collection of Western Americana, Beinecke Rare Book and Manuscript Library

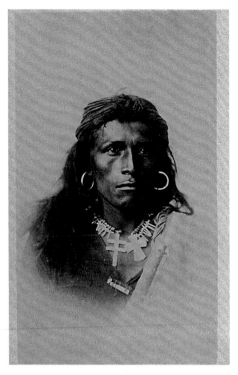

J. N. Choate, *Tom Torlino, Upon Arrival at
Carlisle Institute.* Albumen silver print, 1882.
Yale Collection of Western Americana,
Beinecke Rare Book and Manuscript Library

J. N. Choate, *Tom Torlino, After Arrival at
Carlisle Institute.* Albumen silver print, 1885.
Yale Collection of Western Americana,
Beinecke Rare Book and Manuscript Library

Indian portraits.[72] The slow, laborious process of making and exposing the wet-plate negatives still in use in the early 1880s made it all but impossible to make photographs under anything other than carefully controlled and orchestrated conditions, a circumstance that put photographers at a considerable disadvantage with regard to their artistic brethren. Painters could simply invent lurid scenes to appeal to popularly held ideas about Indian savagery—hence a plethora of mid-nineteenth-century paintings depicting wagon train attacks, the abduction of white women, frightening ceremonial scenes.[73] But for photographers, who were hard-pressed to capture action, it was easier to render the Indians exotic, archaic, or even friendly. Thus, in the mid-1880s, when the Tucson photographers Henry Buehman and F. A. Hartwell wanted to portray Apaches as a particularly fierce and warlike people, they actually photographed a *painting* of

some well-armed Apaches stalking white miners and issued it in the same mounted format as the rest of their series on Arizona Territory Indian life. The caption and the photograph of the painting conveyed what no photograph of an actual scene could depict: "The Apaches made prospecting dangerous and tragical."[74] Such an image reiterates the degree to which photographers who wanted to depict native subjects as hostile or dangerous generally had to resort to visual subterfuge or words to impute such meanings to their pictures. And except in egregious cases such as that of the painted Apaches, who would be wise to such stratagems? It seems unlikely, for example, that many viewers of Eadweard Muybridge's carefully titled 1873 Modoc War stereograph *A Modoc Brave on the War Path*, would actually know that the subject was not a hostile Modoc at all, but rather a Warm Spring Indian scout working for the United States Army, transformed into the enemy by literary sleight of hand.[75]

But the emphasis on "good" Indians reflected more than just personal opportunity on the part of the photographers. The very word hints at the cultural absolutism and

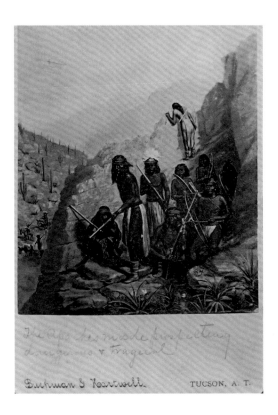

virulent racism in American thought that helped create a commercial market for some truly horrific pictures. Consider, for example, a late-nineteenth-century commercial stereograph published by the Miles City, Montana, photographer Laton Huffman, best known for his pictures of Yellowstone and his documentation of cowboy life. The picture depicts an Indian lying beneath a scaffold in front of what looks like a stockade; at a casual glance he would appear to be asleep. A handwritten caption on the back of one copy of the print reveals

Henry Buehman and F. A. Hartwell, *Apaches in Ambush.* Albumen silver print, c. 1885. Arizona Historical Society, Tucson (AHS #9645)

that the subject of the photograph is in fact dead, having committed suicide in the Miles City jail. Such words are sobering enough, and reflect a particular knowledge not every viewer of the print would have. But Huffman's printed caption cuts right to the heart of the racial prejudice that lay behind so many visual characterizations of Indian peoples and cultures. The caption declares that this is stereograph number 26, *A Good Indian*.[76]

The biggest publisher of Indian pictures during the nineteenth century was probably the federal government. In 1858, the Washington, D.C., photographers Julian Vannerson and Samuel Cohner, both in the employ of the James E. McClees Studio, made a systematic effort to photograph the ninety delegates from some thirteen tribes who were in the nation's capital to engage in treaty negotiations. The following year, the Smithsonian Institution's first secretary, Joseph Henry, proposed that the government take on such a photographic documentation project of its own. His words went unheeded until 1865, when a terrible fire destroyed the Smithsonian's art collection, which included most of the delegation paintings that Charles Bird King had made for Thomas McKenney some four decades before. Henry then suggested it was time "to begin anew . . . a far more authentic and trustworthy collection of likenesses of the principal tribes of the US. The negatives of these might be preserved and copies supplied at cost to any who might desire them." Although Henry failed to secure government funding for a grand project, contributions from photographers and private philanthropists resulted in a collection of Indian portraits on deposit at the Smithsonian by the late 1860s.[77]

In 1869, Washington photographer A. Zeno Shindler produced for the Smithsonian a catalogue of 301 of these images titled *Photographic Por-*

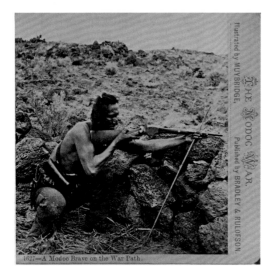

Eadweard Muybridge, *A Modoc Brave on the War Path*. Albumen silver print, stereograph half, 1873. Courtesy of the Bancroft Library, University of California, Berkeley (Bancroft Pic 1971 055:1626-ster)

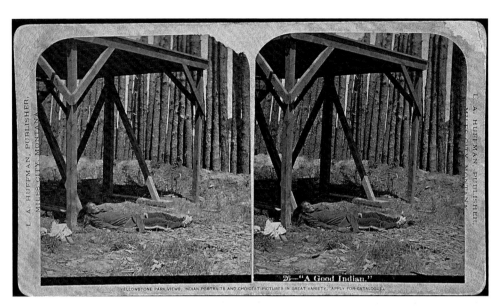

Laton A. Huffman, *A Good Indian.* Albumen silver print, stereograph, 1879. Montana Historical Society

traits of North American Indians in the Gallery of the Smithsonian Institution. The listings generally provide simple, bare-bones information—a catalogue number, the transliteration of an Indian name, an English translation of that name, a tribal identification (often with an indication of the subject's status as warrior, chief, or head-man), and a general indication of the geographical area in which the subject resided. With few exceptions the subjects were males, and a disproportionate number were chiefs, not surprising since many of the portraits depicted delegates sent to Washington, D.C., on behalf of their tribes.[78]

Only a few of the catalogue entries include more extensive biographical or anecdotal information, but these expanded narratives construct a public meaning and a moral message for the entire collection of photographs. The "good" Indians are those whose mixed blood or friendly actions mark their capacity to transcend their seeming racial destiny and move toward cultural assimilation. Thus the catalogue writers make special note of several Choctaws of mixed European/Indian heritage, and single out for special attention: two Indians who rescued a group of white women and children from "hostile Indians"; a loyal guide who—despite grievous wounds inflicted by hostile

Indians—led General Sibley's military expedition through the badlands of Dakota; and a wealthy Isleta Pueblo man who loaned money to the American government in New Mexico. They likewise identify a handful of "bad" Indians, including a leader of the so-called Minnesota Massacre of 1862. With words, Shindler thus imputes broader cultural meanings to seemingly neutral photographs, reminding us that most portraits have little capacity to evoke emotional responses or convey specific historical information without the contextualizing words that direct a reader's response.

The far more elaborate *Descriptive Catalogue of Photographs of North American Indians,* prepared by photographer William Henry Jackson and published under the aegis of geologist Ferdinand V. Hayden's Geological Survey of the Territories eight years later in 1877, incorporates most of the images from the Shindler catalogue but augments them to create a much more complex narrative about Native American life. The collection, Hayden claimed, now included over one thousand negatives, "representing no less than twenty-five tribes," and was destined to have enormous historical value, for the "present" recorded in these photographs, made over a period of twenty-five years, was already the past. "Many of the Indians portrayed have meanwhile died," Hayden wrote, "others, from various causes are not now accessible; the opportunity of securing many of the subjects, such as scenes and incidents, has of course passed away."[79] When the Indians themselves were gone, these pictures would remain, silent substitutes for the untidy realities of lived experience.

In explaining the construction of the catalogue, Jackson noted that "particular attention has been paid to proving the authenticity of the portraits of the various individuals represented." He included the physical measurements of the subjects whenever possible, and pieced together his biographies from published works, from the Indian delegates themselves, and through "correspondence with agents and others living in the Indian country."[80] In an age in which physiognomy and phrenology were widely regarded as indices of human character and abnormal behaviors, Jackson's attention to such details underscored the perceived importance of the collection as an archive of information, valuable to historians and anthropologists alike. But it was an archive organized and controlled by its government creators, and they alone spoke for their Indian subjects. In the public arena, the Indians pictured in these photographs were mute; they had no identity, no history, save that invented for them by someone else.

The portraits described in the *Descriptive Catalogue* were at once documents of particular people and bits of data whose value lay in the aggregate. Accordingly, each

portrait was labeled with a name *and* number upon its face, an inscription that simultaneously marked each picture with what the critic Alan Sekula has called its "honorific" and "repressive" functions.[81] The name and number referred the catalogue reader to a biographical entry that gave selective attention to the subject's life, emphasizing those events or circumstances that best served the needs of the editors. But the number simultaneously suggested that each photograph took its meaning from its place within the broader grid of visual and literary information represented by the collection and publication project as a whole; each photograph was a bit of scientific information equivalent to any other. In his catalogue introduction, Hayden explained that "front and profile views have been secured whenever practicable," but he apologized to anthropologists for one seemingly "insurmountable" problem. "Usually it is only when an Indian is subjected to confinement," he wrote, "that those measurements of his person which are suitable for anthropological purposes can be secured." Indeed, who among Hayden's own intimates would wish to be prodded and measured by metal calipers? For Hayden and his professional peers, anthropology was not so much the study of peoples, as the study of peoples quite unlike oneself. "In most cases the Indian will not allow his person to be handled at all," Hayden wrote with dismay, "nor submit to any inconvenience whatever."[82] In the government's Indian catalogue, photographs did not provide the information to support new historical or anthropological theories. Those stories were already in place, and the captions that enveloped the photographs—photographs which to all appearances could support any number of theoretical stories—carefully conscripted the photographs as bits of supporting evidence.

The central story of the catalogue was a straightforward and familiar narrative of progressive civilization, the discarding of old ways in favor of the new. The Lakota peoples living on the lower Missouri and in eastern Dakota, according to the text, were "nearly self-supporting. The Santees in Nebraska especially have entirely renounced their old form of life; have churches and sabbath-schools, which are regularly attended." They even had a monthly tribal newspaper. The Omahas were successfully turning to agriculture and had three good schools. Their "older Indians are also abandoning their old habits and assisting in building for themselves upon forty-acre allotments of their lands." The Osage were "making rapid progress toward a self-supporting condition." The Pawnees "have well-organized day and industrial schools, and are well-supplied with implements and means to carry forward a systematic cultivation of the soil."[83] Things remained a bit more problematic on the northern Plains, where on

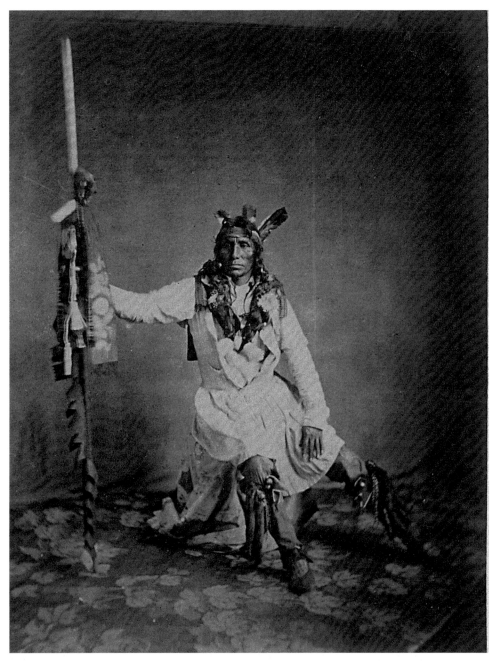

Julian Vannerson and Samuel A. Cohner (James E. McClees Studio), *Little Crow [Tshe-ta' Wa-ku'-wa Ua-ni]*.
Albumen silver print, 1858. Yale Collection of Western Americana, Beinecke Rare Book and
Manuscript Library

the Crow reservation, for example, "the best farming lands . . . are most exposed to these hostile incursions." Nonetheless, "a mile and a half of ditch, sufficient to irrigate several hundred acres, has been dug, and it is hoped that another season will see at least a beginning made toward the civilization of these 4,000 wild but always loyal Crows."[84] In dozens of similar tribal histories, Indians surrender to the federal government, "restless young raiders" move into log houses, pagans become Christians. Portraits alone could not sustain such a narrative of cultural transformation. But wedded to words, the photographs tell the tale of the progression from savagery to civilization. It was a story akin to the tale of progress narrated in countless photographs and prints that documented the transformation of the American frontier. But where white Americans' Manifest Destiny led them toward the realization of their greatest potential, the Indians' Manifest Destiny led them toward cultural destruction.

While the brief tribal narratives made broad, sweeping generalizations about the histories of the different culture groups, shorter narratives in Jackson's publication explicated many of the individual portraits. These brief biographical sketches appeared both in the published catalogue and on the backs of the portraits given away and sold by the government. Anyone who purchased a portrait could turn it over and be instructed as to its meaning and significance. One could learn who was well-spoken, well-developed, or well-off. One could learn that the Mdewakanton leader Little Crow, who "had not only visited Washington, and was supposed to be friendly to the whites, but had promised to have his hair cut and become civilized," later led a group of Sioux against the whites in the so-called Minnesota massacre of 1862. Little Crow's biographical sketch notes that he was killed after fleeing into Canada, and deftly transforms the portrait from one that could serve as a parable for civilizing progress to one that represents a cautionary tale of deceit and treachery.[85] The portraits in the catalogue thus function synecdochically, with the life stories of individuals recapitulating and predicting the imagined histories of large culture groups. In the individual tales of treachery and assimilation, disaster and progress, would-be buyers of the photographs could read the entire history of the vanishing race.

The vanishing race narrative articulated in the Jackson catalogue with picture and word, played in a kind of musical counterpart to two other photographic narratives promulgated by Hayden and his fellow expedition leaders of the 1870s. The first, pieced together from the grand western landscapes made by the survey photographers,

Thomas M. Easterly, *Big Mound, Fifth and Mound Streets*. Daguerreotype, half-plate, c. 1854.
Missouri Historical Society, St. Louis

presented a progressive vision of American life in which the nation would expand into an empty region whose wondrous natural resources were there for the taking. The second narrative, supported by pictures of the ancient Indian sites of the Southwest, looked back to an heroic Indian presence in the West and claimed it as part of America's national legacy. One narrative looked resolutely to the future, the other to the past. But both sounded triumphant notes of American nationalism that played in counterpart to the sad dirge of the vanishing race.

In the story woven with and around the surveys' landscape photographs, the West seemed a place that scarcely had a past; its meaning and importance lay in the future, in its potential as a site of natural wealth and spiritual renewal for the expanding American nation. Such a transcendent, forward-looking narrative depended on the imaginative erasure of the land's native inhabitants whose very presence challenged the

Thomas M. Easterly, *Big Mound, Looking East from 5th and Mound Streets*. Daguerreotype, half-plate, 1868–9. Missouri Historical Society, St. Louis

notion of the West as an empty and available landscape, and whose different ways of life challenged the moral righteousness of other American systems of land use and settlement. This progressive narrative of settlement supported by the landscape photographs coexisted in a kind of unexamined intimacy with the parallel narrative of decline supported by photographs of native peoples and their worlds. If decisive action implicitly animated and made possible the narrative of settlement and expansion, the parallel tale of the vanishing race was a curiously, if necessarily, passive story that hinged upon the inevitability of Indian decline. Native people would disappear through the machinations of fate—not warfare, legal chicanery, competition for scant resources, or economic exploitation. With the quiet waning of savagery would come the noisy triumph of civilization.

Thomas M. Easterly, *Destruction of the Big Mound*. Daguerreotype, half-plate, 1869.
Missouri Historical Society, St. Louis

The second photographic story that emerged to play in an uneasy and complicated counterpoint to the pictorial story of Indian decline devolved around pictures of archeological sites. The rhetoric of the vanishing race ideal instructed Americans to devalue and dismiss native cultures, but the language cast out with the photographs of the cliff dwellings, watchtowers, and other architectural wonders of the arid Four Corners region spun a quite different tale of cultural competence and resourcefulness. In photographs of the ruins, Americans were asked to see a favorable, even laudatory, image of Native American life, evidence of an heroic and indigenous heritage for their national identity. If the landscape photographs ignored the Indian history of the West in order to downplay the importance of contemporary native peoples to the region's unfolding future, the photographs of ruins looked resolutely to a distant native past, so

Thomas M. Easterly, *Big Mound During Destruction*. Daguerreotype, half-plate, 1869.
Missouri Historical Society, St. Louis

glorious and remote that it, too, seemed to exist at an unbridgeable divide from the world of the nineteenth-century Indians.

The first series of photographs of early Indian sites had actually been made far from the desert Southwest in the burgeoning industrial metropolis of mid-nineteenth-century St. Louis by the eccentric daguerreotypist Thomas Easterly, whose own career marked his peculiar devotion to things of the past. He continued using the daguerreotype process until 1880, more than two decades after nearly every photographer had abandoned it in favor of the more commercially viable wet-plate negative process. He photographed shiny train locomotives, crowded steamboat wharfs, and the construction of new civic buildings in downtown St. Louis, all marks of the city's headlong rush into the industrial future. But he also documented the remaining architectural evidence

of St. Louis's French and Creole past, deliberately calling into question the virtues of urban growth and material progress. With a similar devotion to history that set him apart from his peers who were more eager to use their craft as a tool of civic boosterism, he also produced his most remarkable series of pictures, a systematic record of the destruction of the so-called Big Mound. The mound was one of just two sites that remained from the twenty-seven Mississippian burial mounds (1000–1400 A.D.) that had once dotted the area that became St. Louis. Despite its archeological significance, it merited little respect in an age of urban expansionism. A restaurant had been erected on its peak in 1844 (and burned a few years later), and by 1852–4, when Easterly first pictured the mound, its base had begun to be scraped away to provide material for road construction. Slowly and steadily, the Big Mound shrank. In 1868, workers for the Northern Missouri Railroad removed the last bits of artifact-laden earth to use as fill for a railway bed, and the mound site became just another building site. In Easterly's daguerreotypes, the large hill of earth becomes a mere splinter of hard packed dirt, just big enough to support a man daring enough to balance on its narrow top. The clash between the past and future could scarcely be pictured in starker terms: an Indian past was destroyed to become the literal foundation of an American future. In an era when the progress of the American nation and the disappearance of her Indian peoples were parallel stories that animated one another but scarcely ever intersected in obvious or explicit ways, Easterly's photographs sound an odd note of regret. And they stand virtually alone as nineteenth-century photographs that implicitly denounce an active and deliberate assault on Indian culture. Easterly died a pauper in 1882, his antiquarian photographs and odd ideas stirring little interest.[86]

Yet increasingly, as photographers began to document the rich archeological holdings of the Southwest in the 1870s, there emerged a larger body of photographic work that—unlike contemporary pictures of the western landscape—could scarcely ignore the fact of an historical Indian presence in this part of the United States. Easterly had been presented with a ready-made story, and with his camera he watched it move toward its inevitable denouement. What visual story, though, might be told about the amazing prehistoric stone structures being discovered in the Southwest? Precisely because they were remote and presented no impediment to urban development or rural settlement, they could be admired and even valorized. But how could one celebrate Indian cultures of the distant past while continuing to discount and denigrate those of the present?

American writers and natural scientists had first asked such questions in the late-eighteenth and early-nineteenth centuries as they attempted to make sense of the monumental earthworks and mounds of the Ohio Valley. Because the sites seemed to yield few clues as to their true origin, they readily took on the cultural meanings projected on them by others. And so to America's intellectual elite, the mounds of earth became proof of the nation's cultural antiquity, a New World counterpart to the ruins of Greece or Rome, that at last gave the nation a deep heritage of her own. If the ruins belonged to an *American* past, how did they relate to an Indian present? Rejecting the explanations of local Indians, writers developed elaborate stories to envelope the ruins within a national narrative. Noah Webster even speculated in 1790 that the Mound Builders were descendants of Mediterranean peoples, who were displaced in the New World by Siberian Tartar invaders. Forced out of their Ohio Valley homes, the Mound Builders moved south to construct the great ancient cities of Mexico and Peru, while the barbarians—not truly *native* Americans themselves—stayed behind to become the people known as North American Indians. It was, writes the scholar Gordon Sayre, "an imperial historiography in which western frontiersmen became the heirs to a classical civilization."[87] The present-day Indians were easily dismissed as latter-day marauders, a people without any legitimate claim to the heroic architectural sites of the distant past.

The discovery of the ancient ruins of the Southwest provoked similar theories. Americans had first become aware of the Southwest's archeological riches during the 1840s and '50s when the Topographical Engineers and other explorers and travelers began to publish accounts of their southwestern ventures. While on a military reconnaissance across the region in 1846–7, during the war between the United States and Mexico, Lieutenant Colonel William H. Emory had proposed a possible connection between the pueblo tribes of New Mexico and Aztecs of central Mexico based on an examination of present-day pueblo architecture.[88] But such cultural and historical arguments quickly came to depend more upon the examination of earlier archeological sites. The spectacular ruins sprawling across Chaco Canyon in western New Mexico and the dramatic "Casa Blanca" or "White House Ruins" tucked up against a cliff wall in Canyon de Chelly drew particular attention from the writers who—in the midst of their military, topographic, or commercial reconnaissances—struggled to make sense of who could have constructed these multistory structures and what the fate of such people might have been. In the late summer of 1849, Lieutenant James H. Simp-

After Richard Kern, *North West View of the Ruins of the Pueblo Pintado in the Valley of the Rio Chaco.*
Lithograph, in James M. Simpson, *Journal of a Military Reconnaissance from Santa Fe, New Mexico, to the Navajo Country* (1852). Yale Collection of Western Americana, Beinecke Rare Book and Manuscript Library

son of the United States Army Corps of Topographical Engineers set out to accompany a military expedition against the Navajos led by Brevet Lieutenant Colonel John M. Washington, the governor of New Mexico, a territory but recently acquired for the United States. While Washington focused on military strategies, Simpson was to study and elucidate the topography and natural history of the region, and he had with him the brothers Richard and Edward Kern, both accomplished artists, who would help illustrate "the personal, natural, and artificial objects met with on the route."[89] In his 1852 report, Simpson included a number of lithographs of the Chaco ruins based on Richard's field sketches, along with additional illustrations of pottery found at the site. And in his own words he suggested how Americans might understand these strange sites in the newly acquired land of the American Southwest. In the masonry of the Chaco ruins, he wrote, was "a combination of science and art which can only be referred to a higher stage of civilization and refinement than is discoverable in the works of Mexicans or Pueblos of the present day." He thus found it perfectly plausible when a Jemez Pueblo guide told him that the structures had been built by Montezuma and his people on their way south. A Navajo informant gave him the same information.

And through a tortured logic and peculiar reading of previous historians—including Humboldt and Prescott—Simpson concluded that it was likely that Chaco was, indeed, of Aztec origin. How then to explain the connection between its ancient inhabitants and the present-day denizens of the Southwest? He left open the possibility that Zuni Pueblo, and perhaps the other pueblos as well, might house the descendants of the Chacoans: architecture pointed to such a possibility, though the diverse pueblo languages mitigated against a common origin. But the Navajos confused him. They were extraordinary weavers, yet they lived in what to Simpson seemed "rude *jacales.*" If these were descendants of the Chaco people, "how is it," he asked, "that they have retrograded in civilization in respect to their habitations, when they have preserved it in their manufactures?"[90]

For Simpson, as for the travelers and explorers who followed him, there seemed two widely divergent ways to understand Indian culture. There was, on the one hand, evidence that Indian peoples in the newly acquired southwestern land of the United States had reached astonishing peaks of cultural achievement, as revealed in the architectural remnants of their elaborate cities, ceremonial sites, and dwelling places. But on the other hand, Indians remained the enemy (Simpson, after all, had come upon Chaco as part of a military campaign against the Navajo), and present-day tribal cultures were clearly inferior to the culture of Euro-America. If the Aztec theory strained historical credulity, it was nonetheless politically expedient. For if the Chaco people had moved south to develop the great Aztec civilization of Mexico, the United States could at last claim some culturally important ruins and an ancient past of her own. And if the Aztecs has subsequently disappeared, well, that was the fault of the Spanish. The contemporary pueblo communities stretching from the Rio Grande west to the Hopi mesas might help one understand the seemingly related architecture to be found at the archeological sites. But analogous communities did not imply social or cultural equity. The present-day Indians of the Southwest were scarcely the equals of the people who had built the great cities and pueblos of Chaco; if the ancient people merited veneration, the contemporary ones did not.

The post–Civil War surveyors and photographers who explored the ancient ruins of the Southwest and created some of the first photographs of important archeological sites operated within the climate of understanding created by their antebellum artist and explorer predecessors. While working for Lieutenant George Wheeler in 1873, Timothy O'Sullivan photographed the impressive White House ruins in Canyon de Chelly, and the following season he pictured some ruins on the San Juan River in New

Timothy O'Sullivan, *Ancient Ruins in the Canon de Chelle, N. M.* Albumen silver print, 1873, from George M. Wheeler, *Photographs . . . Obtained in Connection with Geographical and Geological Explorations and Surveys West of the 100th Meridian* (1874). Yale Collection of Western Americana, Beinecke Rare Book and Manuscript Library

RUINS IN ANCIENT PUEBLO OF SAN JUAN, COLORADO.

Timothy O'Sullivan, *Ruins in Ancient Pueblo of San Juan, Colorado [New Mexico]*. Albumen silver print, 1874, from George M. Wheeler, *Photographs . . . Obtained in Connection with Geographical and Geological Explorations and Surveys West of the 100th Meridian* (1874). Yale Collection of Western Americana, Beinecke Rare Book and Manuscript Library

Mexico. In the published caption that explicated O'Sullivan's photograph of the ruins, Wheeler explained that "this ruin is characteristic of an ancient people and civilization of which the present tribes know nothing, not even in tradition." But Wheeler was scarcely reluctant to repeat the story that "the Aztec race . . . centuries ago inhabited this San Juan region" before being led south to Mexico by Montezuma and erecting the great cities subsequently found by Cortez.[91] Working in the Canyon de Chelly in 1877, the commercial photographer H. T. Heister noted that the prehistoric cliff dwellings he photographed were built by "hands of no mean skill," and in the absence of any hard evidence spun a fantastic story about the architects of these ruined structures. They were, he decided, "civilized" and "peaceable" Indians, whose "pictures and hiero-

glyphics" undoubtedly recorded their history and whose handprints on the walls seemed proof that they had invented the art of printing "before it was thought of in Europe." However, though, did they reach their precarious cliff-side homes? Heister had no idea; he could only joke that they must have had wings. Almost the only thing of which he could be absolutely sure was that there was a "great contrast" between these marvelous cliff dwellers whose "permanent buildings" had withstood the "ravages of centuries," and the present-day Navajo inhabitants of the canyon, who lived in rude shelters.[92] The village-dwelling Pueblos, he thought, might be "the remnants" of the Aztec and Toltec peoples.[93] But any study of the comparative material culture of the two periods made clear that there had been a trajectory of decline.

The photographer who compiled the most comprehensive early visual record of the ruins steered away from such speculation about lines of descent, though he, too, made telling contrasts between the cultural sophistication of the ruins' architects and the Southwest's present-day native peoples. William Henry Jackson first came upon the ruins, nestled high up into the walls of the side canyons along the Mancos River in southwestern Colorado, in the summer of 1874 while working for F. V. Hayden's Geological and Geographical Survey of the Territories. Hayden had sent Jackson, who was in command of his own small party, off "in search of the picturesque and interesting ruins of a long-forgotten race."[94] With only two weeks to travel west from the survey's camp in the San Juan Mountains, locate and explore the ruins, and return, Jackson determined to focus on those sites "in which the picturesque predominated." Thus predisposed to focus on the most dramatic sites, he came away from his travels convinced that the "old ruined houses and towns" displayed "a civilization and intelligence far beyond that of any of the present inhabitants of the adjacent Territory." Hauling his chemicals and his 5×8 and stereo cameras up and down the rock walls that sheltered the precariously situated cliff dwellings, he made some forty negatives that documented the architecture of the sites and depicted the ways in which they fit into the surrounding landscape. It was the adventure of the project as much as the architecture itself that seemed to instill within him a sense of awe at the cliff dwellers' life. He marveled at their "wonderful perseverance, ingenuity, and . . . taste," and was amazed at their "temerity." Eventually, he and his party left the Mancos River canyon, turning their "backs upon these relics of a forgotten race" with "many regrets." The naturalist Ernest Ingersoll, who accompanied Jackson on the trip, speculated that the ruins had once been occupied by a peaceful and prosperous people who had been driven from

their homes by "their troublesome neighbors—ancestors of the present Utes," a useful hypothesis that seemed to legitimate the ongoing government efforts to persuade the Utes to abandon their nomadic life. Avoiding any speculation about a connection to the Aztecs, Ingersoll reasoned (presumably on the basis of apparent architectural similarities), that the Hopis might be descendants of the cliff dwellers. But they seemed to preserve "more carefully and purely the veneration of their forefathers than their skill or wisdom," he wrote.[95] One could, in other words, venerate the builders of the ancient ruins—always imagined from the start as a peaceful people—without having to extend any sort of equal respect to the region's present-day native inhabitants.

"The first trip proving so successful," Hayden sent Jackson back to explore and photograph the ancient ruins of the Four Corners region during the 1875 survey season. The pictures from 1874 had been widely distributed, and "excited a very general interest," Hayden wrote. With his "uncompromising lens," Jackson had captured remote sites few could see for themselves, and his pictures could be sent "all over the world, and practically answer the purpose of a general inspection." In 1875, Jackson thus returned to the Mancos River region (though he and his party never stumbled across the spectacular ruins that would later become the centerpiece of Mesa Verde National Park), then traveled south to Canyon de Chelly and west to the Hopi mesas. The pictures would serve many uses, Hayden claimed. They could be enlarged to produce transparent images on glass in which "the varied details of an old ruin" could be "brought so vividly before the eye that they can be studied to much better advantage than in nature, the mind being in rest, and far from the perplexities of the surroundings." They would likewise prove useful to Jackson and others at work on preparing scale models of the ruins that would represent the survey "as forcibly as possible" at the 1876 Centennial Exhibition in Philadelphia.[96]

For Hayden, the ruins evoked images of an "old, old people, whom even the imagination can hardly clothe with reality," and he, too, posited a story of cultural decline to explain any possible linkages between the architects of the ruins along the Mancos River and the present-day Hopis. Any comparison, he wrote, was "very much in favor" of the ancient builders. "The highest perfection was reached in the cliff-houses of the Rio Mancos, then traveling toward the Moquis [Hopis], there is a gradual merging of one style into the other, from the neatly-cut rock and correct angles to the comparatively crude buildings now inhabited."[97] Such architectural evidence, preserved in field sketches and photographs, joined the ceramics and stone tools that Hay-

William Henry Jackson, *Cliff House. Rio San Juan*. Albumen silver print, 1875. Yale Collection of
Western Americana, Beinecke Rare Book and Manuscript Library

den collected as well, and provided critical documentation for the two stories he
sought to tell—that of the decline of America's Indians, and that of the incredible rich-
ness of the western landscape. Jackson, too, seemed to regard his photographs as sim-
ply one kind of evidence. As he photographed, he also collected stone tools, ceramics,
and even skeletal remains, sometimes disinterred from Indian graves.[98] Photography
was the means by which the immovable ruins, like these other archeological specimens,
could be acquired, possessed, and used to simultaneously represent and explain a cul-
ture that had died away. Like the ruins themselves, photographs were fragments of a
bigger whole, mute representations of another world that could speak only through the
words and imaginings of those who looked at them.

In 1875, Jackson published his catalogue of the photographs made on the Hayden
survey, providing short narratives for his pictures of Yellowstone, his celebrated photo-
graph of the Mount of the Holy Cross, his images of the Rockies. The publication
included few of the Indian portraits or group shots Jackson had made in conjunction
with the survey; several views of Hopi architecture—seemingly ageless in appearance—

provide almost the only visual references to contemporary Indian life. Jackson's Indian portraits, along with those gathered from private and government sources, instead appeared in his separate 1877 catalogue, the *Descriptive Catalogue of Photographs of North American Indians,* which so explicitly laid out the inevitability and logic of the vanishing race in its summary histories of tribes and its descriptive biographies of selected individuals. Where to put the photographs of Indian ruins? With the portraits of the Indians themselves or with the pictures that laid out the natural wonders and economic potential of the western landscape? One could imagine an argument being constructed in favor of either option. The pictures might be used to support the rhetoric of cultural decline, or promoted as pictures of yet another one of the West's natural wonders, worthy of the attention of potential tourists. In the end, Hayden and Jackson opted to include the photographs of the Mancos Canyon cliff dwellings, the Hovenweep towers, and the ruins at Aztec Springs in the catalogue devoted to the wonders of the natural landscape. Within the context of the Indian catalogue, such pictures might have reinforced a narrative of decline. But they would also have raised troubling questions about the value of native cultures. What if there was, in Indian culture, something to be truly valued and treasured? Such a possibility would surely complicate the logic of the vanishing race rhetoric and cast into doubt the government's own emphasis on assimilation and the eradication of strong tribal cultures. Moreover, placed within the landscape catalogue, the ruins seemed to exist as truly *American* sites and resources, as pieces of a national heritage.

With the discovery of the most spectacular cliff dwellings at Mesa Verde in the late 1880s, an event nearly simultaneous with the advent of the handheld Kodak camera, increasing numbers of amateur and professional photographers turned their attention to the seeming wonder of America's newly discovered ancient past. And so, too, did pothunters. In response to a growing problem of private artifact hunting on public lands and to a burgeoning interest in preserving the ancient ruins of the Southwest, Congress passed the so-called Antiquities Act in 1906, which allowed the president to act by executive fiat to reserve as national monuments sites on federal land deemed to have significant prehistoric, historic, or natural features. During the next two years, President Theodore Roosevelt acted to preserve: a large Hohokam and Hakataya Indian structure in Arizona, known as Montezuma's Castle; more than seventeen thousand acres encompassing the ruins spread throughout Chaco Canyon; the Gila Cliff Dwellings in southwestern New Mexico; and even the Grand Canyon, a site that would

become a full-fledged national park just a few years later, in 1919. The framers of the Act regarded the preservation of prehistoric ruins as an end in itself. But the political arguments made on the bill's behalf revealed a broader set of concerns. In decisively taking charge of the ruined remnants of a civilization that had tried, but failed, to keep a toehold in the harsh environment of the American Southwest, Euro-Americans subtly asserted their superiority and demonstrated their confidence that their own way of conquering the environment was the best. And in sharply restricting native use of prehistoric sites that happened to be within the newly established national monuments, the Act suggested that professional archeologists—not native peoples themselves— were the best stewards of America's ancient past. "With the Antiquities Act," writes archeologist David Hurst Thomas, "Congress had legally defined the American Indian past as part of the larger public trust, like Yellowstone and the American bison."[99] Jackson's photographs had already done much the same thing, presenting the southwestern archeological sites as part of a national story that had little to do with the unfolding trajectory of contemporary Indian life.

Early on in the history of photography, commentators noted the photograph's capacity to preserve details that had gone unobserved by the photographer himself. "This is one infinite charm of the photograph," the essayist Oliver Wendell Holmes wrote in 1859. "Theoretically, a perfect photograph is absolutely inexhaustible. In a picture you can find nothing which the artist has not seen before you; but in a perfect photograph there will be as many beauties lurking, unobserved, as there are flowers that blush unseen in forests and meadows."[100] For Holmes, a photograph seemed a set of objective facts, captured both intentionally and unintentionally by the photographer's choice of framing, and he suggested, indirectly, that a photograph might not reveal its wealth of detail to every viewer in precisely the same way. Different observers, with different interests and questions in mind, might find different sorts of material information locked within the photographic image. Pictorial value was in the eye of the beholder. The photograph of a Boston street scene, for example, might yield one type of information to an architectural historian, a different sort to an arborist, and yet a different kind of data to a student of contemporary clothing styles. Likewise, the portrait of a nineteenth-century Lakota man might convey one kind of information to a cultural anthropologist or art historian interested in beadwork, and quite a different sort to a descendent interested in tracing a particular physical trait.

Yet photographs do more than preserve information; they also evoke memories, elicit stories, and stimulate ideas. And such associations are more likely to be triggered and shaped by a viewer's own experiences than by a photographer's intent. Ultimately, the interpretation of photographs is thus a culture-bound activity, shaped by broad social practices, cultural conventions, and personal experience. Twenty-first-century viewers bring to early photographs different kinds of knowledge and expectations than did their nineteenth-century counterparts. Native American viewers find in pictures of their ancestors associations, meanings, and values entirely unimagined by the Euro-American photographers who made them. Despite their seeming correspondence to scenes from the material world, photographs have unstable meanings that shift and mutate across time and cultures. Countless nineteenth-century photographers did, indeed, inscribe their photographs of Indian peoples with directive narratives meant to shape and fix their viewers' understanding of their pictures. But their ability to convey their point of view remained dependent upon the degree to which their audience shared their experiences and concerns, their ambitions and their essential point of view. The ubiquitous nineteenth-century photographic story of the vanishing race represented a kind of willing embrace between the needs and desires of late-nineteenth-century photographic consumers and the producers who made the photographs, penned the descriptive captions, published the pictures, and cast them out into the marketplace. Consumers and producers alike were willing believers in an historical myth, and together they forged a collective memory of an imagined Indian past.

There are any number of points where this felicitous embrace between photographers (nearly all Euro-Americans) and their audiences (largely middle to upper class, and white) begins to weaken. One can look to the stories of native peoples incorporating commercial pictures into their daily lives, or look closely at images for evidence of the ways in which subjects sought to assert their own control over the picture. One can look more closely at the work of someone like Thomas Eaton, a Tsimshian photographer from Metlakatla, Alaska, active in the late nineteenth century, who on the back of his pictures stamped "Thomas Eaton, Native Photographer."[101] Likewise, one could look more closely at the pictures of Angel de Cora, a Winnebago graduate of Smith College (1896) and a student of artist Howard Pyle who went west one summer to photograph and sketch at Fort Berthold, in North Dakota. There, a reporter noted, "the Indians watched her skill with interest and pride, and became so fond of her and her bright, witty sayings, that she had no trouble in getting any number of people to pose for her."[102]

But even the vast majority of pictures long inscribed with the rhetoric of the vanishing race are subject to reinterpretation, as new audiences approach them with new questions and expose the fluid nature of photographic meaning. Photographs that to late-nineteenth-century picture-buying audiences simultaneously documented and predicted the inevitable end of distinctive tribal ways of life are now read by contemporary Native Americans as evidence of cultural vibrancy and the vitality of the native past. As they reject the vanishing race rhetoric with which nineteenth-century portraits were once cast before the public eye, and attach to them new meanings, these new viewers reveal the pictorial story of the vanishing race as a fragile time- and culture-bound construction. "Two individuals from different cultures viewing an identical scene are not necessarily seeing the same thing," writes the anthropologist Edward T. Hall. There is an assumption, he says, that "seeing is . . . passive," an assumption "which happens to be blatantly wrong."[103]

In the early 1980s, a group of Yankton Sioux people came together to reexamine some of the nineteenth-century portraits included in the 1877 Jackson Indian catalogue.[104] Jackson's compendium had included entries for thirty Yankton subjects. None had a biographical profile attached, but all appeared within the context of Jackson's general remarks about the Yanktons and their associated tribal groups who had "made more substantial progress in civilization, many of them having permanently discarded their Indian habits and dress."[105] In the modern Yankton Sioux publication that resulted from this investigation, Jackson's images are infused with new meanings, as his simple trajectory of cultural change is complicated by the recollections of the sitters' relatives, who refuse to see these portraits as emblems of cultural disintegration. The photographs themselves remain as mute as ever; now, though, they are animated not by the rigid logic of a government publication but by the stories of descendents.

Struck By The Ree, who appears in four photographs included in Jackson's collection, here has his own story as a peace-loving leader and gifted orator. Born in 1804 while Lewis and Clark were camped near a Yankton village on the upper Missouri, he had been wrapped in an American flag shortly after birth amid predictions he would become a great friend of the whites. But later in life he had troubling and recurrent visions of whites building new houses over ruins of Lakota homes and came to regret his earlier support of the 1858 treaty that had ceded away so much tribal land. Smutty Bear, who is also featured in the Jackson catalogue, appears here as an expert hunter, especially skilled at self-camouflage, who became a symbol of resistance to white poli-

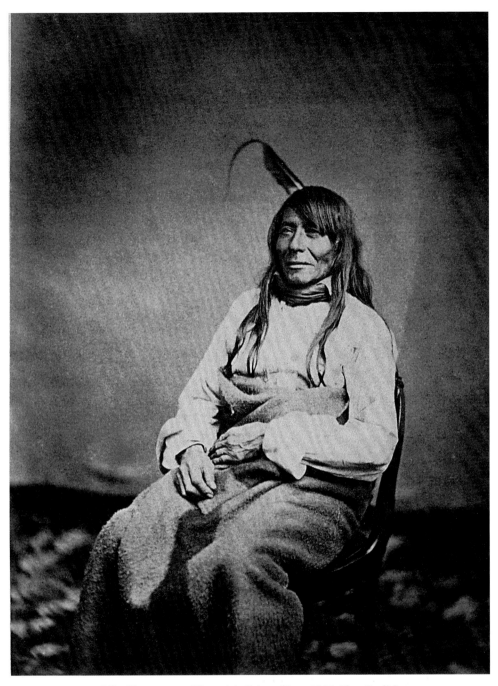

Julian Vannerson and Samuel A. Cohner (James E. McClees Studio),
Struck By The Ree (Pa-da-ni A-pa-pi; He Whom a Pawnee Struck). Albumen silver print, 1857–8.
Yale Collection of Western Americana, Beinecke Rare Book and Manuscript Library

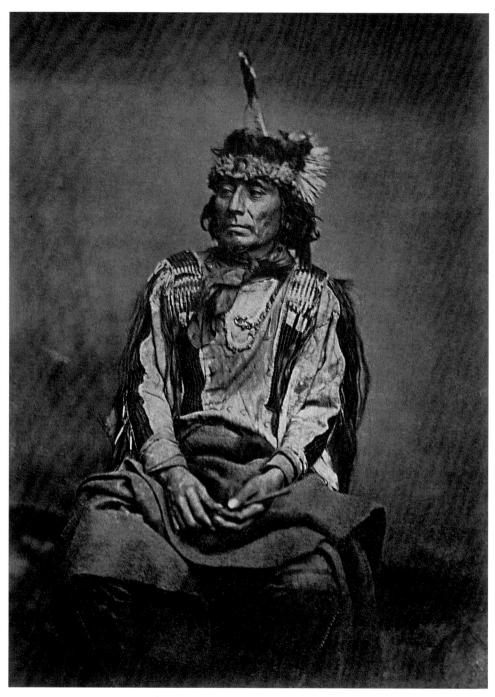

Julian Vannerson and Samuel A. Cohner (James E. McClees Studio), *Smutty Bear (Ma-to-sa-bi-tshi-a)*. Albumen silver print, 1857–8. Yale Collection of Western Americana, Beinecke Rare Book and Manuscript Library

cies. Feather in His Ear, his name more properly translated as Feather Necklace, is presented as an opponent of white missionaries who gained respect as one of the first to foresee the possibilities of religious and cultural oppression by the newly arrived Americans. Here is Little White Swan, known for his intelligence, wit, and humor; and Walking Elk, still celebrated for his thirty-year fight to win government reparations for the Yankton scouts who in 1864 helped federal authorities relocate Indians displaced by the Sioux wars.[106] Men once held up as poster boys for the vanishing race, living symbols of the inevitable disappearance of tribal cultures, are here venerated as men of heroic resistance, fierce defenders of a life under attack from all sides. Pictures cast out into the nineteenth-century marketplace as fragments of one story are thus reeled back in to support another.

In recent years, various Native American tribes have moved to restrict public access to historical photographs of tribal communities and practices. These requests come in the wake of the Native American Graves Protection and Repatriation Act (1990), a federal law establishing a mechanism for the repatriation of human remains and ritual objects from federally funded institutions to affiliated tribes. The Act says nothing about images, recordings, or field notes, focusing instead on a definition of "cultural patrimony" that refers only to material objects. But in the new climate of cooperation between institutions and tribes fostered by the Act, several tribes have moved to expand the spirit of the law by staking claims to visual, auditory, and literary representations of tribal members, objects, and cultural practices. In 1994, the Hopi tribal chairman, Vernon Masayesva, wrote a letter to museums formally stating the tribe's interest in all published and unpublished material relating to the Hopi, including photographs, and asked that the museums deny access to this material to anyone without written permission from the Hopi tribe. The following year, a consortium of Apache tribes issued a similar declaration demanding exclusive decision-making control over all Apache "cultural property," again including images. The Pueblo of Zuni likewise began debating a policy regarding access to photographs of tribal religious ceremonies. Such discussions come amidst broader international debates about the "cultural heritage" of indigenous peoples, as well as ongoing national discussions about intellectual property law, privacy, and First Amendment rights, and they reveal cultural divides of vast dimensions.[107] The Hopi have a fundamentally different view about the importance of the freedom of expression, declares a website posted by the tribe's Cultural Preservation Office. While acknowledging the "tradition of scientific

inquiry" that prevails in dominant society, they insist that the "integrity of specific cultural knowledge" must be protected for the privileged few who have a right to know it.[108] Tribal requests to limit access to materials already in the public domain, as well as to unpublished materials long made available to scholars in public and private archives, are sure to grow over the coming years, and they raise a host of troubling problems about ethnically differentiated access to materials in public institutions. Scholars and the general public alike will have to confront issues relating to the imagined exploitation or culpability of tribal members who might have acquiesced or participated in the making of the photographs in the first place, the sheer impossibility of withdrawing from circulation knowledge or information that might already exist in multiple forms, and competing cultural norms of privacy.

Implicit in the calls for restricted access to historical photographs are two unarticulated assumptions: one about the pictures' mode of production, another about their capacity to convey information. The requests silently presume an exploitation model for the photography of American Indians, a presumption casually voiced elsewhere as well: the photography of American Indians represented the "most brutal" and "predatory side" of photography, writes the contemporary critic Susan Sontag.[109] And to be sure, many early photographs of Indian peoples were made without the subjects' consent or willing participation. But history does not support the contention that the vast body of nineteenth-century photographs of Indian peoples and practices was made under coercive circumstances. The subjects of these pictures may have had reasons for cooperating with photographers that are not easily discerned from the visual narratives subsequently created by these photographers or the public uses to which the pictures were put. The sitters' needs for the pictures may not have been the same as the photographers'; they may not have prevailed in the marketplace of commerce. But such events should not cause one to look back at the photographic encounter itself as a one-sided exploitative act; it was often a form of exchange. And with the hindsight of history, and the continually shifting needs of photographers and viewers, subjects, and descendants, the seeming value and merit of the exchange can shift. Modern critics might lambast Edward S. Curtis for his romanticism, for his staged pictures, for his efforts to make his early-twentieth-century subjects seem to narrate the story of the vanishing race.[110] But should we imagine his sitters as exploited victims and discard the pictures as the time- and culture-bound expression of the photographer's misguided thoughts? No, says Gros Ventre scholar and curator George P. Horse Capture, whose

Skeet McAuley, *Interior of Navajo Weaver's Hogan, Monument Valley Tribal Park, Arizona, 1985.*
Color print, 1985. Courtesy of the artist

great-grandfather was photographed by Curtis. "Real Indians are extremely grateful to see what their ancestors look like or what they did and we know they are no stereotypes. No one staged the people. And we see them at their classic finest."[111]

The requests for restricted access to photographs likewise veil an underlying assumption about the capacity of photographs to convey valuable information that can betray sacred knowledge. Here, too, the issues are muddied. Certainly there exist photographs, made without permission, that document the physical appearance of sacred objects or practices not meant to be seen by outside observers. But the mutable, culture-bound meaning of images suggests that information present to one observer might remain hidden to a second. In the mid-1980s, Texas photographer Skeet McAuley traveled through the Southwest making color photographs that documented the ways in which

contemporary Indian peoples, particularly the Navajo and White Mountain Apache, lived within a modern landscape shaped by mining, tourism, and tract housing, as well as by long-standing ceremonial practices. Explicit about making his project one of exchange, he collaborated with Mike Mitchell, a medicine man at the Navajo Community College (now Diné College), showing him copies of his work, taping his responses, and translating and transcribing these comments for publication in a book with the photographs themselves. Mitchell's readings of the pictures make starkly clear the culture-bound nature of photographic understanding and the capacity of photographs to convey different information to different readers. Indeed, he suggests, knowledge lies at least as much within the mind of the viewer as within the photograph itself. Where a non-Navajo viewer might see the photograph of a concrete irrigation ditch and contemplate the impact of expanding populations in a fragile desert environment, Mitchell sees the photograph as a meditation about the holiness of water and its sacred place in Navajo life. The picture of a tourist standing in a Monument Valley hogan bedecked with trinkets might well trigger thoughts about the commodification of culture and the impact of tourism on Indian life. Mitchell seems not even to notice the young white tourist, seeing instead the spirituality of the hogan; "life lies inside, hope is inside, love lies inside."[112] Photographs are not necessarily a universal form of communication, conveying the same thing to all viewers; what is clearly present and visible to him remains unseeable and unknowable to others. Photographs may reveal, but they can also conceal. Visual evidence is not the same thing as knowledge; indeed, knowledge often comes first, a prerequisite to the interpretation and understanding of visual evidence. The historical photographs stored away in museums and libraries may reveal less about their subjects than some observers fear; they whisper their secrets most loudly to those who already know what they are.

During the nineteenth century, countless thousands of photographs of American Indians were cast out into the marketplace as part of a story about the necessary and inevitable disappearance of traditional tribal cultures. If the photographs themselves were the centerpiece of the story, they were nonetheless incapable of conveying the burden of narrative themselves. Only with words could the mute pictures speak. And so it was with words that they entered the crowded visual marketplace of American life, words inscribed across their face, words affixed to their mounts, words printed in the explanatory catalogues that provided access to huge numbers of pictures. Only a complicity between photographer and viewer could make the story seem plausible or per-

suasive; and such an alliance was easily forged on grounds of common interest. By inscribing Indians with strangeness and predicting their cultural decline, the pictorial narrative of the vanishing race served the interests of Americans unable and unwilling to examine the moral costs of the nation's expansion into the West. If the disappearance of the nation's native peoples was inevitable, Americans bore no real culpability for the political actions that deprived these individuals of their civil rights, robbed them of their homelands, confined them to reservations, and devalued (or even forbade) the use of tribal languages and traditional religious practices. If it was simply nature's course, no one was right or wrong.

But the public meaning affixed to these pictures, the meaning affirmed in the transaction between photographer and buyer, was never the only message embedded in these pictures even if it was the most visible and, for a time, the most stable one. Sitters, too, had needs for these photographs. And, particularly in the age before the invention of the snapshot camera, they were often collaborators in the picture-making process. The same facial expression that for a photographer might affirm the passivity of Indian culture might for the sitter convey an image of inner strength. The beaded shirt enlisted to reaffirm the strangeness of Indian culture might to its wearer mark a particular personal achievement. There have always been multilayered stories attached to these photographs; in the late-nineteenth-century marketplace, however, only one won out. The trajectory of cultural loss narrated by countless nineteenth-century photographs of Indian people remains a visible and compelling story. But increasingly it must be understood as a construction of a particular moment of American history, a particular public need fed by shrewd photographers. As new audiences approach these photographs with new needs and questions of their own, the photographs—ever mute themselves—reemerge with new captions and new words, ready to meet different cultural needs and to tell new stories about the shape and history of American Indian life. Some of these stories will remain private ones, like the personal family stories that enveloped the very first portraits of Native American peoples made in the 1840s. Others will inevitably become loud, noisy stories, cast out into the world to compete with the nineteenth-century stories that for so long shaped popular American thought about nineteenth-century Indian life, asserting loudly and forcibly that the vanishing race is still here.

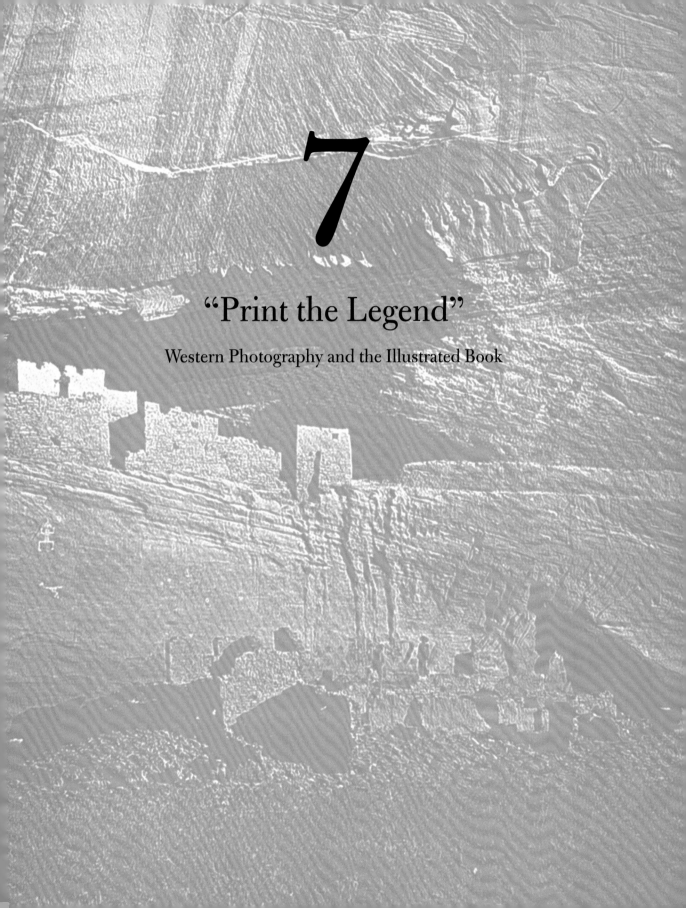

7

"Print the Legend"

Western Photography and the Illustrated Book

"[Until photography came into common use] very few people had been aware of the difference between pictorial expression and pictorial communication of statements of fact. The profound difference between creating something and making a statement about the quality and character of something had not been perceived."

—William M. Ivins, Jr., 1953

In 1868, with his ambitious eight-year survey of California winding down, Josiah Dwight Whitney published *The Yosemite Book*, a masterpiece of photographic bookmaking that exemplified the twinned spirits of scientific inquiry and unabashed boosterism that had marked the survey's exploration of the Bear Flag state. The state legislature had authorized Whitney to prepare a description of the Yosemite region, recently set aside as a state park, in "order to serve as a guide book for travelers." And with a generous impulse seemingly at odds with their more practical demands of the survey team, they declared that the "'Gift Book' shall be as elegant a volume as has ever been published in this country."[1] Accordingly, Whitney acquired twenty-eight photographic images to use as tipped-in illustrations in the book, twenty-four by the well-known photographer of Yosemite, Carleton Watkins, and four by W. Harris, who had briefly accompanied the survey team. Appearing in the order in which their scenes would be encountered by a traveler, the photographs simultaneously described Yosemite's marvelous geologic forms and evoked the "general picturesque effect" of the place. Whitney wrote that he presented the photographs, "with full confidence that they will give satisfaction to those who are themselves unable to visit the scenes which they represent." To those who *had* been there, he hoped they would "be of greatest interest as recalling some of the most striking points of view in and about the Yosemite Valley."[2] But there was one overwhelming obstacle to Whitney's ambitions for the book. "As only a small number of prints could be obtained from the photographic artist," he explained, "the number of copies of the illustrated volume . . . which could be issued was necessarily limited to 250." Another, cheaper, edition, smaller in size and illustrated with woodcuts rather than with tipped-in photographic prints, would be issued later to serve as a more generally accessible "guide book."[3] Whitney's dilemma, and the evident reluctance of his photographic printer, is easy to imagine. The two hundred fifty copies of the book, each illustrated with twenty-eight albumen prints carefully tipped onto sheets and

276

THE YOSEMITE FALLS.

Carleton E. Watkins, *The Yosemite Falls*. Albumen silver print, 1866, from J. D. Whitney, *The Yosemite Book* (1868). Yale Collection of Western Americana, Beinecke Rare Book and Manuscript Library

bound into the back of the text, required a staggering seven thousand photographic prints to be produced, at a considerable expenditure of time, labor, and money. Photography was a medium of mass communication, but it was not easily wed to the mass production technologies of the printed book. Its relative affordability may have made it a democratic art, but as a medium of book illustration it was decidedly undemocratic, used sparingly and at great expense only in books of the most deluxe and elite sort.

The slow and tedious process of producing a book with original photographic illustrations could entail all but overwhelming logistics. John Carbutt of Chicago produced fifty thousand cabinet card portraits for a book on that city's civic leaders published in 1869, and J. Landry printed an astonishing sixty-five thousand portraits for a single edition of *Cincinnati, Past and Present* (1873).[4] Charles Granville Johnson, a photographer and entrepreneur working along the lower Colorado River in Arizona in the mid-1860s, watched his project founder on far more modest numbers. Hoping to persuade the American government to acquire more land from Mexico in order to give Arizona her own Gulf of California port, he proposed a twenty-five-part publication on Arizona's history and prospects, each part to contain "one or more photographs taken on the spot or from life." Only three numbers appeared, however, the subscription project being "too costly" to continue.[5] And understandably so. Printed on albumen paper placed in contact with a negative under direct sunlight, each of the photographs used in these books could take a half hour or so to print, with additional time required to finish them and affix them by hand to paper or board mounts. The bulk and weight of these photographs, each on a sheet that had to be inserted by hand into a signature of printed text pages, also increased the difficulty and cost of the book-binding process. As the critic Estelle Jussim writes, "While photography seemed the ultimate in the mechanization of visual information, it could not itself be easily mechanized."[6] The production of books illustrated with original photographs essentially required two distinctive printing methods to be joined by hand; the two media of mass communication could become one only with the help of old-fashioned, hands-on craftsmanship.

Not surprisingly then, few photographically illustrated books about the trans-Mississippi West appeared in the nineteenth century. A recent bibliography lists only sixty-seven titles that meet the criteria of having at least thirty-two pages and more than two original mounted photographs, a definition that embraces photographic albums with printed title pages.[7] Even if one adds extra-illustrated titles, shorter publications, variant editions of the albums, and books with only one or two tipped-in plates

DRY DOCK OF THE COLORADO NAVIGATION COMPANY AT THE HEAD WATERS OF THE GULF OF CALIFORNIA—PORT ISABEL.

Charles Granville Johnson, *Dry Dock of the Colorado Navigation Company at the Head Waters of the Gulf of California—Port Isabel*. Albumen silver print, from Charles Granville Johnson, *History of the Territory of Arizona . . .* (1868). Yale Collection of Western Americana, Beinecke Rare Book and Manuscript Library

(notably memorial volumes and books illustrated with portraits of the author), the total number likely remains less than two hundred. Such books thus make up a relatively small collection of work, and one that never reached a mass readership. Yet considered in concert with the far larger number of nineteenth-century books about the West illustrated with engraved, lithographic, or photomechanical reproductions *derived* from photographs, these elaborate works of photographic bookmaking help illuminate photography's shifting status as a tool of visual communication. In the little-studied pages of nineteenth-century illustrated books we can begin to trace how photography continued to compete with other forms of visual representation, how it emerged as and dis-

tinguished itself as a distinctive mode of communication and how the medium did—or did not—finally gain a place in the cultural marketplace as a way of narrating complex stories about the shape of western life.

To read nineteenth-century illustrated books as primers about photography, to critique them as texts about the broader cultural response to the medium, requires a different sort of reading; one must scan the pictures first, before turning to the text. And one must look beyond the apparent content of those images—the subject they seem to be *about*—to ask questions about how they were selected and produced. When, one might ask, was photography used as a *source* for illustrative material? How and why would it be selected over more imaginative sketched or painted renderings? And when were photography or the new photomechanical printing technologies used as a *means of reproduction* for source materials, utilized instead of the older reproductive media that required the original image to be redrawn by hand on a printer's plate? It was not simply the apparent *content* of a printed illustration, but its physical *form*, the ways in which it was constituted as a pattern of ink or photographic chemicals on paper, that shaped its meaning for readers.

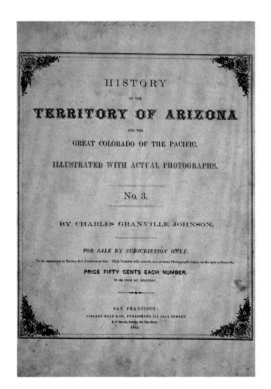

Charles Granville Johnson, *History of the Territory of Arizona* . . . (1868). Yale Collection of Western Americana, Beinecke Rare Book and Manuscript Library

The first photographically illustrated book produced in the American West was George Fardon's *San Francisco Album* (1856), an album of thirty carefully sequenced photographic plates, bound with a printed index sheet and a lithographic title page upon which was mounted an additional photographic view. The book's subtitle, *Photographs of the Most Beautiful Views and Public Buildings of San Francisco*, and the

George Fardon, *San Francisco Album* (1856). Yale Collection of Western Americana, Beinecke Rare Book and Manuscript Library

publisher's location "at the office of the San Francisco Journal," signaled the project's grand civic agenda. Photographs of individual structures—including the Merchants' Exchange, the Custom House, a Catholic church, and a full three photographs of firehouses in that fire-prone city—spoke to the city's prosperous present, while sweeping urban views surveyed the land still available for development. The only image at odds with the carefully constructed picture of urban growth was the concluding photograph of the Mission "Los Dolores," whose very position in the album simultaneously acknowledged and marginalized the city's Hispanic past and marked its quaint irrelevance to the city's American future.[8]

The photographically illustrated books produced in the West between the publication of Fardon's city-view book of 1856 and the end of the century fall into four main categories: private memorial projects that commemorate the lives or adventures of particular individuals; commercial (or in some cases government-financed) projects designed to stimulate western settlement, urban growth, and industrial development; historical or documentary texts intended to record local historical or biographical information; and tourist manuals designed to attract visitors to the historic and scenic wonders of the West. And within these categories of publications, original photographs appear in two distinctly different ways: as transcriptions of physical facts, intended to give readers the illusion of an unmediated glimpse of the material world, and as forms of graphic reproduction, faster to produce than engravings or lithographs and possessed of superior virtues of accuracy.

In the nineteenth-century West, the California bookmaker Edward Vischer was perhaps the foremost champion of photography as a medium of reproduction for book

illustrations. In 1862, he issued Vischer's *Views of California: The Mammoth Tree Grove, Calaveras Country, California, and Its Avenues*, which included thirteen lithographs made after drawings that he had made on a trip through California. But frustrated by lithography's inability to reproduce his field sketches without considerable loss of accuracy and detail, Vischer turned to photography for his next project, hiring the photographer George H. Johnson to make photographic copies of the sketches he had assembled for a published portfolio about the Washoe mining region (1862). Over the next decade he used this method repeatedly, publishing works on California life illustrated with original photographic prints that had been made not from nature, but from sketches and drawings. The process may have been "tedious and expensive," Vischer conceded, but it worked because it could "increase intensity [of the original] by a reduction in size" and result in images well-sized for inclusion in his portfolios, no matter what the size of the original might have been. His intent, he explained, was "more *graphic* than artistic," for he sought pictorial accuracy, "no striving for effect at the expense of truth."[9] Unvoiced was his assumption that the field artist's sketch was what captured the graphic "truth"; photography's real value lay in its ability to reproduce that singular image for a broader public.

The other western writers and publishers who used photography as a reproductive medium generally combined this use of the technology with photography as an originating source. That is, they mixed photographic reproductions of drawings or paintings with photographs made directly from negatives of the pictured scene. When the California Historical Society, for example, published a four-volume edition of the late-eighteenth-century writings of Father Francisco Palou in 1874, it added tipped-in photographic illustrations as "an afterthought." Recent photographs of the missions at San Diego, Santa Barbara, and San Carmelo documented the present-day appearances of those sites. But other missions, too far decayed to convey a sense of their former splendor, were represented with photographs of earlier paintings or prints.[10] The photographs made from original negatives and the photographic copies of artworks appeared in the same format. One can only wonder whether nineteenth-century readers could distinguish between the different sources—the photographic negative and the artist's sketch—or understand that the photographic illustrations depicted different moments in the history of the missions.

George Augustus Brackett's photographically illustrated book, *A Winter Evening's Tale*, presented a similar interpretive problem. An independent beef contrac-

George H. Johnson, *Vischer's Sketches of Washoe. The Washoe Mining Region. 25 Numbers: Photographs Reduced from Original Drawings.* Albumen silver print on printed board, from Edward Vischer, *Sketches of the Washoe Mining Region* (1862). Yale Collection of Western Americana, Beinecke Rare Book and Manuscript Library

tor who had ridden with Sibley's First Minnesota Mounted Rangers against the Sioux during the uprising of 1862, Brackett self-published the account of his adventures in 1880. The book included a tipped-in photograph of the author, a photograph of a military lieutenant involved in the fight, and a studio photo of two unidentified Sioux subjects posed in front of a painted backdrop. But Brackett could not obtain an original photograph of a scene he deemed critical to the narrative of his book, so made a photographic copy of a *painting* of Sioux on the warpath to tip into his book with the others.[11] Confronted with four photographic illustrations, could readers distinguish between the scenes that appeared before the camera's lens and the one wholly invented by an artist? Did the battle scene seem to them as persuasive as the studio portrait? In

Unidentified photographer, *Painting of Sioux on the Warpath*. Albumen silver print, from George Augustus Brackett, *A Winter Evening's Tale* (1880). Yale Collection of Western Americana, Beinecke Rare Book and Manuscript Library

using a single technology to produce like-formatted illustrations from radically different kinds of images, the Palou and Brackett books blurred the distinctions between the scene observed and the scene imagined, and gave equal weight to the two sorts of visual sources.

For most authors who used original photographic illustrations, however, the medium's chief virtue was not the ease with which it could reproduce other images but the accuracy and absolute clarity with which it could represent the natural world. "No engravings could do justice to the scenes or convey perfect confidence in the accuracy of the drawing" of Yosemite's immense peaks, wrote John S. Hittell, explaining why he used reduced copies of Eadweard Muybridge's photographs in his guidebook, *Yosemite: Its Wonders and Its Beauties* (1868).[12] Ferdinand V. Hayden argued similarly that the photographs included in his *Sun Pictures of Rocky Mountain Scenery* (1870) offered the "nearest approach to a truthful delineation of nature."[13] Photographs, explained the writer Edgar Cherry, are "memoranda of unquestioned truth." His book on the redwood groves of northern California, *Redwood and Lumbering in California Forests* (1884), exaggerated not a bit about the size of the mammoth trees, he said. "Inas-

much as engravings are usually cut from sketches, drawn perhaps by enthused artists, perfect satisfaction is not given; but with photographic views, which cannot lie, argument as to truthfulness is unnecessary."[14] For Cherry, as for Hittell or Hayden, the very literalism of photography, its seeming ability to transcribe and convey the details of the physical world in two-dimensional form, made it the ideal medium of illustration. How could one argue with its detail, its accuracy, its absolute fidelity to the thing observed?

Yet for some late-nineteenth-century writers, this was precisely photography's biggest liability; it seemed too literal to use as a source or medium of book illustration. Thus when he published his *Pencil Sketches of Montana* in 1868, the Denver-based artist A. E. Mathews opted to include lithographic illustrations based on his original sketches. He had frequently been asked, he said, why he had not taken a "Photographic Instrument" along in order to photograph the mountain scenery, "for it is generally supposed that a photograph of Mountain scenery is always perfectly accurate." This was "far from the case," he explained; cameras could not record near and distant objects with equal precision and tended to record shadow areas as overly dark. A good artist "with pencil or brush" could produce more "accurate and pleasing" pictures than any cameraman.[15] The writer William Cullen Bryant picked up on this theme of the "pleasing" picture, patiently explaining that he did not include photographs in his extravagantly illustrated coffee-table book, *Picturesque America* (1874), because "photographs, however accurate, lack the spirit and personal quality which the accomplished painter or draughtsman infuses into his work." He preferred engravings, for they possessed a "spirit, animation, and beauty, which give to the work of an artist a value higher than could be derived from mere topographical accuracy."[16]

Such disdain for "mere topographical accuracy," for what seemed like the camera's slavish imitation of nature, had marked the debates about the relative merits of photography and painting since the invention of the daguerreotype. And though photography had won a firm footing in the marketplace by the late-nineteenth century, such debates continued to flare. What sort of image was most useful, the one that set down a myriad of detail or the one that recorded an observer's subjective impression? "The artist can take what the reader wants, and that only," the writer Philip Gilbert Hamerton explained in 1889, "and make the needed facts very plain and intelligible, whilst in a photograph they may be entangled with many other details that are not wanted." In fact, he proclaimed, "a pure photograph from nature is out of place in any book whatsoever."[17] Its cluttered wealth of visual information made it an ineffective tool of communication. The novelist Albion Tourgee likewise argued for the subjectivity of human sight

and its superiority to the camera's seeming objectivity. "The sensitized plate does not see as the eye does," he wrote. Thus he found it hard to understand the allure of Eadweard Muybridge's celebrated motion studies, which broke the complex patterns of human and animal locomotion into a series of stop action frames. It was no more "true"

A NAVAJO INDIAN BOY.

to draw an animal in a position which the human eye could not recognize as natural, than it would be to present "a professional beauty as she would appear under the microscope." Both pictures might be "literally true," but both were "practically false."[18] The sketch artist, with his subjective eye and selective hand, could better capture the spirit of an event, better convey the emotional experience of the eyewitness observer. Thus even as photographs became ever more available, the verdict as to their illustrative value or worth was still out. Their merit was there to be debated, by writers, artists, and publishers alike, and such debates shaped the physical content and form of the illustrated western books produced in the late nineteenth century.

The vast majority of late-nineteenth-century books and journals with photographically based illustrations employed conventional engraving or lithographic techniques to re-present the image contained in a photographic

A Navajo Indian Boy. Engraving after a photograph, from Enoch Conklin, *Picturesque Arizona* (1878). Yale Collection of Western Americana, Beinecke Rare Book and Manuscript Library

source. Photographs had to be copied by hand onto a metal, wood, or stone printing surface that would then be etched, carved, or marked with a greasy crayon to form an image that could retain ink for transfer to the printed page. Inevitably, the minute detail and broad tonal range of an original photograph would be lost, and, more often than not, the distinctive feel and syntax of a photographic image would disappear.

For printmakers, there was thus little advantage to working from a photograph, as opposed to a sketch or drawing. Photographs had some value as intermediary images; a painting, for example, could be photographed and reduced in scale, making it easier for a lithographer to copy the image onto a printing stone. But as original materials, photographs remained problematic. The pictures still had to be scaled to fit the printing plate and laterally reversed from left to right in order to print in their correct orientation. Their continual tones still had to be transposed into a series of lines or stippled dots on the surface of a printing plate, with a consequent loss of tonal subtleties. In an age in which graphic reproduction still relied on the craftsman's intervening hand, there was no necessary correspondence between the original image and its printed reproduction. Some printmakers struggled to give their photographically based prints a slavish detail that hinted at their photographic source, and claimed visual authority for these images by identifying them as being "after a photograph." Others, though, used photographs as aide-mémoire or starting points for more imaginatively conceived prints, leaving only the most visually literate viewer aware of the print's pictorial source.

Indeed, since both engraving and

AN ANCIENT WAR DANCE OF THE APACHES.

An Ancient War Dance of the Apaches. Engraving from Enoch Conklin, *Picturesque Arizona* (1878). Yale Collection of Western Americana, Beinecke Rare Book and Manuscript Library

lithography required that a photograph be redrawn by hand on the surface of a printing plate, it might not always be clear to viewers that a print was based on a photograph. As was the case in photographically illustrated books (such as Brackett's or Palou's), a common syntax of reproduction could obscure the differences between pictorial sources. In *Picturesque Arizona* (1878), for example—a promotional travel book aimed at "a miner in search of mines, a farmer in search of fertile valleys, or a tourist or scientist in search of the beauties of nature"—the publisher mixed engravings made after un-credited photographs of southwestern Indians, with engravings of such fictive scenes as *A Stage Coach Robbery* and *An Ancient War Dance of the Apaches.*[19] These imagined views each depicted a moment in a popular fantasy version of Arizona history that visually reinforced the author's story about the territory's transition from barbarism to civilization. When the writer's storytelling needs outstripped the storytelling capacity of his photographs, he found an artist to supply what no photographer could invent.

Numerous western writers chafed, in similar ways, at what seemed the confining realism of their available photographic sources. In his book *The Plains of the Great West* (1877), for example, Richard Dodge freely mixed reproductive engravings based on Alexander Gardner's photographs of the principals involved in the Fort Laramie Treaty of 1868, with inventive engravings that visualized the more "savage" aspects of Indian life, including a scalp dance, a border raid, and a "noontime repast on the war path." Photographs could be useful, but even in reproduction they could not give visual endorsement for Dodge's argument that the Indians were "cruel, inhuman savage[s]" in need of stricter, less "sentimental humanitarian" treatment from the federal government.[20] Such a mixing of photographic and nonphotographic sources appeared, too, in books—such as Brackett's account of his adventures with the Sioux—that were illustrated with original photographic plates. But where a perceptive viewer might be able to look at a photograph of a painting and discern its true subject, such distinctions were much more difficult to make when the source imagery had already been redrawn for reproduction. Photograph and invented sketch alike were reduced to a pattern of lines drawn on an engraving plate, and the homogenizing effect of the draftsman's engraving tool narrowed the difference between the scene photographed and the scene imagined, minimizing the eyewitness authority of the photographic source even as it lent credence, by association, to the invented scenes. Not surprisingly, the scenes that Dodge and his contemporaries most often chose to represent with invented images were those that related to western violence, a theme so deeply ingrained in popular literature and

myth about the West (and so utterly absent from eyewitness photographs) that audiences would not only *expect* such imagery but would be predisposed to accept its veracity.

The development of new photomechanical reproduction technologies during the second half of the nineteenth century challenged the primacy of engraving and lithography as reproductive media. These new technologies—including photolithography, the albertype and heliotype processes, and later the halftone—each offered an alternative to the older printing techniques, employing photography itself to reproduce photographs without having them redrawn for the printing plate. The resulting reproductions were more faithful to their sources, preserving much of the detail, the tonal values, and the distinctive quality of the original photographs. As such they offered new possibilities to the publishers of scientific or technical treatises, at last giving them a way to convey the wealth of detail contained within a photographic document. And yet, although photolithographs and heliotypes appeared in some of the government reports about the West issued during the 1870s and 1880s, these new processes never fully supplanted the older, more conventional reproduction techniques that relied upon drawing, and photographs never fully replaced paintings or drawings as a source for western book illustrations. A continuing taste for the sorts of fictive representations of the West that photography was ill-equipped to provide meant that photographs still had to compete in the marketplace with other more dramatic and explicitly narrative forms of visual representation. The kinds of tension that had once marked the competition between daguerreotypes and narrative prints, between early paper photographs and the moving panoramas, continued to haunt photography in the closing decades of the nineteenth century. The medium remained, for many, too literal, too insistently descriptive to convey the kind of dramatic story they wanted to find.

Photolithography was the first of the new technologies to find a niche in the marketplace, emerging as a practical reproduction process simultaneously in the United States and Europe during the 1850s and '60s. It depended upon a specially prepared lithographic stone that could receive a photographic image—either through a direct transfer process or through exposure to a negative—upon its light-sensitive surface. This image could retain a greasy printer's ink and be printed like any other lithographic stone.[21] Almost immediately, the process proved useful as an inexpensive method of reproducing maps, for it allowed hand-drawn maps to be quickly photographed and

reproduced without being redrawn for an engraving plate. In fact, the grainy surface of the lithographic stone was actually better suited for the reproduction of line drawings than for the continuous tone imagery of a photograph. Yet beginning with Thomas M. Brewer's work on bird eggs, *North American Oology, part I: Raptores and Fissirostres*, published in 1857, the process also found limited use as a method for reproducing photographs in American scientific texts. Its more popular uses lagged far behind; the first United States newspaper to use the process was the New York *Daily Graphic* in 1873.[22]

The albertype and heliotype—both variations on the collotype printing process—likewise employed printer's ink to reproduce photographic images, but because they relied on smoother surface supports they conveyed the broad tonal range of a photograph far more accurately than could the stone-based photolithograph. Indeed, albertypes and heliotypes might so closely match the continual tones of the photographic originals from which they were made that they could be difficult to distinguish from these original photographic prints. Invented in Munich in 1868 by printer Josef Albert, the albertype employed a glass plate as the base for a sensitized gelatin emulsion that would harden after exposure to a negative and could retain a greasy printing ink, much like a lithographic stone. In the hands of a skilled printer, an albertype plate could produce nearly two hundred impressions per day, and would last for up to four thousand prints. Photographer Edward Bierstadt acquired the American rights to the process and quickly became its foremost American practitioner, but the technology never achieved widespread

Cynopithecus niger in a placid condition. The same when pleased by being caressed. Engraving from Charles Darwin, *Expression of the Emotions* (1872). Beinecke Rare Book and Manuscript Library

Expressions of Grief. Heliotype reproductions of photographs by Duchenne, Rejlander, and others, from Charles Darwin, *Expression of the Emotions* (1872). Beinecke Rare Book and Manuscript Library

commercial applications, chiefly because it remained as expensive as using original photographs as tipped-in book illustrations.[23]

The variant heliotype process required one to strip the hardened gelatin matrix from the glass support that had been used in the albertype method, expose it under a reversed negative, and transfer the resulting film to a stronger metallic support for inking and printing. Charles Darwin's *Expression of the Emotions* (London, 1872), the first book illustrated by the new process, mixed heliotypes with more conventional engravings, employing the new heliotype process to reproduce photographic sources while relying on engravings for the reproduction of freehand sketches. Heliotypy was thus linked to the graphic precision of photographic evidence, and the clarity and detail of

the heliotype reproductions clearly demonstrated the utility of the process for scientific illustration. But as with photolithography (or photography itself), the process also seemed useful as an inexpensive medium for the reproduction of other forms of graphic art. The Boston publisher James R. Osgood acquired the exclusive American rights to the heliotype process in 1872, and enlisted the services of the process's English inventor, Ernest Edwards.[24] Persuaded that the new technology offered a "democracy in art" that had "long been hoped for but never realized," Osgood approached Harvard University and won permission to photograph and reproduce its celebrated Gray Collection of engravings. Within a few months, his company had nearly two dozen presses at work producing heliotypes from some fifteen hundred photographs he had made of the university's engravings.[25] The heliotypes would be cheaper than the rare originals, observed Osgood, and more permanent than any photographic copy, for "the ordinary photograph is produced in evanescent materials, and will fade: the Heliotype is printed with permanent ink, and can never fade."[26] This physical stability made the process especially valuable for "artistic and scientific education," argued Edwards, and useful for bringing within the reach of all not just reproductions of works of art but the "records of science which would be otherwise unobtainable."[27] To the entrepreneurial Osgood, the federal government no doubt seemed a likely client for his services. Surely it would have a vested interest in distributing to a wider audience the photographs made during the federal surveys of the West.

Before 1843, government reports had been illustrated only sporadically. During the late 1840s, however, both the navy and the army began to make extensive use of images in the official reports of their explorations. And with the publication of the five-volume narrative (1845) of the U.S. Exploring Expedition of 1838–42, led by navy Lieutenant Charles Wilkes, illustrations became a truly essential and integral part of exploration reports. This account of the United States' first major expedition to lands outside the North American continent set the pattern for the naval reports to be published in the ensuing years. Topography, events, flora and fauna, and small-scale vignettes of genre scenes appeared in the copper and steel engravings distributed throughout the book, and in the two hundred fifty woodcuts printed on pages along with the text. All of the Wilkes images derived from sketches, but the navy's 1855 report on a four-year naval expedition to South America incorporated plates based on daguerreotypes, the earliest such use in a government document. Its 1856 report on Commodore Perry's travels to Japan likewise included lithographs based on daguer-

rean originals. The army, too, began issuing illustrated reports in the mid-1840s, relying principally on lithography to illustrate the reports by Frémont, Abert, and Emory that chronicled the Army Corps of Topographical Engineers' explorations of the interior West. It trumped the navy in its use of color, including chromolithographic images for the first time in 1850, in the report of Lieutenant James H. Simpson's exploration of the Navajo country. But it lagged behind the navy in the use of illustrations derived from photographic sources. Not until 1861, in Lieutenant Joseph Ives's report on the exploration of the Colorado River, did there appear an army illustration—in this case a lithograph—based on a photograph. The difficulties faced by the photographers walking and riding across the interior West far exceeded those of the cameramen who traveled in the relative luxury of a naval ship.[28]

Between 1843 and 1863, more than seven hundred different prints of western scenes (and many more prints of western flora and fauna) came before the public eye in the form of reproductions in government reports. The extravagant highlight of this flowering of western bookmaking was the twelve-volume report on the Pacific Railroad Survey (1855–61), whose seven illustrated volumes proved a veritable boon for some of the nation's preeminent engraving and lithographic firms. The twelfth and final volume of the report, illustrated with fifty-seven images, was issued in an edition of fifty-three thousand, thus casting into the public arena more than three million individual prints of western subjects available for public review. In all, some 6.6 million prints of western scenes appeared in the railroad survey reports, a truly staggering number that worked out to roughly one for every five Americans. The publication of these reports cost more, by a factor of two, than the survey expeditions themselves.[29]

By the 1870s, however, the increasing success of field photographers and the advent of new photomechanical reproduction processes had altered the landscape of book publishing, vastly expanded the printing options for illustrated government reports about the West, and had given to the leaders of the great postwar surveys a rich set of options for the visualization of their reports. Unlike their explorer counterparts of the 1850s, the leaders of the so-called Great Surveys faced real choices as to whether their published illustrations would derive from photographs or drawings. Their survey photographers—notably Timothy O'Sullivan, William Henry Jackson, John K. Hillers, Carleton Watkins, and William Bell—had succeeded in the field as none of their antebellum predecessors had, giving the survey leaders a great many photographs from which to choose, in addition to topographic drawings, paintings, and field sketches.

And how would these prospective illustrations be incorporated into a publication? In the surveys' deluxe albums, they might appear as original photographic prints. In the official reports they could be reproduced as wood engravings and set within a block of type on a printed page, or appear as copper engravings or lithographs, printed on separate sheets and later inserted into the book. They might also be reproduced with one of the new photomechanical processes such as photolithography or, later, heliotypy.

The survey leaders and their publishers would thus have to choose between reproductive prints that closely mimicked the original source and those that allowed for the intervening hand of the artist who would redraw the original on a printing plate. Sometimes the decisions were purely economic, revealing little about the broader cultural perceptions of photographs as purveyors of visual messages. Ferdinand Vandiveer Hayden, civilian geologist in charge of the United States Geological and Geographical Survey of the Territories, gave effusive praise to the photographs of William Henry Jackson, who accompanied his surveys into the Rockies. The photographs "throw great light on the singular geographical and geological features of the West," he wrote in a report of his 1870 expedition, "and are, in my opinion, a real contribution to science as well as to landscape photography."[30] Moreover, he argued the following year, they are "of very great value in the preparation of the maps and report." But when he illustrated his reports, Hayden opted for economy over detail, recycling woodcuts from *Scribner's Monthly* for his annual report of 1871, engravings from the *Illustrated Christian Weekly* for his report of 1872, and electrotypes

Figure 44.—An'-ti-naints, Pu-tu'-siv, and Wi'-chuts.

After John K. Hillers, *An'-ti-naints, Pu-tu'-siv, and Wi'-chuts*. Wood engraving, from J. W. Powell, *Exploration of the Colorado River of the West* (1875). Amherst College Library

(produced with copper molds of engraved plates) from D. Appleton & Co.'s illustrated book *Picturesque America* for his report of 1874. When he could find no existing illustrations to borrow for his annual reports, he often relied on inexpensive woodcuts, whose crudely drawn lines preserved little of the detailed specificity of the Jackson photographs he purported to value.[31]

John Wesley Powell made a similar decision. In his 1875 publication *Exploration of the Colorado River of the West*, he eschewed the available photomechanical reproduction processes and relied instead on engraved illustrations, some from sketches and drawings made by Thomas Moran, who traveled with him during the 1873 survey season, and some after photographs by John Hillers, who had become his survey photographer in 1872.[32] It was not that Powell did not grasp the popular appeal of photographic prints or the allure of photographic reproductions. Indeed, he had made formal arrangements with his survey photographers—first with E. O. Beaman, who left his post in 1872, and later with Hillers—to share personally in the proceeds from the sale of any

Fig. 34.—Climbing the Grand Cañon.

stereographs of his trips. In the first six months of 1874, the proceeds on these sales totaled some $4,100, and Washington wags joked that Powell paid off the mortgage on his house with the sale of these views. Powell also understood how to use the stereos as political capital, distributing sets of views to congressmen when the appropriation for his survey seemed threatened in 1877.[33] But financial imperatives drove Powell to rely on engravings in his book. In exchange for writing a series of three articles for *Scribner's Monthly* (appear-

After Thomas Moran, *Climbing the Grand Canon*. Wood engraving, from J. W. Powell, *Exploration of the Colorado River of the West* (1875). Amherst College Library

ing in January–March 1875) and providing them with "twelve engravings on wood of Indian subjects," Powell received $500 and the right to purchase, for $1,000, some $2,000 worth of illustrations "mostly of landscapes" that Scribner's had commissioned. In this way, he acquired for his own use thirty wood engravings made by Thomas Moran—many after photographs by Beaman and Hillers—as well as engravings by other artists that he would use and reuse in his publications about the Grand Canyon.[34]

Though Powell's motives were surely financial, he undoubtedly recognized that the freely drawn wood engravings would serve his purposes better than any photomechanical reproductions of photographs ever could. Moran's romantic engravings—filled with stormy skies and moonlit nights, tiny figures and looming canyon walls—add to the tense dramatic narrative of Powell's adventure story. But they also abet the lie of his writing. Although Powell's story purports to be about his first river voyage of 1869, and thus claims readers' interest as a gripping day-by-day account of the first American descent of the Colorado, it incorporates incidents from Powell's second descent of 1872. Moreover, since Powell's original river party included no photographers or sketch artists, none of the illustrations truly reflect eyewitness impressions of Powell's epic first descent. By reproducing as wood engravings both Hillers's photographs and Moran's drawings, Powell moves the pictures into a realm of imaginative reconstruction that parallels his literary narrative. Photomechanical reproductions of Hillers's photographs would

After William Henry Holmes, *Smithsonian Butte—Valley of the Virgin*. Chromolithograph, 1882, from Clarence Dutton, *The Tertiary History of the Grand Canyon District* (1882). Archives and Special Collections, Amherst College Library

have unsettled his fiction. Quite apart from the expense or technical challenge of using the new photomechanical technologies to reproduce Hillers's photographs, Powell perhaps preferred a reproduction method that established some distance between him and the eyewitness recorder who was not supposed to have even been there.

Gradually, however, in some of the other illustrated publications issued in conjunction with the postwar surveys, the broad range of available reproduction technologies starts to acquire a logic as a system of visual communication, inspired less by financial imperative or a desire for concealment than by a growing realization that photographs and sketches, photomechanical reproductions, and more conventional engravings and lithographs might convey visual information in distinctive and different ways. Photography operated not only within a matrix of economics but also within a matrix of ideas.

In *The Tertiary History of the Grand Canyon District* (1882), for example, Powell's associate Clarence Dutton implicitly associated particular ideological messages with the physical forms of his illustrations.[35] A Yale-trained scientist, later schooled in geology under Powell, with whom he first went west in 1874, Dutton had taken on increasing responsibility for the government's southwestern surveys as Powell assumed increasing administrative duties in Washington—first as director of the Bureau of Ethnology in 1879 and later, in 1881, as director of the U.S. Geological Survey. Dutton was both poet and scientist, and his book was an ebullient geological treatise that combined vivid evocations of the pictorial sublime with technical explications of the Earth's history. "In his reports," wrote an admiring Wallace Stegner, "a rich and embroidered nineteenth-century traveler's prose flows around bastions of geological fact as some of the lava coulees on the Uinkaret flow around gables of sedimentary strata."[36] Dutton selected the illustrations for his major work on the Grand Canyon with a similar sort of attention to scientific imperative and poetic impulse, and, in the pages of his text, images communicate to readers through their content as well as through their syntax of reproduction. Here, photographs and sketches, lithographs and heliotypes, convey their messages in distinctive and different ways.

Dutton introduces his pictorial agenda with a brightly colored chromolithographic frontispiece, *Smithsonian Butte—Valley of the Virgin*, based on a sketch by the artist-topographer William H. Holmes. The viewer looks out over a tree-shaded structure to the dramatic rock formations across the desert floor. A soft green frames the comfortable human-shaped landscape of the foreground, while the colored striations

on the distant rocks mark the region's geological past and underscore the site's fantastic topography. "I have in many places departed from the severe ascetic style which has become conventional in scientific monographs," Dutton writes in his preface. "Give the imagination an inch and it is as apt to take an ell, and the fundamental requirement of scientific method—accuracy of statement—is imperiled." But with the Grand Canyon, he explains, exaggeration scarcely seemed possible. "The stimulants which are demoralizing elsewhere are necessary here to exalt the mind sufficiently to comprehend the sublimity of the subjects."[37] Color well-suited the canyon's grandeur, making vivid its dramatic hues, its stunning geological formations. The book's only other chromolithograph, *Sunset on the Kanab Desert*, also after a sketch by Holmes, likewise confirmed Dutton's word portrait of an "exquisitely beautiful" scene whose colors were "self-luminous" in the fading light of day.[38]

In the published list of his fifty-two illustrations, Dutton carefully stated the content of each image as well as its means of reproduction, implicitly associating particular reproduction technologies with specific rhetorical strategies. His vision of the Grand Canyon as a site of the sublime gained visual amplification from the two chromolithographs after Holmes and the monotone woodcuts made after sketches by Holmes and Thomas Moran (some of which were actually drawn from photographs). The more straightforward linear photoengravings after Holmes's topographical sketches conveyed a simpler, more functional vision of the canyon's geological formations.[39] Dutton underscored the importance of personal perception in comprehending the vastness of the Grand Canyon by naming the artists of the sketches that provided the bases for these reproductive prints. Yet John K. Hillers, the creator of the four photographs reproduced here as heliotypes, went unnamed. It was as if photography involved no element of personal apprehension, existing only as a self-evident transcription of fact. And by surrounding the heliotypes with more discursive scientific writing, Dutton suggested that these images seemed to describe rather than evoke, to confirm scientific fact rather than elicit imaginative speculation. If the warmly colored chromolithographs and dramatically configured woodcuts bolstered the poetry of his prose, the photographic images simply amplified its technological precision. For Dutton, no photograph could convey the emotional or perceptual experience of looking out over the canyon's fantastic, dizzying topography. A picture made with a mechanical camera could no more explain the significance of the Grand Canyon than could an analysis of core rock samples.[40]

This sense of a necessary division of labor between images sketched by an artist and images recorded with a camera, as well as between printed illustrations and photomechanical reproductions, pervades the illustrated western survey reports of the 1870s and 1880s. If the literary descriptions in these reports teeter between an aspired-to objectivity of scientific analysis and an unabashedly romantic streak of travel writing, the illustrations likewise flip back and forth between pictures calculated to convey scientific fact and those meant to inspire a more emotional response to the western American landscape. The physical form of the illustrations—like the content of the images— conveyed subtle clues about meaning to the attentive reader. Increasingly, photographic sources and photomechanical reproductions came to be associated with the literary rhetoric of science; drawings, paintings, and the more conventional reproduction media of engraving and lithography with the language of personal perception.

Thus, when Clarence King selected the illustrations for his seven-volume report

After John K. Hillers, *Vermilion Cliffs at Kanab*. Heliotype, from Clarence Dutton, *The Tertiary History of the Grand Canyon District* (1882). Archives and Special Collections, Amherst College Library

EOCENE BAD LANDS _ WASHAKIE BASIN _WYOMING

After Timothy O'Sullivan, *Eocene Bad-lands, Washakie Basin, Wyoming*. Photolithograph, 1877, from Arnold Hague and S. F. Emmons, *Descriptive Geology* (1877). Archives and Special Collections, Amherst College Library

on the Fortieth Parallel survey, he used Timothy O'Sullivan's field photographs sparingly. The photographs could not rival for emotional impact the evocatively colored landscape sketches and paintings he had at his disposal. Nor did they seem just right for the scientific illustration of nongeological subjects—still better conveyed in woodcuts, engravings, or lithographs that could give selective visual attention to physical features of particular importance. Nonetheless, they did seem useful for describing topography and rock formations. And whenever King incorporated photographic sources into his reports (as he did in three of his seven volumes), he reproduced them as photolithographs, carefully marking their seeming difference from the sketched and painted source materials he reproduced with the older reproduction media that required the originals to be redrawn. In the second volume of King's report, Arnold Hague and S. F. Emmons's *Descriptive Geology* (1877), all of the illustrations are photolithographs of the Great Basin landscape, based on O'Sullivan's field photographs and printed by the tal-

After Gilbert Munger, *Natural Column, Washakie Bad-lands, Wyoming*. Chromolithograph, 1878, from Clarence King, *Systematic Geology* (1878). Archives and Special Collections, Amherst College Library

ented New York artisan Julius Bien.[41] Seemingly mindful of the illustrations' didactic function, Bien preserved the quiet stillness of O'Sullivan's landscapes in his tinted photolithographs. Only occasionally did he visibly alter the original, adding faint wisps of clouds to a blank white sky, or enhancing the geological detail evident in a photograph of a rock.[42] The pictures are intended to serve as factual illustrations. When the dry descriptive text establishes the photographer's viewpoint in order to reiterate the topographical accuracy of his pictures, the illustrations grow in pictorial authority.

The pictorial function of these photolithographs becomes even clearer when they are read in tandem with the illustrations in King's own *Systematic Geology* (1878), the companion report published a year after the Hague and Emmons volume. Both books, for example, include illustrations of the badlands in Wyoming's Washakie Basin. The image in *Descriptive Geology* is a monochromatic photolithograph made from one of O'Sullivan's photographs; a bearded man, presumably a member of King's survey

party, stands beside an eroded rock column, establishing a sense of pictorial scale and reinforcing the image's status as a scientific record. But when the same topography is featured as the frontispiece of King's *Systematic Geology*, it is in a softly colored chromolithograph based on a sketch by the painter Gilbert Munger, who had traveled with King during the 1869 survey season. Like the photolithograph, the Munger image includes a human figure (actually two) beside a dramatic tower of eroded rock. But the geological precision of the O'Sullivan image is gone. Munger's solitary tower stands in a vast desert landscape, bathed in the warm orange glow of late afternoon light. The two figures are not scientists but vaguely identifiable as Native Americans, and the picture is less about geology than about the hazy romance of the desert. The column, King writes, "could hardly be a more perfect specimen of an isolated monumental form if sculptured by the hand of man," and the badlands themselves seemed "sculptured into innumerable turrets, isolated towers, and citadel-like masses," which from a distance appeared like "a great walled city."[43] To illustrate the metaphors he drew from the worlds of art and architecture, King selected an image informed by the conventions of romantic landscape painting. The more precise descriptiveness of O'Sullivan's photograph could not convey the desired effect.

Thus King, like Dutton, employed two visual vocabularies, distinguishing in *Systematic Geology* between the didactic function of photographic views and reproduction technologies, and the more subjective language of an artist's representations. The tinted photolithographs of O'Sullivan's photographs carry the weight of King's descriptive prose about the geology of the region, while the chromolithographs of Gilbert Munger's paintings push the reader to imagine a landscape that could scarcely be comprehended through the dry discourse of geological writing.[44] King makes this contrast explicit in the book by several times pairing an O'Sullivan image with a corresponding Munger view of the same scene. A photolithograph of O'Sullivan's *Eocene Bluffs—Green River Wyoming* provides precise visual evidence of the geological layering of the eroded bluff, while the Munger chromolithograph of the same name instead provides a panoramic sweep of the river bluffs without conveying any geologic detail. Paired images of Mt. Agassiz and Shoshone Falls communicate similar differences. Where the photolithographs provide clear geologic detail, the chromolithographs rely on color and atmospheric effect to describe a more general scene. The one instructs, the other inspires, and both illustrative functions had a place in King's work.

When King strays from descriptive accuracy in his carefully chosen illustrations,

After Gilbert Munger, *Cañon of Lodore, Uinta Range, Colorado*. Chromolithograph, 1878, from Clarence King, *Systematic Geology* (1878). Archives and Special Collections, Amherst College Library

it is thus a matter of choice, not a failure of judgment. In *Systematic Geology* he includes a chromolithograph of Munger's painting *Canon of Lodore, Uinta Range, Colorado,* which depicts a small Indian encampment with tipis perched high on a rock ledge above the Green River. Calling attention to this "grossly inaccurate" representation of Colorado plateau Indians with distinctively Plains dwellings, the historian William Goetzmann argued that King's "selection of illustration is occasionally flawed."[45] But the photolithographic rendering of an O'Sullivan picture of the same canyon in *Descriptive Geology* suggests the deliberateness of King's choice. Where O'Sullivan's photograph depicts the geologic stratigraphy and topography along a particular stretch of the Green River without any sense of human scale, Munger's chromolithograph places the small Indian community at center stage. Dwarfed by the towering height and rocky gloom of the canyon walls, the incongruous tipis mark this canyon as a place where the spectacles of nature resist and overwhelm all permanent human communities. No geological explication—either visual or literary—could so powerfully suggest a visitor's simultaneous feelings of awe and powerlessness.

Like his colleague and rival Clarence King, Lieutenant George M. Wheeler, the leader of the Corps of Engineers' 1872–9 survey of the lands west of the hundredth meridian, recognized the distinctive virtues of photography even as he acknowledged its pictorial and narrative limitations. In his geological report (1875), the first of the seven survey volumes he would publish, Wheeler argued eloquently that "the camera affords the greatest aid to the geologist. Only with infinite pains could the draughtsman give expression to the systematic heterogeneity of the material. . . . But to photography the complicated is as easy as the simple; the novel, as the familiar." With a photograph, he wrote, one had "a guaranty of accuracy afforded only by the work of the sun."[46]

For all his enthusiasm about the medium, however, Wheeler sometimes appeared relatively uninterested in the human labor that went into producing photographs. In his geological report, he reproduced photographs by two distinct means, heliotypy and lithography.[47] And though he gave credit to the printmakers who translated the photographic originals into a pattern of ink on paper, he did not name the actual photographers—Timothy O'Sullivan, who accompanied him during the survey seasons of 1871, 1873, and 1874, and William Bell, who filled in during 1872. They were, it seemed, simply conduits for the straightforward visual information that the more skillful printmakers would render into graphic form.

By reproducing his photographic sources in two different ways, Wheeler created meaning for his readers by associating the pictures' content and narrative function with a particular mode of representation. His three photographs of rock specimens appear as heliotypes, a medium well-suited to conveying the articulated surface of the rocks with detailed clarity, and the landscape views intended to provide precise geographical information likewise appear as heliotypic reproductions. By contrast, the photographs that focus on the human perception of the southwestern landscape all appear as lithographic reproductions. In three of the four lithographs, a human figure poses in thought—under a perched rock, overlooking the Grand Canyon, beside the Colorado River. Reproduced in the grainy syntax of lithography, the pictures lose the precision of their photographic originals and become more like imaginative renderings that invite readers to visualize for themselves the experience of being lost in reverie in the face of nature's grandeur. The fourth lithographic image, a distant panoramic view of a Colorado River canyon, likewise invites the viewer to imagine himself at the brink of the chasm, gazing off into a dimly visible distance. The distinction between the two reproductive processes seemed clear. Lithography was the language of the imagination; heliotypy the language of science.[48]

Wheeler invoked a similar sort of association between reproduction method and ideological import in his archeological report (1879). O'Sullivan's "very fine photograph" of the White House ruins in Canyon de Chelly appears as a heliotype, and

Unidentified photographer, *Pebbles Carved by Sand, Colorado River*. Heliotype, from George M. Wheeler, *Report upon Geographical and Geological Explorations and Surveys West of the One Hundredth Meridian*, vol. III (Geology), 1875. Archives and Special Collections, Amherst College Library

VOL. III. GEOLOGY.

PLATE XI.

PERCHED ROCK,
ROCKER CREEK. ARIZONA.

After William Bell, *Perched Rock, Rocker Creek, Arizona*. Lithograph, from George M. Wheeler, *Report upon Geographical and Geological Explorations and Surveys West of the One Hundredth Meridian*, vol. III (Geology), 1875. Archives and Special Collections, Amherst College Library

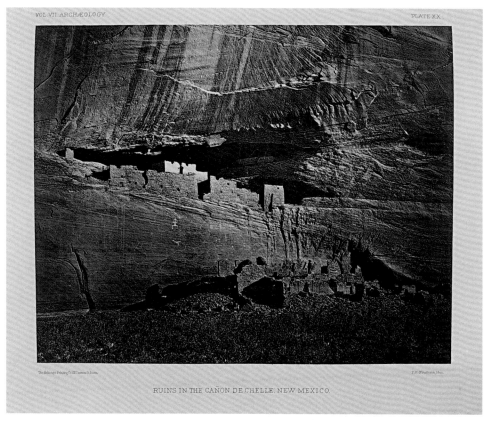

VOL. VII ARCHÆOLOGY PLATE XX

RUINS IN THE CAÑON DE CHELLE, NEW MEXICO.

After Timothy O'Sullivan, *Ruins in the Cañon de Chelle, New Mexico*. Heliotype, from George M. Wheeler, *Report upon U.S. Geographical Surveys West of the One Hundredth Meridian*, vol. VII (Archeology), 1879. Archives and Special Collections, Amherst College Library

After Francis Klett, *The Cachina (A Sacred Dance) at the Zuni Pueblo/New Mexico 1873*. Chromolithograph, from George M. Wheeler, *Report of the U.S. Geographical Surveys West of the One Hundredth Meridian*, vol. VII (Archeology), 1879. Archives and Special Collections, Amherst College Library

projects an aura of photographic or archeological authenticity; this ruin, it seems to proclaim, looks exactly like this. But the frontispiece that sets the visual tone for the book is a gaudy chromolithograph of Francis Klett's drawing of *The Cachina (A Sacred Dance) at the Zuni Pueblo/New Mexico 1873*. The brightly clad dancers are caught in mid-step, their hands grasp rattles raised high in the air. The picture is "of importance in representing some of the costumes of this interesting tribe," claims the volume's author, F. W. Putnam.[49] And, indeed, its coloring conveys information that no mono-chromatic rendering could provide. Yet one must wonder which illustration seemed most interesting or persuasive to the readers of the report. Did they most value the photographic precision of the archeological view or the descriptive color of the ethno-graphic scene? At this transitional moment in the history of photography and in the history of photographic reproduction it remained unclear how valuable photography truly was as a way to convey information about a particular place, a material object, or an ethnographic practice. Sometimes, its apparent literalism seemed confining, insuffi-ciently evocative. And conversely, particularly when the color of a scene or object was important, photography could seem not literal enough, too vague to convey what a viewer might need to know.

By the time Wheeler's report on geography finally appeared in 1889, some ten years after most of it had been written, the world of book illustration was in flux yet again. James Osgood and his heliotype company had gone bankrupt in 1885, and no one else had stepped forward as a commercial manufacturer of heliotypes for govern-ment reports. The advent of halftone printing technologies, which used photomechan-ical techniques to print copies of photographs within blocks of type, had, in any case, all but rendered heliotypy an archaic reproduction process. Halftones had none of the lustrous beauty of good heliotypes, and there was no mistaking them for a continuous tone photographic original. But the relative inexpensiveness of the process, and the ease with which it could be used to reproduce either photographic or nonphoto-graphic sources, surely made it a candidate to replace all of the older reproduction processes, the photomechanical ones as well as engraving and lithography alike.

Wheeler's geographical report, however, eschewed all use of the new halftone process and relied instead on older reproduction strategies—the lithograph, the photo-lithograph, and the chromolithograph—to reproduce both sketches and photographs. Though Wheeler professed an interest in eyewitness accuracy and here praised the "skill and endurance" with which photographer Timothy O'Sullivan executed his

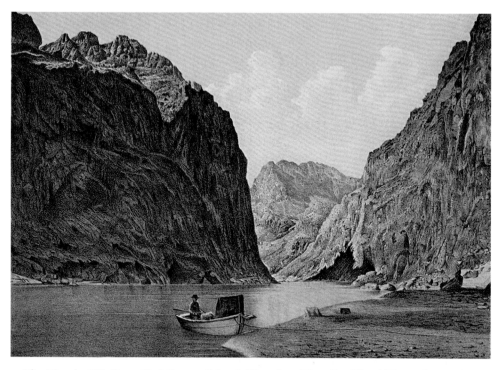

After Timothy O'Sullivan, *Black Canyon, Colorado River, from Mirror Bar*. Tinted lithograph, 1889, from George M. Wheeler, *Report upon United States Geographical Surveys West of the One Hundredth Meridian,* vol. I (Geographical Report), 1889. Archives and Special Collections, Amherst College Library

landscape work, his reproduction choices muted the immediacy and descriptive accuracy of the photographs he used (by both Bell and O'Sullivan), and minimized their essential difference from the imaginative sketches that provided the sources for other illustrations.[50] For example, by using a tinted lithography process to reproduce both *Black Canyon, Colorado River. From Camp 8. Looking Above*, a widely distributed photograph by Timothy O'Sullivan, and *Crossing of the Colorado River near Mouth of Paria Creek*, a sketch by Gilbert Thompson, Wheeler muted the syntactic differences between the sources and conferred upon them an equivalent documentary value. Likewise employing chromolithography to reproduce photographic sources as well as hand-drawn sketches, Wheeler effectively "colorizes" the monotone photographs, removes one of the most distinctive differences between photographic and painted images, and makes it difficult for the casual viewer to determine whether an image does

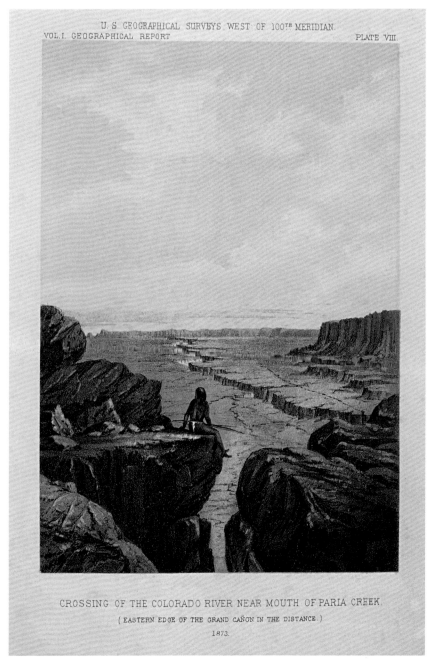

After Gilbert Thompson, *Crossing of the Colorado River near Mouth of Paria Creek.*
Tinted lithograph, 1889, from George M. Wheeler, *Report upon United States Geographical Surveys West of the One Hundredth Meridian,* vol. I (Geographical Report), 1889.
Archives and Special Collections, Amherst College Library

or does not have a photographic source. Redrawn as lithographs or chromolithographs, all of the plates in the book carry a similar weight of visual authority.

In moving away from the photomechanical reproduction processes he had used fifteen years earlier in the first of his published reports, Wheeler created an illustrations program that reinforced the shifting message of his text, which increasingly had come to convey a more distanced and romantic perspective on a particular moment of western exploration history, now a decade and a half in the past. But Wheeler's return to lithographic and chromolithographic illustrations, coupled with the more general reluctance to embrace heliotypy in the printed western survey reports of the 1870s and 1880s, raise broader questions about American attitudes toward photography. Wheeler and his colleagues often hailed the value of photography as a recording device and promoted the sale of original photographic prints from their surveys. Why, then, did they so often reject photography as a medium of illustration for their printed scientific reports? Why in particular, was there not a more enthusiastic embrace of heliotypy as a means of transcribing in ink the detail and continual tone realism of the photographic print?

Certainly, there were technical drawbacks to the heliotype process itself. Although a heliotype plate could produce some four thousand to five thousand prints, it had to be dampened after every impression, making the process somewhat slow and unwieldy. And because heliotypes could not be produced on sheets with type (the raised type of the letters and the smooth planographic surface of a heliotype plate were fundamentally incompatible), they had to be printed on separate sheets that were then inserted by hand into the printed signatures of a book. The photomechanical process could be nearly as expensive for book illustration as using tipped-in original photographs.

But there was also resistance to the heliotype process for reasons that extended beyond the practical. Heliotype reproductions of photographs—screenless prints often hard to distinguish from the original—reinforced the inherent problems of the photographic image itself. And as western photographers intent upon finding a market for their pictures had discovered, there was much that photographs could not do. They could not depict events from the past or show action. They could not picture physically inaccessible sites or convey a broad panoramic perspective. They could not show color. They could not easily incorporate references to other historically resonant images. They could not easily emphasize selected details of complex scenes. If the daguerreotypists of the 1840s and '50s often struggled to find ways to make their

After unidentified photographer, *Eagle Cliff*. Heliotype, from C. H. Hitchcock, *Geology of New Hampshire*, vol. II (1874–8). Archives and Special Collections, Amherst College Library

images prevail in the marketplace against the more dramatic representations of sketch artists, painters, and printmakers, so too did their counterparts in the final decades of the nineteenth century. For all its technical transformations, photography remained a medium of limited narrative potential.

Even those who enthusiastically embraced the heliotype struggled against the inherent limitation of photographic prints. In his three-volume *Geology of New Hampshire* (1874–8), C. H. Hitchcock made extensive use of the heliotype technology to reproduce both drawings and photographic prints.[51] Or, as the author claimed, he had "heliotypes from drawings" and "heliotypes from nature," a curious expression that seemed to deny the existence of the intermediary photographic print.[52] But these heliotypes were far from perfect illustrations, and Hitchcock's text reads as a running apologia for his ambitious printing experiment. His very list of illustrations, divided

After unidentified photographer, *Mt. Pequawket. Colored to show formations*. Hand-colored heliotype, from C. H. Hitchcock, *Geology of New Hampshire*, vol. II (1874–8). Archives and Special Collections, Amherst College Library

into "Illustrations printed with the text" and "Illustrations not printed with the text," lays out one of the chief drawbacks of photographic and photomechanical reproductions; unlike woodcuts, they could still not be printed on the sheet with type.[53] But the problems went beyond the mere mechanical. There was the problem of proximity: a photographer had to be relatively close to his subject, in space and time, a limiting factor artists could overcome through simple invention. Thus when Hitchcock could not obtain satisfactory photographs from two particular mountaintops, he substituted a photographic view from a different mountain in one case, and in the other simply used a drawing.[54] When he wanted to depict a geological event from the historic past, he used an imaginative sketch.[55] And then there was the problem of format. To capture the panoramic perspective favored by geologists for topographic drawings, he had to mount two heliotypes side by side with a distracting gap in between.[56] To honor

another custom of geological illustration, he went to great lengths to introduce color to his heliotypic landscapes in order to show rock stratifications. Explaining in a note that some of the heliotypes were made and then hand-colored after the relevant passages of the book had already been printed, Hitchcock wrote, "It is not possible at this time to say what these colors are; but it is hoped that, by comparing the heliotypes with their descriptions, the significations of the several tints will be perfectly understood."[57] A true pioneer in the field of photographic illustration, he nonetheless struggled with the medium at every turn.

Even to ardent proponents of photography, the absence of color remained a particular stumbling block. Ferdinand V. Hayden forcefully defended the value of the photographs that William Henry Jackson made while attached to his survey of the Rocky Mountain region during the early 1870s. Jackson's two thousand negatives "have done very much . . . to secure truthfulness in the representation of mountain and other

W. H. Jackson, *Hot Spring and Castle Geyser*. Albumen silver print, 1871–3. Yale Collection of Western Americana, Beinecke Rare Book and Manuscript Library

After Thomas Moran, *The Castle Geyser, Upper Geyser Basin.* Chromolithograph, 1875. Yale Collection of Western Americana, Beinecke Rare Book and Manuscript Library

scenery," he argued in his 1875 report. "Twenty years ago, hardly more than caricatures existed, as a general rule, of the leading features of overland exploration. . . . The truthful representations of photography render such careless work so apparent that it would not be tolerated at the present day." Hayden singled out for special praise Jackson's "views of the remarkable hot-spring deposits of the Yellowstone National Park, where the exceedingly intricate and delicate tracery of the incrustations, that would defy the most expert pencil, is readily secured in all its varied forms."[58] But the same year, Hayden wrote the preface to a portfolio of fifteen chromolithographic reproductions of Thomas Moran's watercolors of Yellowstone. Here he argued that the scenery of Yellowstone "had become tolerably well known" through photographs and printed illustrations. "But," he argued, "however accurate these illustrations may have been, they were all wanting in one particular, which no woodcut, engraving, or photograph can supply, and which, nevertheless, is of the greatest importance, especially in the case

under consideration. All representations of landscape scenery must necessarily lose the greater part of their charm when deprived of color; but of any representation in black and white of the scenery of Yellowstone it may truly be said that it is like Hamlet with the part of Hamlet omitted." Hayden concluded, "To a person who has not visited the Yellowstone and the territory adjacent to it, it is simply impossible to conceive of the character of its scenery . . . unless accompanied by colored illustrations."[59] For all its virtues, photography remained unable to capture one of the quintessential aspects of the western landscape.

Photographers themselves fretted about this inherent liability of the wet-plate photographic process, acutely aware that their medium could not even convey relative color values; the light sensitivity of the collodion negative was such that yellow and red both appeared as black in the resulting print, while blue was rendered as white, a particular problem with large sky-filled landscapes. A. J. Russell, who had documented the construction of the Union Pacific Railroad, lamented in 1870 that an inability to capture color was "the only thorn in the side of the camera." In an article written for a photographic journal, he wistfully imagined that when he exposed a negative of a particularly beautiful scene "with flowers of every hue and color," he heard his camera say "'only this and nothing more.'" Only a "peculiar softness" in the resulting picture could "reconcile" him to the loss of color.[60]

If the absence of color remained one barrier to full acceptance of photographic illustration, so too did the insistently realistic and specific content of photographs, a drawback simultaneously underscored and avoided through the reproduction processes that required the original to be redrawn on a printing plate. C. S. Fly, the Arizona photographer who would become well known for his portraits of Geronimo, first saw one of his photographs engraved for a broad audience in 1880, when the new Tombstone newspaper, *The Arizona Quarterly Illustrated*, began to publish illustrations based on his work. In October, they used his panoramic landscape of the city of Tombstone, but inserted into the image a figure wholly invented by the engraver. There on a rise overlooking the town was a seated Indian in a feather headdress, "sitting as if he were contemplating the march of civilization, with seeming astonishment at the change that has come over this part of his former hunting-grounds."[61] Quite apart from the anachronistic headdress, Fly would surely have had some difficulty getting a local Apache man to collaborate with such a composition. The engraver could narrate a

story as Fly himself could not, and the engraved reproduction of Fly's photograph could finesse its relation to the original as no photomechanical reproduction could.

The relative anonymity of the craftsmen who translated photographs into prints makes it difficult to unravel the rationale or mechanics of such transformations. In the collection of the Huntington Library, however, is an annotated set of the photographs made in conjunction with the Kansas Pacific Railroad's survey of a prospective route across the continent in 1867–8. The printed mounts identify the pictures as photographs by Alexander Gardner (who worked along the northern route), but the prints are from the personal collection of William A. Bell (who photographed along the survey's southern route), and thus do little to clear up a long-standing confusion about which photographer made which image.[62] But the pictures seem to be those that Bell supplied to the English printmakers charged with producing illustrations for his two-volume book about his western travels, *New Tracks in North America: A Journal of*

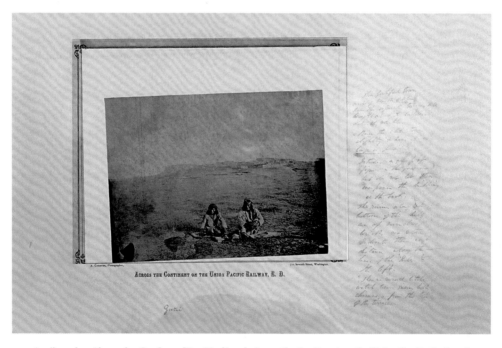

Attributed to Alexander Gardner, *[Zuni Indians], Across the Continent on the Union Pacific Railroad.*
Albumen silver print with pencil annotations, 1867. The Huntington Library, San Marino, California,
RB 470377 (119)

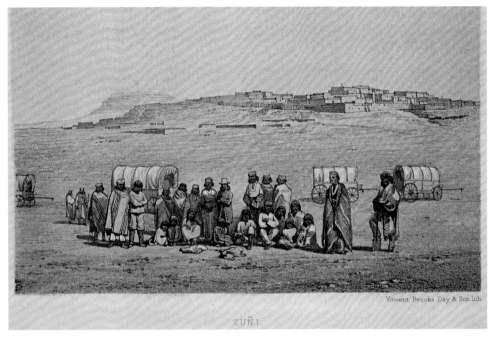

ZUÑI

Vincent Brooks Day & Son lith.

[After Alexander Gardner], *Zuni*. Lithograph, in William A. Bell, *New Tracks Across North America*, vol. I (1869). Yale Collection of Western Americana, Beinecke Rare Book and Manuscript Library

Travel and Adventure . . . (1869), for they are replete with handwritten suggestions for how the photographic originals might be improved in reproduction. In his preface Bell writes, "I have kept closely to fact throughout, and even in choosing my illustrations have taken great pains that everything should be true to nature." The artist, he says, has introduced a figure "here and there," but "with few exceptions all are exact copies from photographs taken on the spot."[63] Yet because the altered images serve the narrative needs of Bell's text, one must wonder about Bell's own role in shaping the changes. "Introduce pistols and guns as distinctly as possible," reads an inscription on the mount of the photograph called *Zuni Tollgate near Agua Fria* (and reproduced as *Surveyors at Work*); add "flags on poles." Such instructions seem intended to compensate for a lack of visual clarity in the original photograph. Others, however, aspire to clarify weak compositions or questions of fact. The annotator directs the lithographer to combine groups of people from different photographs, to add "a few deer (not many)"

coming out of the trees in a landscape photograph, and to work particularly hard on a photograph of Zuni Pueblo. "This fortified town is made of *blocks of stone*," he writes. "Raise the separate terraces till brought out and the ladders distinctly visible. Raise the whole town slightly and have it as *large as possible*. Introduce a group of figures in the foreground but do not let them overpower the building at the back."[64] None of the directives ask the printmaker to fundamentally alter the content of the photographs, but each serves as a subtle reminder of photography's continuing inadequacies as a medium of description and narration.

Even the Smithsonian Institution's Bureau of American Ethnology, which had its own rich collection of photographs, shied away from photographic illustrations in the illustrated annual reports it began issuing in 1881. The reports relied on both photographic and drawn originals, and reproduced them by means of steel engravings, woodcuts, lithographs, and chromolithographs. The government had collected anthropological photographs since the 1860s, and the Bureau had made and collected anthropological photographs since its inception in 1879. But such documentary photographs seemed less useful—even in formal ethnographic reports—than more imaginative scenes, often inspired by literary descriptions, that could evoke other historical and art historical sources, or amplify specific sections of the text. Thus in the BAE's first annual report (1881), an article on the mortuary customs of North American Indians appeared with lithographic and chromolithographic illustrations based

Unidentified artist, *Launching the Burial Canoe.* Chromolithograph, c. 1881, from *First Annual Report of the Bureau of Ethnology . . .* (1881). Amherst College Library

on drawings by the expeditionary artist W. H. Holmes that were, in turn, based on literary descriptions. The chromolithograph of a Parsee burial scene interjected a visual note of oriental exoticism; the chromolithograph *Launching the Burial Canoe* evoked the biblical story of the baby Moses; the tinted lithograph of a *Tolkotin Cremation* drew from the iconography of medieval and renaissance lamentation pictures.[65] Such fictive illustrations documented antiquated or seldom observed practices that no photographer could record, but they also created a complex set of associations in the viewer's mind. By visually linking North American Indian practices to Christian religious practices, they enveloped the exotic strangeness of Indian life within a comfortingly familiar tradition, removing it from politics and the tumult of recent history. Photography might provide detailed evidence, but it could not do all the narrative labor demanded of and provided by more imaginative renderings.

This resistance to photographic illustration persists, even into the halftone era when the development of the screened halftone printing process made the reproduction of photographs easier and cheaper and facilitated the reproduction of image and text on a single printed page. The halftone process involved a specially prepared metal plate onto which technicians could transfer a screened photographic image made up of a pattern of countless tiny dots. The space between these dots could be etched away and the plate then printed on a regular printing press, along with set type. Images with near-photographic detail (though without the continual tone imagery of the originals) could thus be reproduced directly onto the sheet that held the printed word, and the laborious handwork required for producing and tipping in other sorts of reproductions could be eliminated. The first halftone reproduction of a photograph appeared in an American newspaper in 1880, and illustrated government publications about the West began to make widespread use of this process in the early 1890s.[66] The widespread adaptation of the process thus coincides with an important transformation in photographic technology—the invention of the Kodak camera in 1888 and the widespread marketing of these so-called snapshot cameras in the 1890s. The small, portable, easy-to-use cameras used a roll of flexible film that was returned directly to the manufacturer for processing and printing. With the exposing of pictures finally separated from the chemical processing of photographs, photography became a widespread activity for amateurs. And with the advent of halftone technology the photographic reproduction of photographic images became cheaper and easier than it had ever been before.

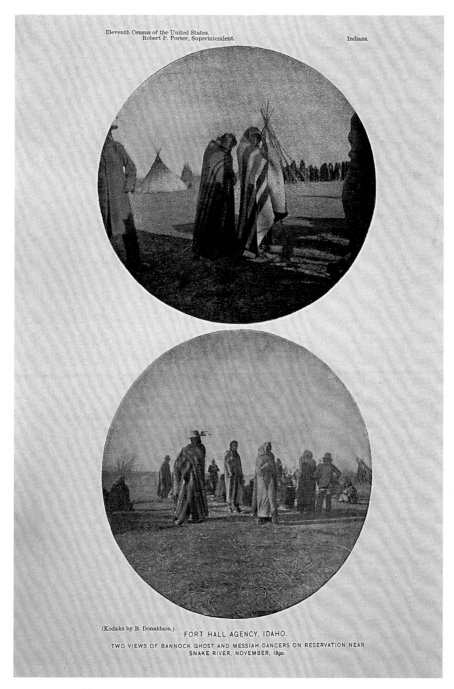

Eleventh Census of the United States.
Robert P. Porter, Superintendent.

Indians.

(Kodaks by B. Donaldson.)
FORT HALL AGENCY, IDAHO.
TWO VIEWS OF BANNOCK GHOST AND MESSIAH DANCERS ON RESERVATION NEAR
SNAKE RIVER, NOVEMBER, 1890.

B. Donaldson, *Fort Hall Agency, Idaho, Bannock Ghost and Messiah Dancers, 1890.*
Halftone reproduction of Kodak snapshot, from *Report on Indians Taxed and Indians Not Taxed* (1894). Amherst College Library

After Walter Shirlaw, *Omaha Dance, Northern Cheyennes—Tongue River Agency, Mont. August, 1890.*
Chromolithograph, from *Report on Indians Taxed and Indians Not Taxed* (1894). Amherst College Library

When photographs became easier to make and cheaper to reproduce, did attitudes toward photographic illustration change? Not, it seems, right away. Consider two curious volumes published in conjunction with the report of the 1890 census, the demographic report that prompted historian Frederick Jackson Turner to make his celebrated observation about the closing of the American frontier. In *Moqui Pueblo Indians of Arizona and Pueblo Indians of New Mexico* (1893) and *Report on Indians Taxed and Indians Not Taxed* (1894) are a bewildering assortment of illustrations that reflect a moment in the history of illustration when everything seems to be in flux—from the methods of gathering visual information in the field, to the technical methods of reproducing images, to the very purpose to which illustrations were put. For the Pueblo Indian volume, the special census agent and artist Julian Scott contributed fieldwork executed in a broad variety of media—ranging from paintings to line drawings to Kodak snapshots—that were reproduced in a comparable variety of processes including chromolithography, engravings, and halftones. The photographs and photomechanical reproductions alone could not carry the weight of the book's argument. An

odd halftone reproduction of a collage of watercolors based on earlier photographs by Adam Clark Vroman sends mixed signals about the utility or value of photographic illustrations. A halftone of John Hillers's albumen photograph of a Hopi mesa makes for an odd pairing with the gaudy chromolithograph of a painting of a Taos Pueblo scene by the artist Henry Poore. The book *Indians Taxed and Indians Not Taxed*, a weighty survey of historical and statistical data, includes a similar jumble of photographic views and invented illustrations. A halftone reproduction of a Kodak snapshot depicting a Bannock and Shoshone ghost dance of November 1890 appears with a brightly colored lithographic reproduction of Walter Shirlaw's paintings of a different dance performed that same year by the Northern Cheyenne. In both books, the photographic evidence and imaginative renderings are of a piece, equally useful to the narrative flow of the work, equally valuable as visual evidence supporting the text's didactic structure. Even in the 1890s, photography alone could not perform all the labor demanded of illustrations in the government-published books on the peoples and places of the American West.[67]

The striking mix of illustrations in these publications reiterates that at the very end of the nineteenth century there remained a continuing resistance to the realism of photographic images and a lingering preference for more dramatic, narrative, and decorative forms of illustration even in informational books. It was a familiar sort of cultural taste, the same kind of preference for visual drama that had led Americans to value lithographs of the Mexican War more than daguerrean images, to prefer moving panoramas of overland travels to the first photographs of unfamiliar western landscapes. By the late nineteenth century, technology made possible photographic reproductions of photographic views, but there remained a broad preference for other sorts of images: images that could evoke associations with other forms of visual representation, images that could document fleeting dramatic moments, images that could document historical events. New reproduction technologies did not immediately create new ways of seeing.

There are several lessons to be drawn here. First, in late-nineteenth-century illustrated books different forms of image-making worked together in dialogue. We miss much if we study, in isolation (as scholars sometimes do), only photographs, or just engravings. For one form of image taught readers how to interpret and understand another. Photographs, for example, gained in factual authority but shrank in imaginative resonance by being juxtaposed with more inventive forms of illustration. Even the

seemingly arcane publications of government agencies served as primers of a sort, offering instructive lessons in how to read visual imagery.

The second lesson pertains more to technology. New reproduction technologies did not immediately create new ways of understanding the world. There was, in the late nineteenth century, a gap between the technological capacity to convey certain sorts of visual information and the more conservative popular expectations for what images should look like. This is a gap that is visible at many moments of technological change, from the development of the daguerreotype to the development of digitized image banks on the World Wide Web. Those of us scrambling to understand the potential uses of the electronic media can surely empathize with those audiences of the late nineteenth century who looked with some anxiety at the radical new forms of photomechanical reproductions made possible by technological innovations. We should probably not be too quick to scorn them for their lingering preference for traditional forms of communication, for images that fit into a comfortable frame of reference created through repeated exposure to other pictures.

The final lesson here pertains to popular cultural beliefs. In his classic western film *The Man Who Shot Liberty Valance* (1962), director John Ford includes one of the great lines of western filmmaking. "This is the West, sir. When the legend becomes a fact print the legend." The newspaper editor who utters the line understands that the interests of his readers are best served by not exposing a much-beloved historical legend as a lie. Like Ford himself, he understood his audience well, understood their preference for the comfortable myth over the unsettling truth. He spoke, of course, of the power of the written word to create and reaffirm popular cultural beliefs. But his words also have much to tell us about the more prosaic field of book illustrations. Time and time again during the second half of the nineteenth century, popular publishers and government printers, travel writers and scientific chroniclers alike were faced with options that would allow them to select between photographically based sources and more imaginative drawings, between photomechanical reproductions and more freeform engraved and lithographic prints. More often than not, they chose the more inventive forms of illustrations. In doing so they betrayed their own values and their perception of what it was their readers really wanted; they chose to print the legend, not the fact.

Epilogue

Pictures as History and Memory

Photography and the Story of the Western Past

... the 'discovery' of old photographs, and the widespread exploitation of them for actuality effect ... poses an entirely different question, one concerned with the meaning which a picture acquires *retrospectively*. ... The power of these pictures is the reverse of what they seem. We may think we are going to them for knowledge about the past, but it is the knowledge we bring to them which makes them historically significant, transforming a more or less chance residue of the past into a precious icon.

—Raphael Samuel, *Theatres of Memory*, 1994

Increasingly, history is narrated through images. In films and on television, in museums and in textbooks, images visualize the past; and historical photographs seem to visualize it best of all, allowing us an unmediated glimpse of lost worlds that radiate an aura of factual authenticity and unquestionable veracity. Photographs seem to tell us about things we could not otherwise know: about the emotion visible in an ancestor's face, about the way a field looked on a particular summer afternoon, about the appearance of a raw western town. Such pictures resonate with authority, in part because of their age, in part (despite all we know about digital manipulation) because we still presume their mimetic accuracy. Carefully displayed on a museum wall, lovingly panned in a documentary film, old photographs seem to speak for and to represent the past. They simultaneously mark a familiar world and remind us of its differentness; for the past, they seem to declare, transpired in black and white. Neither museum curators nor film producers do much to discourage the illusion that photographs can actually confer a deep understanding of this monochromatic past. Their livelihoods depend, in part, upon persuading us that what matters most is visible or easily visualized.

But how useful are photographs as historical evidence? Do pictures themselves tell stories, or do viewers tell stories *about* them? Are their meanings created by their makers, or by their audiences? And if viewers can bring to photographs different interpretations, how stable is the photograph as a kind of fixed document of the past? Literary documents, too, are subject to shifting and malleable meanings. But if photographs share some interpretive problems with literary records—and demand a similar sort of attention to issues of date and provenance, authorship and audience—they also present peculiar problems of their own.

326

Certainly, despite their increasing ubiquity in American life over the past one hundred and sixty years, photographs can never provide more than deeply selective sorts of evidence. Selective not just in the sense of favoring what appeared before the photographer's sight on a particular day, but favoring what is within the range of human sight at all. Powerful economic forces, political ideologies, long-term weather cycles, are not easily photographed. Our vast archive of historical photographs favors the anecdotal, the vernacular, the everyday; the seeming ordinariness of photographic evidence, particularly in the snapshot era, seems to imply its value as a record of daily life. But photographs cannot explicate complex events. They more readily depict a particular consequence of a drought—one farmer's dried-up field, for example, or a malnourished child—than the more general causes and effects of economic disaster. Pictures more easily depict the material trappings of wealth than the global economic forces that might have brought it about; they can more easily document the appearance of a particular piece of land than explain the political or diplomatic machinations that brought it within the control of a specific nation. This inherent particularity of photography, its insistence on easily defined and delimited subjects, has several important consequences for anyone who would use photographs as a source of historical understanding. It makes most history seem personal. It emphasizes material consequences at the expense of ideological forces, and it creates an illusion that photographs are so concrete they are simply self-explanatory. But they almost never are. Photographs can *describe* the past; they have a limited capacity, however, to *explain* it, no matter how much we might wish that they could.

The photographic record of the past is quirky, uneven, given to emphasizing certain places, things, and events at the expense of others; it consists of selected moments that flash up from the continuum of flowing time. Unlike writers or painters, photographers (at least in the era before computers) had to be in close proximity to their subject. Such an observation seems obvious, but its consequences are far-reaching. Hence we more often (and usually unthinkingly) visualize the Civil War through the appearance of Union activities and northern sites rather than through southern ones, giving little thought to the naval blockade of southern ports that made it difficult for southern photographers to make a comparable visual record. We easily visualize the much-photographed Union general William T. Sherman, but are hard-pressed to conjure up the likeness of his Confederate counterpart, Joseph E. Johnston, who was photographed only twice during the war. The battlefields, the mortars, the warships for which photographs survive gain a kind of primacy in historical films, history books, and textbooks, simply because visual documentation of them happens to exist.[1]

327

Similar sorts of visual inequities exist in the documentation of western American history. The economic boom of gold-rush California attracted photographers, who created a far more extensive visual record of that state in the 1850s than ever existed for Arizona or New Mexico, Nebraska or Kansas. Despite photography's relative affordability, nineteenth-century studio photographs still favor certain social classes over others, leaving us with relatively few pictures of the urban poor, for example, or of migrants who moved from one place to another. The whims of patrons meant that new roads, new buildings, new towns bustling with the promise of a glorious future were photographed more than those that had fallen into ruin and disrepair. Mines in need of investors were photographed more extensively than urban sweatshops, and landscapes attractive to developers or tourists were pictured more often than the foreboding deserts of the arid West. Similarly, the tastes of eastern consumers dictated that dramatic mountain vistas would be depicted more often than prairies, Indians photographed more often than Hispanic peoples, cowboys pictured more often than urban clerks. In the market-driven world of nineteenth-century photography, progress—particularly for the West's Euro-American peoples—triumphed over failure.

If the making of photographs of the nineteenth-century West was a process ruled by chance and circumstance, patrons and markets, the subsequent use of these pictures has proved even more selective and idiosyncratic, with some pictures being reproduced again and again, while others languish in archives. Use begets use; most historians find it easier to do their picture research in published books than in files of vintage photographs. And many times, the most-used pictures are not only torn from the contexts in which they originally appeared—in published series, in albums, in carefully labeled sets of stereographs—they are often used synecdochically, the specific made to represent the general, the singular to represent the typical. When, in his multipart television history of the West, Ken Burns used an 1860s photograph of an immigrant family with a covered wagon to visualize another that had traveled West some twenty years earlier, the effect is poetic, but it is scarcely good history. Would any responsible filmmaker or writer ascribe the words of one speaker to another? If not, then why should we not demand the same stringent standards of responsibility with regard to historical images? The end result is relatively harmless in the case of the hapless overland immigrants, disguised, in Burns's film, like renamed participants in a historian's witness protection program. But the generic and synecdochic use of historic photographs can have more insidious effects, unconsciously shaping a viewer's response to the story the pic-

tures visualize. When Burns uses early-twentieth-century photographs of southwestern Indians to represent the participants in the 1680 Pueblo revolt, but relies on images of architecture or landscapes to visualize their unseen Spanish foes (presumably eschewing twentieth-century photographs of Hispanic New Mexicans as too ahistoric), he silently suggests that the Indian peoples of the Southwest remained unchanged, while their Euro-American neighbors moved forward into the modern age.[2] His illustration strategy thus reinforces the ill-conceived logic of the vanishing race rhetoric of the nineteenth century: Indians were incapable of changing or adapting over time; cultural progress was the prerogative of the Europeans. In retrospect, one can only admire the prescience of Crazy Horse, the Lakota leader who, unlike his contemporary Sitting Bull, steadfastly refused to be photographed. His decision has kept his likeness from being valorized in textbooks or transformed into the iconic poster image for an Indian past; for better or worse, though, it has not prevented his imagined face from being carved into a mountainside in South Dakota, where his head is now eighty-seven and one-half feet high, his pupils eight inches deep.[3]

From the start, photographers working in the West understood the potential historical value of their work. This historical consciousness pervaded the documentation not just of the region's native peoples, but of its other inhabitants as well. In 1854, a photographic journal praised the work of James and James H. Selkirk of Matagorda, Texas, who had "collected numerous likenesses of some of our oldest settlers, including some of the 'old three hundred' who first came out in Austin's Colony" in the early 1820s. These pictures "will be regarded in after years as objects of great interest," the journal noted, "when the originals have departed from the busy field of their labors."[4] Portraits such as those the Selkirks made are, in a sense, the easiest sorts of documents for historians to use, for if properly labeled they can provide useful evidence of the simplest sort, giving a human visage to names in an historical chronicle. But it is ultimately a limited sort of evidence. If the face of an early Texas settler might inspire empathy or understanding or even adulation from a modern viewer, it cannot in fact reveal anything about the character or feelings or motivations of that Texan pioneer. A viewer can bring to the picture his own surmises, informed by his own experiences; but as evocative as it seems, the portrait is mute, incapable of explaining why its subject behaved as he did, what sort of person he was, why he should be an object of local veneration by the 1850s. Such pictures are thus subject to the uses to which historians most often put old photographs—as illustrations of what they already know. And like chameleons, the

pictures are thus apt to take on the protective coloring of their surroundings: in a book celebrating the heroic origins of Anglo-American Texas, the pictures would presumably narrate and represent a different story than they would in a Mexican text deriding the imperial invasion of the nation's northern territories.

The capacity of photographs to evoke rather than tell, to suggest rather than explain, makes them alluring material for the historian or anthropologist or art historian who would pluck a single picture from a large collection and use it to narrate his or her own stories. But such stories may or may not have anything to do with the original narrative context of the photograph, the intent of its creator, or the ways in which it was used by its original audience. Consider, for example, the scattered nineteenth-century photographs of cowboys. (What would a book about nineteenth-century photographs of the West be without at least a passing reference to these oft-used pictures?) If such pictures are now often used as historical bulletins from the front, visual news releases from one of the most mythically potent moments of the nation's western past, they in fact were not created as straightforward reportage. From the start they were invested with the power of myth and cloaked in the gauzy haze of nostalgia; they evoked a longing for the past rather than an understanding of the present.

In *The Virginian,* Owen Wister's popular 1902 historical romance of western life, a photograph introduces heroine Molly Wood's staid New England family to her cowboy suitor. Returning to Vermont with "a number of photographs from Wyoming to show to her friends at home," Molly passes around the "views of scenery and of cattle round-ups, and other scenes characteristic of ranch life." When her great-aunt begs to see the portrait she knows has been held back, Molly dutifully retrieves her picture of the Virginian. "It was full-length, displaying him in all his cow-boy trappings,—the leathern chaps, the belt and pistol, and in his hand a coil of rope." Overcoming her shock at the subject's mode of dress and the photograph's intimations of violence, the aunt eventually endorses Molly's favorable judgment of the Virginian. "She is like us all. She wants a man that is a man."[5] The photograph evokes the romance of the open range, an associated aura of masculinity, and a brief moment of the cattle industry that had ended some fifteen years before Wister penned his book. For Wister, the photograph was a kind of visual shorthand, a way of translating a complex set of associations into a symbolic language easily grasped by his audience. His readers would be holding in their hands an unillustrated text; with words alone he would have to summon up a visual image to stir the imagination and evoke nostalgia for a world that was lost.

The majority of cowboy photographs were created after the brutal winters of the mid-1880s that spelled the end of ranching on the open plains, and made with self-conscious awareness that the way of life they purported to represent was already under siege. But even earlier, such pictures—like those in Wister's novel—were objects of historical romance, fictive images created together by photographer and subject. G. D. Freeman traveled through Kansas with a portable photographic wagon during the winter of 1878–9, stopping in small towns to take portraits. Arriving in Caldwell, Kansas, in April 1879 he opened a gallery and later recalled that he "did a profitable business among the 'cowboys,' who were anxious to get a photograph of themselves in 'cowboy' style to send to their friends living in the eastern states." This cowboy style amused Freeman, who found some of the outfits "novel in the extreme." "Some of the boys would wear a large sombrero and have several revolvers hanging from a belt worn around their waist, others would be represented in leather leggins, two large Texas spurs on their boots, revolvers in hand and looking as much like a desperado as their custom and appearance would admit."[6] And indeed, such dress had more to do with the business of *acting* like a cowboy than with the business of actually *being* one. Intent upon claiming a particular kind of cultural authority and evoking a romantic image that belied the realities and practicalities of working life, nineteenth-century cowhands were more likely to wear guns inside a studio than outside it, more likely to wear chaps for the photographer than for their horse.[7] When he posed for his portrait, the fictional Virginian understood the powerful symbolism of his dress. Being media-savvy is not simply a product of the television age.

While studio portraits of working cattlemen were often produced as private keepsakes, others were marketed as parts of more elaborate series on cowboy life. Among the most ambitious was Charles D. Kirkland's eighty-part set, *Views of Cow-boy Life and the Cattle Business*, assembled some time between 1881 and 1887 during Kirkland's tenure in Cheyenne, Wyoming.[8] Each 5×8 in. print came mounted on a card whose back was printed with the titles of all the images in the set, a strategy that simultaneously made the mounts interchangeable and cheaper to produce, provided viewers with a short-title list of the essential components of cowboy life, and suggested to collectors which prints they could purchase next. In no apparent order, the titles laid out the basic parameters of cattle-ranching life, from roundups, herding and branding, to eating, resting, and leisure-time play. Absent are the tedium and violence of cowboy life, any suggestion that these "lords of the plains" were generally poorly paid wage

laborers with little control over the day-to-day rhythms of their lives. Such images would have ill-served Kirkland's ambitions for his pictures. "The photographs . . . were taken on the line of the Union Pacific Railroad (the Overland Route)," proclaims the text on Kirkland's printed mount, "and illustrate graphically and truthfully the cattle business of the Great West. The views have been taken instantaneously from life."[9] Offering up his cowboys as both commodities and spectacles, Kirkland hoped to reach the tourists and armchair travelers attracted by the seeming authenticity of his views and the possibility of witnessing this ranch life from the comfortable confines of a transcontinental railroad parlor car. He presumably sold his pictures to the Union Pacific travelers who passed through Cheyenne, and distributed his photographs through sales agents spread out along the rail line. The Denver and Rio Grande Railroad even distributed to its customers a small folding book on *Cowboy Life* that included uncredited lithographic reproductions of Kirkland's photographs.[10] But the invocation of rail accessibility is ironic, for railroads not only brought tourists, they brought the demarcation of private property boundaries that placed new limits on open range ranching.

In the late winter and early spring of 1887, Kirkland's photographs came to national attention as woodcut reproductions in *Frank Leslie's Illustrated Newspaper*. The year before, bitter cold and snow had dealt a terrible blow to the cattle industry on the southern plains. Now, the northern plains were enduring the most brutal winter in recorded history, a winter that would claim some four hundred and forty thousand cattle in Wyoming and Montana alone and lead dispirited cattlemen—stunned by the carcasses that littered the early spring landscape—to reorganize their industry. Smaller herds, fenced pastures, and winter feed would replace the sprawling herds on the open plains. In *Leslie's,* however, Kirkland's pictures are presented as timeless images of cowboy life, a life that has less to do with changing business fortunes and economic practices than with stylized modes of behavior. "The cowboy has at the present time become a personage; nay, more, he is rapidly becoming a mythical one," wrote an English visitor to the West in 1887. "Distance is doing for him what lapse of time did for the heroes of antiquity. His admirers are investing him with all manner of romantic qualities; they descant upon his manifold virtues and his pardonable weaknesses as if he were a demi-god." Kirkland's pictures underscored this adulation of the quintessential western laborer whose "genuine qualities are lost in fantastic tales of impossible daring and skill, of daring equitations and unexampled endurance."[11] Published at the precise

Charles D. Kirkland, *Dinner on Hunton Creek.* Albumen silver print, c. 1880s. Amon Carter Museum, Fort Worth, Texas (P1979.36.4)

historical moment that marked the end of classic open range ranching, the photographs aggressively denied the economic exigencies and uncertainties of the present, and instead confirmed popular belief, transforming a moment of industrial chaos into a timeless image of an historic West. "In the Photograph," writes the critic Roland Barthes, "the power of authentication exceeds the power of representation."[12] And so it did in Kirkland's photographs; the pictures were more fiction than prose, more readily verifying expectations than conveying information.

The text accompanying the first appearance of Kirkland's cowboy images in *Leslie's* on March 12, 1887, construed change as progress. The cover picture of cattle being driven north into Canada signaled the fact that "the feeding grounds of the Territories, vast as they are, have already become overcrowded."[13] But the next two stories about Kirkland's views—published in *Leslie's* on April 9 and April 30, even as the dimensions of the winter's disaster were becoming increasingly apparent—deny all reference to economic or ecological change. Kirkland's cowboys pitch broncos and brand steers; they pose in fancy dress, ride yearlings, throw steers, and pause for dinner on a

Charles D. Kirkland, *Wyoming Cow-boy*. Albumen silver print, c. 1877–95.
Amon Carter Museum, Fort Worth, Texas (P1979.36.3)

roundup. Creatures of romance, they labor in timeless fashion, above all complexity and contingency, oblivious to the shifting economic terrain of their work. A "favorite dime-novel hero . . . [the cowboy] is not himself averse to humoring the exaggerated notions of 'tenderfoot' visitors from the East," the paper explained. "Not a few can solve a mathematical problem, or parse a Latin sentence" with the same skill with which they can "throw a steer or punch a brand."[14] These cowboys existed outside of the world of temporal change. First pictured as visual representations of a romantic tourist's West, they quickly came to serve as elegies to an imagined past. In both cases, they gave to consumers the world they desired.

Those who followed Kirkland photographed with even more self-conscious awareness that the symbolic meaning of their pictures would be reinforced by the disappearance of open range ranching. John C. H. Grabill, who proclaimed himself "official photographer of the Black Hills and F.P.R.R. and Home Stake Mining Co.," and maintained studios in both Deadwood and Lead City, South Dakota, copyrighted one hundred sixty-five views between 1888 and 1891, including scenes made at Pine Ridge in January 1891, just after the American military's massacre of more than two hundred fifty members of Big Foot's Lakota band.[15] His cowboy views are reminiscent of Kirkland's—with pictures of dinnertime scenes, branding, and other trail activities—but his marketing strategies show that he understood his cowboy pictures to be about a particular moment of western history. His photographs of "cowboys racing a buffalo," "branding cattle," "mess scenes," and "a cowboy on a bucking bronco" were marketed as part of a series of historical views that included "the old Deadwood coach, the new coach and past coach" and "'Bigfoots' band of Indian before killed."[16] They were clearly about a moment in western history that was already over.

Montana photographer Laton A. Huffman, whose pictures of late-nineteenth-century cowboy life have been reissued continuously up to the present day, likewise marketed his work as a retrospective glimpse of a vanished life.[17] Moving to Montana in late 1878, Huffman eventually settled in Miles City and established a studio from which he would roam as far afield as Yellowstone in order to secure views to sell through his gallery and mail-order business. With an acute sense of himself as an historian, he collected artifacts along with his pictorial records of Montana life. By 1883, he had a reported eighty-three thousand prints in his inventory; by 1885, however, his "view business had played out."[18] Later, he recalled, the years 1879, 1880, and 1881 were the best of all. "There was no more West," he believed, after the arrival of the rail-

road in Miles City in September 1881. "It was a dream and a forgetting, a chapter forever closed."[19]

In 1883 Huffman printed a catalogue of available views that offered the "Latest Yellowstone National Park Views, Indian Portraits, Miscellaneous Montana Views and the Only Choice Hunting Scenes Published," as well as a selection of fourteen views of "Custer's Battle Field."[20] Fully a third of the views depicted the new national park, and these, coupled with twenty-five hunting scenes, suggested Montana's shifting cultural terrain. The land where Custer had fallen just seven years earlier was becoming a playground for the well-to-do. Montana's future as a tourist destination seemed to devolve around the diminishing dangers presented by her Indian residents. Huffman's catalogue

Laton A. Huffman, *Roping Cattle*. Gelatin silver print, c. 1885. Amon Carter Museum, Fort Worth, Texas (P1979.51.24)

of "Yellowstone Views" concludes with three pictures that implicitly make the case for a safe Montana: "Major Pollack Inspecting Indian Laborers," "Monster Petrified Bone ... ," and "An Indian Grub Dance, Main Street, Miles City" transform Indian peoples into safe and quaint curiosities fated to follow the path of the long-extinct mastodon.

In 1898, however, Huffman published a more elaborate catalogue of one hundred and fifty-four photographs—featuring many ranching scenes made after 1883—that looked not to Montana's future, but to her past, to the "chapter forever closed." The opportunities for securing the sorts of negatives he had made over the past twenty years, Huffman wrote in the catalogue introduction, have "for the most part passed away. The Buffalo has long since become practically extinct.... The 'Blanket Indian,' in his gay garb with his lodge of skins and his pony herd, must ere long be sought in the 'wild west show.' The great cattle Roundups, with their army of cowboys, will soon be wholly discontinued."[21] Montana's charm lay not in the complicated present, but in a storied past characterized by picturesque scenes of cowboy life. "The real cowboy with his 'sixpistol', his leather leggings, sombrero and all the rest is fast disappearing from the plains;" Huffman wrote, "few new ones are being brought into the business."[22] Like so many late-nineteenth-century photographs of Indians, these pictures claimed the public interest as documents of a fast-disappearing world, but even Huffman seemed to know that the world he purported to document had changed before he ever made his photographs. The past is always an elusive target, but as is so often true when it is enlarged and made diffuse by nostalgia, it is easy to hit. In 1905, Huffman closed his studio to new clients to concentrate on the production of postcards, prints, collotypes, and hand-tinted photographs from his old negatives of life on the range.[23] "Huffman Pictures tell a story that, as time goes on, grows more interesting," Huffman told prospective clients.[24] And for those left unsatisfied by the visual information contained in the original negative, Huffman promised to make his photographic prints more true to imagined memory than even the original scenes had been. All it took was a brush and a steady hand. "With hair on a stick," he claimed, he could brush "in the wanted details, Prairie Dogs, Buffalo Chips, distant hill or nearer Buttes." Seemingly unaware of the irony, he claimed his hand-altered pictures as authentic souvenirs, "saved" from the past for posterity.[25] For the complex dynamics of historical change, he would substitute his historical picture memories.

Nostalgia was a potent force in late-nineteenth-century western photography, as it was in turn-of-the-century western painting. And it was a force, explains the cultural

historian Michael Kammen, that "tends to deny the notion that progress or change is very likely to have fortuitous consequences."[26] The cowboy artist Charles M. Russell titled many of his painting exhibitions *The West That Has Passed*, aptly characterizing the work created in his studio whose walls were hung with L. A. Huffman's photographic tributes to the cowboy and Edward Curtis's photographic mementoes of the "vanishing race."[27] The region's distinctiveness once seemed to lie in her boundless future. But now, as the West became more and more like the rest of America, an increasingly urban region tied to the nation through a web of rail lines and telegraph wires, its distinctiveness seemed to lie in its history, and its future seemed unknown. "Secure a picture of life in the far west while you can," the Nebraska photographer Solomon Butcher wrote on the back of his pictures of Custer County pioneers in 1888. "Sod houses will soon be a thing of the past."[28] Butcher's poignant photographs of rural families posed outside their prairie homes with all their worldly possessions—brought from indoors, from barns, from toolsheds arrayed about them to testify to their prosperity, created self-contained photographic narratives as few other nineteenth-century photographs did. Look how far we have come, the people in the photographs seem to say; look how much we have accumulated since we first immigrated to this little piece of earth. But while the subjects of the photographs seem determined to construct narratives of progress from their personal struggles, to have their eyes on the day when they would no longer need to live in a sod shanty, Butcher valued more highly the evidence of those early days of hardship. He marketed the pictures not as markers of self-improvement, but as mementoes of a storied past. For him, as for most of the western photographers who made and marketed photographs of cowboys or Indians, the photographs were implicated in a larger argument about the shifting shape of the western past from the very moment he exposed his plate. The Custer County pioneers photographs, like many late-nineteenth-century pictures of cowboys or Indians, are often used to illustrate historical texts and film about the way things were. But their makers always understood that they were, in a sense, fictive creations, pictures about the way things might once have been in a more distant past. It would be wrong to pretend that they are unmediated slices of real life. They are, in fact, more complex sorts of historical documents that, like autobiographies or memoirs, can be used as sources, but only with an awareness that they reflect the makers' desires to shape a viewer's understanding of the past. In this case, they reflect their creators' sense that the West that had *been* was more alluring and marketable than the West that might yet *be*.

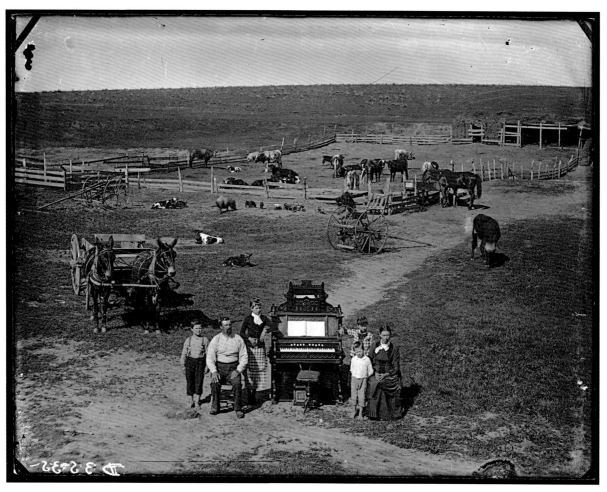

Solomon Butcher, *David Hilton Homestead, Custer County, Nebraska.* Modern gelatin silver print, from the original negative, 1887. According to Butcher, Mrs. Hilton was embarrassed by her sod house and insisted on being photographed away from her home, with her pump organ by her side—showing evidence of her prosperity without revealing the truth of her living arrangements. Nebraska State Historical Society

339

Any story about the West during the second half of the nineteenth century constructed solely from photographic sources would necessarily be incomplete, idiosyncratic, lacking in any narrative shape save that provided by the storyteller. We might be able to reconstruct the vision that a particular captain of industry had for his prospective railroad line, but would be hard-pressed to reconstruct the experiences of his road crew. We might perhaps glimpse what the Spanish missions of California looked like to those who raised the funds to restore them, but could not show how they appeared to their Hispanic or Indian parishioners. If we could show what Plains Indian life looked like from the perspective of a military fort, we could not convey what it looked like from inside a tipi. And even to accomplish the above we would have to bring in outside knowledge about the production of these pictures, bringing to bear on their content what we might know about who paid for and made them, who published and marketed them. We might be able to include in our history a great many people about whom and from whom we have no written records, but the scope of our work would nonetheless remain narrow and incomplete. And we would need to guard against the constant temptation to let particular photographs stand for general events, or conversely, to let unidentified images stand for the experiences of particular individuals. Photographs seem so insistently concrete, it is always a challenge to incorporate them into any discussion about historical possibilities, about the uncertainties and multiple possibilities that inhabit any particular moment of historical time. It is difficult to exclude from our readings of them the knowledge of what comes next.

If photographs have shifting meanings, unstable sorts of messages shaped by the contexts in which they were made and marketed, encountered and read, should we discard them as useful historical documents? Not at all, I'd argue. The very qualities that make old photographs problematic as historical documents—their quirky selectiveness, their capacity to sustain shifting meanings, their illusions of veracity, their emphasis on the vernacular—are the very conditions that make them fascinating and compelling. If they can't always convey the complexities of their construction, they can nonetheless exert an almost magnetic sort of pull between our present and the past they depict. They elicit empathy and imagination, create bonds of imaginative understanding between us and people we will never know, places we will never see. For all the differences they mark between our world and an earlier moment of our nation's history—in their monochromatic rendering of a world filled with little details that can

shock us with their strangeness as easily as with their familiarity—they still underscore the common ground we share with our ancestors. In showing us what that physical landscape used to look like, they give us a way to measure change and the impact of our own actions. In making visible human passions and emotions that we ourselves seem to recognize, they allow us to create sympathetic links, across the divides of time, to those who lived and worked in this landscape before us. They enable us to imagine what these people experienced, what they dreamed of, what they longed for. They cannot explain such emotions to us; for all their visual richness, photographs remain unable to supply simple causal explanations of complex emotions or events. But simply by stimulating such thoughts in us they enhance our capacity to be better historians, for an essential quality for any historian is a kind of instinctive empathy for his subject, an ability to imagine and understand the human motives of his subjects. Photographs, of course, have existed for less than two centuries. But they help us to imagine other pasts, working by analogy to help us construct imaginative ties to peoples who lived before the photographic era, instructing us in ways to flee the constraints of the present.

There is, in the interpretation of historical photographs, no separating the viewer from the object of his gaze. "For every image of the past that is not recognized by the present as one of its own concerns threatens to disappear irretrievably," writes the critic Walter Benjamin.[29] Our engagement with the picture, our questioning of it, shapes and defines the ways we draw meanings from it. Pictures tell stories only to the extent that we ask them to; and as our questions change, those stories do as well.

Throughout this book, I have been concerned with the multiple ways in which we can use photographs as primary source documents to illuminate broader questions about the nineteenth-century West. In their modes of production, in their forms of publication, in the ways in which they did and did not find public audiences, nineteenth-century photographs of the West and its native peoples have the potential to teach us much about the world in which they were made. Reinserted into the imagined world of their production, they offer at least partial answers to our questions about how Euro-Americans understood the West, how they imagined its future, how they grasped the potential of its natural resources, how they understood the fate of its first inhabitants. They speak to the dynamics between creators and audiences, to the ways in which ideas are communicated. They provide evidence of the ways in which patronage shaped the production of western views and the ways in which particular publication strategies shaped the reception of these views. They allow us to look in new ways at the

interplay between photography and the other visual arts, to look at how American audiences created and sustained the enduring gap between the complex West of history and the West of the imagination.

But removed from this historical context, taken out of the rich nexus of patron and publisher, marketplace imperative and technological constraint, nineteenth-century western photographs function differently. When we face them simply as isolated images, whether in reproduction or as nineteenth-century prints, what we encounter is less the material of history than the stuff of memory: pictures more inviting of subjective, personal response than critical evaluation, pictures of interest for their endless capacity to be reimagined and to proliferate new meanings. "Memory takes root in the concrete, in spaces, gestures, images, and objects," writes the French historian Pierre Nora; "history binds itself to temporal continuities, to progressions and to relations between things."[30] During the nineteenth century, photographers and photographic publishers worked hard to transform their intrinsically fragmentary images of the western landscape into complex visual narratives, relying on printed captions and the elaborate sequencing of serial views to create stories of temporal change. But wrenched from these original publication contexts, nineteenth-century western photographs are indeed ill-suited to speaking to "progressions" or the "relations between things." They necessarily represent a kind of discontinuous history in which neither the shape nor the cause of change is easily discerned. And if they cannot mimic the flow of history, neither can they easily mimic the shape of popular literature, for change is a hallmark of popular literary representations of the nineteenth-century West. The wilderness is subdued, the deserts bloom, heroes grow in moral stature, and more modest narratives of self-improvement play out again and again across the frontier. Photographs can serve such narratives of change and can, indeed, evoke deep-felt memories of such cultural myths. But particularly when wrenched from their original publication contexts, they can rarely depict or explain such change themselves; products of history, they cannot always serve history well. They resemble what Nora calls *lieux de memoire*, sites of memory: "moments of history torn away from the movement of history, then returned; no longer quite life, not yet death, like shells on the shore when the sea of living memory has receded."[31] Artifacts of the past, they can still evoke that past, but always in negotiated and contingent ways. When we read nineteenth-century photographs *in* history, when we try to reinsert them into the rich economic and cultural world of their production we can indeed learn much about the world from which they come. But, of

course, we cannot truly do so without also reading the photographs *through* history, and approaching them with questions and concerns of our own. Photographs are stable objects, but they have unstable meanings.

If the meanings and messages of nineteenth-century photographs are constantly shifting and being invented anew, despite all the seeming specificity of their subject matter, the pictures nonetheless remain remarkably rich and useful to all those who would study the national past. For ultimately, their greatest value lies not in the physical information they convey—about the appearance of a place, the shape of an object, the cast of a face—but in the ways in which they elicit stories from their viewers. In one sense, photographs stop time, but they remain paradoxically dynamic artifacts. If, in the mid-nineteenth century, they seemed unable to alter Americans' collective imaginings of the West, they have come over time to inform and shape our master narrative of the nation's western past and to fix it in the collective imagination. Encountered now through the veil of social memory, they evoke and elicit different stories each time they are read anew. We would do well to listen to these picture stories, to these tales that mediate between past and present, instructing us in ways to know the West as well as how to visualize it. In these shifting tales are the whispers of ambitions and dreams, hopes and disappointments, loves and hatreds, of our own time and of the past.

Notes

BRBML = Beinecke Rare Book and Manuscript Library, Yale University

Introduction
Picture Stories

1. Lewis Gaylord Clark, *The Knickerbocker,* vol. 14 (1839), p. 560, cited in Robert Taft, *Photography and the American Scene: A Social History, 1839–1889* (1938; Dover Publications, Inc., 1964), p. 3.
2. R. A. C., "Photography in California," *Photography and Fine Art Journal* (April 1857), p. 112.
3. Frank W. Bye to [his mother] Bye, 14 November 1864, Princeton Collections of Western Americana. Citation courtesy Alfred Bush.
4. Andreas Huyssen, *Twilight Memories: Marking Time in a Culture of Amnesia* (New York and London: Routledge, 1995), p. 3.

1
"The Spirit Is Wanting"

Epigraph: William M. Ivins, Jr., *Prints and Visual Communication* (1953; Cambridge: MIT Press, 1992), p. 180.

1. New Orleans *Daily Picayune* 15 May 1847, p. 2; *Daily Picayune* 16 May 1847, p. 2; *Daily National Intelligencer* 24 May 1847, p. 3.
2. *Richmond Enquirer* 8 June 1847, p. 4.
3. *Richmond Enquirer* 24 April 1847, p. 4.
4. *Daily National Intelligencer* 23 April 1847, p. 3.
5. *Daily Picayune* 22 April 1847, p. 2.
6. *Richmond Enquirer* 11 May 1847, p. 2.
7. Ibid.
8. *Richmond Enquirer* 14 May 1847, p. 4.
9. For an excellent overview of the ways in which the Mexican War was covered in the press and represented in popular culture, see Robert W. Johannsen, *To the Halls of the Montezumas: The Mexican War in the American Imagination* (New York: Oxford University Press, 1985).

10. *The New York Herald Tribune* 28 Aug. 1847, p. 1; *The New York Herald Tribune* 4 July 1847, p. ?; Washington, D.C., *Daily National Intelligencer* 23 March 1847, p. 2.

11. Josiah Gregg, *Diary and Letters of Josiah Gregg,* edited by Maurice Garland Fulton, 2 vols. (Norman: University of Oklahoma Press, 1941–44), vol. 1, p. 62 (diary entry for 11 March 1847).

12. Full descriptions and reproductions of all of these daguerreotypes can be found in Martha A. Sandweiss, Rick Stewart, and Ben W. Huseman, *Eyewitness to War: Prints and Daguerreotypes of the Mexican War, 1846–1848* (Washington, D.C., and Fort Worth, Tex.: Smithsonian Institution Press and Amon Carter Museum, 1989). Some of the issues I explore here were first raised in the essay I contributed to this work, "Daguerreotypes of the Mexican War."

13. The only war-related print known to be made directly from a daguerreotype made in Mexico is a lithographic portrait of General Zachary Taylor, copyrighted in 1847 (copy located in Special Collections, The University of Texas at Arlington Libraries, Arlington, Texas). Neither the lithographer nor the publisher is identified on the print, but the caption reads, "Rough and Ready as he is. Facsimile of Gl. Zach. Taylor from a Daguerreotype full lenght (sic) likeness taken at Buena Vista, J. H. William Smith." Neither Smith's precise identity nor the circumstances under which his daguerreotype might have been made are known.

 The daguerreotypes received public attention only in the twentieth century. H. Armour Smith, later director of the Yonkers Museum of Science and Art, acquired the daguerreotypes currently at Yale from a Fifth Avenue bookseller in approximately 1927 (H. Armour Smith to Robert Taft, 17 Dec. 1937; Taft Papers, Kansas State Historical Society). Robert Taft wrote about them in his pioneering book *Photography and the American Scene* (1938), calling them the only known photographs of the Mexican War and, indeed, the world's first photographs of war. Though he noted the historic value of the images and suggested that they merited further study, the daguerreotypes again slipped from view. Around 1960, Archibald Hanna, Jr., curator of Western Americana at Yale's Beinecke Rare Book and Manuscript Library, rediscovered them at Whitlock's Book Barn in Bethany, Connecticut, and purchased them for the Yale collection (George Miles to the author, 6 Sept. 1983). The 38 Amon Carter daguerreotypes of Mexican War scenes and portraits were found in 1981 in a Connecticut barn and subsequently purchased for the museum.

14. Robert Shlaer, *Sights Once Seen: Daguerreotyping Fremont's Last Expedition Through the Rockies* (Santa Fe: Museum of New Mexico Press, 2000), pp. 35–8, 51–61.

15. "Diary of Richard Carr," Archives of British Columbia, references courtesy Peter Palmquist, Arcata, California. See also Peter Palmquist, "An Account of California's First Photographer," in Palmquist, ed., *Photography in the West* (Manhattan, Kans.: Sunflower University Press, 1987), pp. 102–5.

16. *El Siglo XIX,* 11 Sept. 1845 (citation courtesy Rosa Casanova); Ralph Greenhill and Andrew Birrell, *Canadian Photography: 1839–1920* (Toronto: The Coach House Press, 1979), pp. 24–5. For additional information on Halsey, see also *Eyewitness to War,* pp. 66–7, n.17.

17. *Diario Oficial,* 3–11 May 1846; *Diario del Gobierno* 15 Feb. 1847, and periodically until 1 April 1847; *Daily American Star,* 12 Sept. 1847, 26 Oct. 1847. For Halsey's post-war career, see *El Siglo XIX* 12 Dec. 1850, *Diario de Avisos* 22 April 1858, and *Mexican Extraordinary* Aug. 1861 (citations courtesy Rosa Casanova). Although none of Halsey's American military portraits have been identified, two of his Mexican portraits survive. His photographic portraits of General Llave and Cosme Varela are in

the National Museum of History, Mexico City (Rosa Casanova to the author, 29 June 1986).

18. *Republic of Rio Grande and Friend of the People* 16 June 1846; *American Flag* 14 Oct. 1846, 3 March 1847; Margaret Denton Smith and Mary Louis Tucker, *Photography in New Orleans: The Early Years, 1840–1865* (Baton Rouge: Louisiana State University Press, 1982), p. 167.

19. *American Flag* 21 Sept., 24 Oct., 28 Oct., 5 Dec., 19 Dec. 1846; Veracruz *American Eagle* 6 April 1847; Puebla *American Star No.* 2 15 July 1847; Mexico City *American Star* 28 Sept., 5 Oct., 29 Oct., 1847.

20. *Eyewitness to War*, pp. 51, 67.

21. Floyd Rinhart and Marion Rinhart, *The American Daguerreotype* (Athens: University of Georgia Press, 1981), p. 403; Veracruz *Sun of Anahuac*, 17 Sept. 1847 (citation courtesy Art Woodward reference collection, Amon Carter Museum); Veracruz *Free American* 22 Nov. 1847; New Orleans *Daily Picayune*, 1 Jan. 1848; *Daily American Star*, 10 Feb. 1848. Two wood engravings done from daguerreotypes Noessel made in New Orleans of Samuel Walker and Benjamin McCullough appear in Samuel C. Reid, Jr., *Scouting Expeditions of McCullough's Texas Rangers* (Philadelphia: G. B. Zieber & Co., 1847).

22. New Orleans *Daily Picayune*, 3 June, 6 July, 3 Aug., 1847; Richmond *Enquirer*, 14 Sept., 21 Sept., 1847. The painting of Taylor and his staff is now in the collection of the National Portrait Gallery, Washington, D.C.

23. Monterrey *American Pioneer*, 31 May 1847; New York *Herald*, 12 Aug. 1847. Taylor's letter to the painter is reproduced on a lithographed version of one of the portraits, published by P. S. Duval of Philadelphia in 1847; see *Eyewitness to War*, p. 171.

24. New Orleans *Daily Picayune*, 7 Sept., 27 Aug., 1847.

25. The most thorough studies of Mexican War lithographs are: Ron Tyler, *The Mexican War: A Lithographic Record* (Austin: Texas State Historical Association, 1973); and Rick Stewart, "Artists and Printmakers of the Mexican War," and Ben W. Huseman, "Catalogue of Prints and Daguerreotypes," in *Eyewitness to War*. Lithography relies on the natural antipathy of water and oil. After sketching a design with a greasy crayon or ink onto a specially prepared stone plate, the lithographer would moisten the stone with water, which would soak into the areas not covered with crayon. He could then ink the plate. The oily ink would adhere to the drawing but be repelled by the wet areas of the stone, and a print could then be made by pressing paper against the inked image.

26. Cited in *Eyewitness to War*, pp. 12–3.

27. Ibid., pp. 19–25. Currier would establish his famous partnership with James Ives after the war, in 1852.

28. *Eyewitness to War*, p. 7.

29. New Orleans *Daily Picayune*, 15 July 1850, p. 2, cited in *Eyewitness to War*, p. 37.

30. Cited in *Eyewitness to War*, p. 38.

31. *American Review*, VII (June 1848), p. 653; cited in *To the Halls of the Montezumas*, p. vii.

32. *Eyewitness to War*, pp. 8–9; 330–5.

33. George Wilkins Kendall, *The War Between the United States and Mexico Illustrated* (New York: D. Appleton & Co., 1851), p. 16.

34. Ibid., preface.

35. *The New York Herald Tribune,* 12 Aug. 1847, p. 2.

36. *The New York Herald Tribune,* 18 Aug. 1847, p. 2.

37. Richmond *Enquirer,* 21 Sept. 1847, p. 2.

38. Richmond *Enquirer,* 24 April 1847, p. 4.

39. Clay was buried here the day after the battle, and disinterred in May to be carried back to his family in Kentucky by his old West Point friend, Jefferson Davis.

40. *Spirit of the Times* 17, 24 April 1847, p. 101; cited in *Eyewitness to War,* p. 28.

41. *Niles National Register* 21, 7 Aug. 1847 and 17 April 1847; cited in *Eyewitness to War,* p. 28.

42. *To the Halls of the Montezumas,* p. 132.

43. I'm unaware of any evidence indicating that any of the Civil War photographers could have known of the photographs of the Second Burma War (1852–3) or the Crimean War (1854–5).

44. *New York Times,* 20 Oct. 1862, p. 5.

45. Oliver Wendell Holmes, "Doings of the Sunbeam," *The Atlantic Monthly,* vol. 12 (July 1863), p. 12.

46. *New York Times,* 20 Oct. 1862, p. 5.

47. Alexander Gardner, *Gardner's Photographic Sketch Book of the War* (1866; New York: Dover Publications, Inc., 1959). For a discussion of the relocation of the body, see William Frassanito, *Gettysburg: A Journey in Time* (New York: Charles Scribner's Sons, 1975), pp. 187–92.

48. *New York Times,* 20 Oct. 1862, p. 5.

49. For a masterful study of the Civil War in American memory, see David W. Blight, *Race and Reunion: The Civil War in American Memory, 1863–1915* (Cambridge: Harvard University Press, 2001).

50. William James, "Robert Gould Shaw," delivered in Boston, 31 May 1897, and reprinted in William James, *Memories and Studies by William James* (1911); cited in David W. Blight, "The Meaning or the Fight: Frederick Douglass and the Memory of the Fifty-Fourth Massachusetts," *Massachusetts Review* 36 (spring 1995), pp. 150–1.

51. For examples of the detailed analysis to which Civil War photographs have been subjected in recent decades, see William Frassanito, *Gettysburg* and *Antietam: The Photographic Legacy of America's Bloodiest Day* (New York: Scribner, 1978).

<div style="text-align:center">

2

"Of Instruction for Their Faithfulness"

</div>

Epigraph: Walter Benjamin, "The Work of Art in the Age of Mechanical Reproduction," in *Illuminations* (1955; New York: Schocken Books, 1969), p. 224.

1. Banvard makes his claim for the length of the painting in numerous places including his *Description of Banvard's Panorama of the Mississippi River* (Boston: John Putnam, Printer, 1847).

2. *Boston Journal* 22 Dec. 1846, cited in Dorothy Dondore, "Banvard's Panorama and the Flowering of New England," *New England Quarterly* XI (Dec. 1938), p. 819.

3. As cited on a back cover of a London 1852 edition of "Description of Banvard's Panorama," reproduced in John Francis McDermott, "Banvard's Mississippi Panorama Pamphlets," *The Papers of the Bibliographical Society of America,* vol. 43 (first quarter 1949), p. 55.

4. John Greenleaf Whittier, "The Panorama" (1856), in John Greenleaf Whittier, *The Writings of John Greenleaf Whittier* (7 vols., Cambridge: Riverside Press, 1888), vol. 3, pp. 193–4.

5. *Description of Banvard's Panorama,* pp. 7, 4, 6.

6. John Ross Dix [pseud.], *Amusing and Thrilling Adventures of a California Artist, While Daguerreo-typing a Continent, Amid Burning Deserts, Savages and Perpetual Snows. And a Poetical Companion to the Pantoscope of California, Nebraska & Kansas, Salt Lake & the Mormons* (Boston: Published for the Author, 1854), pp. 85, 87.

7. Undated "extract from the Boston Traveller," cited in *Amusing and Thrilling Adventures,* p. 45.

8. Undated "extract from the Congregationalist and Christian Times," cited in ibid., p. 45.

9. The basic source for information on the Mississippi River panoramas is John Francis McDermott, *The Lost Panoramas of the Mississippi* (Chicago: The University of Chicago Press, 1958). See also, Perry T. Rathbone, ed., *Mississippi Panorama,* exhibition catalogue (St. Louis: City Art Museum of St. Louis, 1950); John Francis McDermott, "Newsreel—Old Style, or Four Miles of Canvas," *Antiques,* XLIV (July 1843), pp. 10–3; Henry Lewis, *Making a Motion Picture* ed. Bertha L. Heilbrun (St. Paul, Minn.: Minnesota Historical Society, 1936); "Mississippi Movies, Rare Panorama Art," exhibition brochure (St. Louis: St. Louis Mercantile Library, 1993).

 Useful general works on panoramas include Wolfgang Born, *American Landscape Painting* (1948; Westport, Conn.: Greenwood Press, 1970), pp. 75–117; Ralph Hyde, *Panoramania: The Art and Entertainment of the 'All-Embracing' View* (London: Trefoil Publications in association with Barbican Art Gallery, 1988); Lee Parry, "Landscape Theater in America," *Art in America* 59 (Nov.–Dec. 1971), 52–61; Angela Miller, "The Imperial Republic: Narratives of National Expansion in American Art, 1820–1860," Ph.D. diss. (Yale University, 1985); Henry M. Sayre, "Surveying the Vast Profound: The Panoramic Landscape in American Consciousness," *Massachusetts Review* 24 (Winter, 1983), 723–42; and John L. Marsh, "Drama and Spectacle by the Yard: The Panorama in America," *Journal of Popular Culture* 10 (Winter 1976), 581–90.

10. "Banvard's Panorama and the Flowering of New England," pp. 819–20.

11. Robert W. Johannsen, *To the Halls of the Montezumas: The Mexican War in the American Imagination* (New York: Oxford University Press, 1985), p. 222.

12. Henry D. Thoreau, "Walking" in *Excursions* (1863), cited in Sayre, p. 731.

13. "Panoramic Excursions," St. Louis *Weekly Reveille* (April 22, 1850); transcript courtesy John Francis McDermott Collection, Research Collections/University Archives, Lovejoy Library, Southern Illinois University, Edwardsville.

14. *Panoramania,* p. 39 n. 51.

15. *The Lost Panoramas of the Mississippi,* p. 158.

16. James F. Wilkins, "Lecture Notes" for his panorama, *Moving Mirror of the Overland Trail,* Henry E. Huntington Library, San Marino, California.

17. Peoria *Democratic Press* 2 Oct. 1850, cited in John Francis McDermott, "Gold Rush Movies," *California Historical Society Quarterly,* vol. 33, no. 1 (March 1954), p. 33; and handbill for "Immense Moving Mirror of the Land Route to California," reproduced in ibid., p. 35.

18. *Oxford English Dictionary,* vol. II, p. 2066.

19. Ibid.

20. On the history of the panorama in Europe, see *Panoramania*, pp. 13–44; *Lost Panoramas of the Mississippi*, pp. 1–7; "Drama and Spectacle," pp. 581–2; "Surveying the Vast Surround," pp. 723–5.

21. Helmut and Alison Gernsheim, *L. J. M. Daguerre: The History of the Diorama and the Daguerreotype* (New York: Dover Publications, 1968), pp. 14–46.

22. "Drama and Spectacle," p. 582; *Oxford English Dictionary*, vol. II, p. 2066.

23. *L. J. M. Daguerre*, p. 43.

24. *Banvard's Geographical Panorama*, p. 48.

25. *The Liberator*, 15 Jan. 1847, and Samuel Longfellow, *Life of Henry Wadsworth Longfellow* (Boston, 1886), II, pp. 67–8. Both cited in Dorothy Dondore, "Banvard's Panorama and the Flowering of New England," *New England Quarterly*, vol. 11 (Dec. 1938), pp. 820–1.

26. John Greenleaf Whittier, "The Panorama," pp. 193–210.

27. Mark Twain, *Life on the Mississippi* (ch. lix). See also Curtis Dahl, "Mark Twain and the Moving Panoramas," *American Quarterly*, vol. 13, no. 1 (Spring 1961), pp. 20–32.

28. *Lost Panoramas*, p. 48.

29. Ibid., p. 56.

30. *The Daguerrean Journal*, 1 July 1851, p. 117.

31. Sam. F. Simpson, "Daguerreotyping on the Mississippi," *The Photographic and Fine Art Journal* (August 1855), p. 252.

32. "J. R. Gorgas," *The St. Louis and Canadian Photographer* (July 1899), vol. 23, no. 7, p. 327.

33. George Devol, *Forty Years a Gambler* (1882; Cincinnati, 1887), pp. 49–50. Citation courtesy of William Reese.

34. "Art Afloat—How a New Jersey Man Is to 'Do' the Mississippi Valley," *Anthony's Photographic Bulletin* (Oct. 1874) p. 345.

35. "Floating Down the Mississippi," *St. Louis Practical Photographer* (Sept. 1878), p. 311.

36. E. J. Stewart, "Photography Afloat," *Anthony's Photographic Bulletin* (Jan. 1876), p. 27.

37. *Anthony's Photographic Bulletin* (April 1877), p. 112. A print of one of these stereos in the Beinecke Rare Book and Manuscript Library at Yale University is labeled "75/Bridge between Davenport &/Rock Island. . . . Oct. 26 1877." The printed mount reads, "This subscriber has built a Floating Photographs Gallery, at a cost, with its appurtenances, of over $4,000, intending to take views of the Mississippi and its tributaries, from the Falls of St. Anthony to the Gulf of Mexico."

38. Muscatine's stereographic panorama is in the Western Americana Collection, BRBML.

39. San Francisco *Alta California*, 19 Dec. 1849.

40. John Francis McDermott, "Gold Rush Movies," *California Historical Society Quarterly*, vol. 33, no. 1 (March 1954), p. 29; Peter E. Palmquist and Thomas R. Kailbourn, *Pioneer Photographers of the Far West: A Biographical Dictionary, 1840–1865* (Stanford: Stanford University Press, 2000), pp. 398–9. On the Frémont panorama, see Leonard Arrington, "Skirving's Moving Panorama: Colonel Fremont's Western Expeditions Pictorialized," *Oregon Historical Quarterly*, vol. LXV no. 2 (June 1964), pp. 133–72; and the discussion below, pp. 94–97.

41. Palmquist and Kailbourn, pp. 629–32.

42. San Francisco *Daily Alta California*, 14 Nov. 1850.

43. San Francisco *Alta California*, 19 Jan. 1851; *Sea Letter* (San Francisco Maritime Museum), vol. 2,

Nos. 2 and 3 (October 1964); Peter E. Palmquist, "The Daguerreotype in San Francisco," *History of Photography* 4 (July 1980), pp. 207–38; David Harris, with Eric Sandweiss, *Eadweard Muybridge and the Photographic Panorama of San Francisco, 1850–1880* (Montreal: Canadian Centre for Architecture, 1993), pp. 37, 52 n.3. For reproductions of two early San Francisco daguerreotype panoramas whose physical format reveals the fundamental incongruity between photographic and painted panoramas, see Harris and Sandweiss, pp. 72–3.

44. Harris and Sandweiss, p. 37.

45. Harris and Sandweiss reproduce the entire panorama and give a full explanation of its history and reception.

46. San Francisco *Daily Herald,* 27 Sept. 1851, cited in ibid., p. 42.

47. William Patterson Jones, untitled tss. of "sketch of family history," ca. 1880, Northwestern University Archives. The typescript was placed in the collection by Stella Voorhees, Jones family descendent and genealogist. See Voorhees to Dr. Walter Dill Scott, 20 Dec. 1959, Northwestern University Archives. The J. W. Jones entry in *The Memorial Cyclopedia of the Twentieth Century* (New York: The Publishing Society of New York, [1906]), p. 340, lists Jones's birth date as May 3, 1826.

48. Stella Jones Voorhees, "Additional Information Re: The Reverend William Patterson Jones, Sr.," tss., McKendree College Archives. Ledger AR [p. 12], McKendree College Archives lists John W. Jones of Alton, Illinois, as one of thirty-five students in the collegiate department for the 1838 school year. His name does not appear on the class lists for either 1837 or 1838. Since Jones insists he was eleven and one half when he entered the school, it is possible he may have begun sometime after the start of the 1837 school year. See J. Wesley Jones, "Copy of a Letter Written by Colonel J. Wesley Jones to His Niece Lydia Hayes (Jones) Trowbridge," Northwestern University Library, p. 2, in which Jones says he began at McKendree in 1837 and stayed for two years.

49. See Voorhees, "Additional Information . . . ," p. 4. Although there is no archival evidence of Clemens's enrollment at McKendree, school lore claims that he attended the school "during an epidemic in Hannibal and in later years sat in on McKendree classes whenever he visited his aunt in Lebanon." See, Dr. Patrick A. Folk, "From the Attic," *McKendree College Bulletin,* vol. 156, no. 3 (March 1984), p. 1.

50. Information on Jones's activites during these years comes from the manuscript diary/memoir of his father, William Patterson Jones, McKendree College Archives, pp. 28–9. Jones clarifies that he was a tutor, rather than a student, at the Seminary in "Copy of a Letter," p. 2. For information on Williams, see Carl Landrum, "From Quincy's Past: He Refused Supreme Court Seat," *The Quincy Herald-Whig,* 9 April 1978; citation courtesy Claire Myers. Jones makes the claim about his connection to Lincoln in "Copy of a Letter," p. 2, and it was often repeated by his family and the popular press. Nonetheless, Jones was a marshall at Lincoln's 1861 inauguration; see "Inauguration Programme" in *Lincoln Lore,* no. 1477 (Fort Wayne, Indiana, March 1961), and there is some evidence that he served as a guard at the White House in the spring of 1861.

51. Jones's bar enrollment record is in the files of the Clerk's Office, State Supreme Court of Illinois, Springfield. An ad for his legal office, dated 16 May 1849, appears in the *Oquawka Spectator,* 12 Dec. 1849. He worked in partnership with the Quincy attorneys William and Charles B. Lawrence.

52. "Ox Team Company," *The Oquawka Spectator* 6 March 1850, p. 2. Jones was well suited to leader-

ship in the group not just from his legal training but from his practice as an orator as well. He was an active debater in the Oquawka Literary Institute. See "Oquawka Literary Institute," *Oquawka Spectator,* 16 Jan. 1850, p. 3.

53. For a list of the names see *Oquawka Spectator*, 3 April 1850. This list incorrectly includes Jones and his brother Thomas among those traveling with horses.

54. W. P. Jones, "Diary," [p. 30]. Thomas died 18 July 1850.

55. Letter from J. W. Jones to Mr. J. Simpson, 11 May 1850, published in the *Oquawka Spectator* 3 July 1850; "Indian Fight," Salt Lake City *Deseret News,* vol. 1, no. 5, 13 July 1850 (misdated July 1); *Deseret News,* vol. 1, no. 6, 20 July 1850, p. 47; J. W. Jones, "From the Ox Train," 4 July 1850, published in the *Oquawka Spectator* 2 Oct. 1850; E. H. N. Patterson, "From California," 30 Aug. 1850, published in *Oquawka Spectator* 23 Oct. 1850.

56. John Ross Dix, *Amusing and Thrilling Adventures,* pp. 19–20.

57. E. H. N. Patterson, "El Dorado" (letter dated 30 Aug. 1850), *Oquawka Spectator,* 20 Nov. 1850, p. 2.

58. The California Information File, California State Library, includes a notation concerning Jones, copied from the 1850 census: "I certify that I have collected the statistics of Calaveras County State of California well and truly and in accordance with my instructions and oath of office." The statement was signed and sealed on 12 Feb. 1851 by "Jno. W. Jones, Asst. Census Agent, Calaveras, Co. California." A report on Jones's progress is found in "Calaveras County," Sacramento City *Weekly Placer Times,* 23 Nov. 1850, p. 1.

59. Calaveras [pseud.], "'Inklings' on the trail of 'the Census Man,'" *Weekly Placer Times,* 23 Nov. 1850, p. 4; "'Inklings' on the trail of 'the Census Man' No. IV," *Daily Placer Times,* 24 Dec. 1850, p. 2. Jones later claimed he directed the state census and became the first white man in Yosemite. These extravagant claims for his California career gained credence through publications such as his biographical entry in *Memorial Cyclopedia.*

60. "California Letter," *Oquawka Spectator,* 26 Feb. 1850. The article cites a letter from Jones to Oquawka resident Nealy Chapin, dated 24 Dec. 1850.

61. Frederic Coolwine, "Letter from California" (Sacramento City, 30 April 1851), *Burlington Daily Telegraph* 14 June 1851, p. 2.

62. "Magnificent Enterprise" (reprint from the *Placer Times*), *Oquawka Spectator and Keithsburg Observer,* 7 May 1851. For biographical information on Jones's colleagues see the individual entries in Palmquist and Kailbourn.

63. "Panorama of California and the Plains," *Alta California,* 19 April 1851, p. 2.

64. *Amusing and Thrilling Adventures,* p. 21, notes the early "defalcation of the travelling manager."

65. "Panorama of the Plains," *Sacramento Union,* 6 May 1851, p. 2; Jones to the Editor, *Sacramento Union,* 8 May 1851, p. 2. *Amusing and Thrilling Adventures,* p. 21, notes, "Mr. Jones was obliged to come to the rescue; and taking hold of the matter with energy, procured other artists, materials, and a carriage so arranged as to obviate the difficulties which had so well nigh proved fatal to the expedition."

66. *Marysville Herald,* 31 May 1851; citation courtesy Tom Kailbourn and Peter Palmquist.

67. F[rederick] C[oolwine] to the Editor of the Telegraph, 26 June 1851, reprinted in the *Burlington Weekly Telegraph,* 16 Aug. 1851, p. 3.

68. Oregon City *Oregon Spectator,* 23 Sept. 1851, p. 2.

69. Undated clipping from the *Placer Times and Transcript,* reproduced in *Amusing and Thrilling Adventures,* pp. 34-5.

70. Undated clipping from the *Sacramento Daily Union,* reprinted in *Amusing and Thrilling Adventures,* p. 36.

71. Sacramento *The Daily Union,* 8 July 1851, p. 2.

72. "Rambler," "From Our Overland Correspondent No. 1" (letter dated Hangtown, 10 July 1851), Sacramento *The Daily Union,* 15 July 1851, p. 2.

73. "Rambler," "From Our Overland Correspondent No. II," Sacramento *The Daily Union,* 1 Aug. 1851, p. 2.

74. Two overland trails sketchbooks by Quesenbury are known to survive. The sketchbook documenting the first portion of Jones's overland trip is a heretofore undiscussed album (incorrectly attributed to John Wesley Jones) in the archives of McKendree College, Lebanon, Illinois. This sketchbook opens with a few sketches made in and around Sacramento in January and February 1851. A number of pages later is a sketched scene of a wagon pulling out of a town that is numbered "No. 1" and dated July 8, 1851, the starting date for the overland portion of Jones's expedition. The sketches then follow an eastern route, corresponding to the descriptions given in Quesenbury's newspaper accounts, to the Humboldt River valley in Nevada. There the sketchbook ends. The sketch numbered #29 is titled "Cont. of Dg. on W." Inscribed under the lower left corner of the image is "Con. of J. Dag."

 The sketchbook presently in the collection of the Omaha *World-Herald* consists of two parts. The first section, apparently made during Quesenbury's overland trip *to* California in the summer of 1850, includes sketches made between the Arkansas River in southern Colorado and California. The second section of the sketchbook includes sketches made on an eastward trip during the summer of 1851 that document the terrain between Devil's Gate and Independence Rock in central Wyoming and Chimney Rock, along the overland trail in western Nebraska.

 The gap between the subject matter covered in the two sketchbooks suggests the existence of other, yet undiscovered Quesenbury sketches.

75. Salt Lake City *Deseret News,* 19 August 1851, p. 308.

76. This, at least, is what Jones claims in the lecture notes written later to accompany a showing of the pantoscope. See J. Wesley Jones, "Lecture to Jones's Pantoscope of California &c.," *California Historical Society Quarterly* vol. VI, No. 2 (June 1927), p. 122.

77. *Daily Missouri Republican,* 5 Oct. 1851, p.1; *Oquawka Spectator,* 8 Oct. 1851, p. 2; *Daily Missouri Republican,* 7 Oct. 1851, p. 2; *Oquawka Spectator,* 15 Oct. 1851, p. 2.

78. *Harper's New Monthly Magazine,* no. XLII, vol. vii (Nov. 1853), p. 851.

79. *Narratives and Adventures,* pp. 23-4. Jones was a gifted and entrepreneurial storyteller; the absence of this story from the contemporary accounts of his trip strongly suggests it was fabricated later.

80. *Daily Missouri Republican,* 1 Nov. 1851, p. 3. There is some uncertainty as to which artists completed the overland journey with Jones. The *Republican* notes that he arrived in St. Louis with Sheldon Shufelt, Joshua Prugh, and J. Arrick. The *Oquawka Spectator* (12 Nov. 1851), however, reported that Prugh, a hometown boy, was "unable to accompany the troupe, having been taken sick before leaving the Mines." In *Narrative and Adventure* (p. 27), Dix notes that six men accompanied Jones

eastward from Salt Lake. An uncredited clipping reproduced in Dix's pamphlet (pp. 48–9), "Sketch of the Artist Troupe and Company," suggests that Jones's companions were Quesenbury, Coolwine, Arrick, and Shoap (Prugh and Shufelt having turned back after crossing the Sierra Nevada), along with frontiersman "Devil Dave" Mitchell. It is possible that Coolwine and Quesenbury were with Jones for most of the trip, but parted company with him before reaching St. Louis to return to Iowa and Arkansas, respectively.

81. William P. Jones, "Diary" (entries for 6 Dec. 1851; 21 Dec. 1851); "Memoirs," p. 31, McKendree College Archives.

82. Journalist B. J. Lossing visited Melrose in November 1852 and procured sketches "from the daguerreotypes of Mr. Jones, then being transferred to canvass by Messrs. Chappel, Bartholomew, Burham, and others." See his endorsement on the back of "Jones' 'Pantoscope' or Overland Journey to California," reprinted in "Jones' Pantoscope of California," *California Historical Society Quarterly,* vol. vi, no. 2 (June 1927), p. 111. An undated clipping from the *Boston Bee,* reprinted in *Amusing and Thrilling Adventures,* pp. 42–3, noted that Jones was working with T. C. Bartholomew, a skilled scenic painter, and Chappell, who excelled in the drawing of figures. The twenty-four drawings procured by Lossing, now in the collection of the California Historical Society, include five sketches signed "W.N. Bartholomew," the half-brother of T(ruman) C. This suggests that the Boston paper erred in naming the Bartholomew brother who was assisting Jones or that both brothers were, in fact, engaged to work on the panorama. The CHS collection also includes three sketches signed "W. Pearson" (presumably the "Piersons" alluded to in a press clipping reproduced in *Amusing and Thrilling Adventures,* p. 42), who may be the William Pearson who exhibited New Hampshire and upstate New York landscapes at the National Academy between 1857 and 1860. See George C. Groce and David H. Wallace, *The New-York Historical Society's Dictionary of Artists in America* (New Haven: Yale University Press, 1957), p. 495.

83. *Boston Post,* 1 Jan. 1853, pp. 1, 3; 7 Jan. 1853, p. 2; 13 Jan. 1853, p. 2; 26 Jan. 1853.

84. See J. Wesley Jones to B. J. Lossing, 9 Sept. 1853, reproduced in "Jones' Pantoscope of California," pp. 109–10. Jones's lecture is reproduced in "Jones' Pantoscope of California," *California Historical Society Quarterly,* vol. vi (June 1927), pp. 109–29; and (Sept. 1927), pp. 238–53. The California Historical Society holds a copy of *The Pantoscope: Devoted to Art, Wit and Humor,* vol. 1, no. 1 (Boston, May 1854). The four-page paper, edited by W. P. Jones (presumably Jones's brother, rather than his father) and published by G. K. Snow, was to be "published monthly for gratuitous circulation at the Exhibition of Jones' renowned and inimitable Pantoscope of California, Nebraska, and Salt Lake." John Ross Dix was the pen name of George S. Phillips. His book *Amusing and Thrilling Adventures* includes a summary of Jones's travels, a selection of undated press clippings, a long poem corresponding to the scenes and sections of the pantoscope, and a defense of Jones's involvement with the "gift enterprise" lottery devised to raise money and eventually to dispose of the pantoscope.

85. *Boston Bee,* undated clipping reproduced in *Amusing and Thrilling Adventures,* pp. 42–3; *New York Herald,* 30 Oct. 1853, p. 5 (ad runs through 3 Dec.).

86. An advertisement for the gift enterprise appears in the *New York Herald,* 10 Dec. 1853, p. 3.

87. "Addenda: A Chapter on Gift Enterprises," in *Amusing and Thrilling Adventures,* pp. 88–92; "Notice to Shareholders, $150,000 Jones' Gift Enterprise" (printed circular), California Historical

Society (reproduced in "Jones's Pantoscope of California," following p. 110).

88. William P. Jones, [Memoirs], p. [33].

89. On Jones's involvement with the Northwestern Female College, which later became a part of Northwestern University, see Dwight F. Clark, "A Forgotten Evanston Institution: The Northwestern Female College," in *Journal of the Illinois State Historical Society,* vol. 35 (1942), pp. 115–32; Estelle Frances Ward, *The Story of Northwestern University* (New York: Dodd, Mead and Company, 1924), pp. 59–70; and the John Wesley Jones biographical file at the Northwestern University Archives. On Jones's political career, see *New York Times,* 14 Aug. 1890, p. 3; 17 Aug. 1890, p. 16; 5 Oct. 1890, p. 16; 26 Oct. 1890, p. 16. On his role as a founder of the United States Volunteer Life Saving Corps, see *New York Times,* 16 Dec. 1905, p. 6. A highly inaccurate account of Jones's life is included in his biographical entry in *The Memorial Cyclopedia of the Twentieth Century,* which reiterates misstatements found in many of his obituaries. Jones's complicated military career can be traced through his personnel file (J-273-CB-1863) on roll 31 of microcopy 1064, "Letters received by the Commission Branch of the Adjutant General's Office," in the National Archives.

90. William P. Jones, [Memoirs], p. [42].

91. See "Jones' Pantoscope of California," and *Amusing and Thrilling Adventures.*

92. "Lecture," p. 242.

93. Ibid., pp. 113, 115, 240.

94. Ibid., pp. 250, 242.

95. Ibid., p. 251.

96. Ibid., pp. 252–3.

97. J. Taylor and M. O. Crooks, *Sketch Book of St. Louis* (St. Louis: George Knapp & Co., 1858), p. 313.

98. *The Photographic and Fine Art Journal* (June 1857), p. 192; "A Correct Picture of Life in Kansas," [April 1857 playbill], unidentified source, collection of Peter Palmquist.

99. On Wimar's early career see Joseph D. Ketner II, "The Indian Painter in Dusseldorf," in Rick Stewart, Joseph D. Ketner II, and Angela L. Miller, *Carl Wimar: Chronicler of the Missouri River Frontier* (Amon Carter Museum: Fort Worth, 1991), pp. 30–75. This book, the most thorough study of Wimar's life and career, makes no reference to his collaboration with Fitzgibbon, which remains a topic for further study.

100. "A Correct Picture of Life in Kansas." See also Palmquist and Kailbourn, pp. 231–5.

101. The panorama, however, may have influenced Wimar's decision to travel to the Upper Missouri with an ambrotype camera in 1858. For an account of Wimar's trips to the Upper Missouri in 1858 and 1859, see Rick Stewart, "An Artist on the Great Missouri," in *Carl Wimar: Chronicler of the Missouri River Frontier,* pp. 80–186.

102. David Mattison, "The World's Panorama Company," *History of Photography,* vol. 8, no. 1 (Jan. 1984), pp. 47–8. Neither the painted panorama nor any images from the project are known to survive.

103. *British Colonist,* 3 Sept. 1862; citation courtesy Joan Schwartz.

104. Curtis Dahl, "Artemus Ward: Comic Panoramist," *The New England Quarterly,* vol. 32 (Winter 1959), pp. 476–85; Madeleine B. Stern, "A Rocky Mountain Book Store: Savage and Ottinger of Utah," *Brigham Young University Studies,* vol. IX (Winter 1969), p. 146.

105. Opal M. Harber, "A Few Early Photographers of Colorado," *Colorado Magazine* (October 1956), p. 291.

106. Deborah Willis-Thomas, *Black Photographers, 1840–1940: An Illustrated Bio-Bibliography* (New York: Garland Publishing, Inc., 1985), p. 3; Joseph D. Ketner, *The Emergence of the African-American Artist: Robert S. Duncanson, 1821–1872* (Columbia: University of Missouri Press, 1993), p. 104. Ketner suggests that the painter Robert S. Duncanson probably assisted with the production of the slave trade panorama.

107. Glenn G. Willumson, "Alfred Hart: Photographer of the Central Pacific Railroad," *History of Photography*, vol. 12 (January–March 1988), pp. 61–3.

108. Susan Danley Walther, "The Landscape Photographs of Alexander Gardner and Andrew Joseph Russell," Ph.D. diss. (Brown University, 1982), pp. 63–6.

109. The description of Catlin's exhibition is from a 6 Dec. 1837 entry in Allan Nevins, ed., *The Diary of Philip Hone 1828–1851* (New York: Dodd, Mead and Company, 1927), pp. 290–1. The best source on Catlin's Indian Gallery is William H. Truettner, *The Natural Man Observed: A Study of Catlin's Indian Gallery* (Washington, D.C.: Smithsonian Institution Press, 1979). See also Brian Dippie's excellent *Catlin and His Contemporaries: The Politics of Patronage* (Lincoln: University of Nebraska Press, 1990).

110. Cited in Julia Ann Schimmel, "John Mix Stanley and Imagery of the West in Nineteenth-Century American Art," Ph. D. diss. (New York University, 1983), pp. 86–7. For a discussion of Stanley's gallery, see Schimmel, pp. 54–9, 85–98.

111. Schimmel, pp. 127, 143–5; Dippie, pp. 265–86.

112. Kane's comments are in the preface to his book, *Wanderings of an Artist* (London, 1859), reprinted in J. Russell Harper, *Paul Kane's Frontier* (Austin: University of Texas Press, 1971), p. 51.

113. Biographical information on Vance comes from the writings of Peter E. Palmquist. See "Western Photographers, II, Robert Vance: Pioneer in Western Landscape Photography," *American West* (Sept.–Oct. 1981), pp. 22–7; "Robert H. Vance: The Maine and Boston Years," *The Daguerreian Annual 1991* (The Daguerreian Society, 1991), pp. 199–216. See also the entry in Palmquist and Kailbourn. The documentation of Vance's South American career is to be found in Abel Alexander, "Robert H. Vance: Pioneer of the Daguerreotype in Chile," *The Daguerreian Annual 1993* (The Daguerreian Society, 1993), pp. 11–30.

114. Palmquist and Kailbourn, p. 560. The authors note the possibility that Vance may also have traveled to Cuzco during his residency in Chile.

115. For information on the Boston showing of Banvard's panorama, see John Francisc McDermott, "Banvard's Mississippi Panorama Pamphlets," p. 49; and the clippings reproduced in John Banvard, *Banvard's Geographical Panorama of the Mississippi River, with the Adventures of the Artist* (Boston: John Putnam Printer, 1847). For the Cressy panorama, see *San Joaquin Republican* (June 18 and June 15, 1851), citation courtesy Peter E. Palmquist.

116. *Photographic Art-Journal* (Feb. 1853), p. 126.

117. *Photographic Art-Journal* (Oct. 1851), pp. 252–3.

118. "Mr. Vance's Photographic Views," *Photographic-Art Journal* (Oct. 1851), p. 253.

119. See the descriptions of plates 75, 76, and 79 in the list of Jones images included in *Photographic and Fine-Art Journal* (Feb. 1853), pp. 126–9. This list, essentially the same as that included in the brochure Vance published, lists 131 different titles, some of which undoubtedly covered groups of

daguerrean views.

120. "Mr. Vance's California Views," *Photographic Art-Journal* (Oct. 1851), pp. 252–3.

121. R[obert]. H. Vance, *Catalogue of Daguerreotype Panoramic Views in California* (New York: Baker, Godwin & Company, 1851), preface.

122. "Daguerreotype Panoramic Views in California," *The Daguerreian Journal* (1 Nov. 1851), p. 371.

123. *Photographic Art-Journal* (Feb. 1853), p. 126.

124. Palmquist and Kailbourn, p. 561; Dolores Kilgo, "Vance's Views in St. Louis: An Update," *The Daguerreian Annual* (1994), pp. 211–2.

3
"A Panorama of the Country"

Epigraph: William H. Goetzmann, *Exploration and Empire: The Explorer and the Scientist in the Winning of the American West* (1966; New York: Vintage Books, 1972), p. 180.

1. Information on Frémont's activities during this period from Jessie Benton Frémont, "Some Account of the Plates," in John Charles Frémont, *Memoirs of My Life* (Chicago and New York: Belford, Clarke & Company, 1887), vol. 1, pp. xv–xvii.

2. Joaquin Miller, *Overland in a Covered Wagon* (1930), cited in William Goetzmann, *Exploration and Empire: The Explorer and the Scientist in the Winning of the American West* (1966; New York: Vintage Books, 1972), pp. 243–4.

3. John C. Frémont, *A Report on an Exploration of the Country Lying Between the Missouri River and the Rocky Mountains on the Line of the Kansas and Great Platte Rivers*, 27th Cong., 3d sess., S. Doc. 243, Serial 416, Washington, D.C., 1843; *Report of the Exploring Expedition to the Rocky Mountains in the Year 1842, and to Oregon and North California in the Years 1843–44*, 28th Cong., 2d sess., S. Exec. Doc. 174, Serial 507 (Washington, D.C.: Gales & Seaton, Printer, 1845); *Geographical Memoir upon Upper California, in Illustration of His Map of Oregon and California*, 30th Cong., 1st sess., S. Misc. Doc. 148 (Washington, D.C.: Wendell & Benthuysen, Printers, 1848).

4. The best estimate of the number of daguerreotypes produced by Carvalho comes from Robert Shlaer, *Sights Once Seen: Daguerreotyping Frémont's Last Expedition Through the Rockies* (Santa Fe: Museum of New Mexico Press, 2000), p. 4.

5. Joseph Earl Arrington, "Skirving's Moving Panorama: Colonel Frémont's Western Expeditions Pictorialized," *Oregon Historical Quarterly* vol. LXV, no. 2 (June 1964), pp. 167–70.

6. Kit Carson, *Kit Carson's Autobiography*, ed. Milo Milton Quaife (Chicago: Lakeside Press, 1935), p. 135.

7. This account of the Northeast Boundary Survey is informed by the discussion of Richard Rudisill, *Mirror Image: The Influence of the Daguerreotype on American Society* (Albuquerque: University of New Mexico, 1971), pp. 99–101.

8. Cited in Shlaer, p. 12.

9. "Report of Commissioners of Survey of Boundary of Northeastern Maine" (U.S. 27th Cong., 3d sess., House Document, no. 31), p. 9.

10. Cited in Shlaer, p. 12.

11. Renwick submitted a "portfolio of drawings" to illustrate his report when he sent his findings to Secretary of State Daniel Webster, but made no formal mention of the daguerreotypes. See "Report of Commissioners," p. 1. Rudisill notes in *Mirror Image*, p. 101, that the National Archives file on the Boundary Survey contains four drawings marked "Daguerreotype views."

12. On the politics of the expedition see William Goetzmann, *Army Exploration in the American West 1803–1863* (1959; Lincoln: University of Nebraska Press, 1979), pp. 75–85.

13. Frémont purchased "1 set of Daguerreotype apparatus" and twenty-five polished daguerreotype plates from Dr. James R. Chilton of New York on 6 May 1842 for $77.50. See "Subvoucher, New York, 6 May 1842 U.S. to James R. Chilton" in Donald Jackson and Mary Lee Spence, eds. *The Expeditions of John Charles Frémont* vol. 1 (Urbana: University of Illinois Press, 1970), p. 145.

14. For a wonderful historical and personal account of Frémont's involvement with daguerreotypy, see Shlaer's *Sights Once Seen*. A practicing daguerreotypist, Shlaer attempted to retrace the steps of Solomon Carvalho, daguerreotypist on Frémont's fifth expedition of 1853, reshooting the scenes represented in Carvalho's long-lost daguerreotypes. He writes with particular understanding of the technical skill and personal perseverance required to make expeditionary daguerreotypes in the mid-nineteenth century.

15. Charles Preuss, *Exploring with Frémont: The Private Diaries of Charles Preuss, Cartographer for John C. Frémont on His First, Second, and Fourth Expeditions to the Far West*, trans. and ed. Erwin G. and Elisabeth K. Gudde (Norman: University of Oklahoma Press, 1958), pp. 32, 35, 38.

16. Robert Hine cites the bill for the first expedition in *In the Shadow of Frémont: Edward Kern and the Art of American Exploration, 1845–1860* (1962; Norman: University of Oklahoma Press, 1982), p. 16n. For documentation of the second camera, see "Abstract of Disbursements on Account of Military and Geographical Surveys West of the Mississippi for the Second, Third, and Fourth Quarters of 1843, and First, Second, and Third Quarters of 1844" in *The Expeditions of John Charles Frémont*, vol. 1, p. 379.

17. For a discussion of the activities of the Topographical Engineers during the 1840s, see Goetzmann, *Army Exploration in the American West, 1803–1863*. The artist on Frémont's third expedition was the talented Edward Kern.

18. For a general discussion of these prints and the illustrations in other government expeditionary reports of the period, see Ron Tyler, *Prints of the West* (Golden, Colo.: Fulcrum Publishing, 1994), pp. 69–108.

19. Thomas Hart Benton, *Thrilling Sketch of the Life of Col. J. C. Frémont (United States Army); With an Account of His Expedition to Oregon and California, Across the Rocky Mountains, and Discovery of the Great Gold Mines* . . . ([London]: J. Field, [1850]), p. 21.

20. The fullest description of the panorama is in Arrington's "Skirving's Moving Panorama: Frémont's Western Expeditions Pictorialized," pp. 133–72. Arrington's analysis is based on press accounts as well as on a rare pamphlet by John Skirving, *Description of Frémont's Overland Route to Oregon and California* (London, 1850).

21. Benton, *Thrilling Sketch*, p. 18.

22. Skirving, p. 149.

23. The publishing history of the variant copies of the guidebook accompanying the panorama is some-

what confusing. Leonard Arrington bases his 1964 article "Skirving's Moving Panorama: Colonel Frémont's Western Expeditions Pictorialized" on John Skirving's *Description of Frémont's Overland Route to Oregon and California* (London, 1850), a pamphlet that varies in content from three other editions in the collection of the Beinecke Rare Book and Manuscript Library at Yale. It is Arrington (p. 167) who cites a contemporary description of the panorama as ending with the Isthmus of Panama image. The image of the miners concludes the version of the panorama described in Thomas Hart Benton, *Descriptive of Colonel Frémont's Overland Route to Oregon and California Across the Rocky Mountains. As Surveyed for the United States Government; Now Exhibiting at the Egyptian Hall* ([London]: J. Field, [1850]). The urban view of San Francisco concludes the version described in Benton, *Descriptive of Colonel Frémont's Overland Route to Oregon and California, Across the Rocky Mountains, as Surveyed for the United States' Government* (London, printed by R. S. Francis [1850?]).

24. Skirving, pp. 167–70.

25. Goetzmann, *Exploration and Empire,* p. 212.

26. David Dale Owen, *Report of a Geological Survey of Wisconsin, Iowa, and Minnesota; and Incidentally of a Portion of Nebraska Territory* (Philadelphia: Lippincott, Grambo & Co., 1852), Table X (n.p.); and Ann Shelby Blum, *Picturing Nature: American Nineteenth-Century Zoological Illustration* (Princeton: Princeton University Press, 1993), pp. 267, 364. Rolf H. Krauss in "Photographs as Early Scientific Book Illustration," *History of Photography,* vol. 2, no. 4 (Oct. 1978), p. 292, cites two early European examples of books with illustrations printed directly from daguerreotype plates: Josef Berres, *Phototyp nach der Erfindung des Professor Berres* (Vienna, 1840) and *Excursions Daguerriennes . . .* (Paris, 1843).

27. "Report of the Sup't of the United States Coast Survey for 1854," *Humphrey's Journal* vol. VII, no. 12 (15 Oct. 1855), pp. 189–92; George Mathiot, "Actino-Engraving," *Humphrey's Journal* vol. VII, no. 14 (15 Nov. 1855), pp. 217–8.

28. William Henry Jackson to Robert Taft, 24 May 1935, Robert Taft Collection, Kansas State Historical Society, Topeka.

29. Accounts of Mayhew's daguerrean activities can be found in Joseph Rowe Smith, "A Diary Account of a Creek Boundary Survey, 1850," in Carl Coke Rister and Bryan W. Lovelace, eds. *Chronicles of Oklahoma* 27, no. 3 (Autumn 1949); and S. W. Woodhouse, *A Naturalist in Indian Territory: The Journals of S. W. Woodhouse, 1849–1850,* ed. John S. Toner and Michael J. Broadhead (Norman and London: University of Oklahoma Press, 1992); citations courtesy Tom Kailbourn. Reproductions of Mayhew's daguerreotypes of the survey party and of survey naturalist S. W. Woodhouse can be found in Weston J. Naef in collaboration with James N. Wood, *Era of Exploration: The Rise of Landscape Photography in the American West, 1860–1885* (n.p.: Albright-Knox Art Gallery and the Metropolitan Museum of Art, 1975), p. 30.

30. Jessie Benton Frémont, "Some Account of the Plates," p. xv. For an overview of the Pacific Railroad surveys see Goetzmann, *Army Exploration in the American West, 1803–1863,* pp. 262–304.

31. Jessie Benton Frémont, "Some Account of the Plates," p. xv.

32. Robert Shlaer challenges the oft-repeated Humboldt story and proposes this new interpretation in *Sights Once Seen,* pp. 30–1.

33. The best sources for biographical information on Carvalho are: *Solomon Nunes Carvalho: Painter, Photographer, and Prophet in Nineteenth Century America,* exhibition catalogue (Baltimore: The Jewish Historical Society of Maryland, 1989), and a biography by his great-great granddaughter, Joan Sturhahn, *Carvalho: Artist-Photographer-Adventurer-Patriot, Portrait of a Forgotten American* (Merrick, N.Y.: Richwood Publishing Co., 1976). Carvalho's own account of his adventures with Frémont is in S. N. Carvalho, *Incidents of Travel and Adventure in the Far West* (New York: Derby & Jackson, 1857).

34. See *Photographic Art-Journal* (April 1852), pp. 256–7.

35. *The Occident,* vol. X, (1852), p. 174, cited in Bernard P. Fishman, "Solomon Nunes Carvalho: Photographer" in *Solomon Nunes Carvalho: Painter, Photographer, and Prophet,* p. 28.

36. *Incidents of Travel,* pp. 17–8.

37. A phrase used to describe Frémont in *Descriptive of Colonel Frémont's Overland Route* (London: R. S. Francis, [c.1850]), p. 34.

38. *Incidents of Travel,* p. 20.

39. According to the *Oxford English Dictionary* (Compact edition, p. 2066), the word "panorama" was first coined by Robert Barker in c. 1789 to refer to the moving painting apparatus he patented in 1787. By the daguerrean era, the word had related meanings. First, it was "a picture of a landscape or other scene, either arranged on the inside of a cylindrical surface round the spectator as a centre . . . or unrolled or unfolded and made to pass before him, so as to show the various parts in succession." The word likewise applied to a less material kind of imagery; "a continuous passing scene; a mental image in which a series of images passes before the mind's eye." Finally, it applied to personal vision, as in "an unbroken view of the whole surrounding region."

40. "Excerpt from Letters: Frémont to Jessie B. Benton and Thomas H. Benton," 26 Nov. 1853, in Jackson and Spence, *The Expeditions of John Charles Frémont,* vol. 3 (Urbana: University of Illinois Press, 1984), p. 422.

41. *Daily National Intelligencer,* 16 June 1854, cited in Joan Sturhahn, "Solomon N. Carvalho's Lost Daguerreotypes" in *Solomon Nunes Carvalho: Painter, Photographer, and Prophet,* p. 37.

42. Jessie Benton Frémont, "Some Account of the Plates," p. xvi.

43. Bomar, or Bomer, was a recent German immigrant compelled to communicate with the assistance of an interpreter, the expedition's topographer Frederick von Egloffstein. See Mark J. Stegmaier and David H. Miller, *James F. Milligan: His Journal of Frémont's Fifth Expedition, 1853–1854; His Adventurous Life on Land and Sea* (Glendale: The Arthur H. Clark Company, 1988), p. 104. Milligan makes a number of references to Carvalho's use of his camera.

44. *Incidents of Travel,* p. 24. Reviewing the contemporary literature, Robert Taft concluded, "Bomar could not have been well-versed in the process he employed, as none of the manuals of the day state that any lengthy washing was necessary." See Robert Taft, *Photography and the American Scene: A Social History, 1839–1889* (1938; New York: Dover Publications, 1964), p. 263.

45. *Incidents of Travel,* pp. 26, 20–1, 76, 106, 33. The estimated weight of Carvalho's supplies comes from Shlaer, *Sights Once Seen,* p. 58.

46. *Incidents of Travel,* pp. 82–3.

47. Ibid., pp. 67–8.

48. This estimate of the number of Carvalho's plates comes from Sturhahn, *Carvalho*, p. 98. Though Sturhahn and others presumed that Carvalho buried his plates in the cache along with his equipment, there is no proof of this. Carvalho, himself, is not precise. He writes, "A place was prepared in the snow, our large buffalo lodge laid out, and all the pack saddles, bales of cloth and blankets, the travelling bags, and extra clothes of the men, my daguerreotype boxes, containing besides, several valuable instruments, and everything that could possibly be spared, together with the surplus gunpowder and lead, were placed in it, and carefully covered up with snow, and then quantities of brush to protect it from the Indians" (Carvalho, *Incidents of Travel and Adventure,* p. 124). Would Carvalho and Frémont have left the precious daguerreotypes behind in the snow? Were they, in fact, *in* those daguerreotype boxes? Contemporary daguerreotypist Robert Shlaer of Santa Fe, New Mexico, who has systematically retraced Carvalho's steps with a daguerreotype camera and has done extensive research on the expedition, contends that the daguerreotypes were too valuable to leave behind and were carried out of the mountains by Frémont or one of his men. See Shlaer, *Sights Once Seen,* p. 153. I concur with his position.

49. On Carvalho in California see Sturhahn, *Carvalho*, pp. 110–3.

50. Jessie Benton Frémont, "Some Account of the Plates," pp. xv–xvi.

51. See Walt Wheelock, "Frémont's Lost Plates," in San Diego Corral of Westerners, *Brand Book II* (San Diego: San Diego Corral of Westerners, 1971), pp. 48–53, and Sturhahn, "Solomon N. Carvalho's Lost Daguerreotypes," in *Solomon Nunes Carvalho: Painter, Photographer, and Prophet,* pp. 37–9. Robert Shlaer reviews the images found in the publisher's prospectus and in a unique bound volume of plates, *The Evolution of the Great West* (in the Bancroft Library) in *Sights Once Seen,* pp. 46–50. Frémont's *Memoirs* is an interesting volume for the way in which it reflects the radical changes in photographic reproduction technology that occurred between his first western expedition of 1842 and the publication of his book in 1887. In addition to the engravings based on daguerreotypes and painted sketches, there are albumen silver photographs reproduced through the new halftone technology.

52. Jessie Benton Frémont, "Some Account of the Plates," p. xvi.

53. Julia Ann Schimmel, "John Mix Stanley and Imagery of the West in Nineteenth-Century American Art" Ph.D. diss. (New York University, 1983), p. 101.

54. Letter of 16 May 1853, cited in Schimmel, "John Mix Stanley," p. 104.

55. For a discussion of Stanley's earliest use of the daguerreotype camera, see chapter 6.

56. J. M. Stanley, "Memoranda in Relation to Sketches in Natural History, Geology, Botany, and to Views of Scenery and Natural Objects," in I. I. Stevens, "Report of Explorations for a Route for the Pacific Railroad, near the Forty-seventh and Forty-ninth Parallels of North Latitude, from St. Paul to Puget Sound," in *Reports of Explorations and Surveys to Ascertain the Most Practicable and Economical Route for a Railroad. . . .* (Washington: Beverley Tucker, Printer, 1855), pp. 7–8 [32d Cong., 2d sess., S. Exec. Doc. 78].

57. [Isaac I. Stevens] *Reports of Explorations and Surveys, to Ascertain the Most Practicable and Economical Route for a Railroad from the Mississippi River to the Pacific Ocean,* U.S. 36th Cong., 1st sess., S. Exec. Doc. (Washington, D.C.: Thomas H. Ford, Printer, 1860), vol. XII, Pt. 1, pp. 87, 103–4.

58. On the number and attribution of the Stevens report illustrations, see Schimmel, "John Mix Stanley," p. 113n.

59. For an account of Stanley's panorama, see Schimmel, "John Mix Stanley," pp. 117–20. See also [Thomas S. Donoho], "Scenes and Incidents of Stanley's Western Wilds" (Washington: printed at the *Evening Star* Office, [1854]), the text of the oral presentation that accompanied presentations of Stanley's panorama. A typescript copy of this brochure is on deposit at the Amon Carter Museum Library, Fort Worth.

60. "Scenes and Incidents of Stanley's Western Wilds," p. 2.

61. On the "Passage to India," its place in the American imagination, and its impact on western exploration see Henry Nash Smith, *Virgin Land: The American West as Symbol and Myth* (Cambridge: Harvard University Press, 1950).

62. John Rodgers to James C. Dobbin, 29 Jan. 1856, in Allan B. Cole, ed. *Yankee Surveyors in the Shogun's Seas: Records of the United States Surveying Expedition to the North Pacific Ocean, 1853–1856* (Princeton: Princeton University Press, 1947), p. 160.

63. Francis L. Hawks, *Narrative of the Expedition of an American Squadron to the China Seas and Japan, Performed in the Years 1852, 1853, and 1854, Under the Command of Commodore M. C. Perry. . . .* , House of Representatives, 32d Cong., 2nd sess., Ex. Doc. 97 (Washington, D.C.: A. O. P. Nicholson, Printer, 1856), vol. 1, p. 154.

64. Ibid., p. 194.

65. Cited in Rudisill, *Mirror Image*, p. 108.

66. See "List of Illustrations," in Hawks, vol. 1, pp. xv–xvi.

67. *New York Times*, 19 Feb. 1856, p. 5. Citation courtesy Tom Kailbourn.

68. On Kyle see Arrington, "Skirving's Moving Panorama: Colonel Frémont's Western Expeditions Pictorialized," pp. 141–3.

69. Hawks, *Narrative of the Expedition*, vol. I, p. 289; Roger Pineau, ed. *The Japan Expedition 1852–1854: The Personal Journey of Commodore Matthew C. Perry* (Washington, D.C.: Smithsonian Institution Press, 1968), p. 120.

70. U.S. 36th Cong., 1st sess., House of Representatives Report No. 208, p. [1], cited in *Mirror Image*, p. 111.

71. *In the Shadow of Frémont*, p. 16. For more on the Kern family see also David J. Weber, *Richard H. Kern: Expeditionary Artist in the Far Southwest, 1848–1853* (Albuquerque: published for the Amon Carter Museum by the University of New Mexico Press, 1985).

72. Cadwalader Ringgold to E. M. Kern, 17 Dec. 1852, Kern Papers, BRBML (UnCat WA Mss 111).

73. *In the Shadow of Frémont*, p. 104.

74. Cadwalader Ringgold to Edward Kern, 3 Feb. 1853, Kern Papers, BRBML: "You are authorized to procure such articles as may be required to enable you to proceed with the experiments on the Talbotype instrument. Should you procure the materials from Mr. Anthony they can be added to the bill already made otherwise get the bill and forward it to me."

75. *In the Shadow of Frémont*, p. 104.

76. Robert Hine offers a good synopsis of the North Pacific Exploring Expedition in *In Frémont's Shadow*, pp. 99–126. See also, A. W. Habersham, *The North Pacific Surveying and Exploring Expe-*

dition; or My Last Cruise. Where We Went and What We Saw. . . . (Philadelphia: J. B. Lippincott & Co., 1858).

77. Edward Kern to "Sir," n.d., Kern Papers, BRBML.

78. A collection of eighty-one drawings and watercolors executed by Kern on the North Pacific Exploring Expedition is in the Boston Museum of Fine Arts. Two oils, "View of the Coast of Japan, North Pacific Exploring Expedition" and "Cutting Up a Whale on the West Coast of Kamchatka" [Glazenapp Harbor], are in the Museum of the United States Naval Academy at Annapolis. *In the Shadow of Frémont,* p. 172.

79. Habersham, *The North Pacific Surveying and Exploring Expedition.*

80. Amos Bonsall, "After Fifty Years," in Rudolph Kersting, ed. *The White World: Life and Adventures Within the Arctic Circle Portrayed by Famous Living Explorer* (New York: Lewis, Scribner, and Co., 1902), p. 43.

81. "The American Arctic Expedition," *The Times* (London), 2 Nov. 1853, p. 8; cited in Douglas Wamsley and William Barr, "Early Photographers of the Canadian Arctic and Greenland," in J. C. H. King and Henrietta Lidchi, eds. *Imaging the Arctic* (London: British Museum Press, 1998), p. 38.

82. Elisha Kent Kane, *Arctic Explorations in the Years 1853, '54, '55* 2 vols. (Philadelphia: Childs and Peterson, 1856) I, p. 6.

83. "After Fifty Years," p. 43.

84. Cuique Suum [pseud.], "The Photographic Galleries of America," *The Photographic and Fine Art Journal* (January 1856), p. 19. See also what is probably the engraved reproduction of this portrait on the cover of *Frank Leslie's Illustrated Newspaper* vol. I, no. I (15 Dec. 1855).

85. *Report of the Board on Behalf of United States Executive Departments at the International Exhibition, Held at Philadelphia, PA., 1876* (Washington: Government Printing Office, 1884), vol. II, p. 32.

86. W. E. Partridge, "Amateur Photography," *Anthony's Photographic Bulletin* vol. 5, no. 4 (April 1884), p. 146.

87. Walter Benjamin, "The Work of Art in the Age of Mechanical Reproduction," in *Illuminations* (New York: Schocken Books, 1969), pp. 220–1.

88. John Berger, *Ways of Seeing* (London: British Broadcasting Corporation and Penguin Books, 1972), p. 24.

4
"The Attempt Has Not Met with Distinguished Success"

Epigraph: Lady Elizabeth Eastlake, "Photography," *London Quarterly Review* (March 1857), cited in Alan Trachtenberg, ed. *Classic Essays on Photography* (New Haven: Leete's Island Books, 1980), p. 59.

1. *Report upon the Colorado River of the West, Explored in 1857 and 1858 by Lieutenant Joseph C. Ives. . . .* 36th Cong., 1st sess., S. Exec. Doc. (Washington: Government Printing Office, 1861). For a discussion of Möllhausen and von Egloffstein's contributions to the visual documentation of the expedition see Ben W. Huseman, *Wild River, Timeless Canyons: Balduin Möllhausen's Watercolors of the Colorado* (Fort Worth: Amon Carter Museum, 1995), pp. 30–56.

2. *Report upon the Colorado River,* plate I. The photograph was later redrawn by artist J. J. Young and reproduced as a toned lithograph in Ives's report. Its present whereabouts are unknown, and there is no evidence that it survived once it was copied for the lithograph.

3. *Report upon the Colorado River,* pp. 32, 34.

4. For an overview of this period of western explorations, see William H. Goetzmann, *Army Exploration in the American West, 1803–1863* (1959; Lincoln: University of Nebraska Press, 1979), pp. 341–426.

5. Robert Taft, *Photography and the American Scene* (1938; New York: Dover Publications, Inc., 1964), pp. 118–9.

6. See for example the work of Thomas Easterly presented in Dolores A. Kilgo, *Likeness and Landscape: Thomas M. Easterly and the Art of the Daguerreotype* (St. Louis: Missouri Historical Society Press, 1994).

7. T. Frederick Hardwich, *A Manual of Photographic Chemistry, Including the Practice of the Collodion Process* sixth edition (London: John Churchill, 1861), pp. 328–9.

8. Richard J. Huyda, *Camera in the Interior: 1858: H. L. Hime, Photographer, The Assiniboin and Saskatchewan Exploring Expedition* (Toronto: The Coach House Press, 1975), p. 45.

9. Engineer Department, U S Army, *Report of Explorations Across the Great Basin of the Territory of Utah for a Direct Wagon-Route from Camp Floyd to Genoa, in Carson Valley, in 1859 by Capt. J.H. Simpson* (Washington: Government Printing Office, 1876), p. 8.

10. Ibid.

11. Goetzmann, *Army Exploration in the American West,* pp. 12–21.

12. Keith Davis, "'A Terrible Distinctness': Photography of the Civil War Era," in Martha A. Sandweiss ed., *Photography in Nineteenth-Century America* (New York: Harry N. Abrams, Inc., 1991), pp. 153–4.

13. Lieutenant R. S. Smith, *A Manual of Topographic Drawing* 2nd ed. (New York: Wiley and Halsted, 1856), p. 1; cited in Davis, "A Terrible Distinctness," p. 155.

14. *Report of Explorations Across the Great Basin,* pp. 8–9.

15. W. H. Jackson to Robert Taft, 24 May 1935, Robert Taft Collection, Kansas State Historical Society, Topeka.

16. J. H. Simpson, *The Shortest Route to California Illustrated by a History of Explorations of the Great Basin of Utah with Its Topographical and Geological Character and Some Account of the Indian Tribes* (Philadelphia: J. B. Lippincott & Co., 1869), pp. 33–4.

17. The National Archives Cartographic Records Section holds a collection of six J. J. Young watercolors prepared as illustrations for Simpson's report. Five of the six are clearly identified as being after the work of H. V. A. van Bekh, the sketch artist who accompanied Simpson on the expedition. Carefully lettered inscriptions on the watercolors indicate that they were intended to be engraved or lithographed as illustrations in the published report. Their existence suggests that there may indeed also be other illustrations prepared—as Simpson claimed—from photographs, and that Simpson may have, in fact, planned a more fully illustrated report that was never realized due to the Civil War. My thanks to Ben W. Huseman, formerly of the Amon Carter Museum, for his assistance on this point.

18. *The Shortest Route,* p. 32.

19. Taft, *Photography and the American Scene,* p. 267.

20. A selection of these photographs can be found in William P. MacKinnon, "125 Years of Conspiracy Theories: Origins of the Utah Expedition," *Utah Historical Quarterly,* vol. 52, no. 3, Summer 1984; and in John P. Langellier, "Desert Documentary: The William Lee Diary Account of the James H. Simpson Expedition, 1858–1859," *Annals of Wyoming,* vol. 59, no. 2, Fall 1987.

21. Raynolds to Hutton, April 22, 1859, Raynolds Account Book, BRBML.

22. On May 28, 1859, Raynolds purchased $99.05 worth of photographic chemicals from supplier W. H. Telford, and three days later he purchased from him a wet-plate camera. See "Invoice of Articles Purchased by Capt. W.F. Raynolds . . . ," Raynolds Papers, BRBML. Hutton is identified as topographer and assistant artist in Raynolds's final report, *Report on the Exploration of the Yellowstone River* (Washington, D.C.: Government Printing Office, 1868), p. 18.

23. The largest collection of Hutton field photographs is at the Beinecke Rare Book and Manuscript Library at Yale. The ten photographs there are a curious mixture of albumen and salt prints, a combination that suggests Hutton was experimenting with photographic techniques after his return from the field. The Beinecke collection also includes a small collection of western and European sketches by Hutton and some photographic copies of Schoenborn sketches that may or may not have been executed by Hutton. Although Raynolds refers in his journal to Hutton making "daguerreotypes" of some Cheyenne subjects (entry for December 16, 1859), he (like Simpson) uses the word as a synonym for photographs. All existing evidence suggests that Hutton was working with a wet-plate camera. When Raynolds returned to Omaha at the close of his expedition in the fall of 1860, he sold the "photographic apparatus" for $31.00. See "Account of Sale of Public Property Belonging to the Yellowstone and Missouri Exploring Expedition . . . ," Raynolds Collection, BRBML.

24. Entry for March 17, 1860, "Journal of Captain William Raynolds for 1859 [–1860]," tss. copy transcribed by F. M. Fryxell on deposit at the American Heritage Center, University of Wyoming, Laramie. Original in the collection of BRBML.

25. "Journal," entry for July 13, 1860; *Report on the Exploration of the Yellowstone,* p. 109.

26. The print is in the collection of BRBML (Uncat WA MS 143).

27. Ferdinand Vandiveer Hayden, "Contributions to the Ethnography and Philology of the Indian Tribes of the Missouri Valley," *Transactions of the American Philosophical Society,* vol. 12 (1863), pp. 457–8. Hayden had made two previous trips to the upper Missouri; first in 1854–5 under the auspices of the American Fur Company and again in 1856–7 with a military exploring party under the command of Lieutenant G. K. Warren.

28. This catalogue is discussed at length in chapter 6.

29. Oliver Wendell Holmes, "The Stereoscope and the Stereograph," *The Atlantic Monthly,* vol. 3 (June 1859), pp. 739, 742.

30. Nancy K. Anderson and Linda S. Ferber, *Albert Bierstadt: Art and Enterprise* (New York: Hudson Hills Press in association with the Brooklyn Museum, 1990), p. 106 n. 7.

31. "Maps and Reports of the Fort Kearney, South Pass, and Honey Lake Wagon Road," 36th Cong., 2d sess., House Exec. Doc. 64. [1861], p. 5.

32. *Albert Bierstadt,* p. 71.

33. Ibid.

34. "[Albert Bierstadt] to Crayon" (10 July 1859), *The Crayon,* vol. 6 (Sept. 1859), p. 287.

35. *The Crayon,* p. 287.

36. Ibid.; *Albert Bierstadt,* p. 106, n.13.

37. *Catalogue of Photographs, Published by Bierstadt Brothers, New Bedford, Mass.* (New Bedford: Mercury Job Press, 1860). A copy of this catalogue can be found in the library of the American Antiquarian Society, Worcester. Printed reproductions of some of Bierstadt's stereos also appeared in *Harper's Weekly,* 13 Aug. 1859, p. 516.

38. Oliver Wendell Holmes, "The Stereoscope and the Stereograph," *The Atlantic Monthly,* vol. 3 (June 1859), 738–48; "Sun-Painting and Sun-Sculpture," *The Atlantic Monthly,* vol. 8 (July 1861), 13–29; "Doings of the Sunbeam," *The Atlantic Monthly,* vol. 12 (July 1863), 1–15.

39. On the popularity of western stereos see Richard N. Marsteller, "Western Views in Eastern Parlors: The Contribution of the Stereograph Photographer to the Conquest of the West," *Prospects* 6 (1981), pp. 55–71.

40. "The Stereoscope and the Stereograph," p. 742.

41. Huyda, *Camera in the Interior,* p. 3.

42. Richard Huyda notes, "The only official use of photography prior to 1858 was in 1857 when the Provincial Secretary issued payment to a Hamilton photographer for a series of views of the Great Desjardins Canal Railway Disaster." Huyda, *Camera in the Interior,* p. 5.

43. Ibid., pp. 5–8; Hind to provincial secretary, April 10, 1858, copy in Hime Research file, Photographic Collections, National Archives of Canada.

44. Hind to provincial secretary, April 23, 1858, Hime Research File, Photographic Collections, National Archives of Canada.

45. Henry Youle Hind, *Northwest Territory. Reports of Progress; Together with a Preliminary and General Report on the Assiniboine and Saskatchewan Exploring Expedition* (Toronto: John Lovell, 1859), p. vi.

46. Huyda, *Camera in the Interior,* pp. 23–5; Armstrong, Beere & Hime to E. A. Meredith, 20 May 1859, Hime Research File, Photographic Collections, National Archives of Canada.

47. Huyda, *Camera in the Interior,* pp. 24–7; Henry Youle Hind, *Narrative of the Canadian Red River Exploring Expedition of 1857 and of the Assiniboine and Saskatchewan Exploring Expedition of 1858,* vols. I and II (London: Longman, Green, Longman and Roberts, 1860); "Photographs Taken at Lord Selkirk's Settlement on the Red River of the North, to Illustrate a Narrative of the Canadian Exploring Expeditions in Rupert's Land," printed portfolio list (London: J. Hogarth, [1860]), Hime Collection, Photographic Collections, National Archives of Canada.

48. "Photographs Taken at Lord Selkirk's Settlement."

49. The first use of the phrase "Great American Desert" and the earliest map using the term are to be found in Edwin James, *Account of an Expedition from Pittsburgh to the Rocky Mountains Under the Command of Stephen H. Long* (Philadelphia: Carey and Lea, 1822–23).

50. Hind, *Narrative,* I, plate opposite p. 135.

51. Andrea Kunhard, "Relationships of Language and Text in the Colonial Inscription of the Canadian West: The Narrative of the Canadian Red River Exploring Expedition and the Photography of H. L. Hime (1858)," unpublished ms., p. 5. By permission of the author.

52. Joseph Harris [American surveyor] to unknown person, n.d., George Clinton Gardner Papers, BRBML; cited in Andrew Birrell, "The North American Boundary Expedition: Three Photographic Expeditions, 1872–74," *History of Photography,* vol. 20, no. 2 (summer 1996), pp. 120–1.

53. The fullest consideration of the photographic aspect of the forty-ninth parallel boundary survey is in Andrew Birrell, "Survey Photography in British Columbia, 1858–1900," in Joan M. Schwartz, ed. *The Past in Focus: Photography & British Columbia, 1858–1914* (a special edition of *BC Studies,* no. 52, winter 1981–82), pp. 39–60.

54. In an interim report transmitted to the British government on 18 Aug. 1859, James Douglas, the governor of British Columbia, included three photographs: two views of the town of Douglas and a photographic copy of a hand-drawn map. See Edward Bulwer Lytton, *Papers Relative to the Affairs of British Columbia,* part II (London: G.E. Eyre and W. Spottiswood, 1859), p. 40. Books illustrated with prints derived from survey photographs include: C. E. Barrett-Lennard, *Travels in British Columbia* (London: Hurst and Blackett, 1862); and John Keast Lord, *The Naturalist in Vancouver Island and British Columbia,* 2 vols. (London, Richard Bentley, 1866).

55. For a reference to the sale of photographs in the field, see Samuel Anderson to [his brother] Jack, 11 Feb. 1861; and Samuel Anderson to [his sister] Janet, 29 Oct. 1860, Anderson Papers, BRBML.

56. *Fifth Report of the Department of Science and Art,* pp. 87–8, quoted in Birrell, p. 40.

57. David Mattison, "Arthur Vipond's Certificate of Competency in Photography," *History of Photography,* vol. 13, no. 3 (July–September 1989), p. 230, n.1.

58. Birrell, "Survey Photography," p. 43. Thanks to Joan Schwartz, senior photography specialist at the National Archives of Canada, for clarifying the meaning of this term.

59. Although his name is unrecorded in official records, a surviving photograph of the base camp, dated July 1858, is signed "J. Johnson," and provides the photographer's probable identification. The photograph titled "First Encampment of the Northwest Land Boundary Commission, Esquimalt V.I." is mounted on p. 17 of a scrapbook assembled by artist James M. Alden, who accompanied the American boundary team from 1858–60. Alden's scrapbook, now at the Beinecke Rare Book and Manuscript Library, provides additional evidence that the British photographers were printing and selling photographs to their colleagues in the field.

60. Birrell, "Survey Photography," p. 44.

61. Samuel Anderson to [his brother] Jack, 28 March 1860, Samuel Anderson Papers, BRBML (WA MSS S-1292).

62. Samuel Anderson to [his brother] Jack, 11 Feb. 1861, Anderson Papers, BRBML.

63. David Mattison, "Arthur Vipond's Certificate of Competency in Photography," pp. 223–33.

64. C. E. Barrett-Lennard, *Travels in British Columbia.* The frontispiece is a lithographic view of Victoria "from a photograph by Lt. Richard Roche."

65. George F. G.Stanley, ed. *Mapping the Frontier. Charles Wilson's Diary of the Survey of the 49th Parallel, 1858–1862* . . . (Seattle: University of Washington Press, c. 1970), p. 5, cited in John Falconer, "Photography and the Royal Engineers," *The Photographic Collector,* vol. 2, no. 3 (autumn 1981), p. 51.

66. [Manuscript list of Royal Engineers photographs in the archives of the Royal Engineers at Chatham], "Royal Engineers" research files, Photographic Archives, National Archives of Canada.

67. Samuel Anderson to [his sister] Janet, 29 Oct 1860, Samuel Anderson Papers, BRBML.

68. Anderson to [his brother] Jack, 11 Feb. 1861, Anderson Papers, BRBML.

69. Robert D. Monroe, "The Earliest Pacific Northwest Indian Photograph (1860)," in James L. Enyeart, Robert D. Monroe, and Philip Stokes, *Three Classic American Photographs Texts and Contexts* (University of Exeter: American Arts Documentation Centre, 1982), pp. 13–20.

70. Collections of North American Boundary Survey photographs can be found in: the papers of American Boundary Commissioner Joseph Smith Harris and in the scrapbook assembled by artist James M. Alden at the Beinecke Rare Book and Manuscript Library; the archives of the Royal Engineers at Chatham; the Victoria and Albert Museum (successor of the South Kensington Museum, where the Royal Engineer's photographic training program was based); the National Archives of Canada; and in an album (probably once belonging to Dr. Lyall, the Royal Navy doctor on the expedition) now in the Prints and Photographs Division of the Library of Congress. In a hearing held to settle a land dispute between the Hudson's Bay Co. and the United States in 1867, George Clinton Gardner, assistant astronomer on the American team, testified that a set of survey photographs "have been presented to the American Commissioner, and also a set of them to me. See "British and American Joint Commission on the Hudson's Bay and Puget's Sound Agricultural Companies' Claims" in the microfilmed papers of the Hudson's Bay Company, London, 1865–9, vol. 4, p. 192. (British Columbia Archives and Records Service microfilm reel 238A; citation courtesy David Mattison.)

71. *Evidence for the United States in the Matter of the Claims of the Hudson's Bay and Puget's Sound Agricultural Companies, Pending Before the British and American Joint Commission for the Final Settlement of the Same* [Miscellaneous] (Washington, D.C.: M'Gill & Witherow, 1867), p. 397. Gardner testified that the copies were made at his Washington, D.C., establishment by "Mr. Sullivan or Mr. Knox" (probably Timothy O'Sullivan and David Knox). See "British and American Joint Commission," vol. 4, pp. 319–20.

72. "List of Photographs Filed by the United States," in *Evidence for the United States,* p. 397. These photographs, on Gardner mounts, can be found in Record Group 76, Records of Boundary and Claims Commissions and Arbitrations, at the U.S. National Archives.

73. Public Record Office (England), FO 5/811, J. S. Hawkins to the secretary of state for foreign affairs, 13 March 1863; cited in Birrell, "Survey Photography in British Columbia, 1858–1900," p. 48, n.10.

5
"Westward the Course of Empire"

Epigraph: Ralph Waldo Emerson, "The Young American," *Dial* vol. 4 (April 1844), p. 492.

1. George Berkeley, "Verses on the Prospect of Planting Arts and Learning in America," in Alexander Campbell Fraser, ed. *The Works of George Berkeley,* vol. IV (Oxford: Clarendon Press, 1901), pp. 365–6.

2. Nathaniel Hawthorne, "Chiefly About War Matters," *The Atlantic Monthly,* vol. 10 (July 1862), p. 46; cited in Patricia Hills, "Picturing Progress in the Era of Westward Expansion," in William Truettner, ed. *The West as America: Reinterpreting Images of the Frontier, 1820–1920* (Washington: Smithsonian Institution Press, 1991), p. 117.

3. Leutze's notes about the picture are reproduced in Justin G. Turner, "Emanuel Leutze's Mural *Westward the Course of Empire Takes Its Way," Manuscript*, vol. 18, no. 2 (spring 1966), p. 15.

4. Bradley W. Richards, *The Savage View: Charles Savage, Pioneer Mormon Photographer* (Nevada City, Calif.: Carl Mautz Publishing, 1995), pp. 50–9.

5. For an imaginative treatment of this absence of any visual evidence of the Chinese laborers at the Golden Spike ceremony, see Frank Chin's humorous *Donald Duk: A Novel* (Minneapolis: Coffee House Press, 1991). Although Chinese workers are absent from the large format views of the scene, picture #539 in a published set of stereo views, "Union Pacific R. R. Stereoscopic Views, Across the Continent West from Omaha," is titled *Chinese at Laying Last Rail*. See [S. J. Sedgwick], *Announcement of Prof. S. J. Sedgwick's Illustrated Course of Lectures and Catalogue of Stereoscopic Views of Scenery in All Parts of the Rocky Mountains, Between Omaha and Sacramento* (New York: Metropolitan Printing and Engraving Establishment, 1873), n.p.

6. Sets of these prints are in the collection of the Boston Public Library, Missouri Historical Society, Minnesota State Historical Society, and the International Museum of Photography, George Eastman House, in Rochester. A set of fifty-two larger imperial-sized images are in the collection of the Getty Museum. The prints at the Missouri Historical Society are from the collection of John D. Perry, president of the Kansas Pacific. On the Missouri Historical Society set see "Alexander Gardner, Photographer of the West," *Missouri Historical Society Bulletin* (Jan. 1975), pp. 139–41. On the Boston Public Library set see Emily Heittman to Mr. Haraszti, [interdepartmental memorandum] 17 April 1944, Alexander Gardner research files, Photographic Collections, Missouri Historical Society.

7. This image is #152 in the stereo set, "Across the Continent on the Union Pacific Railway, Eastern Division," a run of which can be found in the Kansas State Historical Society. See Robert Taft, "A Photographic History of Early Kansas," *The Kansas Historical Quarterly*, vol. 3 (Feb. 1934), pp. 3–14; and Taft, "Additional Notes on the Gardner Photographs of Kansas," *The Kansas Historical Quarterly*, vol. VI (May 1937), pp. 175–7. A list of the titles is reprinted in D. Mark Katz, *Witness to an Era: The Life and Photographs of Alexander Gardner* (New York: Viking, 1991), pp. 292–4. Initially one of several feeder lines for the transcontinental railroad system, the Union Pacific, Eastern Division was renamed the Kansas Pacific in 1869. See William R. Petrowski, "The Kansas Pacific Railroad in the Southwest," *Arizona and the West* vol. 11 (Summer 1969), pp. 129–46.

8. Susan Danly Walther cites archivist and photo-historian Josephine Cobb as the source of this information that Gardner had photographed the Leutze painting in "Landscape Photographs of Alexander Gardner and Andrew Joseph Russell" (Ph.D. diss., Brown University, 1983[?]), p. 41.

9. Gardner printed this quote from Shakespeare's *As You Like It* (2.7.139) on the mount of this final image in the series.

10. William J. Palmer, *Report of Surveys Across the Continent, in 1867–68, on the Thirty-Fifth and Thirty-Second Parallels, for a Route Extending the Kansas Pacific Railway to the Pacific Ocean at San Francisco and San Diego* (Philadelphia: W. B. Selheimer, 1869), pp. 190, 195.

11. William A. Bell, *New Tracks in North America: A Journal of Travel and Adventure Whilst Engaged in the Survey for a Southern Railroad to the Pacific Ocean During 1867–8* (London: Chapman and Hall, 1869).

12. On Hart, see Glenn G. Willumson, "Alfred Hart: Photographer of the Central Pacific Railroad,"

History of Photography vol. 12, no. 1 (Jan.–March 1988), pp. 61–75; and Mead B. Kibbey, *The Railroad Photographs of Alfred A. Hart, Artist* (Sacramento: The California State Library Foundation, 1996). The Kibbey book reproduces the images and printed titles of Hart's entire stereo set.

13. Charles Savage, ["1869 Diary"], mss. Harold B. Lee Library, Brigham Young University.

14. On Russell, see: Walther, "The Landscape Photographs of Alexander Gardner and Andrew Joseph Russell"; Susan Danly, "Andrew Joseph Russell's *The Great West Illustrated*," in Susan Danley and Leo Marx, eds. *The Railroad in American Art* (Cambridge: MIT Press, 1988), pp. 93–112; Charles F. Cooney, "Andrew J. Russell: The Union Army's Forgotten Photographer," *Civil War Times Illustrated* 21 (April 1982), pp. 32–5; Keith F. Davis, "A Terrible Distinctness: Photography of the Civil War Era," in Martha A. Sandweiss, ed. *Photography in Nineteenth-Century America* (New York: Harry N. Abrams, Inc., 1991), pp. 157–9; William Gladstone, "Captain Andrew J. Russell: First Army Photographer," *Photographica* vol. X, no. 2 (Feb. 1978), pp. 7–9. Russell's album is formally titled *The Great West Illustrated in a Series of Photographic Views Across the Continent; Taken Along the Line of the Union Pacific Railroad West from Omaha, Nebraska, with an Annotated Table of Contents Giving a Brief Description of Each View; Its Peculiarities, Characteristics, and Connection with the Different Points on the Road,* vol. 1 (New York: Union Pacific Railroad Company, 1869). Volume two of the proposed work was never issued.

15. C. W. H. "New York Correspondence," *The Philadelphia Photographer* (March 1870), pp. 82–3.

16. It should be noted that it is not entirely clear whether Russell himself wrote this preface and the accompanying captions, though he is noted as the author on the title page of the bound album.

17. "Table of Contents" in *The Great West Illustrated*.

18. F. V. Hayden, *Sun Pictures of Rocky Mountain Scenery, with a Description of the Geographical and Geological Features, and Some Account of the Resources of the Great West; Containing Thirty Photographic Views Along the Line of the Pacific Rail Road, from Omaha to Sacramento* (New York: Julius Bien, 1870).

19. *Sun Pictures*, p. vii.

20. Ibid., p. 123.

21. See William D. Pattison, "Westward by Rail with Professor Sedgwick: A Lantern Journey of 1873," *The Historical Society of Southern California Quarterly* vol. 42 (Dec. 1960), pp. 335–49. Pattison's article is based on a collection of Sedgwick material in the Department of Special Collections, University Library, University of California, Los Angeles. My own examination of Sedgwick's work is based on a collection of his letters and correspondence at the Beinecke Rare Book and Manuscript Library, Yale University.

22. The Russell and Hart photographs are generally identifiable by their titles. The Sedgwick collection at the Beinecke, however, also includes an undated letter from Sedgwick to Hart seeking to purchase one dozen stereoscopic views made along the Central Pacific Railroad route. S. J. Sedgwick to Alfred A. Hart (n.d.). Sedgwick asked that Hart furnish him with "the point of compass towards which we are looking when viewing the scene" and promised to buy several dozen views if he was satisfied.

23. S. J. Sedgwick to J. W. Miner, 12 June 1875; Thomas Houseworth to S. J. Sedgwick, 20 Dec. 1869; S. J. Sedgwick to J. Crissman, 30 July 1875; Sedgwick Collection, BRBML.

24. Brief descriptions of the lectures are printed on the letterhead stationery that Sedgwick used during the mid-1870s. See Sedgwick collection, BRBML.

25. S. J. Sedgwick to C. W. Race, 30 July 1875; S. J. Sedgwick to Charles Greene, 30 July 1875, Sedgwick Collection, BRBML.

26. "280 Nights! Prof. S. J. Sedgwick's Illuminated Lectures Across the Continent" [undated broadside] and [Opera House broadside], n.d., Sedgwick Collection, BRBML.

27. See the miscellaneous and largely uncredited reviews reproduced in *Announcement of Prof. S. J. Sedgwick's Illustrated Course of Lectures*, n.p. On Sedgwick's connection with Crofutt, see [Contract between Crofutt and Sedgwick] 15 July 1873, BRBML, which specifies that Sedgwick would receive free transportation over the Pacific Railroad and $100 per month for three months in exchange for selling Crofutt's guide and related materials, gathering information for the 1874 edition, and generally promoting the publication.

28. *Announcement of Prof. S. J. Sedgwick's Illustrated Course of Lectures*, n.p.

29. See Box 2, print #102, A. J. Russell photograph collection, BRBML.

30. An extensive collection of these stereographs can be found in the Russell holdings of the Union Pacific Railroad Collection, Omaha, Nebraska.

31. Hayden, *Sun Pictures of Rocky Mountain Scenery*, pp. 121–2, 150.

32. See prints #80, #83 in the "Across the Continent on the Kansas Pacific Railroad" series of prints in the Alexander Gardner collection of the Photo Archives, Missouri Historical Society. See also their typescript list of images in the series, "Alexander Gardner/John D. Perry Collection/ 'Across the Continent with the Kansas-Pacific Railroad'."

33. Reproductions of these Fort Mojave views can be found in James E. Babbitt, "Surveyors Along the 35th Parallel: Alexander Gardener's Photographs of Northern Arizona, 1867–1868," *The Journal of Arizona History* (autumn 1981), pp. 325–48.

34. E. L. Godkin, "The Constitution and Its Defects," *North American Review* vol. 99 (July 1864), p. 137; cited in Michael Kammen, *Mystic Chords of Memory: The Transformation of Tradition in American Culture* (1991; pbk. New York: Vintage Books, 1993), p. 51.

35. In a report on his surveying activities in Wyoming during the summer of 1870, F. V. Hayden thanked the officers of the Central Pacific, Kansas Pacific, and Denver Pacific Railways for extending "important favors" to him and his party, thus saving the government "hundreds of dollars." He also acknowledged his continuing indebtedness to the Union Pacific for "free transportation and other courtesies." F. V. Hayden, *Preliminary Report of the United States Geological Survey of Wyoming . . .* (Washington: Government Printing Office, 1872), p. 7.

36. F. V. Hayden, [Statement to Committee on Public Lands, May 14, 1874] in [George M. Wheeler, comp.], *Notes Relating to Surveys in the Western Territory of the United States* [Binder's title; a collection of documents issued by various government surveys together with government documents and periodical articles relating to them. Copy in BRBML Zc10 870wh], p. 35.

37. F. V. Hayden, *Ninth Annual Report of the United States Geological and Geographical Survey of the Territories . . . for the Year 1875* (Washington: Government Printing Office, 1877), p. 22.

38. William Henry Jackson to Dr. [F. V. Hayden] 11 Sept. 1876 in "Record Group 57: Records of the United States Geological and Geographical Survey of the Territories; General Letters Received, W.

H. Jackson" (Washington: General Services Administration, the National Archives, 1952), tss. copy in the collection of the American Heritage Center, University of Wyoming, Laramie.

39. Basic starting points for any discussion of the great surveys are: Richard A. Bartlett, *Great Surveys of the American West* (Norman: University of Oklahoma Press, 1962), and William H. Goetzmann, *Exploration and Empire: The Explorer and the Scientist in the Winning of the American West* (New York: Alfred A. Knopf, Inc., 1966). Note that the William Bell who worked on the Wheeler survey is *not* the same William Bell who made pictures for the Kansas Pacific Railroad. A long-standing confusion between the two contemporaries is sorted out in Terence Pitts, "William Bell: Philadelphia Photographer," M.A. thesis (University of Arizona, 1987), a biographical discussion of the Wheeler survey's photographer.

40. At the age of ninety, William Henry Jackson remained an assiduous researcher in the field of early western photography, as his letters to photographic historian Robert Taft reveal. Having known many of the important figures in western photography in the 1860s and 1870s, he was a walking treasure trove of anecdotal information. But his correspondence suggests that his own research into early western expeditionary photography did not begin until the 1920s, and in 1933, as he was assisting Taft with the research for a book on American photographic history, he remained unaware that anyone had experimented with wet-plate cameras on western expeditions before the Civil War. See William Henry Jackson to Robert Taft, 2 Jan. 1933, Taft Collection, Kansas State Historical Society.

41. Hayden, *Preliminary Report of the United States Geological Survey of Wyoming . . .*, p. 5.

42. The University of Kansas chemistry professor Robert Taft was the first to write a social history of American photography. His extensively researched *Photography and the American Scene: A Social History, 1839–1889* (1938; rpt. New York: Dover Publications, Inc., 1964) drew on extensive correspondence with surviving nineteenth-century western photographers and their families and devoted two chapters to "photographing the frontier." Working on his own history of photography for the Museum of Modern Art at precisely the same time Taft was working on his, the art historian Beaumont Newhall constructed a more art historical analysis of American photography, relating the history of photography to the history of art. He argued that photography was an art with master practitioners, seminal images, and a particular logic of pictorial and stylistic development. See Beaumont Newhall, *Photography, 1839–1937* (New York: Museum of Modern Art, 1937).

43. Ansel Adams, "Introduction," in *Pageant of Photography,* exhibition catalogue (San Francisco: Crocker-Union, 1940), unpaged.

44. As in Weston J. Naef, in collaboration with James N. Wood, *Era of Exploration: The Rise of Landscape Photography in the American West, 1860–1885* (Boston: New York Graphic Society, 1975), p. 12.

45. *Report of the Board on Behalf of United States Executive Departments at the International Exhibition. . . .* vol. I (Washington: Government Printing Office, 1884), pp. 310–11, 351, 360–7.

46. See for example, Richard Rudisill, "A Problem in Attribution" [review of *William H. Jackson* by Beaumont Newhall and Diana E. Edkins] (Research Report No. 1, Photo Collections, Museum of New Mexico, March 1975).

47. Don D. Fowler, ed. *"Photographed All the Best Scenery": Jack Hillers's Diary of the Powell Expeditions, 1871–1875* (Salt Lake City: University of Utah Press, 1972), pp. 7–8, n.13.

48. Joel Snyder, *American Frontiers: The Photographs of Timothy H. O'Sullivan, 1867–1874* (Millerton, N.Y.: Aperture, Inc. in association with the Philadelphia Museum of Art, 1981), pp. 30–1.

49. Jonathan Heller, comp., "O'Sullivan Albumen Prints in Official Publications," in Snyder, *American Frontiers*, p. 117.

50. War Department, Corps of Engineers, U.S. Army, *Photographs Showing Landscapes, Geological and Other Features, of Portions of the Western Territory of the United States. Obtained in Connection with Geographical and Geological Explorations and Surveys West of the 100th Meridian, Seasons of 1871, 1872, 1873, and 1874.* First Lieutenant Geo. M. Wheeler, Corps of Engineers, U.S. Army in Charge (n.p. c. 1874). Whether or not Wheeler himself wrote the descriptive texts, given the lavishness and expense of this album, one can assume he probably approved of their content.

51. Wheeler, cited in Bartlett, *Great Surveys*, p. 338.

52. General A. A. Humphreys to Wheeler, cited in Bartlett, *Great Surveys*, p. 339.

53. James N. Wood in *Era of Exploration*, p. 130.

54. Engineer Department, U.S. Army, *Report Upon United States Geological Surveys West of the One Hundredth Meridian in Charge of Captain Geo. M. Wheeler*, vol. 1, Geographical Report (Washington, D.C.: Government Printing Office, 1889), p. 75 and plate IX.

55. Stereo #22, [Wheeler survey] *Geographical and Geological Explorations and Surveys West of the 100th Meridian*, 1871 Series. BRBML.

56. John Samson, "Photographs from the High Rockies," *Harper's New Monthly Magazine* 39 (September 1869), p. 475. It is widely thought that this article, which is illustrated with woodcuts from O'Sullivan's photographs, fairly represents O'Sullivan's point of view. Although he is never named, the author refers to "our photographer," quoting directly from him and elsewhere attributing to him indirect remarks. According to Rick Dingus, "some believe that O'Sullivan actually wrote the article himself." See Dingus, *The Photographic Artifacts of Timothy O'Sullivan* (Albuquerque: University of New Mexico Press, 1982), p. 145, n.23. Dingus's book contains the fullest description of O'Sullivan's work at Shoshone Fall (and elsewhere).

57. Clarence King, *Mountaineering in the Sierra Nevada* (1872; reprint, Lincoln: University of Nebraska Press, 1970), pp. 192–3.

58. Two lithographs based on O'Sullivan's photographs of the falls did appear in King's official report, *Systematic Geology* (1878), but while King acknowledged that the cataract was "one of the most picturesque in the world," he devoted most of his text to dry geological descriptions of the terrain. O'Sullivan's images are merely factual adjuncts to the text, and King's words give them little power. Clarence King, *Systematic Geology* (Washington: Government Printing Office, 1878), p. 593.

59. I have consulted three versions of Jackson's expanding catalogue: Wm. H. Jackson, *Catalogue of Stereoscopic 6 × 8 and 8 × 10 Photographs* (Washington: Cunningham & McIntosh, Printers, 1871); Department of the Interior. United States Geological Survey of the Territories. Miscellaneous Publication No. 5, *Descriptive Catalogue of the Photographs of the United States Geological Survey of the Territories for the Years 1869 to 1873, Inclusive. W. H. Jackson Photographer* (Washington: Government Printing Office, 1874); Department of the Interior. United States Geological Survey of the Territories. Miscellaneous Publication No. 5. Second edition, *Descriptive Catalogue of the Photographs of the United States Geological Survey of the Territories for the Years 1869 to 1875, Inclusive. W. H.*

Jackson, Photographer (Washington: Government Printing Office, 1875). A variant version of the 1875 catalogue is listed as an unclassified publication of the survey in L. F. Schmeckebier, *Catalogue and Index of the Publications of the Hayden, King, Powell, and Wheeler Surveys* (Washington: Government Printing Office, 1904), p. 33.

60. "Diary of W. H. Jackson While Photographing Along the Line of the Union Pacific Railroad, June 19–Sept. 26, 1869," entries for June 26–28, typescript copy, Robert Taft Collection, Kansas State Historical Society.

61. Jackson acknowledges the Crissman views in *Descriptive Catalogue (1875)*, pp. 44–5. His inclusion of Savage views is established by Peter Bacon Hales in "American Views and the Romance of Modernization," in Martha A. Sandweiss, ed. *Photography in Nineteenth-Century America*, pp. 214–5.

62. Newhall became the first Curator of Photographs at the Museum of Modern Art in 1940 after serving as Librarian since 1935. He related this anecdote to me during several personal conversations during the 1980s. The story is obliquely documented in Rudisill, "A Problem in Attribution," p. 2.

63. Savage ["1869 Diary"], entry for 18 May 1869.

64. Mark David Spence, *Dispossessing the Wilderness: Indian Removal and the Making of the National Parks* (New York: Oxford University Press, 1999), pp. 41–70.

65. See Hiram Martin Chittendon, *Yellowstone National Park: Historical and Descriptive* (1895; 5th ed. Stanford: Stanford University Press, 1949), pp. 6–12.

66. *Dispossessing the Wilderness,* p. 42; Nathaniel Langford, "The Wonders of Yellowstone," Parts 1 and 2, *Scribner's Monthly* 2 (May 1871), pp. 1–17; (June 1871), pp. 113–29.

67. These Indian photographs were made with his smaller stereoscopic camera and appear in the list of images taken during the 1871–2 seasons in *Descriptive Catalogue (1875)*, pp. 33, 48. They do not here receive any explication.

68. Howard Bossen reviews and assesses the claims for the significance of Jackson's photographs to the congressional debates in "A Tall Tale Retold: The Influence of the Photographs of William Henry Jackson on the Passage of the Yellowstone Park Act of 1872," *Studies in Visual Communication* 8, no. 1 (Winter 1982), pp. 98–109.

69. On the various albums, see Hales, *William Henry Jackson*, pp. 124–5, 312. In an interesting symbiotic relationship with the private sector, Hayden actually reproduced in his annual reports engravings and woodcuts originally made for *Scribner's* and the *Illustrated Christian Weekly* from the photographs provided by his survey. F. V. Hayden, *Preliminary Report of the United States Geological Survey of Montana and Portions of Adjacent Territories; Being a Fifthe Annual Report of Progress* (Washington: Government Printing Office, 1872), p. 7, and F. V. Hayden, *Sixth Annual Report of the United States Geological Survey of the Territories. . . .* (Washington: Government Printing Office, 1873), p. 9.

70. J. D. Dana, in *American Journal of Sciences* (January 1873), cited in Hayden, *Sixth Annual Report*, p. 6.

71. William Henry Jackson, *Photographs of the Yellowstone National Park and Views in Montana and Wyoming Territories* (Washington: Government Printing Office, 1873), captions for plates 10, 15, 18.

72. Jackson, *Descriptive Catalogue (1874)*, p. 69.

73. Wm. H. Jackson to Dr. [Hayden], 11 September 1876, Record Group 57, General Letters Received, National Archives, tss. copy, American Heritage Center, University of Wyoming.

74. W. H. Jackson, *Descriptive Catalogue of Photographs of North American Indians* (Department of the Interior. United States Geological Survey of the Territories. Miscellaneous Publications, no. 9) (Washington: Government Printing Office, 1877).

75. Jackson, *Descriptive Catalogue (1875),* pp. 3–4.

76. "Introduction," in *Wonder-Places. . . . The Most Perfect Pictures of Magnificent Scenes in the Rocky Mountains. . . . The Master-Works of the World's Greatest Photographic Artist, W. H. Jackson* (Chicago and Denver: The Great Divide Publishing Co., [c. 1894]).

77. Frederick Jackson Turner, "The Significance of the Frontier in American History," *Annual Report of the American Historical Association for the Year 1893* (Washington: Government Printing Office, 1894), pp. 199, 200, 226–7.

78. Henry Nash Smith, *Virgin Land* (1950; Cambridge: Harvard University Press, 1970), p. 251.

<div align="center">

6

"Momentoes of the Race"

</div>

Epigraph: "Glimpses of Indian Life," *Appleton's Journal,* vol. 4, no. 72 (13 Aug. 1870), p. 177.

1. Lynn Davis, *Na Pa'i Ki'i: The Photographers in the Hawaiian Islands, 1845–1900* (Honolulu: Bishop Museum Press, 1980), p. 16. Richards's quote, cited there, is from his journal, May 30, 1843, Hawai'i State Archives. See also, Ralph S. Kuykendall and A. Grove Day, *Hawaii; A History: From Polynesian Kingdom to American Commonwealth* (New York: Prentice-Hall, Inc., 1948), pp. 63–75; "Kingdom of Hawai'i Constitution of 1840" (http://www.hawaii-nation.org/constitution-1840.html).

2. Julie Schimmel, "John Mix Stanley and Imagery of the West in Nineteenth-Century American Art" (Ph.D. diss., New York University, 1983), pp. 42–4, 47. The first person to bring a daguerreotype camera to the region was probably C. P. Moore, who advertised in a Little Rock, Arkansas, newspaper in July 1842 that he had previously made portraits in Fort Gibson and the Cherokee Nation. Nothing more is known of his possible Cherokee work, and none of these portraits have come to light. Personal correspondence, Tom Kailbourn to the author, 8 March 2001.

3. Donald B. Smith, *Sacred Feathers: The Reverend Peter Jones (Kahkewaquonaby) & the Mississauga Indians* (Toronto and London: University of Toronto Press, 1987), updates and expands some of the previous writing about these images, see esp. pp. 169–71, 198. See also, David Bruce, *Sun Pictures: The Hill and Adamson Calotypes* (Greenwich, Conn.: New York Graphic Society, 1973), pp. 80–1; Colin Ford, ed., *An Early Victorian Album: The Photographic Masterpieces (1843–1847) of David Octavius Hill and Robert Adamson* (New York: Alfred A. Knopf, 1976), pp. 34–5, 287–91. An 1845 poster advertising Jones's lectures is reproduced in Jane Alison, ed. *Native Nations: Journeys in American Photography* (London: Barbican Art Gallery, 1998), p. 210.

4. Dolores A. Kilgo, *Likeness and Landscape: Thomas M. Easterly and the Art of the Daguerreotype* (St. Louis: Missouri Historical Society Press, 1994), pp. 123–9. The circus performance is cited in the St. Louis *Daily Union,* March 24 and March 25, 1847, and quoted in Kilgo, p. 125.

5. Kilgo, p. 125.

6. W. H. Jackson, *Descriptive Catalogue of Photographs of North American Indians*. Department of the Interior, United States Geological Survey of the Territories, F. V. Hayden, U.S. Geologist, Miscellaneous Publications, No. 9 (Washington: Government Printing Office, 1877), p. 17; Thomas L. McKenney and James Hall, *History of the Indian Tribes of North America . . .* vol. II (Philadelphia: Daniel Rice and James G. Clark, 1842), p. 71.

7. Cited in Mick Gidley, *Edward S. Curtis and the North American Indian, Incorporated* (Cambridge: Cambridge University Press, 1998), p. 281.

8. S. F. Haven, "Report of the Librarian," *Proceedings of the American Antiquarian Society at the Annual Meeting . . . Oct. 21, 1876* (Worcester: Charles Hamilton, 1876), p. 57. Reference to a gift of photographs collected by Robert Cassie Waterman.

9. George Catlin, *Letters and Notes on the Manners, Customs, and Condition of the North American Indians* (1841; rpt. New York: Dover Publications, 1873), I, p. 3.

10. Cited in Paula Richardson Fleming and Judith Luskey, *The North American Indians in Early Photographs* (New York: Harper and Row, 1986), p. 22.

11. F. V. Hayden, "Prefatory Note," in Jackson, *Descriptive Catalogue,* p. iii.

12. Ibid., p. iii.

13. "Kag-ge-ga-gah Bowh's [sic] First Daguerreotype," *The Daguerreian Journal* vol. II, no. 5 (16 July 1851), p. 153.

14. Elwell's ad is reproduced in Bonnie G. Wilson, "Working the Light: Nineteenth-Century Professional Photographers in Minnesota," *Minnesota History* vol. 52, no. 2 (summer 1990), p. 44.

15. Joseph Henry to John W. Denver, 2 Feb. 1859, cited in Herman Viola, *Diplomats in Buckskin: A History of Indian Delegations in Washington City* (Washington, D.C.: Smithsonian Institution Press, 1981), p. 180.

16. Ridgway Glover, "Photography Among the Indians," *The Philadelphia Photographer* vol. III, no. 32 (Aug. 1866), pp. 239–40; "Obituary," *The Philadelphia Photographer* vol. III, no. 36 (Dec. 1866), p. 371.

17. [Isaac I. Stevens, U.S. War Department], *Report of Explorations and Surveys, to Ascertain the Most Practicable and Economical Route for a Railroad from the Mississippi River to the Pacific Ocean,* U.S. 36th Cong., 1st sess., S. Exec. Doc. (Washington, D.C.: Thomas H. Ford, Printer, 1860), vol. XII, book I, pp. 103–4.

18. S. N. Carvalho, *Incident of Travel and Adventure in the Far West. . . .* (New York: Derby & Jackson, 1857), p. 68.

19. Paula Richardson Fleming and Judith Luskey, *The North American Indians in Early Photographs* (New York: Harper & Row, 1986), p. 194.

20. E. O. Beaman, "The Canon of the Colorado and the Moquis Pueblos," *Appleton's Journal* vol. XI, no. 270 (May 23, 1874), pp. 642, 644.

21. E. O. Beaman, "The Colorado Exploring Expedition," *Anthony's Photographic Bulletin* (Feb. 1872), p. 465.

22. Margaret B. Blackman, "'Copying People': Northwest Coast Native Response to Early Photography," in Joan M. Schwartz, ed., *The Past in Focus: Photography & British Columbia, 1858–1914* (A special issue of *BC Studies* no. 52, winter 1981–82), pp. 90–1.

23. C. F. Lummis, *Mesa, Canon, and Pueblo* (New York: Century Company, 1925), p. ix.

24. E. O. Beaman, "Among the Aztecs," *Anthony's Photographic Bulletin* (Dec. 1872), pp. 746–7.

25. E. O. Beaman, "The Canon of the Colorado, and the Moquis Pueblos," *Appletons' Journal* vol. XI, no. 267 (May 2, 1874), p. 548.

26. Margaret B. Blackman, "'Copying People': Northwest Coast Native Response to Early Photography," p. 90. Far to the south, in the Mayan highlands of Mexico, the Tzotzil speaking people used a similar word, but with a more violent twist. The intransitive verb "lok' sat" meant to photograph or take out a face. (Gary Gossen, personal communication, 31 May 2001.)

27. Ibid., p. 104.

28. Carolyn Marr, with essays by Lloyd Colfax and Robert D. Monroe, *Portrait in Time: Photographs of the Makah by Samuel G. Morse, 1896–1903* (n.p.: published by the Makah Cultural and Research Center in Cooperation with the Washington State Historical Society, 1987), p. 67.

29. Don D. Fowler, *The Western Photographs of John K. Hillers* (Washington: Smithsonian Institution Press, 1989), p. 47.

30. Thomas M. Heski, *"Icastinyanka Cikala Hanzi," The Little Shadow Catcher D. F. Barry, Celebrated Photographer of Famous Indians* (Seattle: Superior Publishing Co., 1978), p. 90.

31. Hopi Dictionary Project, comp. *Hopi Dictionary* (Tucson: University of Arizona Press, 1998).

32. Carolyn J. Marr, "Marking Oneself: Use of Photographs by Native Americans of the Southern Northwest Coast," *American Indian Culture and Research Journal* vol. 20, no. 3 (1996), p. 53.

33. Oliver Wendell Holmes, "The Stereoscope and the Stereograph," *The Atlantic Monthly,* vol. 3, no. 20 (June 1859), p. 748.

34. Oliver Wendell Holmes, "Sun Painting and Sun Sculpture, With a Stereoscopic Trip Across the Atlantic," *The Atlantic Monthly,* vol. 8 (July 1861), p. 13.

35. Hermann W. Vogel, "German Correspondent," *The Philadelphia Photographer* vol. 4, no. 47 (Nov. 1867), p. 362.

36. *The Compact Edition of the Oxford English Dictionary,* s.v. "snapshot"; s.v. "stalk."

37. Holmes, "Sun Painting," p. 4.

38. *Harper's New Monthly Magazine,* vol. VII, no. XLII (Nov. 1853), p. 851.

39. Ridgway Glover, "Photography Among the Indians, No. 2," *The Philadelphia Photographer* vol. III, no. 35 (Nov. 1866), p. 339.

40. E. O. Beaman, "The Colorado Exploring Expedition," *Anthony's Photographic Bulletin* (Feb. 1872), p. 465.

41. Fanny Kelly, *Narrative of My Captivity Among the Sioux Indians* (Cincinnati: Wilsatch, Baldwin & Co., Printers, 1871), p. 38. See also, Sarah L. Larimer, *The Capture and Escape; or, Life Among the Sioux* (Philadelphia: Claxton, Remsen & Haffelfinger, 1870); and Peter E. Palmquist and Thomas R. Kailbourn, *Pioneer Photographers of the Far West: A Biographical Dictionary, 1840–1865* (Stanford: Stanford University Press, 2000), pp. 358–9.

42. *Chicago Times,* 7 May 1893, cited in Ira Jacknis, "Franz Boas and Photography," *Visual Communication* vol. 10, no. 1 (winter 1984), p. 13.

43. On the invention of the Kodak camera, see Reese V. Jenkins, *Images and Enterprise: Technology and the American Photographic Industry, 1839–1925* (Baltimore and London: The Johns Hopkins Uni-

versity Press, 1975), pp. 96–133. Robert Taft notes that the now ubiquitous name of the "Kodak," was made up by its inventor George Eastman. "He originated this word as a mark of identity for his camera and his photographic products and arrived at it by starting with K, which seemed to him a 'strong, incisive sort of letter.' By trying out various combinations of other letters with the K the short, easily pronounceable, easily spellable, and remarkably distinctive word was finally obtained." Robert Taft, *Photography and the American Scene: A Social History, 1839–1889* (1938; New York: Dover Publications, Inc., 1964), p. 389.

44. Frederick I. Monsen, "Picturing Indians with the Camera," *Photo-Era: The American Journal of Photography* vol. XXV, no. 4 (Oct. 1910), pp. 165–6.

45. Owen Wister, "Bad Medicine" in *When West Was West* (New York: The Macmillan Company, 1928), pp. 1–48.

46. George Wharton James, "The Snake Dance of the Hopis," *Camera Craft: A Photographic Monthly* vol. VI, no. 1 (Nov. 1902), p. 10.

47. D. H. Thomas, *The Southwestern Indian Detours* (Phoenix: Hunter Publishing Co., 1978), p. 198.

48. See Luke Lyon, "History of Prohibition of Photography of Southwestern Indian Ceremonies," in Anne Van Arsdall Poore, ed., *Reflections: Papers on Southwestern Culture History in Honor of Charles H. Lange.* Papers of the Archeological Society of New Mexico, no. 14 (Santa Fe: Published for the Archeological Society of New Mexico by Ancient City Press, 1988), pp. 238–72.

49. Nigel Holman, "Photography as Social and Economic Exchange: Understanding the Challenges Posed by Photography of Zuni Religious Ceremonies," *American Indian Culture and Research Journal* vol. 20, no. 3 (1996), pp. 99–100.

50. William Henry Jackson, *Time Exposure: The Autobiography of William Henry Jackson* (1940; Albuquerque: University of New Mexico Press, 1986), pp. 226–7.

51. Raymond W. Thorp, "Conquering the Rockies with a Camera," *Old West* (fall 1966), pp. 41, 72.

52. Jana L. Bara, "Cody's Wild West Show in Canada," *History of Photography* vol. 20 (summer 1996), p. 153.

53. Paul Chaat Smith, "Every Picture Tells a Story," in Lucy R. Lippard, ed., *Partial Recall* (New York: The New Press, 1992), p. 98.

54. *Geronimo's Story of His Life,* taken down and edited by S. M. Barrett (New York: Duffield and Co., 1906), p. 153.

55. These photographs are all included in *Geronimo's Story.*

56. Jimmie Durham, "Geronimo," in *Partial Recall*, p. 56.

57. Paul Chaat Smith, "Every Picture Tells a Story," p. 97.

58. Leslie Marmon Silko, *Storyteller* (New York: Arcade Publishing, 1981), p. 1.

59. As recorded by William Curtis and cited in Nigel Holman, "Photography as Social and Economic Exchange: Understanding the Challenges Posed by Photography of Zuni Religious Ceremonies," p. 99.

60. George P. Horse Capture, "The Camera Eye of Sumner Matteson and the People Who Fooled Them All," *Montana Magazine of Western History* (summer 1977), p. 70.

61. Carolyn J. Marr, "Marking Oneself . . . ," pp. 55–6.

62. For more on Bierstadt and the Lander expedition, see chapter four.

63. *Catalogue of Photographs, Published by Bierstadt Brothers, New Bedford, Mass.* (New Bedford: Mercury Job Press, 1860). On Bierstadt's western photographs, see also Nancy K. Anderson and Linda S. Ferber, *Albert Bierstadt: Art and Enterprise* (New York: Hudson Hills Press in association with the Brooklyn Museum, 1990), pp. 140–5.

64. Ferdinand Vandiveer Hayden, "Contributions to the Ethnography and Philology of the Indian Tribes of the Missouri Valley," *Transactions of the American Philosophical Society* vol. 12, new series, [Philadelphia, 1863], pp. 457–8. See chapter four for one of Hayden's reproductions of Hutton's photographs.

65. Renato Rosaldo, *Culture and Truth: The Remaking of Social Analysis* (Boston: Beacon Press, 1989), p. 69.

66. A collection of Mitchell and McGowan images can be found in the collections of the Nebraska State Historical Society, Lincoln, with related documentation in the Historical Society's artist files.

67. On Morrow, see Wesley R. Hurt and William E. Lass, *Frontier Photographer: Stanley J. Morrow's Dakota Years* (n.p.: University of Nebraska Press and University of South Dakota Press, 1956). A significant collection of his work is found in the Montana Historical Society, Helena. A collection of his back-lists is included in J. J. Wilburn and T. K. Treadwell, "Stereoview Back-lists," an undated typescript publication of the National Stereoscopic Association.

68. A full set of the twenty-four cabinet cards by Bailey, Dix, and Mead is in the photographic collections of the Montana Historical Society, Helena.

69. A collection of Z. Gilbert cabinet cards are found in the collection of the Beinecke Rare Book and Manuscript Library, Yale University.

70. Bennet and Brown, "The Indian Pueblo of San Juan, New Mexico" (albumen silver print, c. 1880–2), Photo Archives, Palace of the Governors, Museum of New Mexico.

71. Lonna M. Malmsheimer, "'Imitation White Man': Images of Transformation at the Carlisle Indian School," *Studies in Visual Communication* vol. 11, no. 4 (fall, 1985), pp. 54–75.

72. *St. Louis Practical Photographer* vol. 2, no. 2 (Feb. 1878), n.p.

73. See, for example, Julie Schimmel, "Inventing 'the Indian'," in William Truettner, ed., *The West as America: Reinterpreting Images of the Frontier* (Washington: Smithsonian Institution Press, 1991), pp. 149–89.

74. See Henry Buehman and F. A. Hartwell, "Apaches in Ambush" (albumen silver print, 1885), Arizona Historical Society, photo collection, no. 9645.

75. Peter E. Palmquist, "Photographing the Modoc Indian War: Louis Heller versus Eadweard Muybridge," *History of Photography* vol. 2, no. 3 (July 1978), p. 196.

76. L. A. Huffman, *A Good Indian*, Montana Historical Society, photograph 981–515.

77. Fleming 22–4; Henry quote p. 22.

78. [Antonio Zeno Shindler], *Photographic Portraits of North American Indians in the Gallery of the Smithsonian Institution* [1869; misdated 1867 on cover], in *Smithsonian Miscellaneous Collections*, vol. 14, no. 216 (1876).

79. F. V. Hayden, "Prefatory Note," in W. H. Jackson, *Descriptive Catalogue of Photographs of North American Indians* (Miscellaneous Publications, No. 9; Department of the Interior, United States Geological Survey of the Territories) (Washington: Government Printing Office, 1877), iii.

80. W. H. Jackson, "Preface," in Jackson, *Descriptive Catalogue* (1877), p. v.

81. On the concept of the photographic archive in nineteenth-century social thought, see Alan Sekula, "The Body and the Archive," in Richard Bolton, ed., *The Contest of Meaning: Critical Histories of Photography* (Cambridge: MIT Press, 1989), pp. 343–88. This is where he develops his argument about photography as "a system of representation capable of functioning both honorifically and repressively" (p. 345).

82. Hayden, "Prefatory Note," p. iv.

83. Ibid., pp. 34, 52, 54, 64.

84. Ibid., p. 30.

85. Ibid., p. 38.

86. On Easterly, see Dolores A. Kilgo, *Likeness and Landscape: Thomas M. Easterly and the Art of the Daguerreotype.*

87. Gordon M. Sayre, "The Mound Builders and the Imagination of American Antiquity in Jefferson, Bartram, and Chateaubriand," *Early American Literature* vol. 33 (1998), p. 229. This article provides an excellent overview of cultural responses to the earthworks during the early republic.

88. W. H. Emory, *Notes of a Military Reconnaissance from Fort Leavenworth, in Missouri, to San Diego, in California* [30th Cong. 1st sess., Exec. Doc. 41] (Washington: Wendell and Van Benthuysen, 1848), pp. 489–92.

89. James H. Simpson, *Journal of a Military Reconnaissance from Santa Fe, New Mexico to the Navajo Country* (Philadelphia: Lippincott, Grambo and Co., 1852), p. 4.

90. Ibid., pp. 34, 44, 78.

91. "Descriptive Legend of View No. 21," in Geographical Surveys West of the 100th Meridian, *Photographs Showing Landscapes, Geological, and Other Features of Portions of the Western Territory of the United States Obtained in Conjunction with Geographical and Geological Explorations and Surveys West of the 100th* Meridian, Seasons of 1871, 1872, 1873, and 1874 [Washington, D.C.: n.p., c. 1874].

92. [H. T. Heister], "A Photographer's Wanderings in the Great Southwest," *St. Louis Practical Photographer* (May 1878), pp. 145–50. A brief editorial note in the journal (p. 173) identifies Heister as the author of this piece.

93. "Our Picture," *St. Louis Practical Photographer* (Oct. 1878), p. 332.

94. F. V. Hayden, *[Eighth] Annual Report of the United States Geological and Geographical Survey of the Territories....* (Washington: Government Printing Office, 1876), p. 11.

95. W. H. Jackson, "Ancient Ruins in Southwestern Colorado," in Hayden, *[Eighth] Annual Report,* pp. 369, 373, 377, 380.

96. F. V. Hayden, *Ninth Annual Report of the United States Geological and Geographical Survey of the Territories....* (Washington: Government Printing Office, 1877), pp. 12, 23.

97. Ibid., pp. 15, 17.

98. W. H. Jackson to Dr. [F. V. Hayden], 27 July 1875 (Record Group 57, Records of the United States Geological and Geographical Survey of the Territories, National Archives; tss. copy on deposit at

the American Heritage Center, University of Wyoming, Laramie).

99. On the Antiquities Act, see Hal Rothman, *America's National Monuments: The Politics of Preservation* (Lawrence: University Press of Kansas, c. 1989). On the ways in which the act intentionally or unintentionally disenfranchised native peoples, see David Hurst Thomas, *Skull Wars: Kennewick Man, Archeology, and the Battle for Native American Identity* (New York: Basic Books, c. 2000), pp. 140–4; quote from p. 144.

100. Oliver Wendell Holmes, "The Stereoscope and the Stereograph," *The Atlantic Monthly* (June 1859), p. 744.

101. See miscellaneous newspaper clipping and census records in the Thomas Eaton Biography File, Alaska Historical Collections, Alaska State Library, Juneau. See also, Alfred L. Bush and Lee Clark Mitchell, *The Photograph and the American Indian* (Princeton: Princeton University Press, 1994), pp. 298–9.

102. Cora M. Folsom, "The Careers of Three Indian Women," *The Congregationalist and Christian World* (12 March 1904), pp. 374–5; Jeanette Atwood, "America's Only Indian Camp for Pale-Face Girls" (unidentified news clipping, Angel de Cora folder, Smith College Archives).

103. Edward T. Hall, "Foreword," in John Collier, Jr., and Malcolm Collier, *Visual Anthropology: Photography as a Research Method* (rev. ed.; Albuquerque: University of New Mexico Press, 1986), p. xvi.

104. Reneé Sansom-Flood and Shirley A. Birnie, edited by Leonard R. Bruguier, *Remember Your Relatives, Yankton Sioux Images, 1851 to 1904*, vol. I (Marty, South Dakota: Marty Indian School, 1985). Interesting readings of Indian portraits by the subjects' descendants can also be found in Lucy R. Lippard, ed., *Partial Recall* (New York: The New Press, 1992), and in George P. Horse Capture's foreword to Christopher Cardozo, ed., *Native Nations: First Americans as Seen by Edward S. Curtis* (Boston: Little, Brown and Company, 1993).

105. *Descriptive Catalogue*, p. 34.

106. *Remember Your Relatives*, pp. 4–5, 10–11, 16–17, 19–20, 25–6.

107. An excellent overview of these issues is presented in Michael Brown, "Can Culture Be Copyrighted?" *Current Anthropology* vol. 39, no. 2 (April 1998), pp. 193–222. He cites the Hopi and Apache cases on p. 194. See also Nigel Holman, "Photography as Social and Economic Exchange: Understanding the Challenges Posed by Photography of Zuni Religious Ceremonies," p. 93.

108. "Respect for Hopi Knowledge," http://www.nau.edu/~hcpo-p/current/hopi.nis.htm, 14 March 2001.

109. Susan Sontag, *On Photography* (New York: Farrar, Straus and Giroux, 1977), p. 64.

110. See, for example, Christopher Lyman, *The Vanishing Race and Other Illusions: Photographs of Indians by Edward S. Curtis* (Washington, D.C.: Smithsonian Institution Press, 1982).

111. George P. Horse Capture, "Foreword," in Christopher Cardozo, ed., *Native Nations: First Americans as Seen by Edward S. Curtis*. Similar sentiments of gratitude for Curtis's work are voiced almost unanimously by the many descendants of his subjects interviewed by Anne Makepeace in her 2001 film *Coming to Light: Edward S. Curtis and the North American Indians*.

112. Skeet McAuley, *Sign Language* (New York: Aperture Foundation Inc., 1989), pp. 58, 64.

7
"Print the Legend"

Epigraph: William M. Ivins, Jr., *Prints and Visual Communication* (1953; Cambridge: MIT Press, 1969), p. 136.

1. J. D. Whitney, "Report of the State Geologist on the Condition of the Geological Survey of California, [1869]," in *Appendix to Journals of Senate and Assembly of the Eighteenth Session of the Legislature of the State of California* vol. II (Sacramento: D. W. Gelwicks, 1870), Appendix, Document 5, p. 5; J. D. Whitney, "Letter of the State Geologist Relative to the Progress of the State Geological Survey of California During the Years 1866–67," in *Appendix to Journals of Senate and Assembly of the Seventeenth Session of the Legislature of the State of California* vol. I (Sacramento: D. W. Gelwicks, 1868), p. 14. For an excellent summary of Whitney's California activities see William H. Goetzmann, *Exploration and Empire: The Explorer and the Scientist in the Winning of the American West* (1966; New York: Vintage Books, 1972), pp. 355–89.

2. J. D. Whitney, *The Yosemite Book* (New York: Julius Bien, 1868), pp. 55, 58, 65, 12.

3. Ibid., p. 13fn.

4. Robert Taft, *Photography and the American Scene: A Social History, 1839–1889* (1938; New York: Dover Publications, Inc., 1964), p. 511 n.492.

5. Charles Granville Johnson, *The Territory of Arizona, embracing a history of the territory; its mineral, agricultural, and commercial advantages; its mineral, agricultural, and commercial advantages; its climate and boundaries; and the Great Colorado of the Pacific; beautifully illustrated with actual photographs of the country, the rivers, the towns, the cities, and the different Indian tribes* (San Francisco: Vincent Ryan & Co., 1869); J. A. Munk, *Story of the Munk Library of Arizoniana* (Los Angeles: The Times-Mirror Press, 1927), pp. 66–7; *California Printing: A Selected List of Books Which Are Significant or Representative of a California Style of Printing* vol. I (San Francisco: Book Club of California, 1980), pp. 20–1.

6. Estelle Jussim, *Visual Communication and the Graphic Arts: Photographic Technologies in the Nineteenth Century* (New York: R. R. Bowker Company, 1974), p. 8.

7. David Margolis, with an introduction by Martha A. Sandweiss, *To Delight the Eye: Original Photographic Book Illustrations of the American West* (Dallas: DeGolyer Library, Southern Methodist University, 1994). In *The Truthful Lens: A Survey of the Photographically Illustrated Book, 1844–1914* (New York: Grolier Club, 1980), authors Lucien Goldschmidt and Weston J. Naef use a somewhat broader definition of photographically illustrated books, including those published with tipped-in plates produced by various photomechanical processes including collotype and photogravure. In the most extensive survey of photographically illustrated books yet compiled, they estimate that there were perhaps twenty-five hundred such books produced around the world before 1915 (p. ix).

8. G. R. Fardon, *San Francisco Album: Photographs of the Most Beautiful Views and Public Buildings of San Francisco* (San Francisco: Herre & Bauer, 1856); George Robinson Fardon, with contributions by Roger Birt, et al., *San Francisco Album: Photographs of the Most Beautiful Views and Public Buildings* (San Francisco: Chronicle Books, 1999).

9. Edward Vischer, *Vischer's Pictorial of California: Landscape, Trees and Forest Scenes. . . .* (San Fran-

cisco: J. Winterburn & Company, 1870), p. 4. See also, *Edward Vischer's Drawings of the California Missions, 1861–1878* with a biography of the artist by Jeanne Van Nostrand (San Francisco: The Book Club of California, 1982); "Edward Vischer," in Peter E. Palmquist and Thomas R. Kailbourn, *Pioneer Photographers of the Far West, A Biographical Dictionary, 1840–1865* (Stanford: Stanford University Press, 2001), pp. 571–3; and Vischer's own publications of the period, including *Sketches of the Washoe Mining Region* (1862), *Vischer's Views of California: the Mammoth Tree Grove, Calaveras County, California, and Its Avenues* (1862), *Pictorial of California Landscape* (1872), and *Missions of Upper California* (1872).

10. Fr. Francisco Palou, *Noticias de la Nueva California* (San Francisco: California Historical Society, 1874).

11. George Augustus Brackett, *A Winter Evening's Tale* (New York: Printed for the Author, 1880); Margolis, pp. 58–60.

12. John S. Hittell, *Yosemite: Its Wonders and Its Beauties* (San Francisco: H. H. Bancroft & Co., 1868), p. iii.

13. Ferdinand V. Hayden, *Sun Pictures of Rocky Mountain Scenery* (New York: Julius Bien, 1870), p. vii.

14. Edgar Cherry, *Redwood and Lumbering in California Forests* (San Francisco: Edgar Cherry & Co., 1884), pp. i–ii.

15. A. E. Mathews, *Pencil Sketches of Montana* (New York: Published by the Author, 1868), "Introductory" (n.p.).

16. William Cullen Bryant, ed. *Picturesque America; or, The Land We Live In* (New York: Appleton and Co., 1874), p. iv.

17. Philip Gilbert Hamerton, *Portfolio Papers* (Boston: Roberts, 1889), pp. 334–5, cited in Estelle Jussim, *Visual Communication and the Graphic Arts: Photographic Technologies in the Nineteenth Century* (New York: R. R. Bowker Company, 1974), p. 235.

18. "Migma," in *Our Continent* vol. II, no. 21 (Nov. 29, 1882), p. 667. Citation courtesy David W. Blight.

19. Enoch Conklin, *Picturesque Arizona. Being the Result of Travels and Observations in Arizona During the Fall and Winter of 1877* (New York: The Mining Record Printing Establishment, 1878). The author is identified as a "representative of the National Associated Press and Artist and Correspondent of Frank Leslie's Publications." An engraved illustration of a scene depicting "The Continent Stereoscopic Company's Artist Viewing in Arizona" suggests that a company photographer might have accompanied Conklin on his trip, but none of the illustrations can clearly be attributed to such photographs. Nonetheless, Conklin writes, "A want has heretofore been felt for a true and accurate illustration of many of Arizona's out-of-the-way wonders. But the Continental Stereoscopic Company of New York has very materially supplied these wants during the past year, by many of these interesting points. Many of these I have secured for illustrations in this book." *Picturesque Arizona*, pp. 200, 206. The photographers whose work serves as the source for the uncredited portraits of southwestern Indians are the Washington, D.C., photographer Charles M. Bell and western survey photographer John K. Hillers.

20. Richard Irving Dodge, *The Plains of the Great West and Their Inhabitants....* (New York: G. P. Putnam's Sons, 1877), pp. 431, 432.

21. On photolithography, see Luis Nadeau, *Encyclopedia of Printing, Photographic, and Photomechan-*

ical Processes (New Brunswick, Canada: privately printed for the author, 1994), pp. 375–6; Josef Maria Eder, trans. by Edward Epstean, *History of Photography* (1905; New York: Dover Publications, Inc., 1978), pp. 608–17; Ann Shelby Blum, *Picturing Nature: American Nineteenth-Century Zoological Illustration* (Princeton: Princeton University Press, 1993), pp. 268–74; and W. T. Wilkinson, revised and enlarged by Edward L. Wilson, *Photo-Engraving, Photo-Etching, and Photo-Lithograph in Line and Half-Tone; Also Collotype and Heliotype,* American (third) edition (New York: Edward L. Wilson, 1888), pp. 129–42.

22. Thomas M. Brewer, *North American Oology, part I: Raptores and Fissirostres* (Washington: Smithsonian Institution, and New York: D. Appleton and Co., 1857). On Brewer's book, see Blum, p. 273. Brewer's book predates by three years the use of the photolithographic process in Austin A. Turner's *Villas on the Hudson* (1860), the text Nadeau cites as "the first major work illustrated with photolithographic plates in the United States." See Nadeau, p. 375, where Nadeau also makes the claim for the *Daily Graphic.* Teresa McIntosh establishes the early Canadian uses of the photolithographic processes in "W. A. Leggo and G. E. Desbarats: Canadian Pioneers in Photomechanical Reproduction," in *History of Photography* vol. 20, no. 2 (summer 1996), pp. 146–149. She notes there that a photolithographic reproduction appeared in *The Canadian Illustrated News* (17 September 1870), nearly three years before one appeared in the American press.

23. Nadeau, p. 26; Blum, p. 274.

24. Nadeau, pp. 125–6. On Osgood, see Carl J. Weber, *The Rise and Fall of James Ripley Osgood: A Biography* (Waterville, Maine: Colby College Press, 1959).

25. Weber, *Osgood,* p. 139.

26. James R. Osgood & Co., *Heliotype Engravings* (Boston: James R. Osgood & Co. Publishers, 1882).

27. Ernest Edwards, *The Heliotype Process* (Boston: James R. Osgood and Company, 1876), p. 10.

28. Charles A. Seavey, "Government Graphics: The Development of Illustration in U.S. Federal Publications, 1817–1861," *Government Publications Review* vol. 17 (1990), pp. 121–42.

29. See, Ron Tyler, "Illustrated Government Documents Related to the American West, 1843–1863," in Edward S. Carter II, ed. *Surveying the Record: North American Scientific Exploration to 1930* [*Memoirs of the American Philosophical Society,* vol. 231] (Philadelphia: American Philosophical Society, 1999), pp. 147–72; Katherine Karpenstein, "Illustrations of the West in Congressional Documents, 1843–1863," (M.A. thesis, University of California, 1939); Robert Taft, *Artists and Illustrators of the Old West* (New York: Charles Scribner's Sons, 1953), p. 256; and Robert Taft, "The Pictorial Record of the Far West: XIV. Illustrators of the Pacific Railroad Reports," *Kansas Historical Quarterly* 19 (November 1951), p. 359.

30. Ferdinand Vandiveer Hayden, *Preliminary Report of the United States Geological Survey of Wyoming and Portions of Contiguous Territories* (Washington: Government Printing Office, 1872), p. 5.

31. Ferdinand Vandiveer Hayden, *Preliminary Report of the United States Geological Survey of Montana.* . . . (Washington: Government Printing Office, 1872), p. 7; *Sixth Annual Report of the United States Geological Survey of the Territories* (Washington: Government Printing Office, 1873), p. 53; *Annual Report of the United States Geological and Geographical Survey of the Territories . . . for the Year 1874* (Washington: Government Printing Office, 1876), p. 16.

32. John Wesley Powell, *Exploration of the Colorado River of the West and Its Tributaries. Explored in*

1869, 1870, 1871, and 1872 (Washington: Government Printing Office, 1875). On the book and its illustrations, see Wallace Stegner, *Beyond the Hundredth Meridian: John Wesley Powell and the Second Opening of the West* (1953; Boston: Houghton Mifflin Company, 1954), esp. pp. 146–55, 174–85; and Joni Louise Kinsey, *Thomas Moran and the Surveying of the American West* (Washington: Smithsonian Institution Press,1992), pp. 95–132.

33. Don D. Fowler, ed. *"Photographed All the Best Scenery": Jack Hillers's Diary of the Powell Expeditions, 1871–1875* (Salt Lake City: University of Utah Press, 1972), pp. 7–8.

34. Kinsey, pp. 125–6.

35. Clarence E. Dutton, *The Tertiary History of the Grand Canon District* (Washington: Government Printing Office, 1882) [House of Representatives. 48th Cong., 2d sess. Miscellaneous Document No. 35. Department of the Interior. Monographs of the United States Geological Survey. vol. II].

36. Stegner, *Beyond the Hundredth Meridian*, p. 164.

37. Dutton, p. viii.

38. Dutton, p. 124.

39. William H. Goetzmann argues that Holmes's drawings "were better than maps, and better than photographs because he could get details of stratigraphy that light and shadow obscured from the camera." Goetzmann, *Exploration and Empire: The Explorer and the Scientist in the Winning of the American West* (1966; New York: Vintage Books, 1972), p. 513.

40. For more on Dutton, see Stegner, *Beyond the Hundredth Meridian*, pp. 158–74.

41. Arnold Hague and S. F. Emmons, *Descriptive Geology* (Washington: Government Printing Office, 1877) [King, *United States Geological Exploration of the Fortieth Parallel*, vol. II], p. ix. Bien is deserving of further study. For information on his life and work, see Peter Marzio, *The Democratic Art: Chromolithography, 1840–1900—Pictures for a Nineteenth-Century America* (Boston: David R. Godine, 1979), pp. 51–9.

42. These blank skies are a characteristic of wet-plate landscapes. The wet-collodion process is sensitive only to blue and ultraviolet light. Since the sky is richer in such light than the ground, a negative exposed to provide maximum detail of the ground will be overexposed in the sky areas. The result was often a mottled gray sky, an effect corrected by O'Sullivan and others by painting an opaque substance on the effected negative so that the skies would print as solid white. See Joel Snyder, *American Frontiers: The Photographs of Timothy H. O'Sullivan, 1867–1874* (Millerton, N.Y.: Aperture, Inc., 1981), p. 111.

43. Clarence King, *Systematic Geology* (Washington: Government Printing Office, 1878) [King, *United States Geological Exploration of the Fortieth Parallel*, vol.I], pp. 398, 9.

44. *Systematic Geology*.

45. William H. Goetzmann, "Desolation, Thy Name Is the Great Basin: Clarence King's 40th Parallel Geological Explorations," in May Castleberry, ed., *Perpetual Mirage: Photographic Narratives of the Desert West* (New York: Whitney Museum of American Art, 1996), pp. 60–1.

46. Engineer Department, United States Army, *Report Upon Geographical and Geological Explorations and Surveys West of the One Hundredth Meridian* vol. III.—Geology (Washington: Government Printing Office, 1875), p. 85.

47. "List of Plates" in ibid., p. 9.

48. The only heliotype to include a human figure is the O'Sullivan frontispiece of "Chocolate Butte, Paria Creek, Arizona." Two figures who look more like attentive scientists than like the dreamy travelers inhabiting Bell's views, gaze at a distinctive rock formation.

49. Ibid., pp. 373, xix–xx.

50. Engineer Department, U.S. Army, *Report Upon United States Geographical Surveys West of the One Hundredth Meridian. . . .* vol. I Geographical Report (Washington: Government Printing Office, 1889), p. 87. Throughout the text Wheeler employs a peculiar mix of phrases to describe the illustration plates that sometimes makes it difficult to determine the precise form and source of the illustration: "a lithograph photographically based" (p. 40); "plate prepared from a photograph by the late T. H. O'Sullivan" (p. 87); "an illuminated sketch made from a photograph" (p. 63); "a sketch from a photograph" (p. 156); and, most baffling, a "crayon lithograph plate . . . produced from a photograph by O'Sullivan, as an original" (p. 77).

51. C. H. Hitchcock, *Geology of New Hampshire,* 3 vols. (Concord: E. A. Jenks, state printer, 1874–78).

52. *Geology of New Hampshire,* vol. I, pp. x–xi; vol. II, pp. viii–xi; vol. III, pp. vii–viii.

53. *Geology of New Hampshire,* vol. I, pp. vii, x.

54. *Geology of New Hampshire,* vol. I, p. iv. Hitchcock writes, "It was found impossible to obtain a satisfactory heliotype of the view of the White Mountain range from Jackson, which was intended for the frontispiece. In its place we have inserted the view illustrating the ledges fractured by frost, upon the summit of Mt. Washington. For a similar reason, the view of the White Mountain Notch from Mt. Willard, accompanying one of the Wiley house, is copied from a hand sketch."

55. See, for example, the printed reproduction of a drawing of the Wiley Slide, *Geology of New Hampshire,* vol. I, p. 76.

56. See "Eagle Cliff Over Echo Lake" in *Geology of New Hampshire,* vol. II, opposite, p. 139.

57. *Geology of New Hampshire,* vol. II, p. 242.

58. Ferdinand Vandiveer Hayden, *Ninth Annual Report of the United States Geological and Geographical Survey of the Territories . . . in the Year 1875* (Washington; Government Printing Office, 1877), p. 22.

59. "Preface," in F. V. Hayden, *The Yellowstone National Park, and the Mountain Regions of Portions of Idaho, Nevada, Colorado, and Utah* (Boston: L. Prang and Company, 1876).

60. A. J. Russell, *Anthony's Photographic Bulletin* (April 1870), p. 34. Richard Irving Dodge invented his own peculiar way to reconcile himself to the photograph's simultaneous utility and inutility as a mode of accurate pictorial description. For his second book about his western adventures, *Our Wild Indians: Thirty-Three Years' Personal Experience Among the Red Men of the Great West* (1882), he used photographs to ensure the pictorial accuracy of his six elaborately colored chromolithographic plates of Plains Indian artifacts, sparing "no expense or pains." Dodge explained that he first photographed each group of artifacts to ensure that the objects would appear accurately in terms of their relative size. Then he placed the photographs and the artifacts themselves "in the hands of a skillful artist, who exercised the most painstaking care in painting the photograph of each article *directly from the object itself.*" Finally, the hand-painted photographs went to lithographers, who redrew the colored images onto the face of printing stones and printed each plate with at least fifteen colors to ensure "faithful representation." Behind Dodge's claims for the "perfect accuracy"

of his chomolithographic illustrations lay the paradox that was at the heart of the problem regarding photography's monochromatic state. In the end, his hand-drawn and laboriously printed chromolithographs were *superior* in descriptive detail to the monotone photographs that simultaneously established the factual authority of the prints. My discussion of this book is based on my examination of an 1884 printing. Richard Irving Dodge, *Our Wild Indians: Thirty-Three Years' Personal Experience Among the Red Men of the Great West* (Hartford: A.D. Worthington and Company, 1884), p. ix.

61. Thomas Vaughan, "C. S. Fly Pioneer Photojournalist," *The Journal of Arizona History,* vol. 30, no. 3 (1989), p. 306.

62. On the basis of stylistic features, Susan Danley argues that Gardner was the photographer in "Across the Continent," in Brooks Johnson et al., *An Enduring Interest: The Photographs of Alexander Gardner* (Norfolk: The Chrysler Museum, 1991), p. 87. D. Mark Katz suggests that Bell was in fact the photographer of these views in *Witness to an Era: The Life and Photographs of Alexander Gardner* (New York: Viking, 1991), p. 220. John Charlton persuasively argues that Gardner deserves most of the credit in "'Westward, the Course of Empire Takes Its Way': Alexander Gardner's 1867 *Across the Continent on the Union Pacific Railway, Eastern Division* Photographic Series," *Kansas History* vol. 20, no. 2 (1997), pp. 116–28.

63. William A. Bell, *New Tracks in North America,* vol. I (London: Chapman and Hall, 1869), p. ix.

64. In the photographic collections of the Henry E. Huntington Library, these are catalogued as photographs by Alexander Gardner (#470377). Unofficial library records note they are from the collection of William A. Bell. See *Huntington Library Quarterly,* vol. 42 (1978), pp. 82–3. It must be noted, however, that neither the handwritten captions, the instructions to the lithographer, nor the occasional inscriptions of Bell's name on these mounts appear to be in Bell's hand.

65. H. C. Yarrow, "Further Contribution to the Study of the Mortuary Customs of the North American Indians," in J. W. Powell, *First Annual Report of the Bureau of Ethnology . . . 1879–'80* (Washington: Government Printing Office, 1881), pp. 89–205.

66. For a general description and guide to various halftone printing processes, see Nadeau, *Encyclopedia of Printing,* pp. 121–3. For an interesting review of the pioneering Canadian attempts to develop a type-compatible halftone process, see Teresa McIntosh, "W. A. Leggo and G. E. Desbarats: Canadian Pioneers in Photomechanical Reproduction," in *History of Photography,* vol. 20, no. 2 (Summer 1996), pp. 146–9. The leggotype halftone process, patented in 1869, was used to illustrate Alex. J. Russell, *The Red River Country, Hudson's Bay & North-West Territories Considered in Relation to Canada,* 3rd ed. (Montreal: G. E. Desbarats, 1870). Perhaps the earliest book about western North America to be illustrated with a photomechanical process, the book includes eight tipped-in folded illustrations after watercolor sketches.

67. United States Census Office, 11th Census, 1890, *Moqui Pueblo Indians of Arizona and Pueblo Indians of New Mexico* (Washington: United States Printing Office, 1893); United States Census Office, 11th Census, 1890, *Report on Indians Taxed and Indians Not Taxed . . .* (Washington: Government Printing Office, 1894). On Scott, see Robert J. Titterton, "Julian Scott: Special Agent for the Eleventh Census," *Persimmon Hill* (Winter 1990–1), pp. 38–43.

Epilogue:
Pictures as History and Memory

Epigraph: Raphael Samuel, *Theatres of Memory: Volume I: Past and Present in Contemporary Culture* (London: Verso, 1994), p. 328.

1. On the selectivity of photographic documentation of the Civil War, see Keith F. David, "'A Terrible Distinctness': Photography of the Civil War Era," in Martha A. Sandweiss, ed. *Photography in Nineteenth-Century America* (New York: Harry N. Abramas, Inc., 1991), pp. 134–5.

2. See Martha A. Sandweiss, "*The West:* The Visual Record," *Western Historical Quarterly* (Autumn, 1997), pp. 304–7.

3. See www.crazyhorse.org.

4. *Humphrey's Journal* 15 January 1854, p. 305.

5. Owen Wister, *The Virginian* (1902; New York: Pocket Books, 1956), pp. 185–7.

6. G. D. Freeman, *Midnight and Noonday, or Dark Deeds Unraveled* (Caldwell, Kans.: G. D. Freeman, 1890), p. 199. Citation courtesy William S. Reese.

7. Laurel E. Wilson, "'I Was a Pretty Proud Kid': An Interpretation of Differences in Posed and Unposed Photographs of Montana Cowboys," *Clothing and Textiles Research Journal* vol. 9, no. 3 (Spring 1991), pp. 49–58.

8. Born in Ohio, Kirkland reportedly learned photography there before moving to Denver in 1872 and opening a photographic studio with his brothers George and P.G. In 1877, Charles moved to Cheyenne and by 1880 was associated with local photographer and businessman D. D. Dare. It seems most likely that Kirkland began his series of cowboy views sometime after taking over Dare's business in 1881. Carol E. Roark, Paula Ann Stewart, and Mary Kennedy McCabe, *Catalogue of the Amon Carter Museum Photography Collection* (Fort Worth: Amon Carter Museum, 1993), pp. 346–7; Cheyenne *Daily Leader* 22 April 1880; "C. D. Kirkland," Wilkerson Biographies file, Wyoming State Archives, Cheyenne. Kirkland continued to operate his photographic studio in Cheyenne until about 1895, when he sold his business (including some of his negatives) to W. G. Walker. Walker and a later owner, Mack Fishback, continued to print Kirkland's cowboy negatives under their own names. Following the sale of his Cheyenne studio, Kirkland moved back to Denver where he operated a photographic studio for several years. He died in 1926. See "Charles D. Kirkland is Buried in Denver" (Cheyenne), *Wyoming State Tribune*, 23 Aug. 1926. A large collection of Kirkland's cowboy pictures as well as a significant number of negatives are in the photographic collections of the Amon Carter Museum.

9. A card back from the seventy-four-print series can be found in the Kirkland file of the Photographic Collection at the Wyoming State Archives. A number of card backs from the eighty-print series are in the Photography Collection of the Amon Carter Museum. Both versions of the card are imprinted with this quote.

10. *Cowboy Life* (Denver: H.H. Tammen, n.d.). The copy of this book in the Beinecke Rare Book and Manuscript Library (Zc10.880cp) has a printed ad for the Denver and Rio Grande Railroad pasted to the back cover.

11. "On a Western Ranch," *Fortnightly Review* 47 (1887), p. 516; cited in Lonn Taylor and Ingrid Maar,

The American Cowboy (New York: Harper & Row, 1983), p. 17.

12. Roland Barthes, *Camera Lucida: Reflections on Photography* Richard Howard, trans. (New York: Hill and Wang, the Noonday Press, 1981), p. 89.

13. "Changes in the West," *Frank Leslie's Illustrated Newspaper,* 12 March 1887, p. 5 [?].

14. "Cowboys' Work and Ways," *Frank Leslie's Illustrated Newspaper,* 8 April 1887, pp. 118–9 [?].

15. The photographs Grabill deposited for copyright are in the Prints and Photographs Division, Library of Congress. For further information on his work at Pine Ridge, see Richard E. Jensen, R. Eli Paul, and John Carter, *Eyewitness at Wounded Knee* (Lincoln: University of Nebraska Press, 1991), pp. 56–7.

16. See the printed verso of Grabill photograph P.37185 in the collection of the Southwest Museum, Los Angeles.

17. According to *Catalogue of the Amon Carter Museum Photography Collection*, p. 308: "Following Huffman's death in 1931 his daughter, Ruth Huffman Scott continued to sell his collotypes, which had been printed in large quantities. She eventually designated Coffrin's Old West Gallery as the agent for her father's stock. They sold prints from Huffman's original inventory until 1981. In 1981, Huffman's granddaughter and great-grandsons formed Huffman Photos Ltd. to sell the remaining collotypes." In 1991 Coffrin's Old West Gallery, Bozeman, Montana, issued a catalogue offering prints, hand-painted oils, and lithographs produced from Huffman's negatives. See Coffrin's Old West Gallery, *The Huffman Pictures: Photographs of the Old West* (Bozeman: Coffrin's Old West Gallery, 1991). A large collection of Huffman prints and manuscripts was also acquired by the Buffalo Bill Historical Center in Cody, Wyoming, in 1998.

18. *L.A. Huffman: Pioneer Photographer,* exhibition catalogue (Billings: Yellowstone Art Center, 1990), p. 10.

19. Mark H. Brown and W. R. Felton, *The Frontier Years: L. A. Huffman, Photographer of the Plains* (New York: Bramhall House, 1955), pp. 26, 37. This book and a companion volume by Brown and Felton, *Before Barbed Wire: L. A. Huffman, Photographer on Horseback* (New York: Henry Holt and Co., 1956), offer the fullest biographical treatment of Huffman. A more recent catalogue, *L. A. Huffman: Pioneer Photographer* (Billings: Yellowstone Art Center, 1990), provides updated biographical information and a more analytical overview of Huffman's pictures.

20. Reproduced in *The Frontier Years,* p. 46.

21. *Huffman's Roundup View, Horses, Cattle, Sheep* . . . , catalogue (Miles City: L.A. Huffman, 1893), American Heritage Center, University of Wyoming, Laramie.

22. Ibid., p. 7.

23. *L.A. Huffman: Pioneer Photographer,* p. 15. He also sought popular venues for his literary accounts of cow-camp life. See L. A. Huffman, "Last Busting at Bow-Gun," *Scribner's Magazine* (July 1907).

24. L. A. Huffman, "The Huffman Pictures," brochure, n.d., Photography Collection, Montana Historical Society, Helena.

25. L. A. Huffman, [untitled brochure for guests of the Northern Hotel], n.d., Photography Collection, Montana Historical Society, Helena.

26. Michael Kammen, *Mystic Chords of Memory: The Transformation of Tradition in American Culture* (1991 rpt. New York: Vintage Books, 1993), pp. 294–5.

27. Brian Dippie, "The Moving Finger Writes: Western Art and the Dynamics of Change," in Jules Prown et al. *Discovered Lands, Invented Pasts: Transforming Visions of the American West* (New Haven: Yale University Press, 1992), p. 114.

28. Solomon Butcher, "Custer Country Scenery," mounted photographic print, Nebraska State Historical Society, Lincoln.

29. Walter Benjamin, *Illuminations: Essays and Reflections*, Hannah Arendt, ed. (1955 rpt., New York: Schocken Books, 1969), p. 255.

30. Pierre Nora, "Between Memory and History: *Les Lieux de Memoire*," *Representations* vol. 26 (Spring 1989), p. 9.

31. Ibid., p. 12.

Index

Geology, 301–4; Mathews, A. E., *Pencil Sketches of Montana*, 285; methods of illustration, 297–98; mixture of photographic and nonphotographic sources, 282–89, 295–314, 322–24; photomechanical reproduction technologies, 295–314; Powell, John Wesley, *Exploration of the Colorado River of the West*, 294, 295–97; precision vs perception, 299–302, 304, 308; United States Census Office, *Moqui Pueblo Indians of Arizona and Pueblo Indians of New Mexico*, 322; United States Census Office, *Report on Indians Taxed and Indians Not Taxed*, 321–23

books, photographically illustrated: Brackett, George Augustus, *A Winter Evening's Tale*, 282–84, 288; Cherry, Edgar, *Redwood and Lumbering in California Forests*, 284–85; Darwin, Charles, *Expression of the Emotions*, 290, 291, 291; defined, 382*n7*; early examples, 280–85, 384*n22*, 387*n66*; Fardon, George, *San Francisco Album*, 280–81, 281; Hayden, Ferdinand Vandiveer, *Sun Pictures of Rocky Mountain Scenery*, 171–74, 177–78, 197, 284; Hitchcock, C. H., *Geology of New Hampshire*, 312, 312–14, 313; Hittell, John S., *Yosemite: Its Wonders and Its Beauties*, 284; Landry, J., *Cincinnati, Past and Present*, 278; mixture of photographic and nonphotographic sources, 282–89, 295–314, 322–24; precision vs perception, 299–302, 304, 308; production process, 276, 278–79; resistance to, 311, 319–20, 322–23; tipped-in illustrations, 276, 282, 283, 291, 311; United States Census Office, *Moqui Pueblo Indians of Arizona and Pueblo Indians of New Mexico*, 322; United States Census Office, *Report on Indians Taxed and Indians Not Taxed*, 321–23; Vischer, Edward, *Sketches of the Wahoe Mining Region*, 283; Vischer, Edward, *Views of California: . . .*, 281–82; Whitney, Josiah Dwight, *The Yosemite Book*, 276–78

boudoir cards. *See* cabinet cards

Brackett, George Augustus, *A Winter Evening's Tale*, 282–84, 288

Brady, Mathew, 39–40, 89, 105

Bragg, Braxton, 32–33

Brewer, Thomas M., *North American Oology, part I: Raptors and Fissirostres*, 290

British Columbia, Canada, 148–54, 151

Brown, Eliphalet, Jr.: expeditionary photography, 112–14, 117; *Kura-Kawa-Kahei, Präfect von Simoda*, 116; *Regent of Lew Chew*, 112

Brown, William Garl, Jr., 27, 32

Bryant, William Cullen, *Picturesque America*, 285

Buehman, Henry, *Apaches in Ambush*, 242–43, 243

Bureau of American Ethnology, 319

Burnham, Thomas Mickell, 70

Burns, Ken, 328–29

Bush, Henry, 76

Butcher, Solomon: *Custer County, Nebraska*, 338–39; *David Hilton Homestead, Custer County, Nebraska*, 339

cabinet cards, 237, 238, 278

California, 12, 82, 277: daguerreotypes, 60–64, 66–69, 81–83; Frémont expeditions, 94, 96, 99; geologic documentation, 172–73; Jones, John Wesley, 60–69, 72–73; mission photographs, 282; panoramas, 49, 60–69, 72–73, 83–84, 96–97; photographically illustrated books, 276–78, 280–82, 284; railroad routes, 166–67; survey photography, 276; transportation routes, 114, 123–24,

128; Vance, Robert H., 81–86; westward expansionism, 156; Whitney, Josiah Dwight, *The Yosemite Book*, 12, 276–78. *See also* goldfields; San Francisco; Yosemite

calotype, 210, 216

camera lucida, 92

Cameron, James, *Death of Lieut. Col. Henry Clay Jr.*, 37

Campbell, Archibald, 148

Canada, 76, 141–54

Canadian Assiniboine and Saskatchewan Exploring Expedition of 1858, 141, 142–47

Canyon de Chelly: descriptive captions, 189; Indian presence, 255, 257–60; survey photography, 257–60, 261, 305, 308. *See also* Arizona; O'Sullivan, Timothy

captions: albums, photographic, 161–72, 176, 183–96, 200–1; attribution, 185–86, 198; cowboy photography, 331; ethnographic documentation, 245–47; as explanatory text, 160–72, 176, 188–97, 237–39, 243, 245–47, 265, 273; impact, 243, 246; Indian portraiture, 233–39, 243–44; photographic catalogues, 184, 196–204, 244–47, 272–73; railroad photography, 161, 163, 166–67; survey photography, 184–93, 200–1; viewer interpretations, 184–85. *See also* literary narratives, as component of photography

Carbutt, John, 278

Carleton, James H., 31

Carlisle Institute, 239, 241

Carr, Richard, 24–25

Carson, Kit, 90

Carvalho, Solomon Nunes: *Cheyenne Family—a Warrior, His Mother, Wife and Child*, 106; *Cheyenne Village at Big Timbers*, 104; Frémont expeditions, 89, 100–8, 120, 181, 358*n14*, 361*n48*; *The Huerfano Butte*, 107; Indian photography, 220

catalogues, photographic: Bierstadt Brothers, *Catalogue of Photographs*, 139–40; cowboy photography, 330–37, 331, 334; Jackson, William Henry, *Descriptive Catalogue of Photographs of North American Indians*, 201–4; Jackson, William Henry, *Descriptive Catalogue of the Photographs of the United States Geological Survey of the Territories, for the Years 1869 to 1875, Inclusive*, 196–98; Jackson, William Henry, *Photographs of the Yellowstone National Park and Views in Montana and Wyoming*, 198–201; Shindler, A. Zeno, *Photographic Portraits of North American Indians in the Gallery of the Smithsonian Institution*, 244–46; Vance, Robert H., *Catalogue of Daguerreotype Panoramic Views in California by R. H. Vance*, 81, 82, 83, 85; Yellowstone National Park, 335–37. *See also* captions; Native Americans; photographs, paper; photography, landscape; photography, survey; portraiture

catastrophism, 195

Catlin, George: Indian Galleries, 78–80, 136, 218–19; *Ioway Indians Performing with Catlin's Indian Gallery Exhibition, Egyptian Hall, London*, 79

cattle ranching, 331–33, 335

Central Pacific Railroad, 158–61, 166–67

Chaco Canyon, 255–57, 263

Chapin, J. S., 66

Chappell, Alonzo, 70, 71, 354*n82*

Cherry, Edgar, *Redwood and Lumbering in California Forests*, 284–85

China, 113–14, 116, 174

Chinese laborers, 160, 369*n5*

Choate, J. N.: Indian photography, 239, 241–42; *Tom Tor-*

59–60; theatrical presentations, 51–53, 61, 70–71, 113; topographic documentation, 48, 57, 96; Twain, Mark, *Life on the Mississippi*, 57; unknown artist, *The Bombardment of Vera Cruz*, 52; unknown artist, *Grand Moving Panorama of California*, 61; unknown artist, *Lectures on Col. Frémont's Travels*, 96; unknown photographer, *View of San Francisco*, 62; urban, 61–63; Weaver, George, *Grand [Moving] Panorama of the Overland Route to California*, 61; western expeditions, 89, 94–96, 111; westward expansionism, 49–50; Wilkins, James F., *Moving Mirror of the Overland Trail*, 64; Wimar, Carl, *Laying Down of Arms, by 2700 Border Ruffians*, 75. *See also* overland travel panoramas; paintings, as documents

pantoscopes. *See* Jones, John Wesley

paper negative process, 210, 216

paper photographs. *See* photographs, paper

Passage to India, 112

Peale, Rembrandt, 129

Peale, Titian Ramsey, 141

Pearson, W., 70, 354*n*82

Perry, Matthew, 113–14

Phillips, George S. *See* Dix, John Ross

photographic narratives, 234, 249–51, 338. *See also* literary narratives, as component of photography; narrative aspects of images

photographic processes: albertype, 200, 289, 290–91; ambrotype, 3, 117, 217; calotype, 210, 216; dry-plate technology, 225; glass lantern slides, 174–76; halftone technology, 107, 289, 308, 320, 323; heliotype, 289, 291–92, 298, 304–5, 308; Kodak camera, 225, 226–27, 263; paper negative, 114, 115, 210, 216; photolithography, 289–90, 300–1, 384*n*22; talbotype, 114, 115; tintype, 8, 217; wax paper negative, 101–2. *See also* daguerreotypes; wet-plate negative process

photographs, paper: adaptability, 166; albums, photographic, 164, 165–66, 169–72, 176, 183–96, 200–1; alterations of, 146, 147, 148, 176, 301, 316–19, 337; Bierstadt Brothers, *Catalogue of Photographs*, 139–40; from daguerreotypes, 89, 105–7, 113–15; expedition reports, 138, 142–45, 146, 152–54; format, 8, 164–76, 183–96, 200–1, 237–38, 280, 299, 313; imagined future, 158–80, 182; interior West, 234; limitations, 304, 311–13, 315–16, 320; literary narratives, 38–39, 126, 166, 169–72, 184–89; marketing strategies, 39, 140, 176, 181, 217, 234, 311–12, 320; meaning, 265–66, 271–72, 299–306; panoramas, 62–64; photographic catalogues, 196–204; as political tool, 142, 146; popularity, 137, 139–41, 166–67, 323–24; portfolios, 144–46; preservation of details, 264–65; publishing innovations, 164–66, 181, 183; reproducibility, 122, 320, 322–23; as scientific documentation, 181–82; as source for graphic reproductions, 153, 165–66, 174–76, 181, 279–80, 286–97, 316–20; value as documentation, 181, 261–64, 323, 327–29; value as images, 13, 41–42, 125–26, 264–66, 286, 287; value as photographic narrative, 234; wet-plate negative process, 39, 98, 105, 118, 122, 125–26. *See also* historical documents, photographs as; photography, survey

photography: as agent of change, 227; changing technology, 7, 205, 216, 225, 234, 289–91, 320–24, 361*n*51; distribution methods, 205–6; emotional impact, 299–300; ethnographic documentation, 109–10, 244–47, 319–20; as historical artifacts, 342–43; as historical documentation,

7–11, 13–14, 42, 160–61, 171; imagined past, 335, 337–38; imagined West, 3–4, 13–14, 21, 45, 158–80, 182; impact, 6–7, 9–10, 243; limitations, 97–98, 122, 304, 311–13, 315–16, 320, 327–28, 385*n*42; linear representation, 163, 166; literalism, 285, 289, 308; mass reproduction, 118–20, 278; metaphorical language, 377*n*26; mixture of photographic and nonphotographic sources, 288–89, 295–324; narrative aspects, 7–10, 13–14, 122, 295–302, 304–5, 329–30, 338; Native American terms for photography, 221–25; negative associations, 220–21; as originating source, 282, 287; panoramas, 62–64, 76; physical stability, 292; as political tool, 212, 295; popularity, 10–11, 13, 323–24; precision vs perception, 299–302, 304–5, 308; private, 4; public, 4; purpose, 2–4, 6–9, 13–14, 23, 233; as reproductive medium, 282–84; restricted access, 269–72; as scientific documentation, 7–11, 13–14, 42, 91, 97, 180, 181–82; snapshot, 222, 225; as source for graphic reproductions, 135–36, 148–49, 165–66, 279–80, 286–97, 304–5; staged scenes, 40, 210; as tool of visual communication, 279, 285; topographic documentation, 96–98, 129, 141; value as documentation, 181, 308, 311, 327–29; violence, as theme, 288–89, 330–31; as visual narrative, 342–43; West Point, 128–29. *See also* accuracy, pictorial; books, photographically illustrated; daguerreotypes; meaning of photographic image; photography, competition with other media; photography, expeditionary; photography, landscape; portraiture

photography, competition with other media: books, photographically illustrated, 279–80, 282–89, 295–324; daguerreotypes, 45, 51, 72–74; as historical documentation, 10–11; narrative aspects, 13, 30–39, 54–57, 77, 205–6, 296–97; Native Americans as threat, 241–43; stereographs, 59–60; Vance, Robert H., 84–86

photography, expeditionary: American Southwest, 255–57; Canadian, 141–54; Carvalho, Solomon Nunes, 89, 100–8, 120, 181, 358*n*14, 361*n*48; daguerreotypes, 90–92, 98–103, 108–19; Frémont, John Charles, 88–89, 92–96, 98–108; Hime, Humphrey Lloyd, 142–47; Hutton, James D., 132–35, 365*n*22, 365*n*23; Ives expedition, 122–23, 293, 364*n*2; Jones, John Wesley, 64–72; landscape photography, 128–35; limitations, 97; marketing strategies, 146, 367*n*59; popularity, 166; railroad photography, 163–65; Raynolds, William F., 132–33; Simpson expedition, 128–32, 255–57; Stevens expedition, 108–11; topographic documentation, 64, 92–94, 122, 128–29, 136–37; transportation routes, 93, 99, 110–12, 113–14; wet-plate negative process, 122–23, 132–34, 137–38, 141–54

photography, field, 90–93, 98, 124, 133–36, 141–42, 149–54, 169–70, 365*n*23

photography, landscape: album format, 183–86; ancient Indian sites, 250–64; attribution, 185–86; Bierstadt, Albert, 137–41; Easterly, Thomas M., 253–54; expeditionary photography, 128–35; human history, 176–78, 180, 190, 200–1, 205–6; imagined future, 205–6, 250–51; Indian portraiture, 201–4; Indian presence, 205, 250–60; limitations, 315–16; literary narratives, 184–85, 206; marketing strategies, 137–41; photographic catalogues, 201–4; photographic metaphors, 222; as political tool, 182, 185, 189, 206; railroad photography, 165–72; resource potential, documentation of, 180, 184, 187, 189, 201, 203–4, 250–51; as scientific documentation, 181–85, 197–204; shifting meanings, 185–86; stereographs, 137; survey

photography, 181–85, 196–205, 249–51; wet-plate negative process, 122–29

photography, railroad: albums, photographic, 164, 165–66, 169–72, 176; Chinese laborers, 160, 369n5; Gardner, Alexander, 161–66, 178–80; glass lantern slides, 174–75; golden spike ceremony, 158–61; Hart, Alfred A., 158–61; as historical documentation, 158–61, 166–67, 176–80, 182; Indian presence, 176–78; Jackson, William Henry, 197; landscape photography, 165–72; linear representation, 77–78, 163, 166, 176; literary narratives, 161–63, 166–67, 176; Russell, Andrew J., 158–61, 169–72, 176–77; Savage, Charles R., 158–61; as source for graphic reproductions, 164–66, 174–76; stereographs, 161, 164, 166–67, 174; theatrical presentations, 174–76. *See also* Russell, Andrew J.

photography, survey: albums, photographic, 183–96, 200–1; American Southwest, 257–64; attribution, 185–86, 298; California, 276; Canyon de Chelly, 255, 257–61; exhibition catalogues, 262; Hayden survey, 136, 180–83, 196–204, 246, 260–63, 294; as historical documentation, 183–84; Jackson, William Henry, 185, 196–204, 260–63; King survey, 181, 194–96, 299–300; landscape photography, 181–85, 196–205, 249–51; legends, descriptive, 184–93, 200–1; North American Boundary Survey (1857), 141, 148–54, 368n70; O'Sullivan, Timothy, 257–59; photographic catalogues, 196–204; photographic output, 293–94; as political tool, 182, 185, 200; popularity, 189, 185; Powell survey, 182, 185, 295–97; purpose, 180–81; reproducibility, 294; shifting meanings, 187–96; Shoshone Falls, Idaho, 194–96, *195*; Wheeler survey (United States Geographic Surveys West of the One Hundredth Meridian), 182, 184, 186–96, 257–59, 304–11

photolithography, 289–90, 300–1, 384n22

photomechanical reproduction technologies: books, photographically illustrated, 295–314; scientific documentation, 289–92, 293–94, 296–300; technological innovations, 7, 205, 216, 225, 234, 289–91, 320–24, 361n51. *See also* albertype; halftone technology; heliotype process

Pillow, Gideon J., 30

Pino, Pedro (Lai-iu-ah-tsai-ah), 233

Plumbe, John, 24

Polk, James K., 17, 99

Polock, L. H., 26

Pomarede, Leon, *Portrait of the Father of the Waters*, 53, 58, 74

Poore, Henry, 323

portfolios, 144–46

portraiture: authenticity, 246; floating photography galleries, 59; as historical documentation, 329–30; impact on families, 4, 6; invented views, 331–34; marketing strategies, 217, 331–32; meaning, 265–66; Native Americans, 109–10, 135–36, 138, 152, 201–4, 208–49, 262–63; photographic catalogues, 217, 244–47, 249; as political tool, 212, 215; public meanings, 235, 237–39, 243, 245–47, 273; purpose, 215–16, 233; visual symbolism, 331

Powell, John Wesley: Beaman, E. O., 185, 224; *Exploration of the Colorado River of the West*, 294, 295–97; government surveys, 182, 185, 295–97; Jackson, William Henry, 185

Powell survey (United States Geographical and Geological Survey of the Rocky Mountain Region), 182, 185, 295–97

prairies, North American, 89, 145–48, 164

Pratt, Richard Henry, 241

Preuss, Charles, 93–94

printmaking: actino-engraving, 97; chromolithography, 29, 293, 297–98, 304, 308–9, 319–20, 386n60; color, 29, 109, 293, 298, 308, 314; invented views, 37; Mexican-American War, 29–39; painting, 3, 27, 122; popularity, 27–39, 45; as reproductive medium, 286–89; scientific drawings, 3, 10; technical process, 287; transparencies, 16–18, 23, 32–34. *See also* engravings; lithographs; panoramas; photographs, paper; sketches

Prugh, Joshua, 66, 353n80

Putnam, F. W., 308

Pyle, Howard, 265

Quesenbury, William: Jones expedition, 68–69, 353n80; *Last View of Laramie River and Continuation of Cañon on North Platte*, 68; sketches, 353n74

Quitman, John A., 30

racial prejudice, 243–46

railroad photography. *See* photography, railroad

Raynolds, William F., 132–34, 365n22, 365n23

Renwick, James, 91–92

Richards, William, 208

Ringgold, Cadwalader, 115, 362n74

Robert Gould Shaw Memorial, 42

Roche, Richard, 150

Rocky Mountains: Bierstadt, Albert, 138; daguerreotypes, 90, 102–3, 106–8, 120; Frémont expeditions, 88, 93–94, 102–3, 106–8, 120; Hayden survey, 180–83; landscape photography, 204; survey photography, 262. *See also* Jackson, William Henry; Yellowstone National Park

Rodgers, John, 112, 115

Roosevelt, Theodore, 263

Rosaldo, Renato, 235

Ross, John, 208

Ross, Lewis, 210, 215

Royal Engineers, 149–50

Running Antelope, 238

Russell, Andrew J.: color in photography, 316; *Dale Creek Bridge from Above*, 170; *East Meets West at the Laying of the Last Rail*, 160; golden spike ceremony, 158–61; *The Great West Illustrated*, 169–72, 176–77; *Panorama of the War for the Union*, 77–78; railroad photography, 169–78, 197, 198; *Salt Lake City*, 173; *Shoshone Indians on Warpath*, 177; *Sun Pictures of Rocky Mountain Scenery*, 171–74, 177–78, 197, 284; *The Wind Mill at Laramie*, 172

Russell, Charles M., *The West That Has Passed*, 338

Ryan, William Redmond, 95

Sacred Feathers. *See* Jones, Peter

Saltillo, Mexico, 21–23, 33, 35, 44, 44–45

salt prints. *See* wet-plate negative process

San Francisco: daguerreotypes, 81, 83; Fardon, George, *San Francisco Album*, 280–81, *281*; illuminated lectures, 174; Mission Dolores, 73, 83, 281; panoramas, 57, 60–64, 83; Vance, Robert H., 81–86, 142

Savage, Charles R., 76, 158–61, 168, 198

Sayre, Gordon, 255

Schoenborn, Antoine, 132

scientific documentation: daguerreotypes, 91, 97; heliotype process, 292, 304–5; naval expeditions, 112; photome-

chanical reproduction technologies, 289–92, 293–94, 296–300; survey photography, 181–85; value of photographs, 180–81; Yellowstone National Park, 198–201
Scott, Julian, 322
Scott, Winfield, 16, 17, 18, 26
sculptors, 27
sectional factionalism, 75
Sedgwick, Stephen J., *280 Nights! Prof. S. J. Sedgwick's Illuminated Lectures Across the Continent*, 174–76, *175*, 370*n22*, 371*n27*
Sekula, Alan, 247
Selkirk, James, 329
Selkirk, James H., 329
Seymour, Samuel, 141
Shaw, Seth Louis, 66–67
Sherman, William T., 327
Shew, William, 62, 67
Shindler, A. Zeno: Indian photography, 201; *Photographic Portraits of North American Indians in the Gallery of the Smithsonian Institution*, 244–46
Shirlaw, Walter, *Omaha Dance, Northern Cheyennes—Tongue River Agency, Mont. August, 1890*, 322, *323*
Shlaer, Robert, 358*n14*, 361*n48*
Shoshone Falls, Idaho, 194–96, *195*
Shufelt, Sheldon, 66, 353*n80*
Silko, Leslie Marmon, 233
Silva, J. P., 174
Simpson, James H., 128–32, 255–57, 293, 364*n17*
Simpson, Samuel F., 58, 60
Sitting Bull, 230, 237, 329
sketches: engravings of, 116, 291; expedition reports, 116, 122, 141, 364*n17*; field documentation, 90–91, 109–11, 124, 129, 154, 261, 282, 322; invented views, 288; lithographs of, 282, 297–98; Mexican-American War, 30–32; panoramas, 50–51, 68–70, 90–93, 113; pictorial accuracy, 282, 286; as source of photograph, 282; topographic documentation, 92, 128–29, 132–35
Skirving, John, *Colonel Frémont's Overland Route to Oregon and California Across the Rocky Mountains*, 94–97
slavery, 49–50, 57, 74, 77, 164
Smith, H. Armour, 346*n13*
Smith, Henry Nash, 205
Smith, J. H. William, 346*n13*
Smith, John Rowson, 53, 58
Smith, O. C., 174
Smith, Paul Chaat, 230
Smith, T. O., 100
Smith, W. Morris, *Dedication of Monument on Bull Run Battlefield*, *43*
Smithsonian Institution, 220, 244, 319
Smutty Bear (Ma-to-sa-bi-tshi-a), 235, 266, *268*
snapshot, 222, 225, 320
Sontag, Susan, 270
South America, 81–82, 84
South Dakota, 335
Stanley, John Mix: Indian Galleries, 80, 136, 210; Indian photography, 220; Lander, Frederick West, 137; *Lieut. Grovers Despatch—Return of Governor Stevens to Fort Benton*, *110*; Stevens expedition, 108–11
Stegner, Wallace, 297
stereographs: Holmes, Oliver Wendell, 136, 140, 222; Indian portraiture, 236–39, 243–44; landscape photography,

137–41; marketing strategies, 235–37; Mississippi River, 59–60; narrative aspects, 236–37; organization, 236; as popular entertainment, 137, 139–41, 161–63, 174–76, 222, 235–39; railroad photography, 161, 163–64, 166–67, 174; survey photography, 183–86
Stevens, Isaac Ingalls, 108–11, 137, 220
Stewart, E. J., 59
Stewart, Sir William Drummond, 95
St. Louis, Missouri, 212, 253–54
Stockwell, Samuel B., 58
Struck By The Ree (Pa-da-ni A-pa-pi; He Whom a Pawnee Struck), 266, *267*
survey photography. *See* photography, survey
Sutter, John, 2

Taft, Robert: historical research, 372*n40*, 372*n42*, 378*n43*; *Photography and the American Scene*, 132, 346*n13*
talbotype process, 114, 115
Taylor, Zachary, 16, 17, 18, 22, 27, 32, 346*n13*, 347*n22*
Texas, 329–30
theatrical presentations, 51–53, 61, 70–71, 80, 113, 174–76
Thomas, David Hurst, 264
Thompson, Gilbert, *Crossing of the Colorado River near Mouth of Paria Creek*, 309, *310*
Thoreau, Henry David, 53
Toplin, N. P., 66–67
topographic documentation: accuracy, 54–58, 64, 68–70, 129, 285, 301–4; daguerreotypes, 91, 96–97, 98, 112, 120; Frémont expeditions, 93–94, 99; Grand Canyon region, 298; Great Basin region, 300; heliotypes, 313; landscape photography, 128–29, 131–35; naval expeditions, 112; panoramas, 48, 57, 96–97; photography as tool, 97, 141; Rocky Mountains, 182; sketches, 92, 128–29, 132–35; survey photography, 187; western expeditions, 64, 92–94, 122, 128–29, 136–37, 256; Yellowstone National Park, 200. *See also* geologic documentation
Tourgée, Albion, 285–86
transcontinental railroad: Frémont expeditions, 88; Pacific Railroad Survey, 99, 108; railroad photography, 176; Stanley, John Mix, 108, 111; Stevens expedition, 108–11; Union Pacific Railroad, 158–61, 164
transparencies, 16–18, 23, 32–34, 45, 52–53
Treaty of Guadalupe Hidalgo, 20–21
Turner, Frederick Jackson, 204–5, 322
Twain, Mark. *See* Clemens, Samuel

Union Pacific Railroad: documentation, 158–61, 169–72; Gardner, Alexander, 164; Jackson, William Henry, 197; Kirkland, Charles D., 332; panoramas, 76; Russell, Andrew J., 77, 158–61, 169–72
United States Census Office, *Moqui Pueblo Indians of Arizona and Pueblo Indians of New Mexico*, 322
United States Census Office, *Report on Indians Taxed and Indians Not Taxed*, 321–23
United States Exploring Expedition of 1838–1842, 292
United States Geographical and Geological Survey of the Rocky Mountain Region. *See* Powell survey (United States Geographical and Geological Survey of the Rocky Mountain Region)
United States Geographic Surveys West of the One Hundredth Meridian. *See* Wheeler survey (United States Geographic Surveys West of the One Hundredth Meridian)

United States Geological and Geographical Survey of the Territories. *See* Hayden survey (United States Geological and Geographical Survey of the Territories)

United States Geological Exploration of the Fortieth Parallel. *See* King survey (United States Geological Exploration of the Fortieth Parallel)

United States Geological Survey, 181, 297

United States Geological Survey of the Territories. *See* Hayden survey (United States Geological and Geographical Survey of the Territories)

United States Surveying Expedition to the North Pacific Ocean, 112, 114, 116

Upham, Charles Wentworth, *Life, Explorations, and Public Services of John Charles Frémont*, 89, 106

Utah: Carvalho, Solomon Nunes, 102, 105; Frémont expeditions, 89, 102; golden spike ceremony, 158–61; Promontory Point, 158, 178; railroad photography, 169–71; Salt Lake City, 169, 172–73, *173*; Savage, Charles R., 76, 158–61, 168, 198; transportation routes, 128. *See also* Mormons

Vance, Robert H.: biographical data, 81–82; *Catalogue of Daguerreotype Panoramic Views in California by R. H. Vance*, 81, 82, 83, 85; daguerrean panoramas, 83–86, 142

vanishing race ideology: ancient Indian sites, 260–64; Burns, Ken, 329; Curtis, Edward S., 219, 270; narrative aspects, 249–54, 260–63; role of photography, 217–19, 223, 227, 233, 235–39, 260–66, 272–73; Wister, Owen, 227

Vannerson, Julian: Indian photography, 244; *Little Crow*, 248; *Smutty Bear*, 268; *Struck By The Ree*, 267

violence, as theme, 288–89, 330–31

Vipond, Arthur, 150

Vischer, Edward: *Sketches of the Wahoe Mining Region*, 283; *Views of California . . .*, 281–82; views on photographically illustrated books, 281–82

visual symbolism: Civil War, 41–42; cowboy photography, 330–37; daguerreotypes, 41–42, 45; Gardner, Alexander, 161–67; Mexican-American War, 32–37, 45; railroad photography, 161–63, 165–67. *See also* heroism

Vogel, Hermann W., 222

von Humboldt, Alexander, 99–100

Vroman, Adam Clark, 323

Walker, James, *The Storming of Chapultepec Sept. 13th. 1847*, 30, 31

Walker, W. G., 388*n*8

Walking Elk, 269

Ward, Artemis, 76

Washakie, 226

Washington, John M., 255–57

Washington Territory, 146, 150–52

Watchful Fox. *See* Keokuk

Watkins, Carleton E.: *El Capitan*, 12; survey photography, 154, 182, 183–84, 293; *The Yosemite Falls*, 276, 277

Weaver, George, *Grand [Moving] Panorama of the Overland Route to California*, 61

Webster, Lucien, 19, 23

Webster, Noah, 255

Weir, Robert Walter, 129

western expeditions. *See* expedition reports; government surveys; photography, expeditionary

West Point, 128–29

westward expansionism: American nationalism, 90, 106, 156–58, 166; Benton, Thomas Hart, 88; daguerreotypes, 74, 78; imagined future, 204–5, 235; literary narratives, 234, 251; panoramas, 49–50; transportation routes, 93, 99, 110–12, 113–14, 128, 138, 139. *See also* photography, railroad; photography, survey

wet-plate negative process: Civil War, 39–44; field documentation, 122–25, 129, 141–42, 365*n*23; historical background, 11, 13, 39, 98; limitations, 122–23, 130, 316, 385*n*42; marketing strategies, 78, 125–26, 137, 140, 144, 146, 205–6, 216–17; paper photographs, 39, 98, 105, 118, 122, 125–26; reproducibility, 122; technical process, 39, 124–28, 242. *See also* photography, landscape; photography, railroad; photography, survey

Wheeler, George Montague: government surveys, 181–82, 184, 186–96, 257–59, 304–11; *Photographs . . . Obtained in Connection with Geographical and Geological Explorations and Surveys West of the 100th Meridian*, 186–96, 258, 259; *Report upon Geographical and Geological Explorations and Surveys West of the One Hundredth Meridian*, 305, 306; *Report upon U.S. Geographical Surveys West of the One Hundredth Meridian*, 305–11, 386*n*50

Wheeler survey (United States Geographic Surveys West of the One Hundredth Meridian), 181–82, 184, 186–96, 257–59, 304–11

White, Mrs., 90

Whitehurst, Jessie, 83

Whitney, Josiah Dwight, *The Yosemite Book*, 12, 276–78

Whittier, John Greenleaf, 48, 57

Wilkes, Charles, 95, 292

Wilkins, James F., *Moving Mirror of the Overland Trail*, 54, 64

Wilson, Charles William, 150

Wimar, Carl: Indian photography, 220; *Laying Down of Arms, by 2700 Border Ruffians*, 75, 355*n*101; Pomarede, Leon, *Portrait of the Father of the Waters*, 74

Wister, Owen: "Bad Medicine," 226–27; *The Virginian*, 225–26, 330–31

Woodruff, Israel, 98

Wool, John E., 21–23, *22*, 44–45

The World's Panorama Company, 75–76

Wyoming: Frémont expeditions, 93, 105; Lander expedition, 138–39; Laramie, 172; railroad photography, 169–71; Washakie Basin, 301–2. *See also* cowboy photography; Kirkland, Charles D.; Russell, Andrew J.; Yellowstone National Park

Yellowstone National Park: geologic documentation, 198–201, 314–16; illuminated lectures, 174; Indian presence, 198–201; photographic catalogues, 335–37; survey photography, 182–83, 262; Wister, Owen, 226–27. *See also* Hayden, Ferdinand Vandiveer; Jackson, William Henry; Moran, Thomas; Rocky Mountains

Yosemite, 12, 174, 276–78, *277*, 284, 352*n*59

Young, J. J.: *Robinson's Landing, Mouth of Colorado River*, *123*, 364*n*2; watercolors, 364*n*17